Malek Alloula//Louis Aragon//J KU-793-047
Walter Benjamin//Nicolas Bourri..., ...ure Breton//
Katrina M. Brown//Benjamin H.D. Buchloh//Johanna
Burton//Deborah Cherry//Douglas Crimp//Thomas
Crow//Guy Debord//Georges Didi-Huberman//Marcel
Duchamp//Paul Éluard//Okwui Enwezor//Robert Fisk//
Gustave Flaubert//Jean-Luc Godard//Jean-Pierre
Gorin//Isabelle Graw//Johan Grimonprez//Boris Groys//
Raoul Hausmann//Barbara Kruger//Sherrie Levine//
Lucy R. Lippard//Sven Lütticken//Cildo Meireles//
David A. Mellor//Kobena Mercer//Slobodan Mijuskovic//
Laura Mulvey//Michael Newman//Miguel Orodea//
Richard Prince//Jorma Puranen//Retort//Lucy Soutter//
Jo Spence//John Stezaker//Susan Stoops//Elisabeth
Sussman//Gene R. Swenson//Lisa Tickner//Reiko
Tomii//Jeff Wall//Andy Warhol//John C. Welchman//
Gil J. Wolman

Whitechapel Gallery
London
The MIT Press
Cambridge, Massachusetts

Edited by David Evans

APPROPRIATION

Documents of Contemporary Art

Co-published by Whitechapel Gallery
and The MIT Press

First published 2009
© 2009 Whitechapel Gallery Ventures Limited
All texts © the authors or the estates of the authors,
unless otherwise stated

Whitechapel Gallery is the imprint of Whitechapel
Gallery Ventures Limited

ISBN 978-0-85488-161-1 (Whitechapel Gallery)
ISBN 978-0-262-55070-3 (The MIT Press)

A catalogue record for this book is available from
the British Library

Library of Congress Cataloging-in-Publication Data

Appropriation / edited by David Evans.
 p. cm. – (Whitechapel, documents
of contemporary art)
 Includes bibliographical references and index.
 ISBN 978-0-262-55070-3 (pbk. : alk. paper)
 1. Appropriation (Art) 2. Art, Modern—20th
century. I. Evans, David.
 N6494.A66A67 2009
 709.04–dc22
 2008037036

10 9 8 7 6 5 4

Series Editor: Iwona Blazwick
Commissioning Editor: Ian Farr
Project Editor: Sarah Auld
Design by SMITH
Justine Schuster
Printed and bound in China

Cover, front: John Stezaker, Love X (2006). Collage.
Private Collection, London. © John Stezaker.
Courtesy of The Approach, London. Inside flap:
Douglas Gordon, Self-Portrait of You + Me (Denise
Richards) (2006). Smoke and mirror. © Douglas
Gordon. Courtesy of Gagosian Gallery.

Whitechapel Gallery Ventures Limited
77-82 Whitechapel High Street
London E1 7QX
whitechapelgallery.org
To order (UK and Europe) call +44 (0)207 522 7888
or email MailOrder@whitechapelgallery.org
Distributed to the book trade (UK and Europe only)
by Central Books
www.centralbooks.com

The MIT Press
Cambridge, MA 02142
MIT Press books may be purchased at special
quantity discounts for business or sales
promotional use. For information, please email
special_sales@mitpress.mit.edu

Whitechapel Gallery

Documents of Contemporary Art

In recent decades artists have progressively expanded the boundaries of art as they have sought to engage with an increasingly pluralistic environment. Teaching, curating and understanding of art and visual culture are likewise no longer grounded in traditional aesthetics but centred on significant ideas, topics and themes ranging from the everyday to the uncanny, the psychoanalytical to the political.

The Documents of Contemporary Art series emerges from this context. Each volume focuses on a specific subject or body of writing that has been of key influence in contemporary art internationally. Edited and introduced by a scholar, artist, critic or curator, each of these source books provides access to a plurality of voices and perspectives defining a significant theme or tendency.

For over a century the Whitechapel Gallery has offered a public platform for art and ideas. In the same spirit, each guest editor represents a distinct yet diverse approach – rather than one institutional position or school of thought – and has conceived each volume to address not only a professional audience but all interested readers.

Series Editor: Iwona Blazwick; Commissioning Editor: Ian Farr; Project Editor: Sarah Auld; Editorial Advisory Board: Roger Conover, Neil Cummings, Mark Francis, David Jenkins, Kirsty Ogg, Magnus af Petersens, Gilane Tawadros

it was plagiarism, a plain piece of plumbing

Anon., 'The Richard Mutt Case', 1917

INTRODUCTION//012

PRECURSORS//024
AGITPROP//048
THE SITUATIONIST LEGACY//064
SIMULATION//074
FEMINIST CRITIQUE//104
POSTCOLONIALISM//126
POSTCOMMUNISM//140
POSTPRODUCTION//156
APPRAISALS//176

BIOGRAPHICAL NOTES//226
BIBLIOGRAPHY//231
INDEX//233
ACKNOWLEDGEMENTS//239

PRECURSORS
Gustave Flaubert Dictionary of Received Ideas,
 1850–80//026
Anon. The Richard Mutt Case, 1917//026
Louis Aragon The Challenge to Painting, 1930//027
Raoul Hausmann Photomontage, 1931//029
André Breton and Paul Éluard The Object, 1938//031
Georges Didi-Huberman Modest Masterpiece:
 Bertolt Brecht's *War Primer* (1955), 2007//032
Guy Debord and Gil J. Wolman Directions for the
 Use of Détournement, 1956//035
Marcel Duchamp Apropos of 'Readymades', 1961//040
Andy Warhol Interview with Gene R. Swenson,
 1963//041
Jeff Wall On Dan Graham's *Homes for America*
 (1966–67), 1988//043
Reiko Tomii Rebel with a Cause: Akasegawa Genpei's
 Greater Japan Zero-Yen Note (1967), 2000//045

AGITPROP
Lucy R. Lippard On the Art Workers' Coalition:
 Q. And babies? A. And babies, 1970//050
Cildo Meireles Insertions in Ideological Circuits,
 1970//051
Jean-Luc Godard and Jean-Pierre Gorin Inquest on
 an Image, 1972//052
Miguel Orodea Álvarez and Vertov, 1980//056
Susan Stoops Martha Rosler: *Bringing the War Home*
 (1967–2004), 2007//058

THE SITUATIONIST LEGACY
Guy Debord The Use of Stolen Films, 1989//066
Johan Grimonprez On *Dial H-I-S-T-O-R-Y*: Interview with
 Pierre Bal-Blanc and Mathieu Marguerin, 1998//067

Retort The New 1914 That Confronts Us: Interview with
 David Evans, 2007//069

SIMULATION
Douglas Crimp Pictures, 1979//076
Jean Baudrillard The Precession of Simulacra,
 1981//080
Sherrie Levine Statement, 1982//081
Michael Newman Simulacra, 1983//082
Richard Prince Interview with Peter Halley, 1984//83
Thomas Crow The Return of Hank Herron, 1986//087
Elisabeth Sussman The Last Picture Show, 1986//092
John Stezaker Interview with John Roberts, 1997//095
David A. Mellor Media-Haunted Humans: Cindy
 Sherman, Richard Prince, John Stezaker, 1998//099

FEMINIST CRITIQUE
Barbara Kruger 'Taking' Pictures, 1982//106
Jo Spence What is a Political Photograph?, 1983//107
Lisa Tickner Sexuality and/in Representation,
 1984//108
Barbara Kruger Interview with Anders Stephanson,
 1987//111
Laura Mulvey A Phantasmagoria of the Female Body:
 The Work of Cindy Sherman, 1991//118
Deborah Cherry Maud Sulter: *Zabat* (1989), 2003//124

POSTCOLONIALISM
Malek Alloula The Colonial Harem, 1981//128
Kobena Mercer Maroonage of the Wandering Eye:
 Keith Piper, 1996//131
Jorma Puranen Imaginary Homecoming, 1999//135
Okwui Enwezor *Créolité* and Creolization, 2002//137
Robert Fisk Retaking Iwo Jima (Tehran 1979), 2005//139

POSTCOMMUNISM

Slobodan Mijuskovic Discourse in the Indefinite
 Person, 1987//142
Walter Benjamin Interview with Beti Zerovc, 2006//149
Boris Groys Interview with John-Paul Stonard,
 2007//153

POSTPRODUCTION

Nicolas Bourriaud Deejaying and Contemporary Art,
 2002//158
Katrina M. Brown Douglas Gordon: *24 Hour Psycho*
 (1993), 2004//163
Lucy Soutter The Collapsed Archive: Idris Khan,
 2006//166
David Evans War Artist: Steve McQueen and
 Postproduction Art, 2007//169

APPRAISALS

Benjamin H.D. Buchloh Parody and Appropriation
in Francis Picabia, Pop and Sigmar Polke, 1982//178
Douglas Crimp Appropriating Appropriation,
 1982//189
John C. Welchman Global Nets: Appropriation
 and Postmodernity, 2001//194
Johanna Burton Subject to Revision, 2004//205
Isabelle Graw Fascination, Subversion and
 Dispossession in Appropriation Art, 2004//214
Sven Lütticken The Feathers of the Eagle, 2005//219

HESE PICTURES HAVE THE CH
NCES OF LOOKING REAL WITH
UT ANY SPECIFIC CHANCES O
BEING REAL

Richard Prince, Interview with Peter Halley, 1984

David Evans
Introduction//Seven Types of Appropriation

Steve Lafreniere You weren't in Douglas Crimp's 'Pictures' exhibition, but a lot of people seem to think you were, maybe because of your later association with Helene Winer, who was at Artists Space before starting Metro Pictures. Did you feel a kinship to the artists in the 'Pictures' show?

Richard Prince I've never said this before, but Doug Crimp actually asked me to be in that show. I read his essay and told him it was for shit, that it sounded like Roland Barthes. We haven't spoken since.[1]

To the Editor:
I have no illusions about being able to control how the 'Pictures' show I organized at Artists Space in 1977 will be understood historically, but for the record I did not, as Richard Prince claims in 'Richard Prince talks to Steve Lafreniere' [March 2003], ask him to be in the exhibition or show him the essay for the catalogue. I didn't know Prince or his work at the time.
– Douglas Crimp, New York[2]

I lied when I said I was invited by Doug Crimp to be in the 'Pictures' show. I was fooling around. I made it up. My judgement frosted. The truth of the matter didn't apply. I tried to get away with it and paint it white. I added on to the story. You could say I was writing under a pseudonym. I was never there to begin with. I had never met him, wasn't aware of the show and didn't know any of the artists in the show.
– Richard Prince[3]

This exchange is suggestive: it provides ample evidence of Richard Prince's skills as a hoaxer, happy to treat the past itself as malleable raw material. It also demonstrates an ongoing rivalry between artists and critic-curators concerning who makes art history. Most importantly, it further enhances the reputation of 'Pictures' (Artists Space, New York, 1977) as the epochal exhibition that launched a now pervasive art based on the possession – usually unauthorized – of the images and artefacts of others.

'Pictures' showcased five artists (Troy Brauntuch, Jack Goldstein, Sherrie Levine, Robert Longo and Philip Smith) who caught the attention of Crimp because of a shared interest in the photographically-based mass media as a resource to be raided and re-used. 'Pictures' was the forerunner of an

appropriationist current that became strongly associated with certain commercial galleries in New York. Metro Pictures, for instance, which represented key figures, such as Richard Prince and Cindy Sherman, who all engaged with media imagery in different ways. Or the Sonnabend Gallery, which foregrounded painters and sculptors such as Ashley Bickerton, Peter Halley, Jeff Koons and Meyer Vaisman, who referenced images and objects associated with both modernist art and American consumer culture. And the first attempt to provide an overview of the whole phenomenon was the exhibition 'Endgame: Reference and Simulation in Recent Painting and Sculpture' (ICA, Boston, 1986). Curated by Elisabeth Sussman, it included 25 artists and a multi-authored catalogue that was symptomatic of the complex, sophisticated critical writing that shadowed appropriation art.

Critics offered various historical pedigrees, most frequently referencing Dadaist innovations like the readymade and photomontage, or the engagement of Pop artists with the mass media. Theoretically, Walter Benjamin was pervasive. His formulation of 1920s montage as modernist allegory seemed pertinent to considerations of appropriation as a new type of double-voiced art. There was even more interest in his writings from the 1930s about photography destroying the aura of traditional art, as well as being an accessible, reproducible medium that had emancipatory potential; all arguments that were used to characterize photographic appropriation as an inherently subversive activity. Roland Barthes was pervasive too. Appropriation art was a practical form of the ideological critique of consumer culture that Barthes developed in *Mythologies* (1957), according to Benjamin Buchloh. In contrast, Craig Owens thought that Barthes' later writing, such as 'The Death of the Author' (1968), was more relevant to a type of art that seemed to question the notion of originality and to court an active role for the viewer. Guy Debord also cropped up frequently, with critics keen to note a precedent for 1980s appropriation in his ideas from the 1950s about *détournement*: the hijacking of dominant words and images to create insubordinate, counter messages. Above all, appropriation art was justified via the ideas of Jean Baudrillard, often presented as an update of Debord. In the 1960s, Debord argued that *The Society of the Spectacle* (the title of his most famous work, first published in Paris in 1967) could be both perceived and challenged. By the 1980s, Baudrillard commiserated, such views were merely of historic interest, for any notion of radical critique had become an impossibility with the merging of reality and its media representation. Baudrillard announced a grim world of simulation and simulacra and expressed surprise when these ideas were quickly picked up by artists and critics in New York, to become another way of discussing the art of appropriation.

Far more was at stake here than the identification of the historical and theoretical roots of a new art style. Rather, the assumption was that appropriation

art was a key component of nothing less than *The Anti-Aesthetic, Art After Modernism, Postmodernism* – all titles of highly influential anthologies from the mid 1980s that had as their starting point the view that a once transgressive modernism had become thoroughly institutionalized by the 1970s, and that an alternative had to be formulated urgently. Probably the one idea that ran through all of these anthologies was a disdain for architects, artists and others who assumed that the impasse of modernism provided a *carte blanche* for a pick and mix approach to all past styles. Such eclecticism was curtly dismissed as reactionary appropriation, associated with reactionary postmodernism, that had to be clearly differentiated from a radical, even revolutionary, postmodernism in which appropriation was expected to carry out very different duties. These duties clearly emerge in the 'Critical Lexicon' compiled by Michael Newman for the anthology *Postmodernism*, published by the ICA, London, in 1985. 'The Death of the Author' is one of the longest entries, which begins with a discussion of the appropriated art and writing of Sherrie Levine, and then goes on to consider how the ideas of Barthes, Foucault and others were 'taken up by postmodernism to construct the critical space for works using appropriated imagery and stereotypes, largely through photography'. 'Allegory' is another long entry, mainly devoted to an exploration of Craig Owens' ideas about 'a mode of reading the already-written' and the artists who 'generate images through the reproduction of other images', presented as decisive breaks with a modernist emphasis on the formal or expressive artist. The section 'Fascination and the Uncanny' includes reflections on Richard Prince, especially the latter's rephotographed advertisements that 'have the quality of *déjà vu*, of repetition, which renders them strange, like the cadaver brought back to life in a horror story'. The entry 'Bricolage' investigates a term associated with the structuralist anthropologist Lévi-Strauss that 'has been used to describe the combination of fragments of quotation from other works in a single work of art, or more specifically the use of found objects and fragments of material in recent sculpture'. 'Simulation': 'To illustrate its application to art, recall the discussion of the work of Richard Prince …' And finally, 'Parody', a form of double coding that is 'so widespread in contemporary art that it is tempting to regard it, together with appropriation, allegory and bricolage, as one of the characteristic strategies by which we might define a postmodernist art'. Significantly, the 'Critical Lexicon' has entries on the 'characteristic strategies' of parody, allegory and bricolage, but nothing devoted to appropriation. An oversight? Or confirmation that for Newman and others, appropriation was not just one strategy amongst many, but rather the very 'language' in which the postmodernist debate was conducted?[4]

These opening remarks delineate what is commonly associated with the term appropriation art: a certain time (late 1970s and 1980s); a certain place (New

York); certain influential galleries (Metro Pictures, Sonnabend); and certain artists who were critically located within ambitious debates around the postmodern. Related source material is included (in the sections 'Simulation' and 'Appraisals', for example). However the New York appropriationists do not dominate this anthology. Rather they rub shoulders with many other contemporary artists who have also been 'practising without a licence', to use one of Richard Prince's phrases.

The first section, *Precursors*, includes materials from the late nineteenth century to the mid twentieth. The key distinction that underpins this section is between traditional and modern notions of the copy. For a painter like Ingres, copying was a vital component of an apprenticeship that was successfully completed when originality became discernible. In contrast, modernist copying is not a means to this end. It *is* the end. Or rather, it is the means to different ends. The readymade, collage and montage are presented as the three innovations of the historic avant-gardes that cumulatively register this fundamental transition, without which any notion of contemporary appropriation art is unimaginable.

Many breaks and continuities are to be discovered within this section. Are the everyday clichés found in Gustave Flaubert's *Dictionary of Received Ideas* (1850–80) a literary anticipation of artists' work with both written and visual clichés or stereotypes? How does the early defence of the readymade in 'The Richard Mutt Case' (1917) measure up against Marcel Duchamp's remarks on the same theme over forty years later? How does Louis Aragon's assessment of the early history of collage relate to Raoul Hausmann's remarks on the parallel history of photomontage, both complementing retrospective exhibitions in Paris (1930) and Berlin (1931), respectively? Is Brecht's *War Primer* (1955) – a series of four-line epigrams that he added to press photographs mainly collected in the Second World War – the last great achievement of modernist montage? Should Debord and Wolman's essay on *détournement* (1956) be appreciated as an attempt to use the weapons of early Surrealism against a movement that was – they believed - a shadow of its former self by the mid 1950s? In what ways are Pop art (here represented by an interview with Andy Warhol from 1963) or Conceptual art (Jeff Wall's assessment of mid 1960s Dan Graham) lynchpins connecting the appropriationism of the historic avant-gardes and more recent manifestations? And is Akasegawa Genpei merely the tip of the iceberg, confirmation that a history of appropriation needs to cast a net beyond Europe and North America?

This section also invites reflections on breaks and continuities *between* sections, although it is assumed that the relations between historic and contemporary practices are far from straightforward. Take, for instance, the exhibition 'Montage and Modern Life' (ICA, Boston, 1991). It was intended as an intervention in postmodernist debates in the United States, and the organizers

were advised by Benjamin Buchloh, whose writings in the 1980s had identified Benjamin's notion of allegory as the fundamental concept that bridged interwar, modernist photomontage and contemporary, postmodern experiments with the photographic fragment. In practice, the exhibition did not attempt explicitly to develop Buchloh's search for a usable past. No recent work was included and writings in the accompanying catalogue clearly register disagreement amongst the organizers about links between the respective arts of the interwar and contemporary periods. Matthew Teitelbaum's preface most explicitly sees continuities in the shared attempts to represent 'the realities of a modern, urban lifestyle' and 'the fantasy and desire of a consumer age'.[5] In contrast, Christopher Phillips is more guarded about contemporary relevance. He cites with approval Adorno's claim that familiarity with montage had already neutralized its shock value by the 1950s, and adds that 'montage may in fact no longer offer the most satisfying or audacious way to represent our own "culture of fragments".'[6]

Contemporary practice is divided into seven categories: *Agitprop*; *The Situationist Legacy*; *Simulation*; *Feminist Critique*; *Postcolonialism*; *Postcommunism*; *Postproduction*. These categories are intended to be useful but not watertight, and readers are invited to identify overlaps between them. The timescale is from the 1970s to date; the perspective international; most documents relate to artists, though references to others like filmmakers and writers are included. Overall, the aim is to convey the diversity of appropriation strategies in the last four decades. Omissions are inevitable. A case could be made, for example, for the inclusion of *The Battle of Orgreave* (2001), Jeremy Deller's important re-enactment of a famous clash between striking miners and policemen that took place in Northern England in 1984, or the activities of the International Performance Group, founded by Marina Abramovic in 2003, and involved in re-enacting historic performances by various artists, including Abramovic herself.[7] Re-enactment, though, is different from appropriation, with its distinctive emphasis on unauthorized possession.

Agitprop, the first of these typological sections, refers to the term for agitation and propaganda historically associated with the dissemination of communist ideas. Communist agitprop, albeit of an unorthodox nature, is represented in this section by French film directors Jean-Luc Godard and Jean-Pierre Gorin (known as the Dziga Vertov group) and the Cuban Santiago Álvarez. *Letter to Jane* (1972) is a film by Godard and Gorin in which they offer a sustained Maoist critique of an appropriated press photograph of Jane Fonda in Vietnam. The image and film script were also published by the journal *Tel Quel* with the title 'Inquest on an Image' (1972) and an extract is reproduced here. Álvarez began making Third Worldist documentaries in the 1960s that often involve an inventive use of appropriated material from diverse American sources, a tactic he claimed was

necessitated by the blockade of Cuba. Miguel Orodea's text reflects on the connections between Álvarez and Vertov, the Soviet documentary filmmaker who had also influenced Godard and Gorin in the early 1970s.

This section uses the term agitprop expansively to also embrace work that has no explicitly communist agenda. Two texts relate to the mass movement that emerged in the United States in the late 1960s in opposition to the war in Vietnam. The item by critic Lucy Lippard, published in 1970, comments on the problems encountered by the Art Workers' Coalition, whose poster about the Song-My massacre of 1968, incorporating a press photograph from *Life*, was banned from The Museum of Modern Art, New York. *Life* was also one of the sources used by Martha Rosler for her famous series of photomontages *Bringing the War Home*, begun in 1967 and initially used in the press and publicity of groups campaigning against the Vietnam war. Curator Susan Stoops offers a subtle assessment of the series, written for a 2007 exhibition devoted to the work at the Worcester Art Museum, Massachusetts. Her text is particularly useful for analysing how Rosler has reworked and extended a project begun in the late 1960s in response to the Gulf War of 1991, and the ongoing 'War on Terror'. The notion of agitprop also underlies the text by Brazilian Cildo Meireles (1970) who discretely inserted messages on banknotes and Coca-Cola bottles and then placed them back in circulation. The connecting thread in this section is the deployment of appropriated imagery to make explicitly political work that is intended to operate mainly outside of the usual art institutions.

The Situationist International (1957–1972) was a neo-Marxist organization, committed to a revolutionary politics that it assumed to be absent in the postwar French Communist Party. *The Situationist Legacy* thus overlaps with *Agitprop*, but the decision was made to have a separate section because of the pervasiveness of Situationist ideas in contemporary art. The identification of a direct linkage between the Situationists and the appropriation art associated with Metro Pictures, or the cut-and-paste aesthetics of punk, has been extensively rehearsed elsewhere,[8] most recently in the exhibition 'Panic Attack!' (Barbican, London, 2007). Therefore, the focus here is on different dimensions of the legacy. The first document is 'The Use of Stolen Films' (1989), a little known, late note by Guy Debord on his own films that relates directly to the co-authored article on *détournement* (1956) found in *Precursors*. Debord is also one important topic in an interview with Belgian artist Johan Grimonprez about his film *Dial H-I-S-T-O-R-Y*, first shown at Documenta X (Kassel, 1998), organized by Catherine David. Grimonprez deals with hijacking in two senses: firstly, his theme is the history of aeroplane hijacking (*détournement d'un avion*); secondly, his method is the hijacking or *détournement* of television news footage. Hijacking in both senses is also a theme tackled in my recent e-mail interview with the Californian collective

Retort about the Situationist dimensions of their polemical book *Afflicted Powers: Capital and Spectacle in a New Age of War* (2005).

The title *Simulation* acknowledges the influence of Jean Baudrillard in 1980s New York and this section corresponds the closest to the popular understanding of appropriation art sketched in the opening paragraphs. Some well established examples are included: an extract from Crimp's catalogue essay for 'Pictures' (1977); Baudrillard on 'the desert of the real' (1981); Sherrie Levine's 'Statement' (1982) that re-works Barthes famous declaration about the death of the author and the birth of the reader; a conversation between Prince and Halley that signals the shared concerns of artists associated with Metro Pictures and Sonnabend Gallery, respectively (1984); and catalogue essays from *Endgame* (1986). But there are also materials that permit a reconstruction of parallel activities in London, such as Michael Newman's catalogue essay for 'Simulacra' (1983), a show he curated for the Riverside Studios. He included the collagist John Stezaker, who emerges in this section as a discrete but significant go-between, a London-based, 'media–haunted human' (to use David Mellor's phrase), who developed close contacts with sympathetic allies in New York.

The *Feminist Critique* section focuses on two ideas that first emerged during the 1970s: that visual culture is one of the principal sites where gender relations are produced and reproduced; and that mainstream accounts of the modern author or artist inevitably foreground men of genius. Both ideas have informed a range of appropriationist strategies to unfix the fixed. Frequently, this work has involved dealing with media stereotypes, and the 1982 statement by Barbara Kruger draws attention to the danger of parodic intent being overwhelmed by the power of the cliché. One seemingly innocent repository of clichés is the family album, which Jo Spence began to examine critically in the mid 1970s, leading to the project *Beyond the Family Album*, first shown at the Hayward Gallery, London, in 1977. Reprinted here is a text from 1983 in which she calls for a radicalized 'amateurism' that would begin to replace 'icons of ritualized harmony' with images of domestic warfare.

Lisa Tickner's catalogue essay was originally written for the international exhibition 'Difference: On Representation and Sexuality' (New York: New Museum of Contemporary Art, 1984). She writes about five British contributors (Victor Burgin, Mary Kelly, Yve Lomax, Ray Barrie and Marie Yates) whose 'theft and deployment of representational codes' aims to foreground a 'sexuality and/in representation'. This work often combines photographs and text and is marked by contemporary theoretical debates, particularly those associated with the British film journal *Screen* that drew on Althusser and Lacan, amongst others, to develop an updated theory of ideology that could account for, and challenge, the entrenchment of gender positions. There are some rich overlaps between

Tickner's essay and the next document – Barbara Kruger's interview with Anders Stephanson, published in *Flash Art* in 1987. Kruger identifies 'the construction of the female subject' as the main theme of her image-text montages and she acknowledges an interest in the journal *Screen*. However, she insists that her distinctive 'appellative' tactics draw more on ten years of experience in the advertising industry than an Althusserian theory of ideology.

In contrast to many of the artists in this section, Cindy Sherman has steered clear of theory-led juxtapositions of word and image, and her reputation is primarily based on the *Untitled Film Stills*, black and white photographs from the late 1970s in which she disguises herself as a range of B-movie heroines. In her 1991 essay, Laura Mulvey notes that the artist's apparent indifference to theory does not preclude her art having great theoretical significance. Mulvey suggests that Sherman's ongoing interest in a 'phantasmagoria of the female body' is not only about unravelling clichés of femininity. Rather, the cumulative work draws attention to a 'homology between the fetishized figure of bodily beauty and the fetishism of the commodity', a homology that first began to take shape in 1950s America and is now globally established.

Another kind of staged appropriation is assessed in the concluding extract, in which art historian Deborah Cherry writes about *Zabat*, a project from the late 1980s by Afro-British artist Maud Sulter. This cibachrome series depicts black women, including Sulter herself, posing as the seven muses, traditionally portrayed in western art as white women. In this context, *Zabat* represents a bridge between this section and the next.

Appropriation was integral to colonialism. Not surprisingly, therefore, a major theme in the texts represented in the *Postcolonialism* section is the re-taking of that which was possessed without authority. An emblematic example is Malek Alloula's book *The Colonial Harem* (1981). It contains reproductions of postcards from colonial Algeria in the early decades of the twentieth century, depicting Algerian women in various alluring poses, veiled and unveiled, which were mass-produced to be sent to metropolitan France. Aptly, Alloula's furious commentary is intended as an extended postcard message, to be returned to sender. The importance of return also informs the book *Imaginary Homecoming* (1999) by Finnish photographer Jorma Puranen that 'returns' nineteenth-century portraits of the Sámi found in a Parisian museum to their Scandinavian homeland, north of the Arctic Circle. (The Sámi were never colonized, it must be stressed, yet were regularly included in the primitivist discourses associated with colonialism.)

Another type of postcolonial appropriation emerges in writings by Kobena Mercer and Okwui Enwezor. Mercer's text from 1996 deals with Keith Piper, a black British artist whose collage-based work is marked by the 'cross-cultural dynamics of a Creole aesthetic of migration and translation'. Similar concerns

emerge in Enwezor's 'Créolité and Creolization' (2002), from his curator's essay for the Documenta 11 catalogue, in which the Creole experience is presented as a paradigm for a global culture based on complex mixing and hybridization. We are all appropriationists now, he proposes.

The final text in this section comes from the book *The Great War for Civilization: The Conquest of the Middle East* (2005) by Beirut-based correspondent Robert Fisk. In the selected extract, Fisk describes the occupation of the American Embassy in Tehran in 1979, and recalls an atmosphere that was both theatrical and carnivalesque. The occupation took this turn, he suggests, when the Muslim revolutionaries erected a large painting based on Joe Rosenthal's famous photograph of US marines taking Iwo Jima. The original version is associated with the defeat of Fascism by the United States in 1945; the new version depicts the defeat of the United States by radical Islam in 1979, and is a vivid reminder that the art of appropriation has no frontiers.

In 1991, East German poet and playwright Heiner Müller introduced a conference on John Heartfield and photomontage that was one of the last events organized by the East German Academy of the Arts before it was forcibly merged with its Western counterpart.[9] Müller's remarks had a valedictory quality that forms a background to the *Postcommunism* section. Since the mid 1950s, Heartfield had been a part of the cultural establishment of East Germany, mainly for his anti-Fascist photomontages of the 1930s. By East German standards, Müller was being scandalous when he expressed scepticism about the impact of Heartfield's photomontages on the working classes and suggested that it was time to appreciate them as art. Müller's revisionist view anticipates a major motif in recent postcommunist art: a subjective appropriation of the official culture imposed by the former Soviet Union at home and abroad, a topic discussed here by Russian critic Boris Groys in an extract from a 2007 interview.

Another dimension of postcommunist appropriation is found in the recent exhibition 'What is Modern Art? (Group Show)' (Künstlerhaus Bethanien, Berlin, 2006) that brought together various projects by artists from former Yugoslavia, including a mysterious 'Walter Benjamin', who foregrounds anonymity and copying in order to scrutinize critically common sense accounts of modern art and its histories.

The term *Postproduction*, within the media, describes the various forms of editing that convert raw footage into a finished product. Within contemporary art, the term signals the ideas of critic-curator Nicolas Bourriaud. His *Postproduction: culture as screenplay: how art reprograms the world* (2002) is an account of art in the 1990s that seeks to foreground new types of appropriation. The book acknowledges important precedents from the historic avant-gardes and liberally references the Situationists, but argues that postproduction art is something

different, closer to the various techniques of the contemporary deejay, the subject of the selected extract. This is followed by Katrina Brown's 2004 text on an artist championed by Bourriaud, Douglas Gordon, on his influential film installation *24 Hour Psycho*.

Two documents are added as counterpoints. Lucy Soutter reviews the work of Idris Khan, whose photographs involve an elaborate layering of every page in a book or every image in a photographic series. Such processes could easily be related to the playlists and cutting of deejays that interest Bourriaud, but Soutter is more drawn to affinities with the composite photographs of nineteenth-century eugenicist Francis Galton. The concluding text considers *Queen and Country* (2006) by Steve McQueen. He was commissioned by the Imperial War Museum in London to respond to the Iraq war, and made sheets of unofficial postage stamps bearing photographic portraits of British soldiers killed in the conflict. My 2007 essay views this work within the context of Bourriaud's ideas.

Appraisals, the concluding section, presents important writings that register the ambitious, politically charged frameworks within which appropriation art was situated in the 1980s. In addition, there are more recent texts that engage critically with that legacy, either to offer revisionist histories, or to identify a post-appropriation art for a different era.

Benjamin Buchloh's 1982 essay is informed by the now famous 'Expressionist debate' from the 1930s in which most of the participants assumed that German Expressionist art and literature promoted an irrationalism that facilitated the establishment of the ultimate irrationalism, the Third Reich. Buchloh still shares this assumption in the 1980s and sees sinister political implications in the international popularity of so-called neo-Expressionist painters like Georg Baselitz. The referencing of Expressionism by Baselitz and others is condemned as mere pastiche, a reactionary form of postmodernism. In contrast, painters Sigmar Polke and Gerhard Richter are promoted as radical postmodernists, appropriationists inventively extending the parodistic tactics of Francis Picabia.

Douglas Crimp, too, identifies regressive and progressive postmodernisms and corresponding forms of appropriation in 'Appropriating Appropriation' (1982). Contemporary painters like David Salle are condemned for their pastiches of past styles, but Sherrie Levine is praised for her copying of reproductions of paintings. Photographer Robert Mapplethorpe is considered reactionary for eclectically imitating the styles of Edward Weston and others, whereas Levine's literal copying of Weston is progressive for drawing attention to the very act of appropriation. Crimp concludes with some acute predictions that radical appropriation art, like Prince's rephotographs of advertisements or Sherman's film stills, will lose much of its use value once it becomes safely accommodated in the art museum.

Art after Appropriation (2001) by John Welchman is a bold attempt to revive

debates around appropriation and postmodernism that were becoming jaded by the 1990s. In the selected extract, Mike Kelley is presented as a major post-appropriationist, in dialogue with critical postmodernists of the 1970s and 1980s, but attempting something new with an art that often involves rehabilitated craft objects. For Welchman, Kelley's work can be usefully related to the ideas of dissident Surrealist Georges Bataille whose expansive understanding of appropriation embraced all forms of possession. Welchman continuously challenges parochialism, whether temporal or topographic, and insists that the broader context for his theme is the 'Western culture of appropriation' that began in earnest with the Roman Empire.

Johanna Burton's title, 'Subject to Revision' (2004), alludes to three dimensions of her essay. Firstly, she seeks to revise the subject of recent appropriation art, most obviously taking issue with Buchloh's claim that Warhol and Pop art had little relevance. Secondly, she wants to draw attention to subjectivity as a theme that is a distinctive feature of the revised appropriation undertaken by current artists like Amy Adler, Glenn Ligon, Aleksandra Mir, Francesco Vezzoli and Kelley Walker. Finally, she shows how critics like Crimp and Owens revised their views to acknowledge subjectivity. Crimp provides her most vivid example, admitting in 1993 that his earlier dismissal of Mapplethorpe had failed to deal with the crucial gay dimension.

Isabelle Graw's essay 'Dedication Replacing Appropriation' (2004) is a sceptical account of many of the radical claims made for appropriation art in the 1980s, including Crimp's confident distinction between regressive and progressive forms. Doubts about these radical claims also emerge in Sven Lütticken's article 'The Feathers of the Eagle' (2005). He is particularly interested in the argument that radical appropriationists were latterday 'mythologists', inspired by the Roland Barthes of the 1950s, and develops his own position through a comparison with an earlier 'mythologist' who read Barthes closely: Marcel Broodthaers.

One of the most fundamental distinctions between appropriation art in the 1980s and post-appropriation art today revolves around history itself. A recurrent theme in postmodernist debates of the 1980s was the supposed death of historical meaning, but major events like the implosion of the Soviet Union resulted in the 're-emergence of a multiplicity of histories in the moment of the 1990s'.[10] The challenge for the appropriationist artist now is to discover new ways of dealing with these 'unresolved histories'.[11]

1 Richard Prince, 'Richard Prince talks to Steve Lafreniere', *Artforum*, vol. XLI, no. 7 (March 2003) 70.

2 Douglas Crimp, Letter to the editor, *Artforum*, vol. XLI, no. 10 (Summer 2003) 18.

3 Richard Prince, 'Paint it White', *Art in America* (May 2008).

4 Michael Newman, 'A Critical Lexicon of Selected Terms from the Discourse of Postmodernism', in *Postmodernism* (ICA Documents series), ed. Lisa Appignanesi (London: Institute of Contemporary Arts/Free Association Books, 1989) 111–45.

5 Matthew Teitelbaum, Preface, *Montage and Modern Life 1919–1942*, ed. idem (Cambridge, Massachusetts: The MIT Press, 1992) 11.

6 Christopher Phillips, Introduction, *Montage and Modern Life 1919–1942*, op. cit., 35.

7 See for example Christophe Kihm, 'Performance in the Age of its Re-enactment', in *artpress 2*, no. 7, special issue on Contemporary Performances (November–December 2007/January 2008).

8 See especially Elisabeth Sussman, ed., *On the Passage of a Few People through a Rather Brief Moment in Time: The Situationist International 1957–1972* (Boston: Institute of Contemporary Art/Cambridge, Massachusetts: The MIT Press, 1989).

9 Heiner Müller, 'On Heartfield', in *John Heartfield*, ed. Peter Pachnicke and Klaus Honnef (New York: Harry N. Abrams, 1992) 9.

10 Jan Verwoert, 'Apropos Appropriation: Why Stealing Images Today Feels Different', in Beatrix Ruf and Clarrie Wallis, eds, *Tate Triennial 2006 - New British Art* (London: Tate Publishing, 2006) 19.

11 Ibid, 21.

WHENEVER
PICABIA
MENTIONED
THE INKBLOT
HE SIGNED,
HE NEVER
FAILED
TO POINT
OUT THE
INIMITABILITY
OF SUCH
SPLATTERS

Louis Aragon, 'The Challenge to Painting', 1930

PRECURSORS

Gustave Flaubert Dictionary of Received Ideas,
 1850–80//026
Anon. The Richard Mutt Case, 1917//026
Louis Aragon The Challenge to Painting, 1930//027
Raoul Hausmann Photomontage, 1931//029
André Breton and Paul Éluard The Object, 1938//031
Georges Didi-Huberman Modest Masterpiece:
 Bertolt Brecht's *War Primer* (1955), 2007//032
Guy Debord and Gil J. Wolman Directions for the
 Use of Détournement, 1956//035
Marcel Duchamp Apropos of 'Readymades', 1961//040
Andy Warhol Interview with Gene R. Swenson,
 1963//041
Jeff Wall On Dan Graham's *Homes for America*
 (1966–67), 1988//043
Reiko Tomii Rebel with a Cause: Akasegawa Genpei's
 Greater Japan Zero-Yen Note (1967), 2000//045

Gustave Flaubert
Dictionary of Received Ideas//1850-80

ANTIQUES Are always modern fakes. [...]
ART Leads to the workhouse. What use is it since machines
 can make things better and quicker?
ARTISTS All charlatans. Praise their disinterestedness [...]
 What artists do can't be called work. [...]
AUTHORS One should 'know a few authors': no need to know their names.

Gustave Flaubert, excerpts from 'Dictionnaire des idées reçues', (1850-80; posthumously published, 1911–13); trans. A.J. Krailsheimer, in *Bouvard and Pécuchet* (Harmondsworth: Penguin, 1976) 294.

Anon.
The Richard Mutt Case//1917

They say any artist paying six dollars may exhibit.

Mr Richard Mutt sent in a fountain. Without discussion this article disappeared and never was exhibited.

What were the grounds for refusing Mr Mutt's fountain:

1. Some contended it was immoral, vulgar.

2. Others, it was plagiarism, a plain piece of plumbing.

Now Mr Mutt's fountain is not immoral, that is absurd, no more than a bath tub is immoral. It is a fixture that you see every day in plumbers' show windows.

Whether Mr Mutt with his own hands made the fountain or not has no importance. He CHOSE it. He took an ordinary article of life, placed it so that its useful significance disappeared under the new title and point of view – created a new thought for that object.

As for plumbing, that is absurd. The only works of art America has given are her plumbing and her bridges.

Anonymous article referring to Marcel Duchamp's urinal readymade *Fountain* (1917) as displayed, signed 'R. Mutt', at the Exhibition of Independent Artists, New York, 1917; *The Blind Man*, no. 2 (New York, May 1917). Written by either Beatrice Wood, H.P. Roché or Duchamp, or collaboratively.

Louis Aragon
The Challenge to Painting//1930

[...] One can imagine a time when the problems of painting, those for example that made for the success of Cézannism, will seem as strange and as ancient as the prosodic torments of poets may appear now. One can imagine a time when the painters who no longer mix their own colours will find it infantile and unworthy to apply the paint themselves and will no longer consider the personal touch, which today still constitutes the value of their canvases, to possess anything more than the documentary interest of a manuscript or autograph. One can imagine a time when painters will no longer even have their colour applied by others and will no longer draw. Collage offers us a foretaste of this time. It is certain that writing is moving in the same direction. This brooks no discussion.

In the Dada period, and actually a bit earlier, this insight about the future of painting comes to light quite precisely thanks to two spirits even more different from each other than Braque and Picasso – Marcel Duchamp and Francis Picabia. And an individual who passed for an eccentric before mysteriously disappearing: the now legendary [boxer and poet] Arthur Cravan, deserter from seventeen countries. The process of painting then was taken so far, the negation of painting so violently declared, that the impossibility of painting imposed itself on the painters. It is perhaps vexing that the sterilizing influence (and here this word is meant in the best sense) of Marcel Duchamp did not purely and simply put an end to painting, instead of applying itself with its utmost rigour against Duchamp himself; but that is what happened. Nevertheless, the example of Duchamp, this silence irritating to those who speak, has made an entire generation ill at ease and perhaps has shamed many canvases which would otherwise have been politely painted. What is certain is that on the day following Cubism's re-creation of the beautiful, a beautiful as special and as defined as its predecessors, Duchamp and Picabia, having watched that crystallization appear before their eyes, having considered the unwavering mechanism of taste, will assault a fundamental element of art, and particularly of painting, by putting personality on trial. The significant stages of this trial: Duchamp adorning the *Mona Lisa* with a moustache and signing it; Cravan signing a urinal; Picabia signing an inkblot and titling it the *Sainte Vierge* (*Blessed Virgin*). To me these are the logical consequences of the initial gesture of collage. What is now maintained, is on the one hand, the negation of technique, as in collage, as well as of the 'technical personality'; the painter, if we can still call him that, is no longer bound to his canvas by a mysterious physical

relationship analogous to procreation. And from these negations an affirmative idea has emerged which has been called 'the personality of choice'. A manufactured object can equally well be incorporated into a painting, it can constitute the painting in itself. An electric lamp becomes for Picabia a young girl. We see that here painters are truly beginning to use objects as words. The new magicians have reinvented incantation. And for those who continue to paint, all sentimentality concerning material has now been abandoned. To Picabia it doesn't matter who spreads the enamel. As for Duchamp, he has just invented a system for playing roulette, and his last work will be a limited edition 'plate' for the exploitation of this system, an engraved certificate which is a collage containing the author's photograph.

To be sure, whenever Picabia mentioned the inkblot he signed, he never failed to point out the inimitability of such splatters. He congratulated himself that his inkblot was more difficult to copy than a Renoir. In this way such undertakings reveal themselves as an essential critique of painting from its origins to our own times. The Cubists as well had collided with the inimitable but had thought they could tame it. The monster, all at once, claimed sole residence in its cage. [...]

> Words that express evil are destined to take on a utilitarian significance. Ideas improve. The meaning of words takes part in this.
>
> Plagiarism is necessary. Progress involves it. It adheres closely to an author's words, makes use of his expressions, erases a false idea, replaces it by a correct one.
>
> To be well made, a maxim does not need to be corrected. It needs to be developed.

For me, these phrases of Isidore Ducasse contain all the morality of expression. For everyone, the morality of collage. [...]

Louis Aragon, extract from 'La peinture au défi', preface to catalogue of collage exhibition, Galerie Goemans, Paris (March 1930); trans. Michael Palmer, in Pontus Hultén, ed., *The Surrealists Look at Art* (Venice, California: The Lapis Press, 1990) 55-7; 63 [footnotes not included].

Raoul Hausmann
Photomontage//1931

In the battle of opinions, it is often claimed that photomontage is practicable in only two forms: political propaganda and commercial advertising. The first photomonteurs, the Dadaists, began from a point of view incontestable for them: that the painting of the war period, post-futurist Expressionism, had failed because it was non-representational and it lacked convictions; and that not only painting but all the arts and their techniques required a revolutionary transformation in order to remain relevant to the life of their times. The members of the Club Dada, who all held more or less left-wing political views, were naturally not interested in setting up new aesthetic rules for art-making. On the contrary, they at first had almost no interest in art, but were all the more concerned with giving materially new forms of expression to new contents. Dada, which was a kind of cultural criticism, stopped at nothing. It is a fact that many of the early photomontages attacked the political events of the day with biting sarcasm. But just as revolutionary as the content of photomontage was its form – photography and printed texts combined and transformed into a kind of static film. The Dadaists, who had 'invented' the static, the simultaneous, and the purely phonetic poem, applied these same principles to pictorial expression. They were the first to use the material of photography to combine heterogeneous, often contradictory structures, figurative and spatial, into a new whole that was in effect a mirror image wrenched from the chaos of war and revolution, as new to the eye as it was to the mind. And they knew that great propagandistic power inhered in their method, and that contemporary life was not courageous enough to develop and absorb it.

Things have changed a great deal since then. The current exhibition ['Fotomontage', Berlin, 1931] shows the importance of photomontage as a means of propaganda in Russia. And every film programme – be it [the musical] *The Melody of the World*, [the comedy of] Chaplin, Buster Keaton, [the working-class drama] *Mother Krausen's Journey to Happiness*, or [the documentary] *Africa Speaks* – proves that the business world has largely recognized the value of this propagandistic effect. The advertisements for these films are unimaginable without photomontage, as though it were an unwritten law.

Today, however, some people argue that in our period of 'new objectivity', photomontage is already outdated and unlikely to develop further. One could make the reply that photography is even older, and that nevertheless there are always new men who, through their photographic lenses, find new visual

pproaches to the world surrounding us. The number of modern photographers is large and growing daily, and no one would think of calling Renger-Patzsch's 'objective' photography outdated because of Sander's 'exact' photography, or of pronouncing the styles of Lerski or Bernatzik more modern or less modern.

The realm of photography, silent film and photomontage lends itself to as many possibilities as there are changes in the environment, its social structure, and resultant psychological superstructures; and the environment is changing every day. Photomontage has not reached the end of its development any more than silent film has. The formal means of both media need to be disciplined, and their respective realms of expression need sifting and reviewing.

If photomontage in its primitive form was an explosion of viewpoints and a whirling confusion of picture planes more radical in its complexity than futuristic painting, it has since undergone an evolution one could call constructive. There has been a general recognition of the great versatility of the optical element in pictorial expression. Photomontage in particular, with its opposing structures and dimensions (such as rough versus smooth, aerial view versus close up, perspective versus flat plane), allows the greatest technical diversity or the clearest working out of the dialectical problems of form. Over time the technique of photomontage has undergone considerable simplification, forced upon it by the opportunities for application that spontaneously presented themselves. As I mentioned previously, these applications are primarily those of political or commercial propaganda. The necessity for clarity in political and commercial slogans will influence photomontage to abandon more and more its initial individualistic playfulness. The ability to weigh and balance the most violent oppositions – in short, the dialectical form-dynamics that are inherent in photomontage – will assure it a long survival and ample opportunities for development.

In the photomontage of the future, the exactness of the material, the clear particularity of objects and the precision of plastic concepts will play the greatest role, despite or because of their mutual juxtaposition. A new form worth mentioning is statistical photomontage – apparently no one has thought of it yet. One might say that like photography and the silent film, photomontage can contribute a great deal to the education of our vision, to our knowledge of optical, psychological and social structures; it can do so thanks to the clarity of its means, in which content and form, meaning and design, become one.

Raoul Hausmann, 'Fotomontage', *a bis z* (Cologne, May 1931) 61–2; trans. Joel Agee, in *Photography in the Modern Era: European Documents and Critical Writings, 1913–1940*, ed. Christopher Phillips (New York: The Metropolitan Museum of Modern Art/Aperture, 1989) 178–81.

André Breton and Paul Éluard
The Object//1938

Object. *Readymades* and *assisted readymades*, objects chosen or composed, beginning in 1914, by Marcel Duchamp, constituting the first surrealist objects.

In 1924, in the *Introduction to the Discourse on the Slightness of Reality*, André Breton proposed to fabricate and put in circulation 'certain of those objects one perceives only in dreams' (oneiric object).

In 1930, Salvador Dalí constructs and defines an *object with symbolic functioning* (object which lends itself to a minimum of mechanical functioning and which is based on the phantasms and representations susceptible to being provoked by the realization of unconscious acts).

Objects with symbolic functionings were envisaged following the mobile and the silent objects: Giacometti's suspended ball which reunited all the essential principles of the preceding definition, but still retained the methods proper to sculpture.

On the passage of Surrealism, a fundamental crisis of the object was produced. Only the very attentive examination of numerous speculations which this object has publicly occasioned can permit the grasp, in all its import, of the actual temptation of Surrealism (*real and virtual object, phantom object, interpreted object, incorporated object, being object*, etc.).

Similarly, Surrealism has attracted attention to diverse categories of objects existing outside of it: *natural object, perturbed object, found object, mathematical object, involuntary object*, etc.

André Breton and Paul Éluard, 'Objet', excerpt from *Dictionnaire abrégé du Surréalisme* (Paris: Éditions José Corti, 1938); trans. Lucy R. Lippard, in Lippard, ed., *Surrealists on Art* (New Jersey: Prentice Hall, 1970) 209.

Georges Didi-Huberman
Modest Masterpiece: Bertolt Brecht's *War Primer* (1955)//2007

A masterpiece for seven euros and twenty centimes. Yes, for that modest sum one can purchase the German edition of montaged photographs and epigrams compiled by Brecht during the second world war and first published in 1955. [...]

We expect a masterpiece to be utterly original. Nothing, it is true, can compare to Monet's *Water Lilies*. But this work of Brecht's is almost entirely made up of quotations cut out from newspapers between 1933 and 1945. It is simply a montage of historical documents. In this sense, it implies a break with the very notion of the artwork as something closed in upon itself – of the work as synthesis. Contrary to the productions of traditional art, 'distant from each other because of their perfection', this corresponds – to borrow Walter Benjamin's terms in *One Way Street* (1928) – to a movement of analysis and not synthesis. The dominant content here is documentary, in other words, historical material in which 'forms stand out' and never merge into each other, are never closed.

We expect a masterpiece to be finished. It never occurs to anyone that there might be a missing snake in the *Laocoön*, a missing person in Rembrandt's *Night Watch*, or a missing light source in Georges de la Tour's candlelit *Madeleine*. But Brecht's work, masterly as it is, has this unfinished quality, which is inherent in the montage process that made it. Because a montage can always be assembled differently, it 'renounces all eternity value' – as Benjamin indeed put it – and is therefore constantly waiting for something like an infinite reworking. This is true in practical terms as well as theoretically. First of all, the *Kriegsfibel* is merely an iconographic excrescence of the 'work diary' (*Arbeitsjournal*) that Brecht began to keep when he was in exile, as of 1933. Here, autobiographical fragments, poems, theatre sketches and philosophical notes coexist in a montage of texts and images that is just as disorienting as the *Documents* assembled by Georges Bataille or Aby Warburg's *Bilderatlas*.

The other reason for the unfinished quality is that in order to make his *War Primer* public Brecht had to cut some of its more 'surreal' images, such as the plate that brings together an old tire, a false leg, an umbrella, two crutches, a few pomegranates – *Granatapfel* ('grenade apples') in German – and a coffee grinder [images reinstated in a 1994 re-edition]. There is always something you can add to a list such as this one. The more one explores the Bertolt-Brecht-Archiv in Berlin, the more connections one finds with other images collected by Brecht and his collaborator on this project, the photographer Ruth Berlau, thus multiplying the attractive powers of the images (this question is linked to

Eisenstein's 'montage of attractions' but also to the 'theatre of attractions' evoked, among others, by Brecht's friend Tretiakov). For example, there is the way in which the 'weeper of Singapore' [*Kriegsfibel*, plate 39][1] in the American bombing raids of 1941 might enable the playwright to envisage the gestures of his future character Mother Courage – the conflation of lament and curse.

We expect a masterpiece to be silent: the grandeur of the sublime goes hand in hand with the feeling of the unsayable. Monet's water lilies do not need to state anything to take our breath away; it is impossible to imagine George de la Tour's Magdalene as a gossip; the open mouths of the *Laocoön* utter only a stony silence. And Brecht, modern as he may have been, here returns to a form recalling phylacteries, long predating the autonomous artwork. Beneath the images he places short texts that, as one soon realizes, have nothing in common with simple captions. Rather, with their white letters against a black background, they evoke most of all the story-boards of silent films or, more probably still, the text projections or commentary-banners of Brechtian epic theatre.

These are the epigrams, the lyrical quatrains for which Brecht would forge the resolutely novel concept of 'photo-epigrams'. But at the same time he knew very well that he was reprising an immemorial tradition. The epigram comes from the laconic poetry inscribed on the tombs of Classical Greeks and Romans, but its conciseness has transported it from the domain of grief to the inverse realms of satire and political critique. In the eighteenth century, Herder appealed to an epigrammatic practice for the articulation of historical narrative itself. Finally, one knows that Brecht had been meticulously informed by Benjamin on the poetic strategies of baroque allegory and on the fact that history – with its wars, disasters, griefs – forms the most essential content of *Trauerspiel* [tragedy; literal trans. 'mourning play'].

By this means, Brecht was able to locate lyricism where it is not normally encountered: amidst assemblages of the most barren historical documentation, even the most unsparing – aerial photographs of bombed cities; metal-workers making weapons; the close-ups of Goebbels, Goering or Hitler; women under machine-gun fire not knowing how to protect their prams; prisoners behind barbed wire (in this image one recognizes the playwright Lion Feuchtwanger, Brecht's friend); resistance fighters shot; military graves; the defeated starving; victors with no remorse ... The contrast created by this *documentary lyricism* singularly modifies the current idea we have of the famous Brechtian 'distanciation'. We are mistaken when we want to separate at all costs *formula* and *pathos*, that is to say form and intensity or emotion. Brecht himself admitted this without hesitation: 'Emotions ungoverned by our understanding must nevertheless be integrated and used just as they are, in their state of disorder [...] by the artist. Assuredly, to integrate and use them is already to state that our

understanding turns them into all kinds of provisional and experimental things' ['Art and Politics', 1933–38]. This is the same experimental lyricism based upon documentary montage that one finds much later on in the novels of W.G. Sebald, in Gerhard Richter's *Atlas*, or the films of Santiago Álvarez, Artavazd Pelechian, Jean-Luc Godard. [...]

1 *Kriegsfibel*, plate 39, shows a Second World War reportage photograph of an agonized woman in Singapore amongst the carnage of a bombing raid, with the source's headline [in English] above: 'Singapore Lament'. Beneath is the text [in German]: 'O cry upon cry of sorrow, O voice / Of victims and killers following orders / The son of the sky needs Singapore / But your son, woman, no one needs as you.'

Georges Didi-Huberman, extract from 'Bertolt Brecht, *ABC de la Guerre*, 1955: Modeste chef-d'oeuvre', trans. Charles Penwarden in bilingual edition, *Art Press Trimestriel/Art Press Quarterly*, no. 5 (Paris, May–July 2007) 17–19. Text slightly revised for this publication.

Guy Debord and Gil J. Wolman
Directions for the Use of Détournement//1956

[...] We can first of all define two main categories of détourned elements, without considering whether or not their being brought together is accompanied by corrections introduced in the originals. These are *minor détournements* and *deceptive détournements*.

Minor détournement is the détournement of an element which has no importance in itself and which thus draws all its meaning from the new context in which it has been placed. For example, a press clipping, a neutral phrase, a commonplace photograph.

Deceptive détournement, which is also termed premonitory proposition détournement, is, in contrast, the détournement of an intrinsically significant element, which derives a different scope from the new context. A slogan of Saint-Just, for example, or a sequence from Eisenstein.

Extended détourned works will thus usually be composed of one or more sequences of deceptive and minor détournements.

Several laws on the use of détournements can now be formulated:

It is the most distant détourned element which contributes most sharply to the overall impression, and not the elements that directly determine the nature of this impression. For example, in a metagraph [poem-collage] relating to the Spanish Civil War the phrase with the most distinctly revolutionary sense is a fragment from a lipstick ad: 'Pretty lips are red'. In another metagraph ('The Death of J.H.'), 125 classified ads of bars for sale express a suicide more strikingly than the newspaper articles that recount it.

The distortions introduced in the détourned elements must be as simplified as possible, since the main force of a détournement is directly related to the conscious or vague recollection of the original contexts of the elements. This is well known. Let us simply note that if this dependence on memory implies that one must determine one's public before devising a détournement, this is only a particular case of a general law that governs not only détournement but also any other form of action on the world. The idea of pure, absolute expression is dead; it only temporarily survives in parodic form as long as our other enemies survive.

Détournement is less effective the more it approaches a rational reply. This is the case with a rather large number of Lautréamont's altered maxims. The more the rational character of the reply is apparent, the more indistinguishable it becomes from the ordinary spirit of repartee, which similarly uses the opponent's words against him. This is naturally not limited to spoken language.

It was in this connection that we objected to the project of some of our comrades who proposed to détourn an anti-Soviet poster of the fascist organization 'Peace and Liberty' – which proclaimed, amid images of overlapping flags of the Western powers, 'Union makes strength' – by adding onto it a smaller sheet with the phrase 'and coalitions make war'.

Détournement by simple reversal is always the most direct and the least effective. Thus, the Black Mass reacts against the construction of an ambiance based on a given metaphysics by constructing an ambiance in the same framework that merely reverses – and thus simultaneously conserves – the values of that metaphysics. Such reversals may nevertheless have a certain progressive aspect. For example, Clemenceau [called 'The Tiger'] could be referred to as 'The Tiger called Clemenceau'.

Of the four laws that have just been set forth, the first is essential and applies universally. The other three are practically applicable only to deceptive détourned elements.

The first visible consequences of a widespread use of détournement, apart from its intrinsic propaganda powers, will be the revival of a multitude of bad books, and thus the extensive (unintended) participation of their unknown authors; an increasingly extensive transformation of sentences or plastic works that happen to be in fashion; and above all an ease of production far surpassing in quantity, variety and quality the automatic writing that has bored us so much.

Not only does détournement lead to the discovery of new aspects of talent but also, clashing head-on with all social and legal conventions, it is bound to appear as a powerful cultural tool in the service of a real class struggle. The cheapness of its products is the heavy artillery that breaks through all the Chinese walls of understanding. It is a real means of proletarian artistic education, the first step towards a *literary communism.*

Ideas and realizations in the realm of détournement can be multiplied at will. For the moment we will limit ourselves to showing a few concrete possibilities starting from various current sectors of communication – it being understood that these separate sectors are significant only in relation to present-day techniques, and are all tending to merge into superior syntheses with the advance of these techniques.

Apart from the various direct uses of détourned phrases in posters, records or radio broadcasts, the two principal applications of détourned prose are metagraphic writings and, to a lesser degree, the adroit perversion of the classical novel form.

There is not much future in the détournement of complete novels, but during the transitional phase there might be a certain number of undertakings of this sort. Such a détournement gains by being accompanied by illustrations whose

relationships to the text are not immediately obvious. In spite of the undeniable difficulties, we believe it would be possible to produce an instructive psychogeographical détournement of George Sand's *Consuelo*, which thus decked out could be relaunched on the literary market disguised under some innocuous title like 'Life in the Suburbs', or even under a title itself détourned, such as 'The Lost Patrol'. (It would be a good idea to re-use in this way many titles of old deteriorated films of which nothing else remains, or of films which continue to stupefy young people in the film clubs.)

Metagraphic writing, no matter how backward may be the plastic framework in which it is materially situated, presents far richer opportunities for détourning prose, as well as other appropriate objects or images. One can get some idea of this from the project, devised in 1951 but then abandoned for lack of sufficient financial means, which envisaged a pinball machine arranged in such a way that the play of the lights and the more or less predictable trajectories of the balls would form a metagraphic-spatial composition entitled *Thermal sensations and desires of people passing by the gates of the Cluny Museum around an hour after sunset in November*. We have since, of course, come to realize that a situationist-analytic work cannot scientifically advance by way of such projects. The means nevertheless remain suitable for less ambitious goals.

It is obviously in the realm of the cinema that détournement can attain its greatest efficacy, and undoubtedly, for those concerned with this aspect, its greatest beauty.

The powers of film are so extensive, and the absence of coordination of those powers is so glaring, that almost any film that is above the miserable average can provide matter for innumerable polemics among spectators or professional critics. Only the conformism of those people prevents them from discovering features just as appealing and faults just as glaring in the worst films. To cut through this absurd confusion of values, we can observe that Griffith's *Birth of a Nation* is one of the most important films in the history of the cinema because of its wealth of new contributions. On the other hand, it is a racist film and therefore absolutely does not merit being shown in its present form. But its total prohibition could be seen as regrettable from the point of view of the secondary, but potentially worthier, domain of the cinema. It would be better to détourn it as a whole, without necessarily even altering the montage, by adding a soundtrack that made a powerful denunciation of the horrors of imperialist war and of the activities of the Ku Klux Klan, which are continuing in the United States even now.

Such a détournement – a very moderate one – is in the final analysis nothing more than the moral equivalent of the restoration of old paintings in museums. But most films only merit being cut up to compose other works. This

reconversion of pre-existing sequences will obviously be accompanied by other elements, musical or pictorial as well as historical. While the filmic rewriting of history has until now been largely along the lines of Guitry's burlesque recreations, one could have Robespierre say, before his execution: 'In spite of so many trials, my experience and the grandeur of my task convinces me that all is well'. If in this case a judicious revival of Greek tragedy serves us in exalting Robespierre, we can conversely imagine a neo-realist sort of sequence, at the counter of a truck-stop bar, for example, with one of the truck-drivers saying seriously to another: 'Ethics was in the books of the philosophers; we have introduced it into the governing of nations'. One can see that this juxtaposition illuminates Maximilien's idea, the idea of a dictatorship of the proletariat.

The light of détournement is propagated in a straight line. To the extent that new architecture seems to have to begin with an experimental baroque stage, the *architectural complex* – which we conceive as the construction of a dynamic environment related to styles of behaviour – will probably détourn existing architectural forms, and in any case will make plastic and emotional use of all sorts of détourned objects: calculatedly arranged cranes or metal scaffolding replacing a defunct sculptural tradition. This is shocking only to the most fanatic admirers of French-style gardens. It is said that in his old age D'Annunzio, that pro-fascist swine, had the prow of a torpedo boat in his park. Leaving aside his patriotic motives, the idea of such a monument is not without a certain charm.

If détournement were extended to urbanistic realizations, not many people would remain unaffected by an exact reconstruction in one city of an entire neighbourhood of another. Life can never be too disorienting: détournements on this level would really make it beautiful.

Titles themselves, as we have already seen, are a basic element of détournement. This follows from two general observations: that all titles are interchangeable and that they have a determinant importance in several genres. All the detective stories in the 'Série Noir' are extremely similar, yet merely continually changing the titles suffices to hold a considerable audience. In music a title always exerts a great influence, yet the choice of one is quite arbitrary. Thus it wouldn't be a bad idea to make a final correction to the title of the 'Eroica Symphony' by changing it, for example, to 'Lenin Symphony'.

The title contributes strongly to a work, but there is an inevitable counteraction of the work on the title. Thus one can make extensive use of specific titles taken from scientific publications ('Coastal Biology of Temperate Seas') or military ones ('Night Combat of Small Infantry Units'), or even of many phrases found in illustrated children's books ('Marvellous Landscapes Greet the Voyagers').

In closing, we should briefly mention some aspects of what we call ultra-détournement, that is, the tendencies for détournement to operate in everyday

social life. Gestures and words can be given other meanings, and have been throughout history for various practical reasons. The secret societies of ancient China made use of quite subtle recognition signals encompassing the greater part of social behaviour (the manner of arranging cups; of drinking; quotations of poems interrupted at agreed-on points). The need for a secret language, for passwords, is inseparable from a tendency toward play. Ultimately, any sign or word is susceptible to being converted into something else, even into its opposite. The royalist insurgents of the Vendée, because they bore the disgusting image of the Sacred Heart of Jesus, were called the Red Army. In the limited domain of political war vocabulary this expression was completely détourned within a century.

Outside of language, it is possible to use the same methods to détourn clothing, with all its strong emotional connotations. Here again we find the notion of disguise closely linked to play. Finally, when we have got to the stage of constructing situations, the ultimate goal of all our activity, it will be open to everyone to détourn entire situations by deliberately changing this or that determinant condition of them.

The methods that we have briefly dealt with here are presented not as our own invention, but as a generally widespread practice which we propose to systematize.

In itself, the theory of détournement scarcely interests us. But we find it linked to almost all the constructive aspects of the pre-situationist period of transition. Thus its enrichment, through practice, seems necessary.

We will postpone the development of these theses until later.

Guy-Ernest Debord and Gil J. Wolman, 'Mode d'emploi du détournement', *Les Lèvres nues*, no. 8 (Brussels, May 1956) [on the cover of which the article was credited to Louis Aragon and André Breton – an ironic appropriation of their names, indicating that the Situationists were taking on the Surrealists, confronting what they had become with what they once were]; trans. Ken Knabb, in Knabb, ed., *Situationist International Anthology* (Berkeley and Los Angeles: Bureau of Public Secrets, 1981) 8–14.

Marcel Duchamp
Apropos of 'Readymades'//1961

In 1913 I had the happy idea to fasten a bicycle wheel to a kitchen stool and watch it turn.

A few months later I bought a cheap reproduction of a winter evening landscape, which I called 'Pharmacy' after adding two small dots, one red and one yellow, in the horizon.

In New York in 1915 I bought at a hardware store a snow shovel on which I wrote 'in advance of the broken arm'.

It was around that time that the word 'readymade' came to mind to designate this form of manifestation.

A point which I want very much to establish is that the choice of these 'readymades' was never dictated by aesthetic delectation.

This choice was based on a reaction of visual indifference with at the same time a total absence of good or bad taste ... In fact a complete anaesthesia.

One important characteristic was the short sentence which I occasionally inscribed on the 'readymade'.

That sentence, instead of describing the object like a title, was meant to carry the mind of the spectator towards other regions more verbal.

Sometimes I would add a graphic detail of presentation which in order to satisfy my craving for alliterations, would be called 'readymade aided'.

At another time – wanting to expose the basic antimony between art and readymades – I imagined a 'reciprocal readymade': use a Rembrandt as an ironing board!

I realized very soon the danger of repeating indiscriminately this form of expression and decided to limit the production of 'readymades' to a small number yearly. I was aware at this time that for the spectator, even more than for the artist, art is a habit-forming drug, and I wanted to protect my 'readymades' against such contamination.

Another aspect of the 'readymade' is its lack of uniqueness – the replica of a 'readymade' delivering the same message; in fact nearly every one of the 'readymades' existing today is not an original in the conventional sense. [...]

Marcel Duchamp, 'Apropos of "Readymades"' (lecture at The Museum of Modern Art, New York, 19 October 1961), in *Art & Artists*, vol. I, no. 4 (July 1966) 47; reprinted in Michel Sanouillet and Elmer Peterson, eds, *Salt Seller: The Writings of Marcel Duchamp (Marchand du Sel)* (New York: Oxford University Press, 1973) 141–2.

Andy Warhol
Interview with Gene R. Swenson//1963

Andy Warhol Someone said that Brecht wanted everybody to think alike. I want everybody to think alike. But Brecht wanted to do it through Communism, in a way. Russia is doing it under government. It's happening here all by itself without being under a strict government; so if it's working without trying, why can't it work without being Communist? Everybody looks alike and acts alike, and we're getting more and more that way. I think everybody should be a machine. I think everybody should like everybody.

Gene R. Swenson Is that what Pop art is all about?

Warhol Yes. It's liking things.

Swenson And liking things is like being a machine?

Warhol Yes, because you do the same thing every time. You do it over and over again.

Swenson And you approve of that?

Warhol Yes, because it's all fantasy. It's hard to be creative and it's also hard not to think what you do is creative or hard not to be called creative because everybody is always talking about that and individuality. Everybody's always being creative. And it's so funny when you say things aren't, like the shoe I would draw for an advertisement was called a 'creation' but the drawing of it was not. But I guess I believe in both ways. All these people who aren't very good should be really good. Everybody is too good now, really. Like, how many actors are there? There are millions of actors. They're all pretty good. And how many painters are there? Millions of painters are all pretty good. How can you say one style is better than another? You ought to be able to be an Abstract Expressionist next week, or a Pop artist, or a realist, without feeling you've given up something. I think the artists who aren't very good should become like everybody else so that people would like things that aren't very good. It's already happening. All you have to do is read the magazines and the catalogues. It's this style or that style, this or that image of man – but that really doesn't make any difference. Some artists get left out that way, and why should they?

Swenson Is Pop art a fad?

Warhol Yes, it's a fad, but I don't see what difference it makes. I just heard a rumour that G. quit working, that she's given up art altogether. And everyone is saying how awful it is that A. gave up his style and is doing it in a different way. I don't think so at all. If an artist can't do any more, then he should just quit; and an artist ought to be able to change his style without feeling bad. I heard that Lichtenstein said he might not be painting comic strips a year or two from now – I think that would be so great, to be able to change styles. And I think that's what's going to happen, that's going to be the whole new scene. That's probably one reason I'm using silkscreens now. I think somebody should be able to do all my paintings for me. I haven't been able to make every image clear and simple and the same as the first one. I think it would be so great if more people took up silkscreens so that no one would know whether my picture was mine or someone else's. [...]

Swenson Why did you start these 'Death' pictures?

Warhol I believe in it. Did you see the *Enquirer* this week? It had 'The Wreck that Made Cops Cry' – a head cut in half, the arms and hands just lying there. It's sick, but I'm sure it happens all the time. I've met a lot of cops recently. They take pictures of everything, only it's almost impossible to get pictures from them.

Swenson When did you start with the 'Death' series?

Warhol I guess it was the big plane crash picture, the front page of a newspaper: 129 DIE. I was also painting the 'Marilyns'. I realized that everything I was doing must have been Death. It was Christmas or Labor Day – a holiday – and every time you turned on the radio they said something like, '4 million are going to die'. That started it. But when you see a gruesome picture over and over again, it doesn't really have any effect. [...]

Andy Warhol and Gene R. Swenson, extracts from interview, *ARTnews*, vol. 62 (New York, November 1963) 60–3; reprinted in Jacob Baal-Teshuva, *Andy Warhol 1928–1987* (Munich: Prestel Verlag, 1993) 131–2.

Jeff Wall
On Dan Graham's *Homes for America* (1966-67)//1988

[...] *Homes for America* is the finest of the group magazine pieces of the late 1960s, all articulating the theme of the defeat of those ideals of rational, critical language by bureaucratic-commercial forms of communication and enforcement. The magazine pieces are structured as small, ironically insignificant defeats for liberationist ideas, as 'defeatist interventions' in the mechanisms of ideological dominations. They are aimed at interrupting the flow of standardized, falsified representation and language, and inducing a 'mini-crisis' for the reader or viewer by means of the inversions they create. [...] Reflected in the provocations and interventions characteristic of 1960s Situationism, in which an unexpected and confrontational gesture interrupts the established rhythm of relationships in a specific context, and induces a form of contestation, paradox or crisis, this approach thereby exposes the forms of authority and domination in the situation, which are normally imperceptible or veiled. The most notable artistic image of this is the unexpected 'void' or 'rupture' in the seamlessly designed social surface, and conceptualism's origins are filled with such blanks, erasures, tears and cuts. These gestures interrupt the induced habits of the urban masses, and the interruption theoretically permits social repression (which is the veiled content of habit) to emerge in a kind of hallucination provoked by the work. This liberating hallucination is the objective of the work, and its claim to value. Such Situationist intervention is also related to Pop, but inversely, as is conceptualism; it aggravates Pop irony by means of *humour noir*, and attempts to elicit a recognition ofthe terroristic aspects of the normalized environment of images, things, spaces and mechanisms.

Graham's magazine pieces fuse a Situationist-inspired strategy of the 'cut', of détournement, with that of the mimesis of bureaucratic forms of 'factography'. The interventions designed by him remain primarily concrete, functioning through the dynamics of specific subjects. Conceptualism, in relapsing into 'radical formalism', tended to empty the 'cut' or intervention of its specific character, thereby absolutizing it as an extreme form of emblematic abstraction. Such interventions are reduced to decorativism, as is the case with many later works by Daniel Buren, for example. Graham uses an actual text – an article, an advertisement, a chart – which constitutes its intervention through a structured difference with the norms of the genre in question. Thus, in these works, a specific social genre, existing functionally, is altered in a prescribed direction aimed at bringing out and making perceptible the underlying historical oppression.

Thus, *Homes for America*'s theme, the subjection of the romantic ideal of the harmonious garden suburb to the systems of 'land development', is presented in the pseudo-Readymade form of a 'think-piece' or popular photo-essay. This format is retained, mimetically, as the means by which the subject-matter is altered and made perceptible in a negative sense. Graham's approach accepts the existing formalism of culture – its rigidified generic structure – as a first principle, and applies pseudo-Readymade, pseudo-Pop and authentically Situationist strategies to it. The result is formalism intensified to the qualitative crisis point. The work makes its intervention in the context of a formalized emptiness of existing genres, but does not create an antithetical emptiness, a purely abstract or emblematic intervention. In fusing the journalistic attitude which accepts the primacy of subject matter together with the Situationist-conceptualist strategy of interventionism and détournement, the work establishes a discourse in which the subject matter, a critique of Minimalism and Pop via a discussion of the architectural disaster upon which they both depend, can be enlarged to the point of a historical critique of reigning American cultural development. […]

Jeff Wall, extract from 'Dan Graham's *Kammerspiel*', *Real Life Magazine*, no. 15 (Winter 1985) 34–6; reprinted in *Jeff Wall: Selected Essays and Interviews* (New York: The Museum of Modern Art, 2007).

Reiko Tomii

Rebel with a Cause: Akasegawa Genpei's *Greater Japan Zero-Yen Note* (1967)//2000

Paper money, as pieces of paper, is worthless, but its theoretical worth becomes real when institutionally underwritten; as such, paper money fuels the financial and economic engine of modern society. Inevitably, it sparks the creative and critical faculties of modern artists. To put it crudely, society sees little harm in what artists do with money, so long as their works innocuously remain in the semiotic empire of images, in the autonomous realm of Art. However, artists with anti-art inclinations tend to violate the boundary between art and life, performing interventional acts in everyday contexts. Should their works trespass into the terrain of criminality, society (or, more precisely, the state) is compelled to strike back.

And courtroom battles over 'money art' are not rare. In Japan, Akasegawa Genpei inadvertently achieved notoriety for his *Model 1,000-Yen Note Incident*, in which the artist's 'mechanically reproduced' money (made in 1963) became an object of criminal investigation, indictment and trials (1965–70).[1]

Judicial views on money art differ from country to country, depending on the laws that govern currency. In a nutshell, the trial surrounding Akasegawa's *Model 1,000-Yen Note* amounted to a contest between art and the state over the balance between constitutionally guaranteed freedom of expression and public welfare. Given the authoritarian nature of the Japanese judiciary system, Akasegawa predictably lost his case in 1967, with his guilty verdict upheld by the Supreme Court in 1970.

For the convicted artist the most pressing issue was no longer the definition of art, because, ironically, this anti-art practitioner had learned to say, with firm conviction, 'art *is* what an artist says is art'. Rather, his concern was how to continue his art without losing the biting edge of his critique of 'civil society',, every corner of which was 'stained by the state's power'.

Now that, thanks to the trial, he was equipped with an intimate understanding of money-making, one logical place to start his post-trial work was money. Thus, he created the parodic *Greater Japan Zero-Yen Note* (1967). He even devised an ingenious strategy of inserting it into everyday life. Through a poster he designed and writings published in magazines, he advertised that he would exchange three actual 100-yen notes for his zero-yen note. His goal was to put 'real money' issued by the state out of circulation, by offering his no-value money in exchange for 300 'real' yen. And many people bought into his idea, sending him their money. (To this day he has the bills preserved in a few 30-cm-

high glass jars, together with the post-office cash mailers they were sent in.)

Without doubt, *Zero-Yen Note* is a funny piece, with its explicit worthlessness (the figure 0 being prominently and repeatedly featured), the artist's insistence that his money is 'THE REAL THING' (as printed in English on its verso), and his quixotic exchange scheme. Still, we short-change ourselves if we focus only on its obvious transgression. The true offence lies in Akasegawa's proclamation that his work is 'law-abiding'. The 'history' of *Zero-Yen Note* in his poster puts it this way:

> Pulling out wet grapevines
> Gutenberg paved the road.
> Seashells, with the sea drawn out of them,
> Turn into paper, passed through iron.
> Throwing a sidelong glance to the tunnel of paper money,
> Civilians press on in their battle,
> Trampling over Kasumigaseki [the government office district].
> In zero they trust,
> This law-abiding painting.

Being law-abiding does not necessarily mean being docile before the state's power. As is the case with 'law-abiding struggles' of labour unions, adherence to every regulation in the book can be an effective measure of legal resistance. In fact, parody, working by definition through appropriation, offers a more devastating commentary on its subject than outright opposition.

Greater Japan Zero-Yen Note exemplifies Akasegawa's manoeuvres to render his money 'real' without being really real, thus keeping it absolutely lawful. Above all, the denomination of 'zero' invalidates any accusation of 'counterfeiting' and 'imitating' real bills (both unlawful acts). Then, there is its size. Although incorporating all the requisite elements of currency design – elaborate borders, authentic-looking typefaces, a serial number, the portrait of a historically important person – it is approximately twice the size of real banknotes in Japan. From this telltale sign alone,, no one would mistake it for 'real' or actually use it.

In addition, two peculiarities on its recto readily signal the parodic nature of the artist's intervention. For one thing, the portrait (which was most likely borrowed from the actual 500-yen bill) has an empty face, with the caption 'the real view'. Secondly, the Japanese word *honmono* ('the real thing') is superimposed to mimic the way 'sample' (*mihon*) bills are officially marked for cancellation. Besides, the work is conspicuously imprinted with the title *Greater Japan Zero-Yen Note* on its recto. In postwar society, not many people would

take seriously anything bearing the phrase 'Greater Japan', a painful reminder of wartime imperialist Japan. The most incongruous iconography is Akasegawa's oblique allusion to paper money as printed matter, represented on the verso by Gutenberg and printing-related objects, including a printing press and typesetters' shelves, among others.

With all the care he took to be law-abiding, Akasegawa could not help making some references to *Model 1,000-Yen Note Incident* in his *Zero-Yen Note*. Notice the three zeros in each corner of its recto.. This is not a design mistake, where only one zero would suffice, but signifies the deletion of 1's from the 1,000-yen note. Its serial number, RA5654659R, is directly transferred from *Model 1,000-Yen Note*. And finally, his 'law-abiding' stance is secretly contradicted by four Chinese characters, hidden in the border decoration, that express his honest sentiment, quoting Chairman Mao: *zo-han-yu-ri*, or 'rebel with a cause'!

1 For further details on this work, see the author's essay in *Global Conceptualism* (New York: Queens Museum of Art, 1999) 20–22.

Reiko Tomii, 'Rebel with a Cause: Akasegawa Genpei's *Greater Japan Zero-Yen Note* (1967)', in *M'Ars: Casopis Moderne galerije Ljubljana/Magazine of the Museum of Modern Art Ljubljana*, XII [referring to the year; the periodical ran from 1989–2001], no. 3–4 (Slovenia, 2000) 10–11.

THE FIRST TIME I SAW
BLEEDING SOLDIERS AND
BURNING HUTS ON TV AT
DINNER HOUR I GOT RID
OF IT. I WAS SHOCKED. IT
WAS THE MOST OFFENSIVE,
OUTRAGEOUS THING I
COULD IMAGINE. I WAS
HORRIFIED. THAT EXPERIENCE
LED DIRECTLY TO THE
BRINGING THE WAR HOME
M O N T A G E S

Martha Rosler, Interview with Molly Nesbit and Hans-Ulrich Obrist, 2005

AGITPROP

Lucy R. Lippard On the Art Workers' Coalition:
 Q. And babies? A. And babies, 1970//**050**

Cildo Meireles Insertions in Ideological Circuits,
 1970//**051**

Jean-Luc Godard and Jean-Pierre Gorin Inquest on
 an Image, 1972//**052**

Miguel Orodea Álvarez and Vertov, 1980//**056**

Susan Stoops Martha Rosler: *Bringing the War Home*
 (1967–2004), 2007//**058**

Lucy R. Lippard
On the Art Workers' Coalition: *Q. And babies? A. And babies*//1970

[...] The bitterest quarrel the Art Workers' Coalition has had with the Museum [of Modern Art, New York] was over joint sponsorship of the Song-My massacre protest poster – a ghastly, coloured photograph of the event by a *Life* photographer [over which the AWC superimposed the text] *Q. And babies? A. And babies* – which was vetoed by the president of the Board of Trustees after an initial, though unexpected, executive staff acceptance of the proposal.

We picketed and protested in front of *Guernica*, published 50,000 posters on our own and distributed them, free, via an informal network of artists and movement people; it has turned up all over the world. Our release read, in part:

'Practically, the outcome is as planned: an artist-sponsored poster protesting the Song-My massacre will receive vast distribution. But the Museum's unprecedented decision to make known, as an institution, its commitment to humanity, has been denied it. Such lack of resolution casts doubts on the strength of the Museum's commitment to art itself, and can only be seen as bitter confirmation of this institution's decadence and/or impotence.' Via this and other experiences we discovered that semi-private institutions are unable to buck their trustees, particularly when the issue is one that presents the trustees with a direct conflict of interest. (As Gregory Battcock said at the Open Hearing: 'The trustees of the museums direct NBC and CBS, the *New York Times* and the Associated Press, and that greatest cultural travesty of modern times – The Lincoln Center. They own AT&T, Ford, General Motors, the great multi-billion dollar foundations, Columbia University, Alcoa, Minnesota Mining, United Fruit and AMK, besides sitting on the boards of each others' museums. The implications of these facts are enormous. Do you realize that it is those art-loving, culturally committed trustees of the Metropolitan and Modern museums who are waging the war in Vietnam?' [...]

For this Art Workers' Coalition action the group superimposed the text onto the US Army photographer Ronald Haeberle's horrific image of the Song-My [syn. My Lai] massacre of 1968, first published in a newspaper in Cleveland, Ohio, and then in *Life* magazine in winter 1969. Picasso's *Guernica* was on loan from the artist to the Museum of Modern Art from 1939 until the restoration of democracy in Spain. The production of the poster and the protest took place in January 1970.

Lucy R. Lippard, extract from 'The Art Workers' Coalition: Not a History', *Studio International*, vol. 17, no. 6 (November 1970) 173.

Cildo Meireles
Insertions in Ideological Circuits[1]//1970

[...] When Marcel Duchamp, defining his work theoretically, stated that his intention was among other things to free art from the sphere of the handmade, he couldn't have imagined the point we'd reach today. What from that early perspective could be easily discerned and effectively resisted now tends to be situated in a place more difficult to access and apprehend: the mind.

Today Duchamp's phrase alerts us to a lesson incorrectly learned. He resisted not so much the role of the handmade in art as its system; in short, the gradual emotional, rational and psychological lethargy that its mechanicalness, its habituation would inevitably produce in the individual. The fact that one's hands are not soiled with art means nothing except that one's hands are clean.

So, rather than against manifestations of a phenomenon, the fight is against the logic of that phenomenon. What we see at present is a certain relief and pleasure in art that resists the handmade. As if things were finally okay, as if at this specific moment people don't need to start resisting a far greater opponent: the habits and handiwork of the mind.

Style, whether manual or mental, is an anomaly, and it's more intelligent to let an anomaly atrophy than help it survive.

If Duchamp's intervention was in terms of art (the logic of the phenomenon), it's correct to say that it applied to aesthetics. If it thus announced the freeing of the habitual from the handmade, it's also correct to say that any intervention in this sphere today would necessarily be a political one (Duchamp's collocations having the merit of shifting our perception of art away from artistic objects towards the phenomena of thought; given that the artworks being made today tend to be concerned with culture in general rather than art alone). For *if aesthetics is the basis of art, politics is the basis of culture.*

1 [In the work *Inserções em circuitos ideológicos* (*Insertions in Ideological Circuits*, 1970) banknotes and recyclable Coca-Cola bottles were temporarily removed from circulation in Rio de Janeiro by the artist, subtly inscribed with political messages and placed back in normal circulation.]

Cildo Meireles, extract from 'Inserções em circuitos ideológicos' (1970), *Malasartes*, no. 1 (September–November 1975); reprinted in Alexander Alberro and Blake Stimson, eds, *Conceptual Art: A Critical Anthology* (Cambridge, Massachusetts: The MIT Press, 1999) 232–3. Translation revised for this publication, 2008.

Jean-Luc Godard and Jean-Pierre Gorin
Inquest on an Image//1972

Dear Jane

When *Tout va bien* was shown at the film festivals of Venice, San Francisco and Carthage, New York, the publicity distributed used a photo of you in Vietnam rather than stills from the film. We found this photo [Jane Fonda speaking with Hanoi residents after a US bombing raid] in an issue of *L'Express* at the beginning of August 1972, and we think it will allow us to talk in very concrete terms about the problems raised by *Tout va bien*. […]

Elements of Elements

– This photo reproduces another photo of the actress that appeared on the cover of the same issue of *L'Express*. The term 'cover' speaks volumes, if you take the trouble to see that a photo can cover up as much as it uncovers. A photo demands silence even as it speaks. In our opinion, that is one of the technological bases of the two-faced Jekyll and Hyde (fixed capital/variable capital) aspect that information/disinformation takes on when it is transmitted by images/sounds in our day, that is, the day of the decline of imperialism and the general trend towards revolution.

– The American Left often says that the tragedy is not taking place in Vietnam but in the USA. The expression on the woman activist's face is indeed the expression of a tragic actress. But she is a tragic actress who has been socially and technically formed by her origins, in other words formed/deformed by the Hollywood school of Stanislavsky-style showbiz.

– The expression on the woman activist's face was the same in reel 3 of *Tout va bien* when, as an actress, she was listening to a woman extra singing a text from *Lotta Continua*.[1]

– The actress also puts on this type of expression when, in *Klute* [dir. Alan Pakula, 1971], she gives her friend, a police officer played by Donald Sutherland, that tragic, pitying look and decides to spend the night with him.

– On the other hand, the same type of expression had already been used in the 1940s by Henry Fonda when he played the exploited worker in *The Grapes of Wrath* by the future fascist Steinbeck. And to go back still further into the actress's paternal history within the history of the cinema, this is also the expression that Henry Fonda borrowed to give the Blacks that tragic, pitying look in *Young Mr Lincoln* by John Ford, the future honorary naval Admiral.

– And on another hand, we find the same expression on the other side, when John

Wayne gets tearful about the ravages of the war in Vietnam in *The Green*
– In our opinion, this expression is borrowed (with interest) fr
exchangeable mask of Roosevelt's New Deal. It is in fact an expressive expression
and it first appeared, thanks to a necessary coincidence, at the time of the
economic birth of the talkies. It is an eloquent expression, but it speaks only in
order to say that it knows a lot (about the Wall Street stock market crash, for
example) but that it will say no more. And that, in our view, is why this
Rooseveltean expression is technically different from the expressions that came
before it in the history of the cinema, the expressions of the great stars on the
silent screen, Lillian Gish, Rudolph Valentino, Falconetti and Vertov, while we hear
the words: *film = a montage of I see.* Just try it; get all those faces to look at a photo
of atrocities in Vietnam, and you will see that not one of them has this expression.
– The reason is that, before the talkies, silent films started out with a materialist
technical base. The actor said 'I am (being filmed), therefore I think (at least I
think I am being filmed, it is because I exist that I think.' After the talkies, there
was a New Deal between the matter that was being filmed (the actor) and
thought. The actor began to say: 'I think (that I am an actor), therefore I am
(being filmed).' It is because I think that I am.
– As we have seen from this experiment, which goes beyond [the Soviet
filmmaker] Kuleshov's, before the expression of the New Deal, every actor in the
silent movies had their own expression, and silent film had real popular bases.
When, in contrast, films begin to talk like the New Deal, every actor began to say
the same thing. You can carry out the same experiments with any film star, sports
star or political star (a few cut-in shots of Raquel Welch, Pompidou, Nixon, Kirk
Douglas, Solzhenitsyn, Jane Fonda, Marlon Brando, of German officials at Munich
72, while we hear the same words I think, therefore I am, as we see a reverse-
angle shot of Vietcong corpses).
– This expression that speaks volumes but says nothing more and nothing less is
therefore an expression that does not help the reader to get a clearer insight into
his most personal problems (to see something in Vietnam that can shed light on
them, for example). So why should we be content with that and say: it's a step in
the right direction, something comes across (the whole trade union speech in reel
3 of *Tout va bien*). And why, if the actress is still incapable of acting differently
(and, for our part, we are still incapable of really helping her to act differently),
why, in this domain, should the North Vietnamese be content with that? And in
any case, why should we be content with the fact that Vietnamese are content
with that? In our opinion, there is a danger that we will do more harm than good
if we acquire a clear conscience on the cheap (to put it in scientific terms: the
transition that takes us from negentropy to information does not cost very much),
After all, this expression is addressed to us too, to those of us who make the effort

.o look at it twice. It is to us that this gaze and this mouth say nothing and become devoid of meaning, like that of the Czech children facing the Russian tanks, or the swollen little bellies in Biafra and Bangladesh, or the feet of the Palestinians in the mud that is so carefully maintained by UNWRA. Devoid of meaning, mind you, for the capital that can cover tracks, that can fill the real gaze of its already-present future enemies with an empty meaning, and which therefore has to be 'absented', made to look nowhere.

– How can we fight this established fact? Not by ceasing to publish the photo(s) in question (we would immediately have to ban all TV and radio programmes in almost every country in the world, as well as newspapers of all kinds, and that is utopia). No. But we can publish them differently. And it is in that 'differently' that stars have a role to play because of their monetary and cultural influence. A crushing role, as they say. And the real tragedy is that they still do not know how to play that crushing role. It is still the Vietnamese, the stars of the revolutionary war of independence, who make the sacrifice. How to play that role? What is to be done to teach them to play it? A lot of questions still arise in Europe and the USA before we can give a clear answer. We ask some of them in *Tout va bien* (just as Marx, in his day, starting out with *The German Ideology*, finally raised the question in *The Poverty of Philosophy*, contra Proudhon, who could no more than philosophize about poverty).

First Conclusions

Finally, say the novelists and philosophers. The bottom line is …, say the bankers. We can see that carrying out an inquest on this photo comes down to correctly posing and exposing (we are still in the domain of photography) the problem of the star. It is the stars, the heroes, that make History, or is it peoples?

– At the same time, we have to raise the question of the shop steward, of representation. Who represents what, and how? I represent the German working class, said the German Communist Party, before sending the main body of its army to those who were about to be encircled at Stalingrad. I represent socialism, says a young Kibutznik as he plants oranges in Arab soil for free to swell the profits of Bank Leoumi.[2] I represent American stability, says Richard Milhouse Nixon. In a word, some represent aspirators, and others, aspirations. They are the same people.

– It seemed to us to be useful, if we want to get some idea of what is going on, to do what journalists never do: ask questions of a photo (photos represent reality too); but not just any photo, and not just any reality. And therefore not just any representation.

Second Conclusions

– Our desire to ask questions of this photo did not come about by chance. The *Tout va bien* machine runs on stars too. Star stars, even, given that it is about a pair of lovers (the star screenplay in Hollywood's imperial system) played by two stars of the capitalist system, coupled with a star director. And what do all these stars do in the film, except listen to the noise of a workers' strike in the same way that Jane Fonda listens to the noise of the Vietnamese revolution in the photo? But there is nothing to say that in the photo. In the film, we do say it.

– In fact we can already say that what interests the Vietnamese is having displaced an American star. And it is by displacing that star that they show that their cause is just and strong. And capital's troops take advantage of that displacement to attack. And for our part, we have to take advantage of the forced displacement of capital to attack in our turn.

– In our opinion, this photo should have been replaced and the two photos that are in the photo should have been juxtaposed: the old photo and the new photo, with a new caption below the old photo, and an old caption under the new photo.

– That would give us something like this: in Vietnam, I am cheerful because there is hope for the revolution, despite the bombs; in America, I am sad even though the financial situation is improving, because there is no future.

– This is the reality: two sounds, two images, the old and the new, and the way they are combined. For it is imperialist capitalism which says that two merge into one (and shows only one photo of you), and the social and scientific revolution which says that one divides into two (and shows how the new struggles with the old within you).

– *Voilà.* There are certainly other things that should be said too. We hope we will have time to see you in the USA and to talk a bit about all that with the views. Good luck, in any case.

1 [The Italian autonomist revolutionary group, founded in 1969.]

2 [Bank Leumi, originally founded at the turn of the last century as the principal financial instrument of the Zionist movement.]

Jean-Luc Godard and Pierre Gorin, extracts from 'Enquête sur une image' [based on the authors' dialogue, interrogating the photograph, which forms the soundtrack of their film *Letter to Jane*, 1972], *Tel quel*, no. 52 (Paris, Winter 1972); reprinted in Alain Bergala, ed., *Jean-Luc Godard par Jean-Luc Godard, vol. I. 1950–1984* (Paris: Éditions Cahiers du Cinéma, 1998) 350; 357–8; 361–2. Translated by David Macey, 2008.

Miguel Orodea
Álvarez and Vertov//1980

[...] Dziga Vertov elaborated a shooting theory which makes an energetic reply to the way the images are recorded within the conventions of bourgeois cinema. He suggested new points of view, angles, camera movements, slow-motion, photomontage, etc., that can be interpreted as elements in the creation of a filmic language in which the association of ideas responds to more than mere succession of images, but also to what is going on within the frame.

The devices employed by [the Cuban filmmaker] Santiago Álvarez, while they result from the same ideological preoccupations, also find practical justification in the lack of available material and resources. Perhaps this is why there isn't a theory that holds Álvarez's work together and why he doesn't seem interested in elaborating one. But we will return to this point.

Technical advances have allowed Álvarez to experiment on a much bigger scale than Vertov could have aimed at, in the use of the techniques of rostrum animation, optical refilming, sound, colour, etc. Álvarez's visual resources vary from the use of photographic material from *Playboy* and the North American press in general, to extracts from Hollywood-style movies, Soviet classics, scientific documentaries, archive footage and television images, newspaper headlines and animated titles, put together in counterpoint with the most eclectic range of music.

> The reason for much of this inventiveness is necessity. The Americans blockade us, so forcing us to improvise. For instance, the greatest inspiration in the photo-collage of American magazines in my films is the American Government, which has prevented me getting hold of live material. (Álvarez)

To accept that the work of Álvarez is the fruit of necessity and intuition leaves less room for its analysis in terms of theory, and presents the first obvious difference with Vertov.

Although Vertov's cinema was also based on the manipulation of available material, his films responded to aesthetic positions that were already defined in the declaration of the Cinema-eye and Cinema-truth principles. Álvarez's cinema does not respond to such planning; neither can we talk about an Álvarez 'style', since it does not exist as such. His style consists in adapting to the needs of the moment and using everything at his disposal. It is a style of constant evolution and change. The only constantly dominant criterion in his cinema is

support for the Revolution and the anti-imperialist offensive. 'My style is the style of hatred for imperialism', as he expressed himself to a recent interviewer.

The aesthetic preoccupations in Vertov's cinema have been seen as a consequence of the declaration of principles and for many this was to the detriment of the content. In *Man with a Movie Camera* (1929) Vertov provides a text that is supposed to help as a guide to the portrayal of reality. He gives the film an aesthetic orientation.

The elaboration of such principles would never have occurred to Álvarez, since the idea of subordinating content to aesthetics worried him. He is always prepared in his films to sacrifice form if at any moment the communicability of the message is at risk. Moreover, he does not reject conventional forms a priori:

> Innovation results from making traditional forms valuable, by revitalizing them. To me, style has unity with content. I don't want to waste my time, nor the time of the audience, only looking at abstractions – the well-made, artistic film without content. We don't care in Cuba about any one style, we don't care if it is naturalistic, impressionist, abstractionist, pop, all styles are good depending on how to use them. Sometimes socialist countries are against certain styles, but we do not subscribe to this thesis. A revolutionary artist cannot separate content from style. We cannot afford though, to make works of art for some small group, there is great urgency in our fight against underdevelopment to provide not just meals, but culture for everyone. (Álvarez)

After this argument it becomes clear that Álvarez and Vertov are quite distant from each other. Vertov would never have subscribed to this thesis, not because he didn't value communication but out of his impulse to combat bourgeois forms, which lay above any consideration about the effectiveness of the message. A dogmatism that led him to face harsh criticisms.

The first quote from Vertov in this extract is from a translation by Michael Chanan of the *Hablemos de Cine* interview included in the BFI Dossier on Álvarez listed below; the second is from Michael Chanan's edit of an interview with Álvarez by Stacy Waddy, from *The Guardian*, 19 July 1969.

Miguel Orodea, extract from 'Álvarez and Vertov', in Michael Chanan, ed., *BFI Dossier no. 2: Santiago Álvarez* (London: British Film Institute, 1980) 25–6.

Susan Stoops
Martha Rosler: *Bringing the War Home* (1967–2004)//2007

'... I began making agitational works 'about' the Vietnam War, collaging magazine images of the casualties and combatants of the war – usually by noted war photographers in mass market magazines – with magazine images that defined an idealized middle-class life at home. I was trying to show that the 'here' and the 'there' of our world picture, defined by our naturalized accounts as separate or even opposite, were one.' [1]
– Martha Rosler

During the forty years since she embarked on the first *Bringing the War Home* images, Martha Rosler has become one of contemporary art's most respected and incisive cultural critics as an artist, writer and teacher. Since the 1970s, she has worked in photography, video, performance and installation, bringing her feminist perspective and critical eye to visual representations of everyday life through a process she describes as 'inserting public narratives into private ones'. [2]

In the pioneering *Bringing the War Home* series, a group of twenty images from 1967–72, Rosler combined news photos of soldiers in combat, burning villages, and the corpses of the Vietnam war from *Life* magazine with images of a prosperous post-World-War II America, epitomized by the domestic interiors reproduced in *House Beautiful*. In jarring juxtapositions, pristine living rooms and cheerful kitchens were 'invaded' by refugees and landscapes of war. Produced during the height of the war, Rosler's images were originally disseminated in underground newspapers, anti-war journals and flyers, or as photocopies.

> At the time it seemed imperative not to show these works – particularly the anti-war montages – in an art context. To show anti-war agitation in such a setting verged on the obscene, for its site seemed more properly 'the street' or the underground press, where such material could help marshall the troops, and that is where they appeared. [3]

Developed in the context of Rosler's anti-war and feminist activism, these images embody the radical ambitions of a counterculture that sought change not only in terms of war policy but also human rights across social lines of race, gender and class. [4] Conceptually, the montages were born from Rosler's 'frustration with the images we saw in television and print media, even with anti-war flyers and posters. The images we saw were always very far away, in a

place we couldn't imagine.'[5] This work was also early evidence of what has become a lifelong role for Rosler – the artist as citizen.

> My politicized practice began when I saw that things were left out of explanations of the world that were crucial to its understanding, that there are always things to be told that are obscured by the prevailing stories. The 1960s brought the delegitimation of all sorts of institutional fictions, one after another. When I understood what it meant to say that the war in Vietnam was not 'an accident', I virtually stopped painting and started doing agitational works ...[6]

The images' entry into the 'art world' can be traced back to the early 1990s, when they were printed from original collages as a limited edition and shown in 1991 at Simon Watson Gallery in New York City. As Rosler recalls, 'I realized that if I wished to have these works written into history, they would have to be somehow normalized.'[7] One of her motivations was to have them serve as models of image combat.[8] Their appearance in an art-world context two decades after they were created not only brought this work fully into the postmodern discourse Rosler's practice had helped shape but also coincided with the 1991 Gulf War. In a feature article by Brian Wallis a few months later in *Art in America*, the author insightfully contrasts Rosler's low-tech montages with the then-current television spectacle of Gulf War imagery: 'While computer–enhanced video-tapes of smart bombs effortlessly tracking and painlessly exploding their targets made the Gulf War seem fictional and distant, Rosler's photomontages invert this perception, matching scale, colour and perspective to make a horrific imaginary situation appear "authentic".'[9] In these works, Rosler knew 'it was important that the space itself appear rational and possible; this was my version of this world picture as a coherent space – a "place".'[10] Her Vietnam war montages reconnected experiences in life that had been falsely separated – a distant war and the living rooms in America[11] – and exposed the powerful relations between media representation and public opinion, advertising and politics, sexism and violence, a 'militarized "outside world" and a pacific interior'.[12]

Photomontage, with roots in German Dada produced in the wake of World War I (by Raoul Hausmann, Hannah Höch and John Heartfield in particular), has a history of being an effective 'aesthetic-political technique'[13] which, with its cut-and-paste process and vernacular imagery culled from the popular press, often exposed the role of photography in constructing false truths or apparent facts. Rosler said she turned to photomontage in the 1960s 'because in the most obvious way a photographic montage disrupts the notion of the real while still employing photographic material, which speaks to people with a great degree of

immediacy'.[14] It has proven to be an ideal medium for Rosler's egalitarian message 'pitched against' what she called 'the mythology of everyday life', in which 'all the things that were supposed to be separate from one another actually were not in any way separate but intertwined practices ...'[15]

Bringing the War Home: House Beautiful, 1967–72

Bringing the War Home carried forward some of the feminist concerns in the other photomontages. ... All of them invoked the domestic interior, specifically, representations of the domestic interior, and the construction of separate categories and thus separate spaces. The subject was 'photos of', rather than simple experience.[16]

Rosler's Vietnam series began in 1967, the year that the three major TV networks began broadcasting fully in colour, and ended in 1972, the last year that *Life* magazine was published as a weekly. '*Life* magazine', Rosler recalls, 'was in my living room every week from my early childhood on.'[17] Her juxtapositions play on the montage character of *Life*, where pages of photo-essays documenting the news alternated with lifestyle and entertainment features, all of which seamlessly flowed into advertisements for the latest appliances, the ideal mattress, the designer sofa or the perfect lawn.

The war in Vietnam came to be known as the 'living room war' and the TV screen, which brought images of daily carnage (interrupted by ads for consumer comforts) into homes across America, appears in Rosler's early montages.[18] But Rosler's incorporation of the transparent glass of the modern picture window brings the outside world even closer and on a human scale. With drapes partially drawn or dispensed with entirely, it designates the transition zone – or no transition – between 'here' and 'there', private and public, security and danger. Compared to the relative distancing provided by the smaller TV screen, the window expanse provides only limited protection from the surrounding violence and indeed threatens to melt away as is suggested by *Cleaning the Drapes*. The picture window's traditional role of framing a manicured landscape now describes a radically different scene: bodies of slain Vietnamese *(House Beautiful [Giacometti])* and destroyed villages patrolled by soldiers and armoured tanks (*Vacation Getaway; Patio View; Cleaning the Drapes*). Rosler often positions us on the inside, where we share the point of view of the residents who are so engaged in their own lives that they are oblivious to the soldiers and victims ambling through their homes, or to the nightmarish conditions just outside the window.

In scenes of estrangement – Vietnamese victims moving uneasily yet believably through fashionable American homes (*Tron [Amputee]* and *Balloons*), a GI sitting outside his once-familiar suburban home (*Tract House Soldier*) –

Rosler emphasizes the irreconcilable gulf and the nonetheless imaginary line between 'here' and 'there', 'us' and 'them', by formally pushing figures well into the foreground or through strategic combinations of black-and-white and colour details. Elsewhere, Rosler's visual collisions of domestic life and the war take the form of a consumer product paired with a war-zone setting, which challenges us to consider the economic and social connections between disparate realities – a luxury Cadillac convertible alongside a riderless, ruined bicycle on a booby-trapped road (*Booby Trap*); a model's eye in a make-up ad replaced by a blindfolded Vietnamese woman surrendering at gunpoint (*Makeup/Hands Up*); a mattress ad complete with lounging family set in a flooded and destroyed dwelling (*Beauty Rest*).

Bringing the War Home: House Beautiful, New Series, 2004

Driven in 2004 to create a new series – collectively titled *Bringing the War Home: House Beautiful, New Series* – by her renewed sense of urgency and outrage in response to the US war on Iraq and its subsequent occupation, Rosler also was cognizant of the way the 'news value' of politically motivated art is eventually 'replaced by a mythologized, universalized message. People can look at the Vietnam war works now and see universal messages. Which is why it was time to do a new series.'[19] Despite the availability of Photoshop technology this time, Rosler relied on her hands-on, cut-and-paste, 'you can do this' collage process, preferring its subtle traces of the seams between images, which remind us of the photos' origins in the popular press.[20]

In the Iraq images, Rosler both revives earlier subjects and strategies and updates them to reflect the latest technologies and fashions, the new perpetrators and victims. She confronts us with chilling juxtapositions of narcissistic models and burkha-covered women, raging fires and hi-tech kitchens, tortured prisoners and leather sofas. The places (Baghdad, Saddam's Palace, Abu Ghraib) and faces (George and Jeb Bush, Lynndie England, Muqtada al-Sadr) are specific to this conflict. Scenes of this war are not confined to the rational spaces, including the living rooms, the picture window or the flat-screen TV – they erupt across any available surface from oven, pillow, mirror, book cover and picture frame to the ubiquitous cellphone screen.

In images including *Photo-Op* and *Cellular*, Rosler uses our current obsession with digital cameras and cellphones 'at home' to expose a cultural disconnection from the 'distant' effects of war. Depictions of young women absorbed with their cellphones, oblivious to the chaotic scene behind them, represent what Rosler identifies as an 'ideal projection (from the corporation that sells cellphones) of what you should be worried about – peering deeply into some obscure little image on a tiny phone that is a narcissistic bubble.'[21] As if attempting to direct

their – and our – attention towards the world stage, Rosler inserts Iraqi images into their cellphone screens.

But the Iraq images – especially those incorporating Abu Ghraib prison photos – also expose the role that this technology (and the internet as a means of distribution) has played in the lives of combatants and victims, and how these particular photos uniquely shaped perceptions of this war around the world. As Rosler notes, 'while trophy photos have long been a part of US soldiers' mementos, the sheer volume and dissemination, the instantaneity, marks a new moment in their use. Where once the technologies of information required many steps from production to dissemination to entry into our personal spaces, now the speed of transmission is dizzying, the steps invisible, and the distances traversed all but eradicated.'[22]

This unprecedented instantaneity in which the personal becomes public, further blurring traditional boundaries between inside and outside, 'us' and 'them', is reflected in the Iraq montages. Experienced together, the Vietnam and Iraq series make explicit the effects of the media evolution associated with each of these conflicts, as it is described by architectural historian and media scholar Beatriz Colomina: 'Each war throughout the twentieth century can be identified with different forms of media – an evolution from newspapers and television to computers and cellphones – that redefine our sense of public and private, inside and outside.'[23] [...]

1 Martha Rosler, 'Place, Position, Power, Politics' (1994), *Decoys and Disruptions: Selected Writings, 1975–2001* (Cambridge, Massachusetts: The MIT Press, 2004) 353, 355.

2 Rosler, unpublished panel presentation for 'The Feminist Future Symposium', The Museum of Modern Art, New York, 26 January 2007.

3 Rosler, *Decoys and Disruptions*, op. cit., 355.

4 Rosler's move from New York to San Diego in 1968 had led to her making work in relation to anti-war and protest journals based there, as well as her active participation in the women's movement. As noted by art historian Alexander Alberro, 'Questions of oppression and resistance, long central to her thinking, acquired concrete application in relation to herself for the first time, as feminism clarified the direct links between everyday life, anti-war work, and struggles for civil rights and political and social transformation.' See Alexander Alberro, 'The Dialectics of Everyday Life: Martha Rosler and the Strategy of the Decoy', in *Martha Rosler: Positions in the Life World*, ed. Catherine de Zegher (Cambridge, Massachusetts: The MIT Press, 1998) 78.

5 Rosler, quoted in Laura Cottingham, 'The War is Always Home: Martha Rosler', Simon Watson Gallery, New York, October 1991(exhibition brochure).

6 Rosler, *Decoys and Disruptions*, op. cit., 353.

7 Rosler, *Decoys and Disruptions*, op. cit., 356.

8 Rosler, in correspondence with the author, 2007.

9 Brian Wallis, 'Living Room War', *Art in America* (February 1992) 105.

10 Rosler, *Decoys and Disruptions*, 355.

11 Cottingham, 'The War is Always Home: Martha Rosler'.

12 Rosler, in correspondence with the author, 2007.

13 Rosler, *Decoys and Disruptions*, op. cit., 279.

14 Rosler, in 'Martha Rosler in Conversation with Molly Nesbit and Hans-Ulrich Obrist', *Martha Rosler: Passionate Signals*, ed. Inka Schube (Hannover: Sprengel Museum/Hatje Cantz, 2005) 30.

15 Rosler, in *Passionate Signals*, op. cit., 34.

16 Rosler, in 'Benjamin Buchloh: A Conversation with Martha Rosler', *Martha Rosler: Positions in the Life World*, op. cit., 47.

17 Rosler, in *Passionate Signals*, op. cit., 24.

18 Rosler remembers her response to the television reporting from Vietnam: 'That's primarily what had made me get rid of my TV. The first time I saw bleeding soldiers and burning huts on TV at dinner hour I got rid of it. I was shocked. It was the most offensive, outrageous thing I could imagine. I was horrified. That experience led directly to the *Bringing the War Home* montages.' See *Passionate Signals*, 50.

19 Rosler, interviewed by Christy Lange, 'Bringin' it All Back Home', *frieze* (November–December 2005) 94–5.

20 Rosler, in unpublished interview by Michael Rush in 2005 on 'Rush Interactive' archived on WPS1 Radio. <www.WPS1.org>

21 Rosler, on 'Rush Interactive'.

22 Rosler, in correspondence with the author, 2007.

23 Tim Griffin, 'Domesticity at War: Beatriz Colomina and Homi K. Bhabha in Conversation', *Artforum* (Summer 2007) 445.

Susan Stoops, extract from introduction, *Martha Rosler: Bringing the War Home, 1967–2004* (Worcester, Massachusetts: Worcester Art Museum, 2007).

IN MY FILM,
THERE IS THE IMAGE OF A MAN
PUSHED FROM AN IRAN AIR PLANE
ON THE RUNWAY AT LARNACA, CYPRUS
AND THEN THE SCREEN GOES BLACK, WITH THE WORDS:

INSERT
COMMERCIAL
HERE

THAT WAS A SEQUENCE I TOOK AS IT STOOD

Johan Grimonprez, On *Dial H-I-S-T-O-R-Y*, 1998

THE SITUATIONIST LEGACY

Guy Debord The Use of Stolen Films, 1989//066

Johan Grimonprez On *Dial H-I-S-T-O-R-Y*: Interview with
 Pierre Bal-Blanc and Mathieu Marguerin, 1998//067

Retort The New 1914 That Confronts Us: Interview with
 David Evans, 2007//069

Guy Debord
The Use of Stolen Films//1989

On the question of stolen films, that is, of fragments of pre-existing films incorporated into my films – notably in *The Society of the Spectacle* – (I'm talking here primarily about the films that *interrupt* and punctuate with their own dialogues the text of the spoken 'commentary' derived from the book), the following should be noted:

In 'Directions for the Use of Détournement' (*Les Lèvres nues*, no. 8) we already noted that 'it is thus necessary to conceive of a parodic-serious stage in which détourned elements are combined ... in order to create a certain sublimity'.

'Détournement' is not an enemy of art. The enemies of art are those who have not wanted to take into account the positive lessons of the 'degeneration of art'.

Thus, in the film *The Society of the Spectacle* the (fiction) films détourned by me are not used as critical *illustrations* of an art of spectacular society (in contrast to the documentaries and news footage, for example). On the contrary, these stolen fiction films, external to my film but brought into it, are used, *regardless of whatever their original meaning may have been*, to represent *the rectification of the 'artistic inversion of life'.*

The spectacle has deported real life behind the screen. I have tried to 'expropriate the expropriators'. *Johnny Guitar* evokes real memories of love, *Shanghai Gesture* other adventurous ambiences, *For Whom the Bell Tolls* the vanquished revolution. The *Rio Grande* sequence is intended to evoke historical action and reflection in general. *Mr Arkadin* is at first brought in to evoke Poland, but then hints at authentic life, life as it should be. The Russian films also in a sense evoke revolution. The American films on the Civil War and General Custer are intended to evoke all the class struggles of the nineteenth century, and even their potential future.

The situation shifts in *In girum* due to several important differences: I directly shot a portion of the images; I wrote the text specifically for this particular film; and the theme of the film is not the spectacle, but real life. The films that interrupt the discourse do so primarily to support it positively, even if there is an element of irony (Lacenaire, the Devil, the fragment from Cocteau, or Custer's last stand). *The Charge of the Light Brigade* is intended crudely and eulogistically to 'represent' a dozen years of the Situationist International's actions! [...]

Guy Debord, 'The use of stolen films', manuscript note, 31 May 1989; trans. Ken Knabb, in idem., ed., *Guy Debord: Complete Cinematic Works* (Oakland, California: AK Press, 2003) 222–3.

Johan Grimonprez
On *Dial H-I-S-T-O-R-Y*: Interview with Pierre Bal-Blanc and Mathieu Marguerin//1998

Pierre Bal-Blanc and Mathieu Marguerin ... Is [your film *Dial H-I-S-T-O-R-Y*] intended as a demonstration of a way of reappropriating and linking sources, on the basis of an arbitrary subject – hijacking – or did you come up with the subject initially, which then determined the form?

Johan Grimonprez In fact there are several points of entry to the project. The theme of hijacking planes can be read as a metaphor for the hijacking of images out of their context, as in the video library project. It is an iconoclastic pleasure accessible to the viewer as well as an aesthetic strategy on which the film is based. On the one hand, there are the images that I hijack in order to arouse a debate, on the other hand are the events that I situate in their historical context, specifying the dates and places, but in a similar way to CNN, for instance, which is already engaged in recontextualization by transforming narration into soap opera or by inserting ads between news items. It also situates the complicity between history and television in terms of a specific timeline: the evolution in the way hijackings have been represented on television. That's why I started the film with the first live televised hijacking. Then there are two levels of comments on the images: a fictional narration based on extracts from the novels *Mao II* and *White Noise* by Don DeLillo, where a discussion is taking place between a terrorist and a novelist, besides of course a more critical personal commentary.

Bal-Blanc/Marguerin Everything that could be identified as an absurd, obscene, funny or dramatic image is placed at a distance both in the editing and in the superimposition of the music, in contrast with the over-dramatization we are used to on television.

Grimonprez I hate the idea of being didactic. My film has already been compared with *Societé du Spectacle* by Guy Debord, which also balances the images with a voice-off, but a rather dry one. With *Dial H-I-S-T-O-R-Y* it was important precisely to explore the phenomena of identification and pleasure, to get viewers to adopt a critical distance while at the same time involving them and incorporating their own voyeurism. Like the Japanese woman looking for her husband at the airport, who is followed by the camera for a very long time. I meant that the intimate body, as meant by Foucault, is completely controlled. Advertising has pervaded the body and made it completely transparent, exposed

in every microscopic detail, and followed permanently by omnipresent monitoring devices, from the camera to X-rays, and we conform to this inquisitive way of surveillance. [...]

Bal-Blanc/Marguerin The hijacking of the images enables them to be linked in the rewriting, that is virtually a fictionalization, with the protagonists ranging from Castro to Clinton to heroes like Leila Khaled. Reality has become fiction already in the way the media handles it, and also in the way you handle it yourself.

Grimonprez In fact, the news has taken over the codes used by the fiction film industry, just as Hollywood has appropriated jumping images and trembling cameras to show an earthquake or military attack, to produce a realistic effect. Television and the cinema exchange aesthetic strategies. CNN and the other channels have also adopted the use of music to dramatize their subjects. The editing of televised news programmes is based on this fictionalization. Conversely, dramatic events we experience in real life lose credibility because there is no violin or dramatic angle to highlight the event [...]

Bal-Blanc/Marguerin The metaphor of hijacking is a comment on the writing and de-programming of images to recontextualize meaning. The terrorists are trying in their own way to change the direction of events. It is rather self-reflective compared with editing.

Grimonprez Yes, the film mirrors this strategy. This also reflects the ideology of zapping, which can be an extreme form of poetry, going much further than collage. The Gulf War was a huge source of inspiration for me: it was a real show, with images of death being served up with ketchup. Only the laugh tracks and applause are missing ... How can images of death be interspersed with advertisements? CNN has turned news into a commodity. In my film, there is the image of a man pushed from an Iran Air plane on the runway at Larnaca, Cyprus, and then the screen goes black, with the words: INSERT COMMERCIAL HERE. That was a sequence I took as it stood. It is a breakdown in meaning, like something Brecht might have produced. In my view, it reflects the combination of two traditions: on the one hand, the fictionalization and the dramatization of history as found in Eisenstein, and on the other hand, that of the presence of the camera in the image, as in Dziga Vertov, which reveals the ideology of the medium. [...]

Johan Grimonprez, retitled extract from 'Beware! In Playing the Phantom, You Become One', 1998 interview with Pierre Bal-Blanc and Mathieu Marguerin, trans. Mary Shovelin, *Blocnotes*, no. 15 (Summer 1998); reprinted in booklet for DVD of *Dial H-I-S-T-O-R-Y* (Other Cinema, 2004).

Retort
The New 1914 That Confronts Us:
Interview with David Evans//2007

David Evans Probably the most infamous image to emerge so far from the current war in Iraq was taken in Abu Ghraib prison in 2003 – a hooded prisoner on a 'plinth' seems to be the recipient of electric shock torture by US forces. This amateur photograph has now been reproduced globally in many contexts. The *Economist* used it on a front cover with the imperative caption 'Rumsfeld must resign'. On anti-war posters it was combined with the question 'Is this your freedom?' You have selected it for your frontispiece [in Retort, *Afflicted Powers: Capital and Spectacle in a New Age of War*, 2005], accompanied by a quotation from Milton's *Paradise Lost*:

> And reassembling our afflicted Powers
> Consult how we may henceforth most offend
> Our Enemy, our own loss how repair,
> How overcome this dire calamity,
> What reinforcements we may gain from Hope,
> If not what resolution from despare.[1]

Could you explain the significance of this pairing?

Retort Our pairing of *Paradise Lost* with the 'wired Christ' in Abu Ghraib reflects the central claim of the book, that the essential task of political thinking and writing at this moment is to confront the strange atavism of the new world situation – a seeming brute return to the seventeenth-century wars of religion familiar to Milton, twinned with an intensified deployment of the apparatus of the production of appearances.

The US in particular feels a double threat: first, to the monopoly of the means of mass destruction and second, to its management of the image-world – in both cases from non-state actors of various kinds. The events of 9/11, were, we believe, a defeat for the imperial state *at the level of spectacle* (to which, by the way, its managers have been unable to stage an answer – not that they haven't tried). Likewise, if the recorded collapse of the World Trade Center wordlessly proposed – revealed, actually – the vulnerability of the US *Heimat*, then the global circulation of the Abu Ghraib snapshot struck a parallel blow at the ideological claim of the US to be the guarantor of 'human rights', 'freedom', and so on.

Now, we further insist that the attack on the towers by a neo-Leninist

vanguard of Islamic militants was a symbolic (but none the less real) defeat not only for the capitalist hegemon but also for those (Retort included) who count themselves enemies of capitalist globalization – for the 'movement of movements' such as it is. In that sense, we intend 'afflicted powers' to refer ambiguously to this Janus-faced defeat. We appreciate that, in identifying with Milton's resonant phrase, we belong to the party of Satan, as he is summoning the rebel angels to storm heaven.

Evans Photographs are used discretely throughout the book. Sometimes you seek dissonance between image and text – a grim, contemporary photograph of the Israeli separation wall and a sardonic reference to 'Making the Desert Bloom', an important motif in Israeli propaganda from the 1950s onwards (in the chapter on US/Israel relations called 'The Future of an Illusion'). And sometimes there is a surprising choice of image – a colour photograph of an Avon lady testing deodorant samples with Indians in Brazil (in the concluding chapter, 'Modernity and Terror'). But mainly you seem to be using interesting but unexceptional press photographs, given straightforward descriptive captions like 'Oil spill, Nembe Creek, Niger Delta, Nigeria, August, 2004' (in the chapter 'Blood for Oil?'). What thinking informed your picture editing?

Retort The selection, placement and captioning of the photographs was very important to us, and we thank you for noticing. We had the help of a photographer friend, Ed Kashi, who was responsible for the cover as well as the shot of the Nembe Creek oil spill you mention. Of course we were alive to the problem of choosing images for a book critical of the current image-regime, and we are not such fools as to believe that we could elude utterly the mills of the spectacle. Each image was chosen to perform a certain kind of work on its own; none was intended as 'illustration'.

We should also say that the universal (that is, from all points on the political/cultural compass) opinion that image has somehow trumped or superseded word in the brave new media world strikes us as nonsense. To the contrary, never has the image-array been so auxiliary to scripts of one kind or another, typically written by modernity's specialists in solicitation – copywriters, public relations hacks, human resources officers, soundbite artists, poets of the advertisement – and delivered into a mediascape in which language itself has been flattened and truncated. One might incidentally mention the very heavy cost of reproducing images in books these days, thanks to the neoliberal regime of intellectual property in which image libraries have become major 'profit centres'. The fees charged by Corbis, Getty, etc., for the images used in *Afflicted Powers* (fewer than a dozen) amounted to several thousand dollars.

Evans German poet and playwright Heiner Müller wrote that to use Bertolt Brecht without changing him was a betrayal. I could imagine Retort saying the same thing about Debord and the Situationist International – materials to be continuously reworked rather than revered. How, then, have you adapted the Situationist notions of the spectacle and the colonization of everyday life to understand the present conjuncture?

Retort We assert in the opening chapter that our intention is to turn the two notions – 'the society of the spectacle' and 'the colonization of everyday life' – back to the task for which they were originally deployed – namely, to understand the powers and vulnerabilities of the capitalist state. We set out to grasp the logic of the present moment, in the aftermath of the events of 9/11, and the seeming historical regression of US statecraft.

Specifically, we asked ourselves about the possibility of *real interaction* between the political economy of neoliberalism, the warfare state, and new developments in the realm of the image. To put it in a single phrase – a dense phrase but one that captures the analytic linkages – we aimed to explore 'the contradictions of military neoliberalism under conditions of spectacle'. We remain agnostic about the possibilities of destabilization in a system that increasingly depends on image-management. The spectacle accelerates as a result of the falling rate of illusion; the disenchantment of the image-world may follow. In any case, we take spectacle in a minimal, matter-of-fact way to characterize this new stage of accumulation of capital. Not just a piling up of images, as media studies would have it, but in Debord's sense of a social relationship between people that is mediated by representations. Crucially, our analysis depends on the complementary notion of the colonization of everyday life, and of subjection to an endless bombardment of brands, logos, slogans, consumption-motifs, invitations to feel happy. Globalization turned inward, as it were. We argue in *Afflicted Powers*, then, that globalization is producing 'weak states' across the world economy and 'weak citizenship' at the spectacular centre, the result of the thinning of the texture of daily life. Weak citizenship may be optimal for the demands of the market but not when the state has to embark on a major round of primitive accumulation, as we argue the US imperial state attempted in Iraq. Never before have politics been conducted in the shadow of defeat both on the ground and at the level of the spectacle.

Evans Situationist writing and picture captioning frequently involved the use of pre-modern literary quotations for various reasons – to wake up readers, perhaps, or to escape the tyranny of the present. To what extent did this tactic inspire your work?

Retort Of the quartet of authors of *Afflicted Powers*, two are historians and the other two are historically minded. Perhaps it is just the deformation of the historian to raid the lumber rooms of the past. But frankly we cannot imagine having embarked on such a project without the assistance of Hannah Arendt, Randolph Bourne or Rosa Luxemburg. And unless Friedrich Nietzsche were at hand, a critique of modernity would be far more difficult to frame. Edmund Burke and Thomas Hobbes were an essential part of the analytic toolkit. Milton, who helped forge a radical, political idiom in the revolutionary decades of the seventeenth century, gave us our title and was an abiding inspiration, not least because his great poem was written in the face of defeat. And of course the indelible line of Tacitus, 'They make a desert and call it peace', speaks to us across the centuries. These were words he put in the mouth of a Gaelic warrior on the eve of battle against a Roman legion in the Scottish highlands, at the far northwestern edge of the empire. We need Tacitus to remind us what kind of peace is meant by the masters of war – the peace of the 'peace process', the peace of cemeteries. Much of the work of the late Pierre Vidal-Naquet, the French historian of ancient Greece and tribune of the people, was concerned with state violence and the assassination of memory, which is central to the spectacle. He was inspired by a line from Chateaubriand that he found his father had transcribed in his diary before his deportation to Auschwitz: 'Nero triumphs in vain, as elsewhere in the empire Tacitus has already been born.'

Evans The Situationist idea of détournement never appears in *Afflicted Powers*. Yet the events of 9/11 could be considered détournement in at least two senses:

1. Literal détournement, since the hard-working French word can mean, among other things, aeroplane hijacking.

2. Reactionary détournement. That is, three elements that have been associated with Americanism since the 1920s – aeroplanes, skyscrapers and mass communications – were taken by Mohammed Atta and his accomplices and recombined. The resulting message may not have been anti-Americanist exactly, but it was certainly anti-American. What do you think?

Retort Détournement, indeed. Remember that the kind of planes that Atta and his crews refunctioned as missile-bombers to strike the World Trade Center and the Pentagon actually originated as weapons of mass destruction. The Boeing Corporation took the old bombers used to create firestorms over European and Japanese cities during the Second World War and redesigned them for purposes of mass tourism and corporate air travel in the 1960s. Atta himself, as we note in the chapter on revolutionary Islam, was an urban planner (in Cairo and Aleppo) disgusted with the Disneyfication he saw coming in the wake of the failure of

secular national development in Egypt and the rest of the Third World. He was right: Dubai is one face of neoliberal globalization, megaslums another.

At the same time it is necessary to acknowledge Al-Qaeda's love affair with image-politics. Even in its rejection of the West, the Islamist vanguard displays a mastery of the virtual and of the new technics of dissemination. This is one aspect of the current moment's mixture of atavism and new-fangledness that those in opposition to both Empire and 'Jihad', two virulent mutations of the Right, must take very seriously. The issue, in fact, is not ultimately America or Americanism, but modernity itself.[2]

1 [footnote 2 in source] John Milton, *Paradise Lost*, Book I, as quoted in Iain Boal, T.J. Clark, Joseph Matthews and Michael Watts, *Afflicted Powers* (London and New York: Verso, 2005).

2 [3] *New Left Review*, 41 (September–October 2006) published a further broadside by Retort, 'All Quiet on the Eastern Front'. Written in July 2006, during the early stages of Israel's attack on Lebanon, it offers additional acerbic commmentary on the 'war on terror'. The text forms part of the installation *Afflicted Powers*, exhibited at the Bienal Internacional de Arte Contemporáneo, Seville (October 2006–January 2007).

David Evans and Retort, extract from 'The New 1914 That Confronts Us: An Interview with Retort', *Afterimage*, vol. 34, no. 4 (January–February 2007) 17–20.

The world is filled to
suffocating. Man has placed
his token on every stone.
Every word, every image,
is leased and mortgaged.
We know that a picture is but
a space in which a variety of
images, none of them
original, blend and clash

Sherrie Levine, Statement, 1982

SIMULATION
Douglas Crimp Pictures, 1979//076
Jean Baudrillard The Precession of Simulacra, 1981//080
Sherrie Levine Statement, 1982//081
Michael Newman Simulacra, 1983//082
Richard Prince Interview with Peter Halley, 1984//83
Thomas Crow The Return of Hank Herron, 1986//087
Elisabeth Sussman The Last Picture Show, 1986//092
John Stezaker Interview with John Roberts, 1997//095
David A. Mellor Media-Haunted Humans: Cindy Sherman, Richard Prince, John Stezaker, 1998//099

Douglas Crimp
Pictures//1979

Pictures *was the title of an exhibition of the work of Troy Brauntuch, Jack Goldstein, Sherrie Levine, Robert Longo and Philip Smith which I organized for Artists Space in the fall of 1977.*[1] *In choosing the word* pictures *for this show, I hoped to convey not only the work's most salient characteristic – recognizable images – but also and importantly the ambiguities it sustains. As is typical of what has come to be called postmodernism, this new work is not confined to any particular medium; instead, it makes use of photography, film, performance, as well as traditional modes of painting, drawing and sculpture.* Picture, *used colloquially, is also nonspecific: a picture book might be a book of drawings or photographs, and in common speech a painting, drawing or print is often called, simply, a picture. Equally important for my purposes,* picture, *in its verb form, can refer to a mental process as well as the production of an aesthetic object.* [...]

In his famous attack against Minimal sculpture, written in 1967, the critic Michael Fried predicted the demise of art as we then knew it, that is, the art of modernist abstract painting and sculpture. '*Art degenerates*', he warned us, '*as it approaches the condition of theatre*', theatre being, according to Fried's argument, '*what lies* between *the arts.*'[2] And indeed, over the past decade we have witnessed a radical break with that modernist tradition, effected precisely by a preoccupation with the 'theatrical'. The work that has laid most serious claim to our attention throughout the 1970s *has* been situated between, or outside the individual arts, with the result that the integrity of the various mediums – those categories the exploration of whose essences and limits constituted the very project of modernism – has dispersed into meaninglessness.[3] Moreover, if we are to agree with Fried that '*the concept of art itself ... [is] meaningful, or wholly meaningful, only* within *the individual arts*', then we must assume that art, too, as an ontological category, has been put in question. What remain are just so many aesthetic activities, but judging from their current vitality we need no longer regret or wish to reclaim, as Fried did then, the shattered integrity of modernist painting and sculpture.

What then are these new aesthetic activities? Simply to enumerate a list of mediums to which 'painters' and 'sculptors' have increasingly turned – film, photography, video, performance – will not locate them precisely, since it is not merely a question of shifting from the conventions of one medium to those of another. The ease with which many artists managed, some ten years ago, to

change mediums – from sculpture, say, to film (Richard Serra, Robert Morris, et al.) or from dance to film (Yvonne Rainer) – or were willing to 'corrupt' one medium with another – to present a work of sculpture, for example, in the form of a photograph (Robert Smithson, Richard Long) – or abjured any physical manifestation of the work (Robert Barry, Lawrence Weiner) makes it clear that the actual characteristics of the medium, per se, cannot any longer tell us much about an artist's activity.

But what disturbed Fried about Minimalism, what constituted, for him, its theatricality, was not only its 'perverse' location *between* painting and sculpture,[4] but also its 'preoccupation with time – more precisely, with the *duration of experience*'. It was temporality that Fried considered 'paradigmatically theatrical', and therefore a threat to modernist abstraction. And in this, too, Fried's fears were well founded. For if temporality was implicit in the way Minimal sculpture was experienced, then it would be made thoroughly explicit – in fact the only possible manner of experience – for much of the art that followed. The mode that was thus to become exemplary during the 1970s was performance – and not only that narrowly defined activity called performance art, but all those works that were constituted *in a situation* and *for a duration* by the artist or the spectator or both together. It can be said quite literally of the art of the 1970s that 'you had to be there'. For example, certain of the video installations of Peter Campus, Dan Graham and Bruce Nauman, and more recently the sound installations of Laurie Anderson, not only required the presence of the spectator to become activated, but were fundamentally concerned with that registration of presence as a means toward establishing meaning.[5] What Fried demanded of art was what he called 'presentness', a transcendent condition (he referred to it as a state of 'grace') in which '*at every moment the work itself is wholly manifest*'; what he feared would replace that condition as a result of the sensibility he saw at work in Minimalism – what *has* replaced it – is presence, the *sine qua non* of theatre. [...]

An art whose strategies are thus grounded in the literal temporality and presence of theatre has been the crucial formulating experience for a group of artists currently beginning to exhibit in New York. The extent to which this experience fully pervades their work is not, however, immediately apparent, for its theatrical dimensions have been transformed and, quite unexpectedly, reinvested in the pictorial image. If many of these artists can be said to have been apprenticed in the field of performance as it issued from Minimalism, they have nevertheless begun to reverse its priorities, making of the literal situation and duration of the performed event a tableau whose presence and temporality are utterly psychologized; performance becomes just one of a number of ways

of 'staging' a picture. Thus the performances of Jack Goldstein do not, as had usually been the case, involve the artist's performing the work, but rather the presentation of an event in such a manner and at such a distance that it is apprehended as representation – representation not, however, conceived as the re-presentation of that which is prior, but as the unavoidable condition of intelligibility of even that which is present. [...]

At the beginning of this essay, I said that it was due precisely to this kind of abandonment of the artistic medium *as such* that we had witnessed a break with modernism, or more precisely with what was espoused as modernism by Michael Fried. Fried's is, however, a very particular and partisan conception of modernism, one that does not, for example, allow for the inclusion of cinema ('cinema, even at its most experimental, is not a *modernist* art') or for the pre-eminently theatrical painting of Surrealism. The work I have attempted to introduce here is related to a modernism conceived differently, whose roots are in the Symbolist aesthetic announced by Mallarmé,[6] which includes works whose dimension is literally or metaphorically temporal, and which does not seek the transcendence of the material condition of the signs through which meaning is generated.

Nevertheless, it remains useful to consider recent work as having effected a break with modernism and therefore as postmodernist. But if *postmodernism* is to have theoretical value, it cannot be used merely as another chronological term; rather it must disclose the particular nature of a breach with modernism.[7] It is in this sense that the radically new approach to mediums is important. If it had been characteristic of the formal descriptions of modernist art that they were topographical, that they mapped the surfaces of artworks in order to determine their structures, then it has now become necessary to think of description as a stratigraphic activity. Those processes of quotation, excerptation, framing and staging that constitute the strategies of the work I have been discussing necessitate uncovering strata of representation. Needless to say, we are not in search of sources or origins, but of structures of signification: underneath each picture there is always another picture.

A theoretical understanding of postmodernism will also betray all those attempts to prolong the life of outmoded forms. Here, in brief, is an example, chosen because of its superficial resemblance to the pictures discussed here: The Whitney Museum recently mounted an exhibition entitled 'New Image Painting', a show of work whose diversity of quality, intention and meaning was hidden by its being forced into conjunction for what was, in most cases, its least important characteristic: recognizable images. What was, in fact, most essential about all of the work was its attempt to preserve the integrity of *painting*. So, for

example, included were Susan Rothenberg's paintings in which rather abstracted images of horses appear. For the way they function in her painted surfaces, however, those horses might just as well be grids. 'The interest in the horse', she explains, 'is because it divides right.'[8] The most successful painting in the exhibition was one by Robert Moskowitz called *The Swimmer*, in which the blue expanse from which the figure of a stroking swimmer emerges is forced into an unresolvable double reading as both painted field and water. And the painting thus shares in that kind of irony towards the medium that we recognize precisely as modernist.

'New Image Painting' is typical of recent museum exhibitions in its complicity with that art which strains to preserve the modernist aesthetic categories which museums themselves have institutionalized: it is not, after all, by chance that the era of modernism coincides with the era of the museum. So if we now have to look for aesthetic activities in so-called alternative spaces, outside the museum, that is because those activities, those *pictures*, pose questions that are postmodernist.

1 'Pictures', New York, Committee for the Visual Arts, 1977. [...]

2 Michael Fried, 'Art and Objecthood', *Artforum*, vol. 5, no. 10 (Summer 1967) 21; reprinted in *Minimal Art: A Critical Anthology*, ed. Gregory Battcock (New York: E.P. Dutton, 1968) 116–47. All subsequent quotations from Fried are from this article; the italics throughout are his.

3 This is not to say that there is not a great deal of art being produced today that can be categorized according to the integrity of its medium, only that production has become thoroughly academic [...]

4 Fried refers to Donald Judd's claim that 'the best new work in the last few years has been neither painting nor sculpture', made in his article 'Specific Objects', *Arts Yearbook*, 8 (1964) 74–82.

5 Rosalind Krauss has discussed this issue in many of her recent essays, notably in 'Video: The aesthetics of Narcissism', *October*, 1 (Spring 1976), and 'Notes on the Index: Seventies Art in America', *October*, 3 (Spring 1977) and 4 (Fall 1977).

6 [footnote 14 in source] For a discussion of this aesthetic in relation to a pictorial medium, see my essay 'Positive/Negative: A Note on Degas' Photographs', *October*, 5 (Summer 1978) 89–100.

7 [15] There is a danger in the notion of postmodernism which we begin to see articulated, that which sees postmodernism as pluralism, and which wishes to deny the possibility that art can any longer achieve a radicalism or avant-gardism. [...]

8 [16] In Richard Marshall, *New Image Painting* (New York: Whitney Museum of American Art, 1978).

Douglas Crimp, extracts from 'Pictures', *October*, no. 8 (Spring 1979) 75–7; 87–8.

Jean Baudrillard
The Precession of Simulacra//1981

The simulacrum is never what hides the truth – it is the truth that hides the fact that there is none.

The simulacrum is true.

– Ecclesiastes

If once we were able to view the Borges fable in which the cartographers of the Empire draw up a map so detailed that it ends up covering the territory exactly (the decline of the Empire witnesses the fraying of this map, little by little, and its fall into ruins, though some shreds are still discernible in the deserts – the metaphysical beauty of this ruined abstraction testifying to a pride equal to the Empire and rotting like a carcass, returning to the substance of the soil, a bit as the double ends by being confused with the real through ageing) – as the most beautiful allegory of simulation, this fable has now come full circle for us, and possesses nothing but the discrete charm of second-order simulacra.

Today abstraction is no longer that of the map, the double, the mirror, or the concept. Simulation is no longer that of a territory, a referential being, or a substance. It is the generation by models of a real without origin or reality: a hyperreal. The territory no longer precedes the map, nor does it survive it. It is nevertheless the map that precedes the territory – *precession of simulacra* – that engenders the territory, and if one must return to the fable, today it is the territory whose shreds slowly rot across the extent of the map. It is the real, and not the map, whose vestiges persist here and there in the deserts that are no longer those of the Empire, but ours. *The desert of the real itself.* [...]

Jean Baudrillard, extract from 'The Precession of Simulacra', *Simulacres et simulation* (Paris: Éditions Galilée, 1981); trans. Sheila Faria Glaser, *Simulacra and Simulation* (Ann Arbor: The University of Michigan Press, 1994) 1.

Sherrie Levine
Statement//1982

The world is filled to suffocating. Man has placed his token on every stone. Every word, every image, is leased and mortgaged. We know that a picture is but a space in which a variety of images, none of them original, blend and clash. A picture is a tissue of quotations drawn from the innumerable centres of culture. Similar to those eternal copyists Bouvard and Péchuchet, we indicate the profound ridiculousness that is precisely the truth of painting. We can only imitate a gesture that is always anterior, never original. Succeeding the painter, the plagiarist no longer bears within him passions, humours, feelings, impressions, but rather this immense encyclopaedia from which he draws. The viewer is the tablet on which all the quotations that make up a painting are inscribed without any of them being lost. A painting's meaning lies not in its origin, but in its destination. The birth of the viewer must be at the cost of the painter.

Sherrie Levine, 'Statement' [incorporating appropriated phrases from sources such as Roland Barthes' 'The Death of the Author'], *Style* magazine, special issue as catalogue of 'Mannerism: A Theory of Culture', Vancouver Art Gallery (Vancouver, March 1982) 48; reprinted in Charles Harrison and Paul Wood, *Art in Theory 1900-2000* (Oxford: Blackwell, 2003) 1067.

Michael Newman
Simulacra//1983

Ridley Scott's sci-fi film *Blade Runner* asks at what point simulation merges with that which it simulates. The only difference between the androids or 'replicants' manufactured by the Tyrell corporation and human beings lies in the capacity for empathy, which the former do not possess. But what if the bounty hunter whose job it is to 'retire' replicants falls in love with one of them and, more crucially, if that replicant, whose implanted memories are those of someone else, falls in love with him? The difference between the simulated and the real is eliminated. The irony of the film is that the frame for simulation is not reality but simulation itself: what we view in the cinema is already a totally simulated reality where the humans conform to stereotypes as much as the replicants, coded in the eclectic mixture of movie genres and period styles. Indeed, towards the end of the film the replicants come to elicit our sympathy, as victims who seem more vivid than the humans. With the collapse of difference in *Blade Runner*, metaphysics reaches its conclusion in the simulacrum.

The simulacrum suspends the distinction between the image as a representation *of* something (originally a deity) and the image as autonomous. The four artists [Jonathan Miles, John Stezaker, Jan Wandja, John Wilkins] that I selected for an exhibition at Riverside Studios Gallery, London, deal in their work with the double nature of the image as simulacrum. They collect images from magazines, newspapers, TV, film, advertising or packaging. The rapid scan to which such images are normally subjected is replaced by a more intense scrutiny, which reveals them as void of the promise they offered or resonant with unintended meanings. These found, stilled images, already mediated and consumed, are the starting point for works of art in which they are recycled and transformed through painting, drawing and screenprinting.

These artists' approach is based on ways of engaging with the mass media and consumer culture. Although they open up the media image to the possibility of connections with the art of the past, their work has nothing to do with the contemporary European revival of painterly expressionism. Neither does it limit itself to the one-dimensional preoccupation with image turnover and stereotype characteristic of so much recent American art. They go beyond the passivity of the aesthetic of pure appropriation, the distancing of irony and the closure of the caption text to explore the life and death of the image in our culture. [...]

Michael Newman, extract from 'Simulacra', *Flash Art International*, no. 110 (January 1983) 38.

Richard Prince
Interview with Peter Halley//1984

Peter Halley Almost everything you've done, that I've seen or read, has seemed to have a particular point of view but not always the same point of view. So I was wondering, is it possible to conduct an interview with you? Because what voice would address me and can you in fact do an interview?

Richard Prince I don't think it's necessarily important to have a particular point of view. Whether you believe me or not, isn't important. It's a question of disassociation. It's still one voice but a voice capable of being outside its own view.

Halley For someone who hasn't talked to you and only knows the images, it's hard to tell what voice the images come from, whether it's an intuitive one or whether the work is based on other voices that have already spoken.

Prince Well, I think this particular voice, the one I like to think of as my own, does in fact entertain the notion that it sometimes finds itself in a movie, and I think to some extent this voice carries on a relationship with the scene in front of him as if what he's looking at can be either produced, directed, acted in or even written about. I wouldn't call that a personal point of view, but I wouldn't call it inhuman or insensitive either. If anything my relationship or contact with what's happening is probably a lot more intimate than personal. A lot more psychologically hopped-up than distanced. It's never been my intention to put any distance between myself and whatever the subject might be. In fact I try to get as close as I can. I suppose my point of view is to try to produce the closest thing to the real thing.

Halley What you've just said has a definite relationship with the work that I've seen of yours over the last two or three years: the *Sunsets* – pictures that have been appropriated along with the picture's technology; the *Cowboys* – a kind of straightforward appropriation of the Marlboro campaign; the *Entertainment Pictures*, taken from publicity stills; and the book *Why I Go to the Movies Alone*. Each of these works seems to have a different approach.

Prince Yes, well it's not something I sit around and try to figure out. Like what's it to be today. You know? Like what hat should I wear.

Halley You don't feel like you're assigning each work, as well as yourself, a role?

Prince It's not that worked out. It's more like I'm conducting an affair or relationship. Each set of pictures has different considerations. In order to produce the effect of what the original picture imagines, you have to play the picture, you can't play yourself.

Halley You seem to have a more genuine interaction, almost an uninterrupted interface, rather than an ideological association with your material.

Prince Yes. Some of these pictures that I see have an alien quality. Almost as if they have a life of their own. Nameless forms of new life. Sort of like the picture of the id that got away from the scientist in that movie *Forbidden Planet.*

Halley You were among the first to rephotograph an image, you've exclusively rephotographed advertising images and you've always been talked about in terms of having a criticality towards those images. Is this interreaction another voice, a new voice I'm hearing?

Prince First let me say rephotography was always a technique to make the image again and to make it look as natural looking as it did when it first appeared. It never had the trailer of an ideology. It never attempted to produce a copy … a resemblance yes, but never a copy. It's not a mechanical technique. It's a technological one. It's also a physical activity that locates the author behind the camera, not in front of it, not beside and not away from it. There's a whole lot of authorship going on. What the technique involves is a way to manage an image and produce simply a photograph from a reproduction. Second, as far as the criticality is concerned, the picture that I take, that I steal … happens to be an image that appears in the advertising section of a magazine. I've always had the ability to misread these images and again, disassociate them from their original intentions. I happen to like these images and see them in much the same way I see moving pictures in a movie.

Halley How has this happened?

Prince Something to do with extended adolescence. These pictures have the chances of looking real without any specific chances of being real. It's a question of satisfaction. I find these images unpredictably reassuring.

Halley So what you're saying is that you treat the unreal as real.

Prince What's unreal for most is an offical fiction for me. It's pretty much what chimneys were to the industrial revolution. They were familiar but still they looked unreal. They had very little history to them. Someone like de Chirico recognized this and was able to additionalize another reality onto them. The look of his chimneys ended up having a virtuoso real [effect]. So it's somewhat the same for me. I don't have many memories of earrings hanging on a tree or of three women looking to the left, or even of the Eiffel Tower next to the Empire State Building next to the Taj Mahal. And if I do have any memories of these scenes, they come from other pictures.

Halley Like the detective in the movie *Blade Runner.*

Prince Yes.

Halley His girlfriend, the replicant. Her memory of her family was based entirely on photographs of her family or at least a photograph of a family.

Prince Yes. That's why I have to produce a photograph. I've always associated a photograph with the *Perry Mason Show.* You know something that can be used as admissible evidence. Something that can be believed. It's unimportant whether it's true. It's only that its truth be possible. That's what the virtuoso real is. The possibility.

Halley Your way of working – collecting, filing, scanning; is there something that shows up in all the different bodies of work you produce, something that's common to all of them?

Prince Generally speaking what shows up is the same within the difference. Specifically, I think if there's any one ingredient or effect that shows up in every photograph produced to date, it's a certain type of uncanniness. And that's always determined by the photograph's ability to project a sensation of normality.

Halley Like the *Cowboys*?

Prince Yes. Normality as a special effect. I like to think that I make normal-looking photographs. The *Cowboys* looked like normal photographs to me. They were framed and matted like normal photographs and presented in a way in which most photographs are presented: in a gallery, on a wall, under a spotlight.

Halley But that's as far as the normality goes.

Prince Yes. Who would guess something that familiar would have looked that unbelievable. It's a shock. Playing the picture straight. It's what I like about social science fiction and hard-boiled film noir. Even though everything is terribly exaggerated and amplified and concocted ... there's always this desire to want to suspend what you know in favour of what you think. I'm a sucker for a good story if it's delivered in a deadpan style.

Halley What is it about the movies that's so important? How do you use them as a background, or I should say as an invisible background for some of your work?

Prince Well, for instance the background for the *Entertainment Pictures* was *The Sweet Smell of Success*. In it, everybody's publicity picture is pretty important. The triviality of the picture wasn't treated with indifference. I liked that. I started going around to nightclubs and cabarets and I started getting these 'pics' off of the entertainers who worked there. I'd go backstage, watch them make-up ... I like the bulbed mirrors in the dressing rooms. Sometimes I'd see one of their 'pics' get into a newspaper column. Just like in the movie. Again I started seeing it as an unpredictably important picture, even though these pictures have always been associated with a low-class type of advertising. Anyway, I started treating the pictures as portraits. You know I'd approach these people and they'd give me a number of photographs of themselves and I'd pick one out and rephotograph it and that would be their portrait. They'd never like come over to my studio and sit for me. In fact I wouldn't have to meet them at all if I didn't want to. I could do their portrait from all the pictures that they'd already have of themselves. This one woman, she must have been sixty ... I picked one out of her when she was thirty and said that's it, this one's your portrait. And of course it was and she was thrilled. Sometimes the whole thing is like that movie *The Time Machine*.

Halley Now what about seeing the result? How would I, as an audience, know that one of these *Entertainment Pictures* had that kind of catalyst or density?

Prince I think eventually certain actors that aren't upfront will gradually make themselves known. My photographs aren't illustrations or allegories ... you know they're not ironies. I don't expect them to be comprehended in the way you'd comprehend a visual one- or two-liner. There's a delayed density. The only thing that should be immediate is that when you first look at them you're not exactly sure what hit you. [...]

Richard Prince and Peter Halley, 'Richard Prince interviewed by Peter Halley', *ZG*, no. 10 (Spring 1984) 5–6.

Thomas Crow
The Return of Hank Herron//1986

In the early 1970s, the extreme involution of late modernist painting and the large philosophical claims that surrounded it were the objects of a sly parody. One of the authors was and remains an important historian of earlier modern art. Consistent, however, with its deadpan self-effacement as satire, the parody was published under the pseudonym of 'Cheryl Bernstein' and included, with no indication as to its fraudulent status, in a widely-consulted anthology of writings on conceptual art.[1] An editor's introduction provided Cheryl Bernstein with a plausible biography appropriate to 'one of New York's younger critics' ('... born in Roslyn, New York ... she attended Hofstra University before taking her MA in art history at Hunter'), including a promised monograph in progress. Her text is entitled 'The Fake as More', and its ostensible subject is the first one-man show by 'the New England artist Hank Herron', whose exhibited work consisted entirely of exact copies of works by Frank Stella.

Bernstein's review is effusively laudatory. Herron, she argues, is in fact superior to Stella in the final analysis, in that the copyist has faced up to the hollowness of originality as a concept in later modernism. Herron's replicas leave behind the fruitless and atavistic search for authenticity in artistic expression, accepting, as Stella himself cannot, that modern experience of the world is mediated by endlessly reduplicated simulations or 'fakes'. While their appearance exactly matches the originals, the replicator's canvases more powerfully manifest the material literalness and relentless visual logic for which Stella had been celebrated. Because Herron had removed the unfolding of that pictorial logic from any notion of biographical development (he had duplicated ten years of Stella's work in one), he had exploded the romantic vestiges still clinging to the formalist and utopian readings of modern art history. Progress in art is closed off by this higher critical apprehension that the record of modernist painting now exists as another congealed image, one among the myriad manufactured simulacra that stand in for the 'real' in our daily lives.

In recounting the thought experiment contained in 'The Fake as More', I have modified its terminology somewhat. The philosophical references in the text are to the intellectual glamour figures of the fifties and sixties: Heidegger, Sartre, Wittgenstein, Merleau-Ponty. I have inflected its language – without, I hope, betraying its ingenious invented logic – in the direction of what today is loosely called 'poststructuralism'. The death of the author as it has been postulated by Barthes and Foucault, the triumph of the simulacrum as asserted by Baudrillard,

are ideas that enjoy wide currency among younger artists and critics in the mid 1980s. Despite her older theoretical terminology, however, these ideas are fully present in Cheryl Bernstein as well.

One only has to juxtapose quotations to discover the closeness of fit between early-1970s satire and present-day practice. Sherrie Levine is the contemporary artist most celebrated for her replication of canonical photographs, drawings and paintings. The author of an admiring 1986 profile of her career wrote the following on the subject of her painstaking copies after Schiele, Malevich and Miró: 'By literally taking the pictures she did, and then showing them as hers, she wanted it understood that she was flatly questioning – no, flatly undermining – those most hallowed principles of art in the modern era: originality, intention, expression.'[2] This is Bernstein in 1973: 'Mr Herron's work, by reproducing the exact appearance of Frank Stella's entire *oeuvre*, nevertheless introduces new content and a new concept ... that is precluded in the work of Mr Stella, i.e., the denial of originality.'[3] Peter Halley, a frequently-published critic as well as a painter, expresses his high regard for Levine's copies by quoting from Baudrillard: art, states the latter, has been overtaken by 'aesthetic reduplication, this phase when, expelling all content and finality, it becomes somehow abstract and non-figurative'.[4] Bernstein speaks of Herron's duplication of Stella's work as 'resolving at one master stroke the problem of content without compromising the purity of the non-referential object as such.'[5]

The referent is in theoretical bad odour these days, and that last catchphrase of modernist formalism fits the new mood very neatly. After lying virtually unnoticed for more than a decade in the pages of the late Gregory Battcock's *Idea Art*, 'The Fake as More' is having its day. References to it have lately turned up in print[6] and in artists' conversations, but not, so far as I have been able to detect, with any recognition of its status as parody. (The authors, of course, were fair to their readers and planted clues to its falsity, starting with the common three-syllable names, rhymed surnames, and further play on the name of baseball player Henry 'Hank' Aaron.) Hank Herron is understood to have exhibited his purloined Stellas just once and then disappeared. It does not in fact matter very much whether he is believed in as a shadowy precedent for Levine, Mike Bidlo or Philip Taaffe. What is striking is that a knowing, imaginary send-up of 1960s modernism has come true in art that is now being taken very seriously indeed. Whether they practice direct appropriation or not, the artists included in 'Endgame' acknowledge affinities between that strategy and their own practice.

'The Fake as More' converges with contemporary practice not only because of its theme of replication, but also because of renewed attention to the record of late modernism on the part of younger artists. Taaffe, for example, has exhibited obsessively crafted homages to Barnett Newman; Levine has most

recently shown (non-appropriated) paintings organized around grids and stripes. Halley, in his critical writings, has independently mapped Herron territory, praising Levine's replicas and finding the most important antecedent for his own work in Stella.[7] Looking back to Malevich, Newman or Stella has been a way for these artists to reject the mannered painterliness and overheated iconography of the 'postmodernist' episode that preceded them. They have aligned themselves with the modernist record, but there can have been no easy passage back to that position. And their imaginary precursor can tell us something important about this return.

'The Fake as More' is a thoroughly unsympathetic attack, displaying more than a tinge of philistinism, on the inwardness of modernist practice and on its claims to pose serious ontological and epistemological questions. Next to the work of a Ryman or a Marden, the authors imply, one might as well elevate to the same stature what is to them the mindless act of replicating Stellas: plug in the standard language of furrowed-brow criticism and it works as well as the average encomium in *Artforum*. When self-reflexivity can be persuasively imagined, and half-persuasively justified, as the deadening trap of identity, the modernist project is surely over: that is the ultimate message of the text. There is in fact an unstated link between Cheryl Bernstein and the mid 1970s group Artists Meeting for Cultural Change. Behind the parody is the assumption that art, by being stripped of its larger tasks of representation in the social world, has been left in a state of pathetic debility.

The artists represented in 'Endgame' think along similar lines, though they evidently draw quite different conclusions in doing so. They agree that modernist painting and sculpture, in progressively isolating themselves from the work of representation, failed to attain any compensating purity and fullness of presence. Or, if abstract art once had served as a haven of authentic experience in a visual world dominated by meretricious distractions and seductions, it can no longer serve that function. Advanced art, they say, was indeed emptied out during the 1960s. But Halley, for example, will go on to argue that art was thereby purged of its bygone, unattainable ambitions, whether social or metaphysical. In the process, it was freed from its complicity with hierarchy and power.[8]

To make this leap, he and others draw equally on Foucault and Baudrillard. The geometric clarity found in De Stijl, Constructivism or 1960s colour-field painting is tied, via the writing of the former, to the linear order of the Panopticon, the coercive surveillance and regimentation of the classical prison or asylum.[9] With Foucault, they see the Panopticon as the model for a pervasive order of discipline established during the Enlightenment and secured by the industrial and bureaucratic regimes of the nineteenth century. Thus Halley contests, as did the Left in the art world during the last two decades, 'the curious

claim that geometry constituted neutral form, which was advanced by Minimalism and 1960s formalism.'[10] The moves in Halley's thinking at this point are somewhat difficult to follow. It is the geometric sign, he states, 'that the managerial class reserves to communicate with itself', all the more today considering the centrality of databases, computer modelling and instantaneous financial and information transfers within the global economy.[11] Thus by reviving linear, hard-edged design, these new artists are confronting a mode of production (and ideological reproduction) on a par with the mass-media images that occupied some of their older peers. Halley argues that his painting, and the abstract art he admires, can address those whose material and status interests are served by the superficial image economy, but can escape at the same time any crippling complicity with those interests. In the act of replication, he states, 'content is negated, the act of production is purified'.[12] He evokes an almost ritual cleansing, like baptism, a symbolic repetition in which an old form of artistic selfhood is extinguished and sin is purged.

In 1939, Clement Greenberg, then at the height of his powers as a theorist if not as a visual critic, argued that an art resolutely concentrated on the problems generated by its own particular medium would escape exploitation either by commerce or by the terrifying mass politics of the day.[13] Through the sacrifice of narrative and eventually figuration of any kind, he maintained, the visual arts would be strengthened in the areas that remained exclusively theirs. The new abstraction turns that argument on its head: art survives now by virtue of being weak, a condition signalled in the ritual sacrifice of the artist's authorial presence. Weakness was the gift of the 1960s, of the drastic reduction of pictorial and sculptural incident, followed by the assaults of the conceptual artists on the hallowed status of the object itself. So debilitated, the art of late modernism has been freed from its own history and made available, like the liberated signifiers of advertising and commercial entertainment, to endless rearrangement and repackaging. Thus there is a perception of direct descent not only from the 'Pictures' generation, the mass-media appropriators of the later 1970s (Levine and Jack Goldstein straddle the line between that group and the new abstraction), but also from Warhol and Pop. By the ironic means of replication and simulation, a young artist who wishes to return to abstraction can place his or her work in relation to the last important episode in that kind of art, while simultaneously preserving a safe distance from any of its intimidating claims to authority. From this derives the current dim glory of Hank Herron; a mockery of mainstream art's perceived sterility in the early 1970s has been transformed, through these artists' words and works, into a kind of celebration. [...]

1 'The Fake as More', in *Idea Art*, ed. Gregory Battcock (New York, 1973) 41–5.

2 Gerald Marzotati, 'Art in the (Re)Making', *ARTnews* (June 1986) 91.

3 Battcock, op. cit., 42; 44–5.

4 Peter Halley, 'The Crisis in Geometry', *Arts* (Summer 1984) 115; quoting Jean Baudrillard, *Simulations*, trans. P. Foss, et al. (New York, 1983) 151.

5 Battcock, op. cit., 42.

6 See C. Carr, 'The Shock of the Old', *The Village Voice* (30 October 1984) 103.

7 See Halley, 'Frank Stella and the Simulacrum', *Flash Art* (February–March 1986) 32–5.

8 Halley, 'The Crisis in Geometry', passim.

9 The key text is Michel Foucault, *Discipline and Punish: The Birth of the Prison*, trans. Alan Sheridan (New York, 1977).

10 Halley, 'The Crisis in Geometry', 112.

11 Ibid., 115.

12 Ibid., 115.

13 See Clement Greenberg, 'Avant-Garde and Kitsch', and 'Towards a New Laocoön', in Frances Frascina, ed., *Art after Pollock* (London and New York, 1985) 21–46.

Thomas Crow, extract from 'The Return of Hank Herron', in Elisabeth Sussman, ed., *Endgame: Reference and Simulation in Recent Painting and Sculpture* (Philadelphia: Institute of Contemporary Art/Cambridge, Massachusetts: The MIT Press, 1986) 11–16.

Elisabeth Sussman
The Last Picture Show//1986

By reformulating 1960s geometric art, the new painting of Ross Bleckner, Peter Halley, Sherrie Levine, and Philip Taaffe revises abstraction as a symbol of the American sixties. For these artists the sixties are a watershed when consumer society, the advance of technology and the loss of political idealism caused changes in nearly all social institutions, including the arts. As an idealistic practice, the painters in 'Endgame'[1] suggest that abstraction has come to an end. Bleckner, Halley, Levine and Taaffe take as their subject the changes wrought on abstraction in the sixties. As a means to this end, they appropriate geometric imagery as the basis for their own new statement. Whether appropriating Op Art as a kitsch symbol and transforming it with a new luminosity; using geometric structure as an expression of our social order; breaking patriarchal taboos by repossessing generic modern conventions; or expanding sixties' geometric art to the cinematic and environmental demands of the theatrical present, these four artists construct an abstraction which is a vehicle for desire: a painting where surface, colour, luminosity, scale and space are complicit in mapping a theoretical terrain.

Bleckner, Halley, Levine and Taaffe are paradigmatic of these tendencies: they form a cohesive group, and have each responded to each other's work. They are typical of a portion of the New York art world that is influenced by critical theory yet wants to make art that is both vivid and accessible. These four artists make paintings from an analytical base and look at culture rather than nature as a source of content. Like several European artists, notably Sigmar Polke and Anselm Kiefer, and the American artist David Salle, these painters are highly conscious of the content of their work. They have chosen to present their ideas by using the expressive potential of painting and its position of high visibility in the art market, instead of dealing with ideas disembodied from an object (i.e., in photography and installations), as had the conceptual artists of the late sixties and seventies, who were, in one sense, the intellectual forebears of this group. Rather Bleckner, Halley, Levine and Taaffe are more connected to the art of the 1960s – to Pop Art and Minimalism, with their synthesis of conceptual and physical qualities. They respond to the ideas within these movements and to the modes of their presentation: that is, traditional painting and sculpture (though the limits of those mediums were strained).

These painters of the eighties examine the abstract painting of the 1960s (from Op Art to Barnett Newman, Brice Marden and Frank Stella). They look at

the painting made just before and after the ironic onslaught of Pop art. Pop artist Roy Lichtenstein has certainly provided a precedent in his Abstract Expressionist brush stroke paintings, and the *Art Moderne* painting and sculpture. Lichtenstein reworked both the idealist (Abstract Expressionist) and popular (Art Moderne) aspects of modernism in ways which suggested the absorption of both into the mass media. But Lichtenstein's reworkings were cool, comic and ironic and seemingly buoyed by the cynicism of the sixties, not the despair of the eighties.

In their reworking or appropriation of the abstraction which dates from the period of Pop art, the painters in 'Endgame' are clearly more expressionistic. Emotion, extending beyond but also including Pop art cynicism, factors in their work, even though it is presented in an ironically cool mode. Size, colour and formal techniques are used to convey the specific emotional intentions of each artist. Lichtenstein could be cynical about modernism and make fun of its ambitions. This liberation from the high seriousness of abstraction allowed other aesthetic attitudes (parody and humour) to flourish. The group under consideration here, however, is further removed from the great period of modernist abstraction, and in addition, has passed through a period of extreme self-examination in the late sixties and seventies which has resulted in the dematerialization of the artwork itself. Their reclaiming of sixties' abstraction is not cynical. The new painters establish an identification with, not a parody of the 'end' which the sixties represent for them. They revise this end as a transformation: a kind of beginning.

The combination of Pop and sixties abstraction in the recent art of these painters may appear as hermetic as earlier forms of abstraction, but it is clear that within their vocabulary lies an American style, almost a vernacular style recognizable internationally as something made in the USA. American abstract art and Pop art function as emblems of America. It is the recognizability of abstraction – the fact that it is an American product, a veritable logo – that is at issue in the paintings of the 1980s. Again the art of the sixties is a precedent. In his Campbell's soup paintings Warhol has shown that the artist can take as his or her subject consumer products: but through formal transformations (i.e., the repetitions and organizing grid of Warhol's paintings) he or she can convey the infinite replication of the product which is simultaneously celebrated and denounced. Similarly, each of the painters under consideration here appropriates something that has become part of the consumer environment – namely, abstraction. Each of these painters sees abstraction as a product, or a social symbol within the traditional aura of painting, as designated by Walter Benjamin in 'The Work of Art in the Age of Mechanical Reproduction'. Their endgame play is an attempt to undercut a situation where even abstraction is an infinitely reproducible product.

The development of this new abstraction begins around 1981 in Ross Bleckner's reaction to what have been called the 'Pictures' artists. The name refers to the title of an exhibition organized by Douglas Crimp for Artists Space in New York which included Troy Brauntuch, Jack Goldstein, Sherrie Levine, Robert Longo and Philip Smith. Significantly, these artists used images that were media-derived 'pictures', not 'originals', and in various ways they deconstructed these pictures to reveal their power as signs in the construction of social meaning. This group, including also Barbara Kruger, Richard Prince and others, were, in the words of Peter Halley, 'ideology-sensitive'. The act of appropriation of imagery from existing sources was radically extended from the mass media to the fine arts by Sherrie Levine in 1981, when she began to take pictures of famous fine art photographs, without any manipulations of the source. In 1981 Rosalind Krauss wrote that an artist such as Levine had entered 'the discourse of the copy ... developed by a variety of authors, among them Roland Barthes [who characterized] the realist as certainly not a copyist from nature, but rather a *pasticheur*, someone who makes copies of copies'. When Levine rephotographed an Edward Weston photograph of a male boy's torso her act was scarcely any different from Weston's, whose own image was ultimately also a kind of copy of Greek sculpture. Although Levine had expanded the discourse of the copy to include the fine arts, the appropriation of abstraction, and particularly abstract art, was not a part of this discourse of the copy and the deconstruction of signs in 1981, except marginally in the work of David Salle (see, for instance. *The Blue Room*, of 1982, in which a small abstract passage is superimposed over unrelated overlapping images.) It was around this time that Ross Bleckner's paintings, Sherrie Levine's early conceptual work and Peter Halley's art and art criticism began to interpret abstraction as a sign within the larger discourse of signs which had preoccupied the 'Pictures' artists. [...]

Undoubtedly our present might be characterized as life at the end of the last picture show, when a certain amount of fantasy fades, revealing itself as only an illusion. This is one way of interpreting these new abstract painters who look back at the great age of modernism through the end they perceive in the sixties. To say that their content is inappropriate to the discourse of painting, or that it is only projected because of the insatiability for novelty built into the market, is overly harsh and premature. That the painters in 'Endgame' recognize and do not shrink from the commodity status of their work is neither a surprise nor a negation of the work's intentionality. [...]

Elisabeth Sussman, extracts from 'The Last Picture Show', in idem., ed., *Endgame: Reference and Simulation in Recent Painting and Sculpture* (Philadelphia: Institute of Contemporary Art/Cambridge, Massachusetts: The MIT Press, 1986) 51–5; 64.

John Stezaker
Interview with John Roberts//1997

John Roberts Would you say that [by the mid 1970s] you felt a confidence in using photography in a way that hitherto you hadn't felt?

John Stezaker Well, by this time I wasn't using my own photographs any more, I was using others – found images. Although, having said that, I can't remember a time when I haven't been collecting images. It's just that the status of that process of collecting has gone through various phases in my life. At one point they were simply stuff that I collected in preparation for paintings; at other times it was just another activity that seemed to go on in parallel with the photo work that I was doing.

By the mid 1970s the actual process of collecting started to take on a significance which I could acknowledge in the main body of my work. I saw myself as looking across a field of images and trying to find connections, mostly through the use of captions, sometimes, though, by diagrammatic activities like forms of wall display, in order to suggest a didactic reading. Although you'd find, if you did try to read it in any linear way, that you would be rebounded around the work. In this sense I couldn't completely relinquish that formalist sense of self-containment, and I think for good reason.

It was probably this that took me away from captions in the end, made captions actually impossible to use, because I wanted to dwell on the image, and language was yet another way of evading the image. However pictorial the imagery I employed, it was reduced, dissimulated in a sense, within the process of presentation.

Roberts This dwelling on the image certainly distinguished your work at the time from Victor Burgin's.

Stezaker Yes, perhaps.

Roberts You were also keen to distance yourself from a politicized semiotic practice. I take it that you were sceptical of Burgin's incipient deconstructionism when you said that you weren't interested in any kind of counter-cultural 'authentic speech'. Could you talk a bit more about this dwelling on the image?

Stezaker The removal of captions, the absorption into the image itself, and an

acknowledgement of the essential ambiguity of the image, was very important to me. Vic was very much more interested in the idea of a semiological reading. I felt, however interesting that was, the semiological reading was always under the gaze of disenchantment, it was always dissimulative. The suggestions and nuances of an image would be teased out, pinned down, reduced to a series of connotations and denotations, and all the rest of it, and what was left was nothing.

I was much more interested in the opposite vantage point. I wanted to simulate as opposed to dissimulate. I wanted to enchant rather than disenchant. That sounds like a more recent speech, but in a way it was partly because I became interested in Jung around that time. I was actually much more interested in the idea that in consumer culture there was a kind of reservoir of the collective unconscious at work. I referred to it in texts at the time as the collectivized unconscious, as a sort of parody of that. But in a way I was interested in how the archetypal manifested itself through the stereotypes of the image culture that we live in, and that was quite different. It made the image irreducible in a strange way. And this is where this absorption in the image came from. I remember I began collecting things in which I began to see the manifestation of an archetype.

One thing I remember very clearly at the time was collecting images of packets or packaging of various kinds. It was a series of images that crossed the whole range of advertising and it occurred to me that what makes one want to compress that connection between the technological and the natural worlds is a sort of archetypal desire, a desire for this fusion and breakdown. So at that point I just lost any sense of a mainstream idea of what I was trying to do and for the first time truly abandoned myself to being guided and taken surprise by the images that I encountered myself. That was the real breakthrough into collage, what I call collage anyway; it doesn't describe what I do, it's just the only word I can happily use.

Picasso hardly said anything in his entire life on the subject of what he was doing, but one of the most interesting things he did say, which always sticks in my mind, and says a great deal about that moment for me, was that he doesn't look for images, he finds them. That was really the key moment for me, when I relinquished control of the image myself by dropping captions. I was allowing myself to be guided by images. Obviously Picasso did search for images; he went around junk yards and scrap heaps and bookshops, finding the readymade objects and bits and pieces that inspired him in his work and which he used in it, so he did search, obviously. What he meant was that the searching is more likely to lead you to not find anything, because you don't really know what you want in the first place, so you have to abandon yourself to a kind of searching which doesn't predispose you to a very specific conclusion or image. The finding

is the key element because that's the point in which you've abandoned yourself from the search, you've taken yourself outside the linearity of a particular channel.

So I became very interested in the periphery of image culture, the sideways, byways of image culture, in which, in a way, images could become guides as opposed to being guided by me. And the sorts of collections of images I started at that time, I'm talking now about I suppose 1974–75, are still among the main types of image I'm collecting today.

Roberts There's a crucial point here, isn't there? In order for this abandonment to take place you actually had theoretically to transform your relationship to the culture; and there's something I want to say on this score. What does appear to distinguish your photography, or your use of the found image in this period, is an overwhelming sense of wanting to be immersed in popular culture, its desires, distractions, ideological structures, its coercions and pleasures. Were you then beginning to think about the possibility of producing a different kind of photographic archive?

Stezaker Yes this is very true. At that time, the other thing that really had a big impact on me was a rediscovery of Surrealism which was happening at that time, and an interest in the unconscious. I felt that the full renunciation of the strategic conceptual basis of my previous work involved a renunciation of the idea of a controlling consciousness. I wanted to find a way of immersing myself in the work, in which I could in some ways escape consciousness.

I was also very interested in the idea of the consumer as unconscious, or the forms of unconsciousness within which one consumes images. I thought there was an interesting possible connection between this idea of the aesthetic unconscious and a consumer unconsciousness or passivity, and I was interested in trying to align the two. At the time I used to talk about things taking on the vantage point of the consumer rather than the producer of images, and had the idea that eventually my various collections of images would be published as books without words, perhaps even without titles. I haven't actually done that, they've become sort of fodder for collages over the years, but many of the books from that period do still survive as independent collections, and they are rather mysterious things. For example the collection of Big Bens, sunsets and skies, or the beginnings of the first collection of nudist images, photo-romans, Maoist images.

I felt these represented something unseen as a kind a cultural connection that perhaps we don't fully understand, the ghostly presence of an archetype – that's if one sees the culture of images as unconscious. Not some collective unconscious in the Jungian sense, not some explicable and dissimulative unconscious as in Freud, but an unconscious that's out there in a world, in the

actual images that are in circulation. I felt that I was looking not just at my own psyche but also at a collectivized psyche. And this I believed was unrepresented, and therefore important because so much of our culture seems to be unconsciously acting out awful apocalyptic scenarios, the most obvious being the threat of the nuclear bomb. How does a fully conscious, rational scientific culture arrive at the actual complete extermination of life on the only planet in the universe known to support it? It's certainly not the product of rational linear thinking, it's something else that's at work beneath that culture. It may be seen to be arrived at through vigilant insomniac irrationality, but it certainly represents a kind of dream, or a fear, that lurks within the culture we inhabit. It's trying to touch really on those kind of collective desires and fears. It's an irrational thing, isn't it, to have a culture of images? I mean, what is the point of producing images; they serve very little social function, they're surplus. What is hidden in that surplus, that excess, is what interested me, because it's clear that it is the tension between the world of that excess and the world of everyday reality governed by its rationalist forces, the gulf between them, that creates the literally disastrous culture that we live in. [...]

John Roberts and John Stezaker, extract from interview, in Roberts, ed., *The Impossible Document: Photography and Conceptual Art in Britain 1966–1976* (London: Cameraworks, 1997) 153–7.

David A. Mellor
Media-Haunted Humans: Cindy Sherman, Richard Prince, John Stezaker//1998

Promotional Epics

There is a moment of transition in photo-conceptual activities around the turn of the decade from the 1970s to the 1980s, a change sometimes described as the arrival of 'second-generation conceptualism'. The transformation was associated with the re-legitimization of previously visual pleasures which had been stigmatized under late modernism. When, in the wake of the landmark 'Pictures' exhibition (Artists Space, New York, 1977) Thomas Lawson sardonically wrote, 'We want entertainment …',[1] he announced a switch in sensibilities towards more spectacularized artefacts of affect. Through a higher investment of labour, technical resources (such as the deployment of large format Cibachrome prints), perhaps in emulation of the high-expense and high-definition entertainment productions of the mass-media spectacle itself, there was a 're-skilling' within photo-conceptualism which reversed the 'amateurism' of the late sixties. As Dennis Oppenheim observed: 'It is strange that so much second-generation conceptualism came about through a reaction to the documentation procedures of this [late sixties] period.'[2] Kate Linker's important essay 'On Artificiality' (1983)[3] isolated the 'sheer pleasure in surfaces, in a "look" – in shimmering synthetic appearances that flaunt their artificial origins'. To her, 'this glossy object world suggests a situation in which both creator and copyist have been replaced by the more complex role of the arranger who, working with sophisticated technology and under a post-industrial model, "manages" the production of imagery'.[5] To perform in this context of high professionalization necessitated new technical skills – for example, Victor Burgin's acquired familiarity with digital imaging techniques in the late eighties. The willed naïvity of the 'de-skilled' modernist photo-conceptualists of 1969 would be caught up in the more managed and entrepreneurially sophisticated frameworks of promotion and exhibition that prevailed under the deregulated popular capitalism of the 1980s.

The Sarcasm of the Image Managers

Linker imagined what amounted to a new kind of constructivist productivism, which (unlike Burgin's montage attempts to renew a politically left mandate in his art of the mid and late 1970s), was now complicit with advanced forms of hyper-capitalist consumer imaging: 'Indeed, there exist today a number of artists who variously manipulate and synthesize images, aiming to negotiate a

relation with consumer culture as it increasingly dominates the urban vernacular. These artists do not place their practice against the institutions of modernism or the conventions of the modernist period, but within the framework of late capitalist postmodernism'.[6] Richard Prince had worked for Time-Life in the mid 1970s and his experience paralleled that of the 'new-wave' painter David Salle, who could also be said to have gained a sense of a world made up of permutable photo-images, while he worked for a magazine publisher in New York. This was the world of those excited but inert commodity pleasures in which Richard Prince revelled with such a visionary sarcasm. It was manifest in his decontextualized rescreenings of advertising images for men's fashion in *Untitled* (1978). Prince's 1978 photographs of these male models became paragons of the new sensibility at the close of Douglas Crimp's 1980 article 'The Photographic Activity of Post-Modernism'.[7] Crimp saw Prince's 'rephotography' being invaded – parasitized – by uncanny fantasies of forfeited existence: '... their rather brutal familiarity gives way to strangeness, as an unintended and unwanted dimension of fiction re-invades them. By isolating, enlarging and juxtaposing fragments of commercial images. Prince points to their invasion by these ghosts of fiction ... the ghostly re-inhabiting of image by a sense of alienated absence and inauthenticity'.[8] As warning phantoms they seemed to predict that representation would no longer be an area or activity of enquiry, possibly cognitive in its outcome – which was the British artist Keith Arnatt's dream – but a hell which infused the demonic into mediatized vistas.

A Living Doll

A delegated functionalism had always characterized photo-conceptualism in its manufacture; just as Keith Arnatt's early works were photographed by Egg Herring, and Dik Bruna lay behind the camera as executor for some of Bruce McLean's satiric poses, so Prince 'took' the Sherman *Untitled Film Stills* in 1978. Unlike her contemporary British feminist photo-conceptualists, to whom she was a provocative inspiration in the early 1980s,[9] Sherman abbreviated multi-part narrative display, reducing it to one enigmatic image that took its place in the context of photo-conceptualist work which foregrounded issues of sexuality and vision. For example, her self-pretending heroine could be the one being stalked in the sexual intrigue pieces of Mac Adams.[10] With Prince and Sherman a new affective code of cynicism was engaged as a defensive structure for the artists' masquerades in the new epic of high media professionalism. Defensiveness had previously been foregrounded in a viable form of self representation during the first epoch of photo-conceptualism. (It was found, for example, in the pathos of Arnatt's comic-masochistic capers). Sherman's *Untitled Film Stills* (1978) appear masterpieces of female vulnerability and

defensiveness, yet they are predicated upon a severing of feeling: this is the universe of the posed – foreshadowed in McLean's dramas of clothing – the calculated assumption of role and emotive register according to a limited code of stereotyped behavioural signs.

Signs of the Undead

In 1983 Rosalind Krauss described this externalized version of the human in Sherman's self-portrayals as being 'a kind of simulacrum of the self through personae which can be learned; the notion she throws up of the self, entirely as function, a view from the outside … is fascinating.'[11] In his article 'War Picture',[12] Prince showed himself as a reflex user of the kind of clichés which Sherman and himself made into fundamental codes for their photo-works. Prince described narrative scenarios from the cinema, clichés that possessed 'prior availability'[13]: 'When we ourselves actually experience a "tight spot", we sometimes refer to it not as an observable reality, but a situation that was once previously observed in a cinema movie.'[14] These conventionalized, cinetized husks have a chilling effect, pacifying 'observable reality'. Prince's category of 'prior availability' resembles the Derridean notion of the endless and origin-less nature of textual traffic in the worlds of representation. In that case, there could be no imaginable 'afterlife' for Sherman's young women or Prince's male models – other than the photo-mechanical representation which preceded them in film cliché or in the image world of magazines: a vampiric re-animation only. They are the undead.[15]

The English Friend

'We came across your work in *Studio International* and we are very interested to meet you. We have weekly meetings to discuss art and culture', wrote Sherrie Levine, from New York, to John Stezaker, in 1978. The 'we' referred to the newly ascendant 'Pictures' group of Prince, Sherman, Levine and Barbara Kruger. What had attracted their attention had been Stezaker's five part photo-suite of 1975, *The Pursuit*,[17] which signalled his growing confidence as a photo-conceptualist during the three years since he had left behind his linguistic and philosophically based work of the early 1970s. In 1976 Stezaker took Hitchcock's *Psycho* (1960) as a point of scripto-photographic departure for his *Vanishing Points/Vantage Points* series and extended this enquiry into that zone of the gaze and voyeurism which was about to engage Victor Burgin. His obsessive invocation of a third, participating and voyeuristic spectator he discovered in Rilke's words describing a personage without whom 'absolutely nothing can happen … everything stops, hesitates, waits'.[18] This haunting figure came to the fore in his series of overlapped and juxtaposed snapshots (which produced an extensive supplementary space exceeding that of Jan Dibbets), in his *Domestic Allegory (of*

the Third) in 1976–77.[19] Shown at The Photographers' Gallery, London, in 1978, this work appears to have cued David Hockney's domestic 'joiner' photoworks. Scavenging and montaging photographs from continental soft-core *fumetti* [photo-novel] magazines, he moved deeper into explorations of stills and frame enlargements from *Psycho*.

Gothic Pictures

By 1980,[20] Stezaker had begun to exploit a precise element from the affectless and depthless photo-works of his US contacts and counterparts, whom he had met the previous year – the latent eeriness and uncanniness that characterized the apparently brute media materialism of the 'Pictures' group fascinated him. His photo-pieces became darkened to a simplified, sooty space of weird happenings and all-but invisible human protagonists, as in *The Voyeur* (1979).[21] With Rosetta Brooks, the editor of the initially St. Martin's School of Art based magazine *ZG*, Stezaker helped bridge New York and London agendas of 'awakenings to new relationships between popular art and culture'.[22] His dialogue with American photo-conceptualists was mutually beneficial: for instance, the *Negotiable Space* series, with their regular geometries of negative space – breaking into frames, scenes and bodies in evocative film stills – is definitely relatable to John Baldessarri's *Violent Space* series, from 1976. Prince admired and purchased Stezaker's *Egg Burial* (1985) of anamorphic baby heads which appear to be all eyeball, like Prince's own monstrous rephotographed vision of a woman's eye in a powder compact. Both are reminiscent of the Symbolist painter Odilon Redon's representations of gigantic eyes – but futurized as part of 'image culture' rather than – as in Redon's case – acting as a signifier of spirituality. If these eyes are omnipotent, it is within the terms of a culture of hyper-consumption. Stezaker's achievement, in the later 1970s and throughout the 1980s, was to combine the worldly and promiscuous image world of the 'Pictures' artists with a regime of British Gothic, of which he is still a leading representative with his petrifying *Angels* series (1998).

1 Thomas Lawson, 'Switching Channels', *Flash Art International*, no. 102 (March–April 1981).

2 Dennis Oppenheim in conversation with Alanna Heiss, *Dennis Oppenheim – Selected Works 1967–1990* (New York: PS1 Contemporary Art Center/Harry N. Abrams, 1990) 145.

3 *Flash Art International*, no. 111 (March 1983) 33–5.

4 Ibid., 35.

5 Ibid.

6 Ibid.

7 *October*, no.15 (1980) 91–101; 100.

8 Ibid., 100.

9 Sherman's work was introduced to a British audience through the film analysis magazine. *Screen*, by the feminist semiologist and advert deconstructor, Judith Williamson, in 1982.

10 e.g., *Mystery 9* (1975).

11 Rosalind Krauss, 'Reflecting on Post-Modernism', *Brand New York* (London: Institute of Contemporary Arts, 1983) 54–7; 57.

12 *ZG*, no. 3 (1981) n.p.

13 Ibid.

14 Ibid.

15 cf. Slavoj Zizek, *The Plague of Fantasies* (London and New York: Verso, 1997) 89.

16 Letter in archive of John Stezaker, undated.

17 Published over 10 pages in *Studio International* in 1976.

18 Quoted by Stezaker from Rainer Maria Rilke's *Notebooks of Malte Laurids Brigge*, in *John Stezaker. Works 1973–78* (Luzern: Kunstmuseum Luzern, 1979) 50. Brian Hatton refers to this 'third' entity as the 'ghost' of the narrative; ibid. xiii.

19 Illustrated in *John Stezaker. Works*, op. cit., 46–8.

20 He was to spend up to three months a year in New York between 1979 and 1985.

21 The portentous formal device of the all-black silhouette appeared in 1979 in both Sherrie Levine and John Stezaker, its source being the US artist Robert Moskowitz. Stezaker admits to a 'Blanchot-like fascination with depth, with blackness'. In discussion with the author, 18 December 1997.

22 John Stezaker to the author, 18 December 1997.

David A. Mellor, 'Part 5: Media-Haunted Humans: Cindy Sherman, Richard Prince, John Stezaker', in *Chemical Traces: Photography and Conceptual Art, 1968–1998* (Kingston upon Hull: Kingston upon Hull City Museums and Art Galleries, 1998) 31–5.

I
am
trying
to
interrupt
the
stunned
silences
of
the
image
with
the
uncouth
impertinences
and
uncool
embarrassments
of
language

Barbara Kruger, Interview with Anders Stephanson, 1987

FEMINIST CRITIQUE
Barbara Kruger 'Taking' Pictures, 1982//106
Jo Spence What is a Political Photograph?, 1983//107
Lisa Tickner Sexuality and/in Representation, 1984//108
Barbara Kruger Interview with Anders Stephanson, 1987//111
Laura Mulvey A Phantasmagoria of the Female Body: The Work of Cindy Sherman, 1991//118
Deborah Cherry Maud Sulter: *Zabat* (1989), 2003//124

Barbara Kruger
'Taking' Pictures//1982

There can be said to exist today a kind of oppositional situation in the arts (principally on a theoretical level only, as the marketplace tends to customize all breeds of activity); the laboratorial or studio versus certain productive or more clearly, reproductive procedures. As parody frees ceremony from ritual, so its 'making alike' allows for a disengaged (or supposedly) distanced reading.

This strategy is employed by a number of artists working today. Their production, contextualized within the art subculture, frequently consists of an appropriation or 'taking' of a picture, the value of which might already be safely esconced within the proven marketability of media imagery. Using, and/or informed by fashion and journalistic photography, advertising, film, television, and even other artworks (photos, painting and scupture), their quotations suggest a consideration of a work's 'original' use and exchange values, thus straining the appearance of naturalism. Their alterations might consist of cropping, reposing, captioning and redoing, and proceed to question ideas of competence, originality, authorship and property.

On a parodic level, this work can pose a deviation from the repetition of stereotype, contradicting the surety of our initial readings. However, the implicit critique within the work might easily be subsumed by the power granted its 'original' thus serving to further elevate cliché. This might prove interesting in the use of repetition as a deconstructive device, but this elevation of cliché might merely shift the ornamental to the religious. And as an adoration the work can read as either another buzz in the image repertoire of popular culture or as simply a kitschy divinity. However, the negativity of this work, located in its humour, can merely serve to congratulate its viewers on their contemptuous acuity. Perhaps the problem is one of implicitness, that what is needed is, again, an alternation, not only called 'from primary to secondary', but from implicit to explicit, from inference to declaration.

Barbara Kruger, Statement printed next to the first reproductions of the artist's work published in Britain, in '"Taking" Pictures: Photo-Texts by Barbara Kruger', *Screen*, vol. 23, no. 2 (July–August 1982) 90.

Jo Spence
What is a Political Photograph?//1983

For me, this would amount to one which mobilized the largest amount of people with the minimum amount of cost or social control. But mobilized for what? Initially it would be towards an understanding that we must find ways to demythologize ourselves (long before we attempt to demythologize others) so that we can begin to formulate different questions about our own identity, our history – perhaps shifting away from national identities (those who cannot remember the past are condemned to repeat it). This would take the form of a radicalized type of 'amateurism'; what would amount to a total questioning and overthrow of the Kodak regime which dominates world markets and fills our memories with visual banalities.

We would start with our domestic cameras and family snaps. Those innocent little bits of paper or plastic which fill albums, wallets, mantlepieces, drawers. Before we can speak, question or answer back, these 'slides of life', these early forms of realism, appear miraculously before us and confirm our unchangeable position, role and status in the family, in the world. Through them we are initially stitched up, then into, the vaster networks of surrogate identities on offer. Positioned, placed, fixed within our family structures.

Within all households, forms of domestic warfare are continually in progress, and although we live this daily power struggle, it is censored, displaced, put off-bounds, transformed into icons of ritualized harmony within family photography. All pain, desire, violence and ultimate power differentials are effaced.

A political practice (with a small 'p') would seek to find ways to question this so that we could discover for ourselves the multiple discourses that so articulately invent and reinvent daily life for us (from the familiar television set to school reading books). We could perhaps then begin to understand that everything is profoundly un-natural, that life itself is a process, and that we are in a constant state of change (not merely fragmented, fixed, static). Moreover I would want primarily schools to hold classes on poststructuralism! Not in order that kids grow up to be good, right-on, radical, professional mediators, but that through the use of their own cameras they could begin to lay down the building blocks for a different sort of visual memory. [...]

Jo Spence, 'What is a Political Photograph?', *Camerawork*, no. 29 (Winter 1983–84) 28.

Lisa Tickner
Sexuality and/in Representation//1984

This exhibition ['Difference: On Representation and Sexuality', New Museum of Contemporary Art, New York] draws together work from both sides of the Atlantic, with shared concerns but different aesthetic, theoretical and political trajectories. It includes work by women and men on sexual difference that is devoted neither to 'image-scavenging' alone (as the theft and deployment of representational codes), nor to 'sexuality' (as a pre-given entity), but to the theoretical questions of their interrelation: sexuality and/in representation.

These questions have been rehearsed by American critics, largely under the diverse influences of Walter Benjamin, Jean Baudrillard, Guy Debord and the Frankfurt School. A comparable body of writing in England has drawn more pointedly on the work of Bertolt Brecht, Louis Althusser, Roland Barthes and of tendencies in European Marxism, poststructuralism, feminism and psychoanalysis.

The crucial European component in the debate has been the theorization of the gendered subject in ideology – a development made possible, first, by Althusser's reworking of base/superstructure definitions of ideology in favour of the ideological as a complex of practices and representations and, second, by the decisive influence of psychoanalysis (chiefly Lacan's re-reading of Freud).

It was psychoanalysis that permitted an understanding of the psycho-social construction of sexual difference in the conscious/unconscious subject. The result was a shift in emphasis from equal rights struggles in the sexual division of labour and a cultural feminism founded on the revaluation of an existing biological or social femininity to a recognition of the processes of sexual *differentiation*, the instability of gender positions, and the hopelessness of excavating a free or original femininity beneath the layers of patriarchal oppression. 'Pure masculinity and femininity', as Freud remarked, 'remain theoretical constructions of uncertain content.'[1]

My concern here is with the work of the British-based artists and the priming influence of material produced over the past ten years. This work has its own history, but that history is bound up with the development of associated debates on the left and within feminism: debates on the nature of subjectivity, ideology, representation, sexuality, pleasure and the contribution made by psychoanalysis to the unravelling of these mutually implicated concerns. What I want to turn to is a consideration of this relationship – that is, the relationship between these arguments and this work – rather than to a biographical account

which treats each artist's authorship as the point of entry into what they make. It is appropriate here to stress the importance of theory – which is always transformed and exceeded in the production of 'art' – as part of the very texture and project of the work itself. [...]

Context: Feminism, Modernism and Postmodernism

The first question to pose is therefore: how can women analyse their exploitation, inscribe their claims, within an order prescribed by the masculine? Is a politics of women possible there? [Luce Irigaray][2]

Since the nineteenth century at least, pro- and anti-feminist positions have been engaged in struggles over the varied propositions that culture is neutral, androgynous or gender-specific. What these debates generally have not addressed is the problematic of culture itself, in which definitions of femininity are produced and contested and in which cultural practices cannot be derived from or mapped directly onto a biological gender.

The most important contribution of the feminism under consideration here is the recognition of the relations between representation and sexed subjectivity *in process*, and of the need to intervene productively within them. The artists considered here hold the common aim of 'unfixing' the feminine, unmasking the relations of specularity that determine its appearance in representation, and undoing its position as a 'marked term' which ensures the category of the masculine as something central and secure.

This is a project within feminism that can be seen as distinct from, say, the work of Judy Chicago. The importance of *The Dinner Party*[3] lies in its scale and ambition, its (controversially) collaborative production, and its audience. But its deployment of the fixed signs of femininity produces a reverse discourse,[4] a political/aesthetic strategy founded on the same terms in which 'difference' has already been laid down. What we find in the work in this exhibition is rather an interrogation of an unfixed femininity produced in *specific systems of signification*. In Victor Burgin's words:

> meaning is perpetually displaced from the *image* to the discursive formations which cross and contain it; there can be no question of either 'progressive' contents or forms in *themselves*, nor any ideally 'effective' synthesis of the two.[5]

This work has been claimed for modernism (for a Russian, rather than a Greenbergian formalism) and for postmodernism (via poststructuralist theory rather than new expressionist practice), but we need, finally, to see it in yet another context. Not as the phototextual work of the 1970s now eclipsed by the

panache of the new, not as one ingredient amongst others guaranteeing the plurality of the new, not even as a 'postmodernism of resistance'[6] (despite the equivocal attractions of the term). Rather as that 'cinematic of the future'[7] Barthes called for, that concern with sexuality in process which Luce Irigaray described as 'woman as the not-yet'[8] – a continued countering of cultural hegemony in its ceaseless and otherwise unquestioned production of meanings and of subject positions for those meanings.

> She had acted out for long enough, inside those four corners: frame, home, tableaux or scene. She no longer wanted to be found, where she was expected to be found, as if each time she was found it were all the same. As if it were all a matter of one pattern from which, on and on, the same was cut out, pressed out, and indeed could be put back. ... She arose. She straightened herself out. She made ready to go. But as she turned to look at what she was leaving behind, she knocked some metaphors off the table ... [Yve Lomax][9]

1 Sigmund Freud, 'Some Psychical Consequences of the Anatomical Distinction between the Sexes' (1925), *The Standard Edition of the Complete Psychological Works of Sigmund Freud*, vol. 19, trans. James Strachey (London: Hogarth Press, 1953) 241–58.

2 [footnote 57 in source] Luce Irigaray, quoted by Mary Jacobus in 'The Question of Language: Men of Maxims and the Mill on the Floss', *Critical Enquiry*, no. 8 (Winter 1981–82) 207.

3 [58] See Judy Chicago, *The Dinner Party: A Symbol of Our Heritage* (New York: Doubleday, 1979) and Judy Chicago and Susan Hill, *Embroidering Our Heritage: The Dinner Party Needlework* (New York: Anchor Press/Doubleday, 1980).

4 [59] Michel Foucault, *The History of Sexuality*, vol. 1, trans. Robert Hurley (New York: Pantheon Books, 1978) 101.

5 [60] Victor Burgin, *Thinking Photography* (London: Macmillan, 1982) 215–16.

6 [61] Hal Foster, ed., *The Anti-Aesthetic: Essays on Postmodern Culture* (Port Townsend, Washington: Bay Press, 1983).

7 [62] Roland Barthes, *Image-Music-Text*, trans. Stephen Heath (London: Fontana, 1977) 66; and Victor Burgin in conversation with Lisa Tickner.

8 [63] Quoted in Meaghan Morris, 'A-Mazing Grace: Notes on Mary Daly's Poetics', *Lip*, no. 7 (1982–83) 39.

9 [64] Yve Lomax, from *Metaphorical Journey*, exhibited in 'Light Reading', B2 Gallery, London, March 1982.

Lisa Tickner, extract from 'Sexuality and/in Representation: Five British Artists', in *Difference: On Representation and Sexuality* (New York: New Museum of Contemporary Art, 1984) 19; 28–9.

Barbara Kruger
Interview with Anders Stephanson//1987

Anders Stephanson In your 'obituary' of Andy Warhol, written with some degree of affection, you point to his realization that 'the cool hum of power [resides] not in hot expulsions of verbiage, but in the elegantly mute thrall of sign language'. Perhaps one might say the same thing about your work?

Barbara Kruger I didn't consider that piece an obituary, but its institutional categorization aside, I think it was written with a kind of critical appreciation rather than affection. Since my inclination is not to write about art, I approached the Warhol piece as an essay about the end of a physical body and the perpetuation of the proper name: its continuance as a historicized and valued commodity. In my production pictures *and* words visually record the collision between our bodies and the days and nights which construct and contain them. I am trying to interrupt the stunned silences of the image with the uncouth impertinences and uncool embarrassments of language.

Stephanson I was thinking of signs in the broader sense that would include language itself.

Kruger I see my picture practice as one gesture among a repertoire of others. In my images, my critical writing and my teaching, I try to muck up 'the pose' with an insistent chorus of commentary. Warhol was into modelling, traipsing down the runway in a slinky, retentive armouring which clung close to the pose and shied away from the sometimes unpredictable irregularities of soundings. I prefer dishevelling the garment or at least splitting its seams in the hopes of exposing the underpinnings of what is seen and spoken.

Stephanson Did Warhol actually ever play any influential role for you?

Kruger I don't have much of an art education and didn't spend much time loitering around the sacred sites of the art world. The little I knew of Warhol's work seemed more accessible to me than most of the other work being produced and touted. I was aware that we shared a background in magazine work. Aside from my editorial and book cover design, I had started out doing shoe and accessory illustration for *Seventeen*. Although I work at times to foreground the commodity status of the *objet d'art*, my positioning vis-à-vis

capital and expenditure seems quite different from Warhol's, as is my relationship to sexuality and representation.

Stephanson This is your first show at the Mary Boone Gallery, in itself an event.

Kruger It isn't the first time I've shown work there. Mary showed a piece of mine in 1979 and I was in a group show in 1983.

Stephanson Boone has otherwise been known to exhibit very forthrightly male artists. Given your feminist orientation, how is this move to be interpreted?

Kruger I consider gender to be biologically defined while sexuality is socially constructed. Because of this, I am prone to a kind of lascivious optimism. I want to question the notions of heroism and skew the conventions which loiter around depiction. I try to pull this off in a number of sites, sort of grazing from the mobility of roadways to the intimacy of postcards and matchbooks, to the pages of magazines, to the institutionalized site of the art gallery. I think my work can be effective (in questioning spectatorial positionings and sexual representations) within the symbolic site of Mary's gallery, given its position in the discourses of contemporary picture-making and aesthetic practices.

Stephanson It is a symbolic gesture then, but will it be understood that way?

Kruger Most probably, as the passages of the supposedly real seem to be mediated through the symbolic. I know that for many women and men, the making present of that which had been unseen and unspoken can have a tremendously generative impact. I only hope that my presence and production can make a difference.

Stephanson Yes, but surely there is a distinction between the Mary Boone Gallery and, say, Artists Space.

Kruger I take no pleasure in collapsing differences, whether they're between genders, opinions, economic orderings or cultural institutions. There's a difference between Artists Space and Mary Boone, Franklin Furnace and The Kitchen, Film Forum and Cineplex Odeon. However, all these sites are contained within a market construction whose density varies from institution to institution. All engage in financial choreographies which, on a minimal level, allow them simply to continue functioning, while others partake of the more elaborate structurings of profit margins and their subsequent glamorous expenditures. Some artists and

writers worry about health insurance, production costs, getting a job and paying the rent, while others fret over their real estate accumulations. I certainly have no investment in effacing the differences that are constituted by economics, gender and race, but I do think that both extravagance and inequity are constructed and maintained by a pervasive global market. […]

Stephanson Baudrillard wrote a catalogue essay for your show. Amidst lengthy stretches of apocalyptic musings about this and that, he writes of it: 'I do not believe that these images create a collective mobilization or awareness. If they had such a political goal, they would be naïve (as naïve as advertising when it believes it is delivering a message, whereas nowadays any text whatsoever is read as an image).' There is, he decides, no one at the other end of the sign. This strikes me as dead wrong, at least if it is set against your statement that 'I want to be effective in making changes in power relations, in social relations.' As you have also indicated, you want to make for 'an active spectator who can decline [the] "You" or accept it, or say, "It's not me but I might know who it is".'

Kruger I do not set my statements up 'against' Baudrillard's, nor would I relegate his comments to the 'incorrect' kingdom of 'deadness' and 'wrongness'. I have always read him *critically*, savouring the rigour and economy of the 'good' parts and then quickly changing channels when 'His Master's Voice' hits the fan. I find much of his writing provocative in a brilliantly economic, yet sometimes reductivist fashion: he kind of cuts through the grease. I think it is possible to disagree without retreating into the armed camps of oppositional warfare, reversals and binaryisms. Actually, I somewhat agree with him that the literal specificities and proper naming of advertising are effaced by the looming centrality of its image and that almost any text can be read as an image owing to the conflation of electronic transmissions which reaches its current apotheosis in television. However, I do think that some kind of incremental communication lurks closer than we might suspect and is capable of inflicting a shock to the system and changing the rules of a few games. Of course, I disagree with Baudrillard in his pronouncement that power and the masculine no longer exist, which strikes me merely as a hilarious idea for a 1990s screwball comedy. Nothing crawls as profoundly between laughter and tragedy as power's cutely disingenuous attempts at self-effacement.

Stephanson The subject matter of your present material appears to signal a shift from the focus on feminist discourse to one on the market.

Kruger You mean that even though my work continues to foreground issues of

power, gender and reception, when I include the positionings of the market, it removes my practice from the concerns of a feminist discourse? Is your question another assertion of the need to categorize or does it also suggest that you think that feminism exists outside the discourses of capital, as a kind of primordial meandering which escapes all economies except those of birth and rhythm? I consider sexuality and capital to be inextricably wedded and this coupling has the power to dictate the feel of the moments of our lives. As my position within the market structure became more palpable, I thought it increasingly important to comment on the financial proclivities which enveloped me: to be in and about consumption at the same time.

Stephanson Let's examine the concept of the market for a moment. You explicitly oppose notions of totality and totalization. Yet the emphasis on difference and heterogeneity is not immediately apparent in your conception of 'the market'. You argue that 'the division between notions of public and private, work and spare time are spurious' and 'outside the market there is nothing – not a piece of lint, a cardigan, a coffee table, a human being'. Is this not theoretically contradictory? Moreover, if one wants to be strict, there are things outside the market in the sense that they are not commodities, not subsumed under the law of valorization. It makes a difference whether or not art is produced by people on (which is sometimes the case in Sweden) public salaries and is destined for public exhibition spaces not within the corporate sphere.

Kruger As I noted before, there are differences between various cultural institutions, and of course, between specific market sites. The flexibility of the market structure allows for a variety of phyla of exchange and capital liquidity, usually (in America) foregrounding finance over productive capital. And obviously, just because something doesn't sell doesn't mean it's not a commodity. I am not alluding to a totalizing amalgam, but rather an aerosol of numerical methodologies, the density of which varies from site to site. Again, I think our 'accomplishments' or lack of them, our property or lack of it, our ability to feed and clothe ourselves and to eke out some degree of sustenance in this world is dependent, to a large extent, on both the power and caprice of monetary flow. And we needn't limit ourselves to the distributions of aesthetic production, but can also talk about foreign trade, global banking and, most importantly at this moment, world health. Perhaps only the pervasiveness of viral contagion can hold a candle to the grandiose dispersals of capital.

Stephanson Granted, but there is a difference in saying 'I know I am functioning within a specific apparatus in such a manner', and then putting it into question;

and, on the other hand, the idea that playing on the theme of the game is in itself somehow critical, a strategy of using the 'always already in the market' argument as an open-ended license for the celebration of the commodity.

Kruger I certainly think it is possible to appropriate certain 'strategies' and in doing so, siphon off their criticality, leaving a shell, a clump of seductive artifact which signifies criticality but has little relationship to its possible displacements. At this point, it seems problematic to even use the term, as criticality itself has become an institutionalized site, whether in academia, in theory and even (believe it or not) in the buzz-worded, power abusing, kiss/slapisms of some art writing (A number of its practitioners seem unaware that writing criticism is *also* a social relation). Nevertheless, I think 'the C word' can still be operational, can still work to put into place certain procedures and ways of looking which have a tumultuously unhinging relationship to the etiquettes of power.

Stephanson An archaeological query. Your 'apellative' tactics, with its reliance on pronouns and so forth, often makes me think of the Althusserian theory of ideology in its later form. The subject and subject-position there is comprehended precisely in terms of appellation or 'hailing'. Furthermore, the curious ambiguity of the subject as a (i) 'centre of initiative' and as (ii) subject(ion) in the sense of freely submitting to authority, seems of obvious relevance in your case as well. Was this ever a historical reference point for you? Did it perhaps in that case come to you circuitously by way of the neo-Althusserian/Lacanian analyses in the British magazine *Screen*?

Kruger This 'hailing', this curious ambiguity of the subject as the 'centre of initiative', is one of the prominent tactics of most public design work, whether it be advertising, corporate signage, or editorial design. In all this work, the economy of the overture is central and involves all manner of short cuts which waste no words. My confrontation with these methodologies was a non-circuitous one, and began in my early twenties when I started working at magazines. My usage of the imagistic and textual strategies of advertising was *not* mediated by ten years of '*Screen*' theory or any other critical writing, but rather, by a relentlessly hands-on need to have a job and pay the rent. If I *had* come across those texts during that time of my life, they probably would have seemed like some kind of Martian geometry, as I lacked the academic training which would allow for my entry into the space of that language. Years later, however, I happily discovered *Screen*, and with a lot of self-help and a bit of peer pressure, I became semi-fluent in its readings. Since then, theory has

intermittently become a source of both pleasure and rigour for me, but I have *never* illustrated it.

Stephanson It is wrong in my view to think about your work primarily in terms of 'appropriation', even though you find the 'originals' elsewhere. My personal line of association, perhaps equally wrong-headed, is more with John Heartfield's agit-prop montages than with the specific question of appropriation or, as it is now inevitably being reformulated, 'post-appropriation'.

Kruger I must mention that I think that this 'inevitability (of) being reformulated (into) 'post-appropriation' is getting a big boost from your mentioning the term in this magazine. (Let's foreground the apparatus a bit.) The inflationary device which fuels all cultures of professionalism serves not only the careers of artists and writers but also their investment in various movements, codings and buzzwords, and is responsible, in part, for transforming 'appropriation' from an active procedure into a journalistically gelled, monumentalized site. In most design work, received images and words are arranged and aligned to produce assigned meanings. I am engaged in rearranging and realigning these dominant assignments. I'm flattered by the comparison to Heartfield. He understood how to create critically strong graphic work within a magazine format, focusing on the specificites of the oppressive order that surrounded him. Obviously, your comment is based on the confluent formalisms of our work, as well as its 'political' content. However, I must restate my concern with the construction of the female subject, and the visual specificities and non-specificities which I employ to foreground this concern.

Stephanson Some time ago, you explicitly denied any concern with 'perpetuating the notion of the moral and the ethical'. This notion has since undergone a remarkable resurgence, from left to right, and surprisingly, even within certain post-structuralist discourses. Would you be less categorical about it today?

Kruger Given today's climate of roving oppressions, intolerant religiosities, global contagion and gargantuan 'moral' hypocrisy, it is with great pleasure that I restate my opinion that the notions of the moral and ethical are due for a sabbatical: a ventilation by a burst of *actual* benevolences and tolerance. Perhaps this would make for fewer zealous designations of 'the sacred' which expel or destroy those that differ, fewer ideologies of univocal 'correctness', fewer ethical arrangements which perpetuate the oppressions of the law of the Father. Having said this, however, I must add that effectivity implies an avoidance of self-righteous naïveties and utopianisms.

Stephanson A 'Barbara Kruger' is now instantly identifiable, its text, red frames and photographic elements working like a tremendously effective trademark. Having done this for some time now, are you looking for other ways of putting things across?

Kruger You mean turning out a new fall line? It's interesting that your question only addresses my 'picture practice' and not the other activities which I engage in and consider to be part of my 'work'. I try to avoid a typical production of verticality: the refinement of a singular gesture which marks most 'professional' practices. I consider my work to be more horizontal in its construction: comprised of object-making activities, teaching, writing criticism, doing billboards and other public projects, sporadic curating and book publishing, and working on the boards of various exhibition venues. Last spring I organized (with Phil Mariani) two nights of panel discussions at the Dia Foundation which we entitled *The Regulation of Fantasy: Sexuality and the Law* and *Journalism and the Construction of the News*. This year we're planning a series of lectures on *The Re-Making of History*, hoping to involve speakers from a number of fields: architecture, medicine, history, sociology, film etc. Again, I consider all of these activities to be part of my 'work'. [...]

Stephanson [...] You've said that your work would be worth much more if it were painting instead. Does this still hold true?

Kruger Not quite, but the disparity is still there. The production costs located in photographic, video and film work are very considerable. But whether it is painting, sculpture, video, an installation or a photograph, an *objet d'art* doesn't just erupt out of the top of a beret, but is the result of a concrete activity: a confluence of thought and action, an expenditure which is both capital and libidinal. But your question addresses the issue of worth, and worth isn't defined merely by material, labour or even capital. Value is established via a complex amalgam of social and market forces which heed the soundings of sighs and whispers, affiliations and grudges, snubs and outbursts. I think that in order to take part in a *systemic* critique rather than a merely substitutional one, one should work to foreground the relations and hierarchies that constitute power, but to do so not in the name of bitterness, warfare, envy and substitutional rancour, but rather through the generosities of difference, tolerance and critical visual and textual pleasure.

Barbara Kruger and Anders Stephanson, extracts from interview, *Flash Art International*, no. 136 (October 1987) 55–9.

Laura Mulvey
A Phantasmagoria of the Female Body: The Work of Cindy Sherman//1991

When I was in school I was getting disgusted with the attitude of art being so religious or sacred, so I wanted to make something which people could relate to without having read a book about it first. So that anybody off the street could appreciate it, even if they couldn't fully understand it; they could still get something out of it. That's the reason why I wanted to imitate something out of the culture, and also make fun of the culture as I was doing it.
– Cindy Sherman[1]

Cindy Sherman had a full-scale retrospective at the Whitney Museum of American Art in 1987 and has recently had work on display at the Saatchi Gallery in London [1991]. At a moment when the art market is rippling with the fallout from the Saatchis' recent decision to sell some conceptual and postmodern work in order to invest in late modernism, this location is a sign of her economic as well as her critical standing. Her art is certainly postmodern. Her works are photographs; she is not a photographer but an artist who uses photography. Each image is built around a photographic depiction of a woman. And each of the women is Sherman herself, simultaneously artist and model, transformed, chameleon-like, into a glossary of pose, gesture and facial expression. As her work developed between 1977 and 1987 a strange process of metamorphosis took place. Apparently easy and accessible postmodern pastiche underwent a gradual transformation into difficult, but still accessible, images that raise serious and challenging questions for contemporary feminist aesthetics. And the metamorphosis provides a hindsight that then alters the significance of her early production. In order to work through the critical implications of this altered perspective, it is necessary to fly in the face of Sherman's own expressly non-, even anti-, theoretical stance. Paradoxically, it is because there is no explicit citation of theory in the work, no explanatory words, no linguistic signposts, that theory can come into its own. Sherman's work stays on the side of enigma, but as a critical challenge not as insoluble mystery. Figuring out the enigma, deciphering its pictographic clues, applying the theoretical tools associated with feminist aesthetics, is – to use one of her favourite words – fun, and draws attention to the way theory, decipherment and the entertainment of riddle- or puzzle-solving may be connected.

A New Politics of the Body

During the 1970s, feminist aesthetics and women artists contributed greatly to the questioning of two great cultural boundary divisions. Throughout the twentieth century, inexorably but discontinuously, pressure had been building up against the separation of art theory from art practice on the one hand, and the separation between high culture and low culture on the other. The collapse of these divisions, crucial to the many and varied components of postmodernism, was also vital to feminist art. Women artists made use of both theory and popular culture through reference and quotation. Cindy Sherman, first showing work in the late 1970s, used popular culture as her source material without using theory as commentary and distanciation device. When her photographs were first shown, their insistent reiteration of representations of the feminine, and her use of herself as model, in infinite varieties of masquerade, won immediate attention from critics who welcomed her as a counterpoint to feminist theoretical and conceptual art. The success of her early work, its acceptance by the centre (the art market and institutions) at a time when many artists were arguing for a politics of the margins, helped to obscure both the work's interest for feminist aesthetics and the fact that the ideas it raised could not have been formulated without a prehistory of feminism and its theorization of the body and representation. Sherman's arrival on the art scene certainly marks the beginning of the end of that era in which the female body had become, if not quite unrepresentable, only representable if refracted through theory. But rather than sidestepping, Sherman reacts and shifts the agenda. She brings a different perspective to the 'images of women question' and recuperates a politics of the body that had, perhaps, been lost or neglected in the twists and turns of seventies feminism.

In the early 1970s, the women's movement claimed the female body as a site for political struggle, mobilizing around abortion rights, above all, but with other ancillary issues spiralling out into agitation over medical marginalizarion and sexuality itself as a source of women's oppression. A politics of the body led logically to a politics of representation of the body. It was only a small step to include the question of images of women in the accompanying debates and campaigns, but it was a step that also moved feminism out of familiar terrains of political action onto that of political aesthetics. And this small step called for a new conceptual vocabulary and opened feminist theory up to the influence of semiotics and psychoanalysis. The initial idea that images contributed to women's alienation from their bodies and from their sexuality, with an attendant hope of liberation and recuperation, gave way to theories of representation as symptom and signifier of the way problems posed by sexual difference under patriarchy could be displaced onto the feminine.

Not surprisingly, this kind of theoretical/political aesthetics also affected artists working in the climate of seventies feminism, and the representability of the female body underwent a crisis. At one extreme, the filmmaker Peter Gidal said in 1978 'I have had a vehement refusal over the last decade, with one or two minor aberrations, to allow images of women into my films at all, since I do not see how those images can be separated from the dominant meanings.'[2] Women artists and filmmakers, while rejecting this wholesale banishment, were extremely wary about the investment of 'dominant meanings' in images of women; and while feminist critics turned to popular culture to analyse these meanings, artists turned to theory, juxtaposing images and ideas, to negate dominant meanings and, slowly and polemically, to invent different ones. Although in this climate Cindy Sherman's concentration on the female body seemed almost shocking, her representations of femininity were not a return, but a re-representation, a making strange.

A visitor to a Cindy Sherman retrospective, who moves through the work in its chronological order, must be almost as struck by the dramatic nature of its development, as by the individual, very striking, works themselves. It is not a question of observing an increasing maturity, a changed style, or new directions, but of following a certain narrative of the feminine from an initial premiss to its very end. And this development takes place over ten years, between 1977 and 1987. The journey through time, through the work's chronological development, is also a journey into space. Sherman dissects the phantasmagoric space conjured up by the female body, from its exteriority to its interiority. The visitor who reaches the final images and then returns, reversing the order, finds that with the hindsight of what was to come, the early images are transformed. The first process of discovery, amusement and amazement is completed by a new curiosity, reverie and decipherment. And then, once the process of bodily disintegration is established in the later work, the early, innocent, images acquire a retrospective uncanniness. [...]

Fifties America: The Democracy of Glamour
By referring to the fifties in her early work, Sherman joins many others in identifying Eisenhower's America as the mythic birthplace of postmodern culture. Reference to the fifties invokes the aftermath of the Korean War and the success of the Marshall Plan, American mass consumption and the 'society of the spectacle'; a time when, in the context of the Cold War, advertising, movies and the actual packaging and seductiveness of commodities all marketed glamour. Glamour proclaimed the desirability of American capitalism to the outside world and, inside, secured American-ness as an aspiration for the newly suburbanized, white, population as it buried incompatible memories of

immigrant origins. In Sherman's early photographs, connotations of vulnerability and instability flow over on to the construction and credibility of the wider, social masquerade. The image of fifties-ness as a particular emblem of American-ness, also masks the fact that it was a decade of social and political repression while profound change gathered on the horizon – the transition, that is, from Joe McCarthy to James Dean. Rather than simply referring to 'fifties-ness' in nostalgia mode, Sherman hints at a world ingesting the seeds of its own decay. She is closer, therefore, to *Blue Velvet* than to *American Graffiti*.

It is interesting, in the light of the American postmodern citation of the fifties, to consider the pivotal place occupied by Marilyn Monroe, as an icon in her own right, and as source of all the subsequent Marilyn iconography, kept alive by gay subculture, surfacing with Debbie Harry in the late seventies and perpetuated by Madonna in the eighties (particularly, of course, her 'Material Girl'). In 1982 Cindy Sherman appeared on the cover of the Anglo-American avant-garde magazine *ZG*. She is immediately recognizable as Marilyn Monroe, in cover-girl pose. She is not the Marilyn of bright lights and diamonds, but the other, equally familiar, Marilyn in slacks and a shirt, still epitomizing the glamour of the period, hand held to thrown-back head, eyes half closed, lips open. But refracted through Sherman's masquerade, Marilyn's masquerade fails to mask her interior anxiety, and unhappiness seems to seep through the cracks. America's favourite fetish never fully succeeded in papering over her interiority, and the veil of sexual allure now seems, in retrospect, to be haunted by death.

Cindy Sherman's impersonations predate, and in some ways prefigure, those of Madonna. Madonna's performances make full use of the potential of cosmetics. As well as fast changing her own chameleon-like appearance on a day-to-day basis, she performs homages to the artificial perfection of the movie stars and also integrates the 'oscillation effect' into the rhythm of her videos, synchronizing editing, personality change and sexual role reversals. Although Madonna, obviously, does not follow the Cindy Sherman narrative of disintegration, her awareness of this, other, side of the topography of feminine masquerade is evidenced in her well-documented admiration for Frida Kahlo. Frida depicted her face, in an infinite number of self- portraits, as a mask, and veiled her body in elaborate Tehuana dresses. Sometimes the veil falls, and her wounded body comes to the surface, condensing her real, physical, wounds with both the imaginary wound of castration and the literal interior space of the female body, the womb, bleeding, in her autobiographical painting, from miscarriage. Frida Kahlo's mask was always her own. Marilyn's was like a trademark. While Cindy Sherman and Madonna shift appearance into a fascinating debunking of stable identity, Marilyn's masquerade had to be always absolutely identical. Her features were able to accept cosmetic modelling into an

instantly recognizable sign of 'Marilyn-ness'. But here, too, the mask is taut, threatened by the gap between public stardom and private pressures (as was the case for everyone caught in the Hollywood Babylon of the studio system's double standards) and also by the logic of the topography itself.

In becoming the democracy of glamour, fifties America completed a process, through the movies and through mass-produced clothes and cosmetics, that had been launched in the thirties and interrupted by the Second World War. It was also a paradigmatic moment for commodity fetishism. Baudrillard has noted the origin of the word 'fetish' in the Portuguese *feitiço*, derived from the Latin *factitius*: 'From the same root (*facio*, *factitius*) as *feitiço* comes the Spanish *afeitar*: "to paint, to adorn, to embellish" and *afeite* "preparation, ornamentation, cosmetics".'[3] He suggests that this etymology from the artificial and the cosmetic implies a homology between the fetishized figure of bodily beauty and the fetishism of the commodity. The commodity, too, is haunted by the gap between knowledge and belief. By exploiting the gap between knowledge and belief, inherent in the complexity of value, the commodity can erase its origin in the labour of the working class, at the production line, and turn a phantasmatic, cosmetic, face to the world. And, as feminists have so often noted, the seal and guarantee of its success in the market place is so often the veneer of sexualized glamour generated by juxtaposition to the sexualized glamour of femininity in advertising. Although Cindy Sherman's work is not about the commodity, the citation of the fifties brings to mind this complex network of homologies. The failure of the fetish, which she traces through images of the feminine, is similar to the polarization of gloss in the shop window, and disavowals of the factory that flourish when society cannot find a way of narrating the contradictions in its history.

In refusing the word/image juxtaposition, so prevalent in the art of the seventies and eighties, Sherman may draw the accusation that she is, herself, stuck in the topographic double bind of the fetish and its collapse. Although she may be thus unable to inscribe the means of decipherment into the work itself, her use of *Untitled* to describe her works turns inability into refusal. Her work does, however, vividly illustrate the way that the human psyche thrives on the division between surface and secret, and that, standing for repression of all kinds, this recurring spatial metaphor cannot be swept away. The wordlessness and despair in her work represents the wordlessness and despair that ensues when a fetishistic structure, the means of erasing history and memory, collapses, leaving a void in its wake. The fetish necessarily wants history to be overlooked. That is its function. The fetish is also a symptom, and as such has a history which may be deciphered, but only by refusing its phantasmatic topography. Freud described the structure of the psyche through spatial metaphor to convey the

burying action of repression, but he analysed the language of the unconscious, its formal expression in condensation and displacement, in terms of signification and decipherment. In the last resort, decipherment is dependent on language. The complete lack of verbal clues and signifiers in Cindy Sherman's work draws attention to the semiotic that precedes a successful translation of the symptom into language, the semiotic of displacements and fetishism, desperately attempting to disguise unconscious ideas from the conscious mind. She uses iconography, connotation, or the sliding of the signifier, in a trajectory that ends by stripping away all accrued meaning to the limit of bodily matter. However, even this bedrock – the vomit and the blood for instance – returns to cultural significance: that is, to the difficulty of the body, and above all the female body, while it is subjected to the icons and narratives of fetishism.

1 Cindy Sherman, statement cited in Sandy Nairne, *State of the Art: Ideas and Images in the 1980s* (London: Chatto & Windus, 1987) 132.

2 From the discussion that follows Peter Gidal, 'Technology and Ideology in/through/and Avant-Garde Film: An Instance', in Teresa de Lauretis and Stephen Heath, eds, *The Cinematic Apparatus* (London: Macmillan, 1980) 169.

3 [footnote 8 in source] Jean Baudrillard, *For a Critique of the Political Economy of the Sign* (1972); trans. Charles Levin (St. Louis: Telos Press, 1981) 91.

Laura Mulvey, extracts from 'A Phantasmagoria of the Female Body: The Work of Cindy Sherman', *New Left Review* (July–August 1991) 137–9; 148–50. A revised version of this essay was published as 'Phantasmagoria of the Female Body', in *Cindy Sherman* (Paris: Musée national du Jeu de Paume/Flammarion, 2006).

Deborah Cherry
Maud Sulter: *Zabat* (1989)//2003

Like many contemporary women artists, Maud Sulter has deployed herself as a model. In *Zabat* of 1989 she appears as *Calliope*, the centrepiece of an installation of nine Cibachrome images, each depicting one of the Muses. Conventionally imaged in the history of Western art as white women, they are here portrayed by Black women writers, artists, musicians and strategists. These are sumptuous, densely layered and strikingly beautiful images, created with the input of the photographer and the sitters and so transforming the conventionally hierarchical relations between the artist and model. Several figures are easily recognizable. Carrying an overflowing cascade of flowers, Alice Walker is *Phalia*,[1] the muse of comedy. The artist Lubaina Himid is imaged as *Urania*, the muse of astrology. The singer Ysaye Maria Barnwell is *Polyhymnia*, the muse of sacred song. Far exceeding the personage who haunts the frame, sitter and figure supplement one another as model and Muse, uncannily oscillating between presence and absence, present and mythical past, in a manner akin to Derrida's 'double session' not so much of inscription, in which, as he argues, any writing goes over its own mark with an 'undecidable stroke,' as a moment when several nor necessarily compatible meanings double upon one another.[2] For the centrepiece of the series the artist (who is, it will be remembered, also a published poet) both becomes and is possessed by the muse of epic poetry. Staged as if in a nineteenth-century portrait photographer's studio, placed on a table are a pair of framed daguerreotypes, diminutive by comparison to the majestic figure of Calliope, wrapped in velvet and rapt in thought. At one level, *Calliope* is the artist's address to the sexualization, marginalization and disappearance of Jeanne Duval, known in literary history only as the mistress of Charles Baudelaire and in Félix Nadar's photographic albums as 'unknown woman,' and to photography's history in the West which, she has argued, was intimately connected to economic, sexual and racial exploitation. 'Its birth pangs ran concurrent with the abolition of slavery and many of the uses to which it was first put was that of categorizing the "other".' But, she continues, as relations of power are not fixed but subject to change, photography can explore 'an area as volatile and so at the centre of our renaming as blackwoman's passion'.[3]

Yet *Zabat* is far more than a response. Each image encased in an ornate gold frame of the kind used for nineteenth-century academic painting, the series as a whole sets up a powerful force field which confronts the portrayals of women of

colour as either liminal, almost unseen forms or as figures of a highly sexualized desire. Its powerful challenge is as much to popular culture as to the elite forms of Western art. *Zabat* participated in a growing urgency to make imposing images which vigorously opposed and critiqued visual stereotypes. This imperative was voiced by Lubaina Himid in 1987, the year of her retrospective exhibition, *New Robes for MaShulan*, in which she showed larger-than-life painted and collaged cut-out figures: 'I make images of blackwomen because there are not enough of them ... I want to change the order of things and take back the art which has been stolen. I am only interested in painting blackwomen as independent, strong, thinking people.'[4] The recasting of the Muses recalls the great library of the 'Shrine of the Muses' at Alexandria which was burnt and destroyed with the rise of Christianity in Egypt. A work of imaginative re-collection, *Zabat* is as much about remembrance, for the muses were daughters of Mnemosyne, or Memory.

1 Reference is made to Alice Walker, *In Search of Our Mothers' Gardens: Womanist Prose* (London: Harvest Books, 1984).

2 Jacques Derrida, *La Dissemination* (Paris, 1972); trans. Barbara Johnson as *Dissemination*, (Chicago: Chicago University Press, 1981) 193.

3 Maud Sulter, 'The Nature of Photography: Black Notes from the Underground', *Feminist Arts News*, vol. 3, no. 1 (1989) 12–14.

4 Lubaina Himid, 'We Will Be', in Rosemary Betterton, ed., *Looking On: Images of Femininity in the Visual Arts and Media* (London and New York: Pandora Press, 1987).

Deborah Cherry, 'Deborah Cherry on Zabat', in *Jeanne Duval: A Melodrama* (Edinburgh: National Galleries of Scotland, 2003) 51–2.

A SORT OF MENTA
L ENVELOPE IN T
HE MIDDLE OF WH
ICH OUR WORLD W
ILL BE BUILT IN
FULL CONSCIOUSN
ESS OF THE OUTE
R WORLD

Jean Bernabé, Patrick Chamoiseau and Raphaël Confiant, *Éloge de la créolité*, 1989

POSTCOLONIALISM

Malek Alloula The Colonial Harem, 1981//128
Kobena Mercer Maroonage of the Wandering Eye:
 Keith Piper, 1996//131
Jorma Puranen Imaginary Homecoming, 1999//135
Okwui Enwezor *Créolité* and Creolization, 2002//137
Robert Fisk Retaking Iwo Jima (Tehran 1979), 2005//139

Malek Alloula
The Colonial Harem//1981

The Orient as Stereotype and as Phantasm

Arrayed in the brilliant colours of exoticism and exuding a full-blown yet uncertain sensuality, the Orient, where unfathomable mysteries dwell and cruel and barbaric scenes are staged, has fascinated and disturbed Europe for a long time. It has been its glittering imaginary but also its mirage.

Orientalism, both pictorial and literary, has made its contribution to the definition of the variegated elements of the sweet dream in which the West has been wallowing for more than four centuries. It has set the stage for the deployment of phantasms.

There is no phantasm, though, without sex, and in this Orientalism, a confection of the best and the worst – mostly the worst – a central figure emerges, the very embodiment of the obsession: the harem. A simple allusion to it is enough to open wide the floodgate of hallucination just as it is about to run dry.

For the Orient is no longer the dreamland. Since the middle of the nineteenth century, it has inched closer. Colonialism makes a grab for it, appropriates it by dint of war, binds it hand and foot with myriad bonds of exploitation, and hands it over to the devouring appetite of the great mother countries, ever hungry for raw materials.

Armies, among them the one that landed one fine 5 July 1830 a little to the east of Algiers, bring missionaries and scholars with their impedimenta as well as painters and photographers forever thirsty for exoticism, folklore, Orientalism. This fine company scatters all over the land, sets up camp around military messes, takes part in punitive expeditions (even Théophile Gautier is not exempt), and dreams of the Orient, its delights and its beauties.

What does it matter if the colonized Orient, the Algeria of the turn of the century, gives more than a glimpse of the other side of its scenery, as long as the phantasm of the harem persists, especially since it has become profitable? Orientalism leads to riches and respectability. Horace Vernet, whom Baudelaire justly called the Raphael of barracks and bivouacs, is the peerless exponent of this smug philistinism. He spawns imitators. Vulgarities and stereotypes draw upon the entire heritage of the older, precolonial Orientalism. They reveal all its presuppositions to the point of caricature.

It matters little if Orientalistic painting begins to run out of wind or falls into mediocrity. Photography steps in to take up the slack and reactivates the phantasm at its lowest level. The postcard does it one better; it becomes the

poor man's phantasm: for a few pennies, display racks full of dreams. The postcard is everywhere, covering all the colonial space, immediately available to the tourist, the soldier, the colonist. It is at once their poetry and their glory captured for the ages; it is also their pseudo-knowledge of the colony. It produces stereotypes in the manner of great seabirds producing guano. It is the fertilizer of the colonial vision.

The postcard is ubiquitous. It can be found not only at the scene of the crime it perpetrates but at a far remove as well. Travel is the essence of the postcard, and expedition is its mode. It is the fragmentary return to the mother country. It straddles two spaces: the one it represents and the one it will reach. It marks out the peregrinations of the tourist, the successive postings of the soldier, the territorial spread of the colonist. It sublimates the spirit of the stop-over and the sense of place; it is an act of unrelenting aggression against sedentariness. In the postcard, there is the suggestion of a complete metaphysics of uprootedness.

It is also a seductive appeal to the spirit of adventure and pioneering. In short, the postcard would be a resounding defence of the colonial spirit in picture form. It is the comic strip of colonial morality.

But it is not merely that; it is more. It is the propagation of the phantasm of the harem by means of photography. It is the degraded, and degrading, revival of this phantasm.

The question arises, then, how are we to read today these postcards that have superimposed their grimacing mask upon the face of the colony and grown like a chancre or a horrible leprosy?

Today, nostalgic wonderment and tearful archaeology (Oh! those colonial days!) are very much in vogue. But to give in to them is to forget a little too quickly the motivations and the effects of this vast operation of systematic distortion. It is also to lay the groundwork for its return in a new guise: a racism and a xenophobia titillated by the nostalgia of the colonial empire.

Beyond such barely veiled apologias that hide behind aesthetic rationalizations, another reading is possible: a symptomatic one.

To map out, from under the plethora of images, the obsessive scheme that regulates the totality of the output of this enterprise and endows it with meaning is to force the postcard to reveal what it holds back (the ideology of colonialism) and to expose what is repressed in it (the sexual phantasm).

The Golden Age of the colonial postcard lies between 1900 and 1930. Although a latecomer to colonial apologetics, it will quickly make up for its belatedness and come to occupy a privileged place, which it owes to the infatuation it elicits, in the preparations for the centennial of the conquest, the apotheosis of the imperial epoch.

In this large inventory of images that History sweeps with broad strokes out

of its way, and which shrewd merchants hoard for future collectors, one theme especially seems to have found favour with the photographers and to have been accorded privileged treatment: the *algérienne*.

History knows of no other society in which women have been photographed on such a large scale to be delivered to public view. This disturbing and paradoxical fact is problematic far beyond the capacity of rationalizations that impute its occurrence to ethnographic attempts at a census and visual documentation of human types.

Behind this image of Algerian women, probably reproduced in the millions, there is visible the broad outline of one of the figures of the colonial perception of the native. This figure can essentially be defined as the practice of a right of (over)sight that the colonizer arrogates to himself and that is the bearer of multiform violence. The postcard folly partakes in such violence; it extends its effects; it is its accomplished expression, no less efficient for being symbolic.

Moreover, its fixation upon the woman's body leads the postcard to paint this body up, ready it, and eroticize it in order to offer it up to any and all comers from a clientele moved by the unambiguous desire of possession,

To track, then, through the colonial representations of Algerian women – the figures of a phantasm – is to attempt a double operation: first, to uncover the nature and the meaning of the colonialist gaze; then, to subvert the stereotype that is so tenaciously attached to the bodies of women.

A reading of the sort that I propose to undertake would be entirely superfluous if there existed photographic traces of the gaze of the colonized upon the colonizer. In their absence, that is, in the absence of a confrontation of opposed gazes, I attempt here, lagging far behind History, to return this immense postcard to its sender.

What I read on these cards does not leave me indifferent. It demonstrates to me, were that still necessary, the desolate poverty of a gaze that I myself, as an Algerian, must have been the object of at some moment in my personal history. Among us, we believe in the nefarious effects of the evil eye (the evil gaze). We conjure them with our hand spread out like a fan. I close my hand back upon a pen to write *my* exorcism: *this text.*

Malek Alloula, extract from *The Colonial Harem*, trans. Myrna Godzich and Wlad Godzich (Minneapolis: University of Minnesota Press, 1986) 3–5 [footnotes not included].

Kobena Mercer
Maroonage of the Wandering Eye: Keith Piper//1996

Keith Piper became the history painter of post-imperial Britain. Considering that History was officially abolished with the advent of the postmodern, one might wonder what remained for artists to represent. When social bonds disintegrate between market space and the security state, all that seems to be left are the visible traces of disappearance and absence – the social body feels abandoned by its narratives of manifest destiny and lies shivering in the shopfronts of national glory, naked beneath its filthy blankets piled up by the debris of Empire's loss and ruination. But even if they have lost it now, did the British ever really have a national identity in the first place?

Tom Nairn remarked that if there was such a deep-seated confidence about the coherence of the nation's identity, then why does this country have not just one name but three? Great Britain, United Kingdom and England.[1] While the answer lies, in part, in the discrepancy between the citizenship rights conferred by the nation state and the more nebulous ties of cultural kinship and ethnic exclusivity that draw upon the language of 'race' to define the limits of its membership, the break-up of any unifying narrative of imagined community has brought to light the jagged and volatile sediment out of which Britishness has been historically composed. Across some fifteen years of practice, Keith Piper has established himself as one of the most important British artists of our time by virtue of his ability to journey through the densely compacted layers of collective cultural history and bring back fresh insights into the social and emotional realities of the images and symbols through which political identities come into existence, and through which they also depart from it.

From early paintings, such as *The Body Politic* (1982) and *The Four Horsemen of the Apocalypse* (1986), through image-text work such as *Go West Young Man* (1988), to such multi-media installations as *A Ship Called Jesus* (1991), *Step Into the Arena* (1992) and *The Exploded City* (1994), Piper's oeuvre bears witness to a Britain becoming other to what it always thought it was. His gift to the nation is to offer an alternate vantage point for a conversation about this time of crossroads we are passing through. If there is 'no future' in 'England's dreaming', as the Sex Pistols once told us, then Piper's work draws upon the 'double consciousness' of a diaspora formation to pierce the consensual hallucination of a homogeneous past and to activate the lived experience of uncertainty in the present as a compass with which to navigate a middle passage through our ambivalent age of extremes.

The computer-generated images commissioned for *Portfolio* [magazine] invite further travels into the fossilized coils of the national imaginary, whose legacy Piper has been exploring with digital technologies in such multi-media installations as *Surveillances (Tagging the Other)* (1991) and *Long Journey* (1995). The works offer a distillation of three overlapping strands that have consistently featured in his projects: a concern with unravelling the constituitive role of representation in the West's 'racializing' perceptions of difference; how the black body thus comes to be visually produced as both an object of fear and fantasy and as a site of colonial power and knowledge; and an interest in the political consequences of such fantasia in disciplinary practices of policing urban space, which seek to control that excess or surplus of symbolism with which the 'otherness' of the black male body has been historically burdened. Captioned by click-on commands, the densely textured palimpsest of each triptych encapsulates Piper's archaeological methodology, for through the windows of the new technologies of the future we are confronted with the saturated residue of the nation's visual archive buried in the imperial past.

Invoking the fragmentation of the colonized subject into body-parts under the master-gaze of Europe's anthropometric photography, the works feature a hand holding a magnifying lens that shows a brain-scan pattern which in turn illuminates a black male profile of a computer-generated photo-fit. Implying the incontestable evidence of the body's biological 'truth' when perceived through the optics of science, the juxtaposition suggests how the body remains the fixed locus of a racist fantasy that wants to 'see' the signs of absolute difference – moving from the outer surface of skin and bones to the interior map of brain-wave activity now that biological determinism is officiaily discredited (even though, as the recent 'bell curve' controversy in the United States attests, such absolutist fantasies are not altogether widely repudiated).

Collage has been the premise for Piper's practice of art and politics from the very start, and far from being didactic or accusative, the seductive fluidity of the lines of inquiry he opens up within the frayed text of his polysemic sources implicates the viewer's self-positioning in a subversive effect of de-suturing, unstitching the identifications that bind us to genealogies we do not yet know. Hence, quoting the allegorical 'Africa' from William Theed's Hyde Park *Prince Albert Memorial* (1872), the images induce the eye to explore unanticipated art historical connections by setting up a puzzle of sensual colour and detail that reveals the compositional unity of the piece.

Arms, hands, fingers and a book's spine enjoin the gaze to pass through multiple viewing planes which are aligned around the gesture of contact signifying England's 'civilizing mission', which is quoted from Thomas Jones Barker's painting *Queen Victoria Presenting a Bible in the Audience Chamber at*

Windsor (*c.* 1861) – a work quite literally dredged up from the vaults and recently shown at London's Tate Gallery in 'Picturing Blackness in British Art'. As Paul Gilroy commented, in the context of that exhibition, 'The changing perception of blackness and Britishness ... is not a minority issue. It is an essential ingredient in the development of a sense of nationality free of 'racial' division, [which] is an urgent goal for us all'.[2] And it is for this very reason, considering the generosity of his contribution to this process, that Piper may be regarded as a history painter of the postcolonial de-coupling of nationality and ethnicity. A painter – not on account of his chosen medium, for he is happy to move and migrate across generic boundaries of representation – but by virtue of a methodology that refuses to flinch from the obstinate and vexing questions of our troubled relationship to the memories, narratives and myths that constitute the collective past. For the notion of modernity itself is precisely about an unstable relation to the past that cannot be fixed, guaranteed or agreed upon and which is in a condition of permanent contestation at the level of representation or, as the Martinican writer, Édouard Glissant, puts it: 'It seems that at least one of the components of "our" modernity is the spread of the awareness we have of it. The awareness of our awareness (the double, the second degree) is our source of strength and our torment.'[3]

Piper has never wished to apologise for his passionate interest in the political. What is most political about his project is how Piper critically positions himself in relation to a subaltern's understanding of history, not as a grand-narrative of progress in which an abstract ideal awaits fulfilment, but as an errant wandering of bodies and flows passing through chance, accident and material circumstance to make themselves anew. It is a conception of history strongly associated with Caribbean writers and intellectuals such as Wilson Harris, Frantz Fanon and Derek Walcott, for whom the Atlantic triangle maps a space of becoming in which the unrecoverable trauma of lost origins is tragic only when it is experienced as the deprivation of a fixed destiny – alternatively, diaspora opens opportunities to exert freedom and responsibility by making a 'home' for subjectivity in the space and time of its own choosing.

Aquatic imagery has antecedents in cultural conceptions of time that go back to Heraclitus and his image of a river that never passes the same point twice. Yet when Walcott invokes 'history is sea', or Harris recounts his voyage on Guyana's Tumatumari falls when a near-death encounter erupts with the 'angelic, terrifying, daemonic phantoms and figures of my own antecedents – the Amerindian/Arawak ones', it is this Caribbean-inflected experience of submarine memory and ex-isle consciousness that we see reworked in Keith Piper's meditations on mourning and moving on in one of his major works, *A Ship Called Jesus.*

'Only a dialogue with the past can produce originality,' argued Wilson Harris, in elaborating his notion of 'fossil identities', that is, the view that insights into futural possibilities arise from a journey into the past that seeks to liberate ancestral memories from historical erasure, in a search not for the end of history, but for the chance to begin again.[4] Glissant, in turn, coaxes the verb *maroonage* out of the story of the Maroons – who sought lines of flight out of plantation space by escaping to the hillside forests of Haïti, Cuba and Jamaica and whose resistance defiantly turned away from the frontiers of the nation-state – to describe the cross-cultural dynamics of a Creole aesthetic of migration and translation that found fertile soil in the ruins of European decline that were implanted in the Americas. In the sense that Piper practices a visual maroonage that steals away fresh insights from the archival sources which his work draws upon, in order to enable his audiences to imagine how a changed relation to the past might reconfigure present-day predicaments, his art offers much to 'this island race'. England, or Britain, or this medium-sized offshore enterprise called UK Ltd, has already become something Other than it was, and would recognize as much in Piper's art should it wake up from the sleep of History to walk about and look and see.

1 Tom Nairn, *The Break-Up of Britain. Crisis and Neo-Nationalism*, 2nd ed. (London and New York, Verso, 1981).

2 Paul Gilroy, booklet essay, *Picturing Blackness in British Art: 1700s–1990s* (London: Tate Gallery, 1995).

3 Édouard Glissant, 'Cross-Cultural Poetics', *Caribbean Discourse: Selected Essays* (Charlottesville: University of Virginia, 1992) 151.

4 Wilson Harris, cited in Kirsten Holst Petersen and Anna Rutherford, 'Fossil and Psyche', in *The Post-Colonial Studies Reader*, ed. Bill Ashcroft, Gareth Griffiths and Helen Tiffin (London and New York: Routledge, 1995) 185.

Kobena Mercer, 'Maroonage of the Wandering Eye: Keith Piper', *Portfolio*, no. 23 (June 1996) 54–5.

Jorma Puranen
Imaginary Homecoming//1999

In the spring of 1988, I visited Nils-Aslak Valkeapää in Pättikkä, near Enontekiö, in Finnish Lapland. He showed me a series of black-and-white photographs, portraits of Sámi people, which he used in his book *Beaivi Áhcázan* (*The Sun My Father*). It was obvious to me that these exceptionally beautiful pictures were taken by a skilled portraitist, and I learned that Valkeapää had discovered them in the Musée de L'Homme, Paris. When I happened to be in Paris myself, to satisfy my curiosity, I visited the picture archive at the museum. The pictures had been taken in 1884, during Prince Roland Bonaparte's expedition to Lapland, by a French photographer called G. Roche. The resulting collection in the Musée de L'Homme comprises some 400 negatives, 250 of them portraits.

Working in a photographic archive is a strange experience: you are faced with boxes and boxes of images of dead people, even entire nations. At times, these material objects – faded, ripped and worn-out photographs of people long deceased – become vivid and strongly present. Some faces look familiar, as though one had seen them in other archives or on the pages of books. The faces are either unnamed or accompanied with careless translations and, frequently, misunderstandings.

Identifying and locating the people photographed by Bonaparte's expedition was eased by the thorough notes that survive. Many of the surnames sounded familiar: the sitters were evidently ancestors of the various families that I had got to know in Lapland in the course of two decades of work there. During this and subsequent visits to the archive at the Musée de L'Homme, I developed a strong need to make something of the images recorded by Bonaparte's expedition. Although I also used numerous other sources, the Paris collection provided the foundation for the project that became *Imaginary Homecoming*.

Imaginary Homecoming concerns temporal and spatial distance. On the one hand, a museum located at the Place du Trocadéro; on the other, the expansive fells of the province of Finnmarken in Norway. The present is juxtaposed with the year 1884. *Imaginary Homecoming* attempts a dialogue between the past and the present; between two landscapes and historical moments, but also between two cultures. To bridge this distance, I tried to return those old photographs to their source, restoring the representations to the place where they originated, and from where they had been severed. To achieve this metaphorical return, I began by rephotographing the images of the Sámi. I developed them on graphic film and mounted them on acrylic boards, which I

arranged in the landscape where they had once been taken. I worked on the pictures included in *Imaginary Homecoming* between 1991 and 1997.

My understanding of the northern landscape was much improved by many long and illuminating discussions with local people such as Ánne and Per Simma from the villages of Karesuando and Idivuoma in Sweden, and Martta Orttonen, who was born in the Sámi community of Kildin, south-east of the Russian city of Murmansk. These conversations on landscape, history and photography represent one of the starting points from which this project sets out. Indeed, subtle visual perceptions and inferences represent a crucial source of information in the Sámi world. However, transforming the resulting information into comprehensible visual form finally entails spending time in the landscape: letting one's eyes linger in the distance, in the wind and the rain; among the sounds of the animals. As Simon Schama writes, to experience 'a sense of place', we must above all use 'the archive of the feet'.

A landscape is speechless. Day by day, its only idiom is the sensory experience afforded by the biological reality, the weather conditions, and the actions that take place in the environment. However, we can also assume that a landscape has another dimension: the potential but invisible field of possibilities nourished by everyday perceptions, lived experiences, different histories, narratives and fantasies. In fact, any understanding of landscape entails a succession of distinct moments and different points of view. The layeredness of landscape, in other words, forms part of our own projection. Every landscape is also a mental landscape.

Jorma Puranen, Foreword, *Imaginary Homecoming* (Oulu, Finland: Pohjoinen, 1999) 11.

Okwui Enwezor
Créolité and Creolization//2002

[...] Two points define the theme of [Platform 3: *Créolité and Creolization*, Documenta 11, 2002]. First, in terms of its poetics, *créolité* is to be understood as a critical theory of the creole language, literary form and mode of producing locality. The locality that envelops this language is, of course, the Caribbean. However, this does not capture the entire complexity around which creole is situated, that is, if we extend its geographical character beyond the borders of the Caribbean. But for the moment let us just imagine the Caribbean as the locus of its international projection to other branches of creole linguistics – in Africa, the Indian Ocean Islands, South America, and even the United States. The founding text of this critical theory as a literary form is expressed in a manifesto, *Éloge de la créolité/In Praise of Creoleness*, published in 1989 by three Martinican intellectuals, Jean Bernabé, Patrick Chamoiseau and Raphaël Confiant. In their controversial text, the three writers underline their intervention: firstly, by furnishing it with a name; and secondly, by designating its intertextual dimension as 'a sort of mental envelope in the middle of which our world will be built in full consciousness of the outer world'.[1] In this 'mental envelope', the writers conceive of their cultural world as emerging out of the world of colonial domination into one of '*non-totalitarian consciousness of a preserved diversity* [italics in original]'.[2] The critical gesture and expression of this diversity is at the heart of the radical discourse of *créolité*, especially as it concerns the question of what it means to live and work from the polycentrism of the Caribbean. In this context Creoleness emerges in the scissions and agglutinations forged in the contact zone of its historical transmission, i.e., 'Creoleness [as] the *interactional or transactional aggregate* of Caribbean, European, African, Asian and Levantine cultural elements, united on the same soil by the yoke of history.'[3]

The second part of the thematic is concerned with defining creolization as a process of emergence of a world culture conceived from the perspective of radical cultural and situational flux. More than five hundred years separates us from the first arrival of slaves in the New World. Slavery and colonialism as the Janus-faced projects of European imperialism and the global institutionalization of capitalism today define an array of configurations through which to understand the paradigms of mixing and hybridization that underpin such concepts as modern culture, identity formation, language, ethnicity and race. Creole societies have their roots in the institutions of slavery and colonialism

and mark the intersections where modern subjectivity and historical processes meet. In recent years, through waves of migration and displacements, creolization has emerged as a dominant modality of contemporary living practices, shaping patterns of dwelling that are crossed and differentiated by massive flows of images and cultural symbols expressed through material culture and language.

Equally, the intersections of modern subjectivity and the historical consciousness that it circumscribes are never smooth. They come out of uneven, and often violent, encounters, and in patterns of articulating and signifying norms of cultural heritage, exchange, difference and resistance strategies seeking to maintain the integrity of non-dominant cultures. If globalization has defined and reworked old circuits of capital, creolization represents its strongest cultural counterpoint. While globalization tends toward consolidation and homogenization, creolization moves towards differentiation and dispersal. Creolization's mode is a 'signifying system through which ... a social order is communicated, reproduced, experienced and explored'.[4] In elaborating its discourse, creolization as a process of transformation of cultural givens subtends its critical fashioning in the Caribbean to involve other areas of its historical manifestation in the Indian Ocean islands of Africa, in South America, the United States, Asia and Europe, and the global world at large. [...]

1 [footnote 18 in source] Jean Bernabé, Patrick Chamoiseau, Raphaël Confiant, *Éloge de la créolité/In Praise of Creoleness,* bilingual edition, English trans. Mohamed B. Taleb-Khyar (Paris: Gallimard, 1993) 75.

2 [19] Ibid., 89.

3 [20] Ibid., 87.

4 [21] Raymond Williams, quoted in Terry Eagleton, *The Idea of Culture* (Oxford: Blackwell, 2000) 33.

Okwui Enwezor, extract from introduction, *Documenta 11* (Ostfildern-Ruit: Hatje Cantz, 2002) n.p.

Robert Fisk
Retaking Iwo Jima (Tehran 1979)//2005

[...] The crowds were strategically placed to catch the television cameras, and journalists were allowed – indeed, encouraged – to approach [the American embassy in Tehran] and stare through the black wrought-iron gates. The hostages locked in the main Embassy buildings – the men with their hands tied – could not be seen, although students had spray-painted slogans on the roof of the reception block. Just inside the forecourt, they now erected a painting 5 metres high, a symbolic work inspired by Joe Rosenthal's photograph of US marines raising the Stars and Stripes on Iwo Jima in 1945; in this case, however, Muslim revolutionaries had replaced the marines and they were struggling to raise a green Islamic flag, one end of which had miraculously turned into a hand strangling the Stars and Stripes. The occupation had thus become theatre, complete with painted scenery. It was more than this. It was a carnival. [...]

Robert Fisk, extract from *The Great War for Civilization: The Conquest of the Middle East* (London: Fourth Estate, 2005) 145.

AS A SOVIET
SPECTATOR I
SAW CAMPBELL
SOUP TINS AND
BRILLO BOXES
FOR THE FIRST
TIME IN ART
BOOKS RATHER
THAN ON THE
SUPERMARKET
SHELF

Boris Groys, Interview with John-Paul Stonard, 2007

POSTCOMMUNISM

Slobodan Mijuskovic Discourse in the Indefinite
 Person, 1987//142
Walter Benjamin Interview with Beti Zerovc, 2006//149
Boris Groys Interview with John-Paul Stonard,
 2007//153

Slobodan Mijuskovic
Discourse in the Indefinite Person//1987

'International Exhibition of Modern Art' (The Salon of the Museum of Contemporary Art, Belgrade, October 1986; the SKUC Gallery, Ljubljana, November/December 1986.)

In the critical and theoretical reflections that accompany recent artistic practice, one could easily notice the strikingly frequent use of terms such as appropriation, repetition, quotation, copying, imitation, simulation, substitution and the like. This alone is a sufficiently telling indication of a change in the state of affairs; the aforementioned terms were not to be found in 'modernist vocabularies', which always insisted on terms such as originality, creativity, innovation, imagination … At the same time, of course, corresponding, characteristic syntagms developed (appropriation art, simulation art, quotational art, substitute painting …) encompassing certain related methods and ways of thinking, operative and conceptual models, and raising them to the semantic level of general tendencies. These, however, do not indicate anything in the nature of trends or movements, let alone styles, in the sense in which they were understood in the era of modernism. Whether we like it or not, the diagnosis towards which many critics incline, the one ascribing to current art 'appropriative mannerism' as one of the very characteristic features of its situation, appears to be sufficiently empirically founded, and therefore cannot be questioned so easily. If, on the other hand, there does, for the most part, exist a consensus on the assumption above, the actual interpretations of its (systematic) implications differ greatly; often occupying the entirely opposite positions of positive and negative judgements. Is current artistic practice no more than a surface-level stirring of the historical humus (Germano Celant), does it merely gather, appropriate, process and repeat the scattered remnants of its own past, in the whirlpool of which it can lose its breath and drown? Is an artist today, as the Italian critic believes, oriented solely towards a passive imitation of the past in order to determine the new as a copy of the new and the old; is he or she really alone in his/her 'art trainer'; has he/she lost his/her own subjectivity and any relation between the subject and the object in this simulated journey? Will this journey take him/her anywhere or will he/she get completely lost in its course, failing to recognize even his/her own image? Or could it be, perhaps, that simulation art does not imply either a continual or a transitory crisis of creativity due to a lack of originality, as Klaus Ottmann

believes? Feeling that we must abandon the modernist concept of extending the avant-garde once and for all, this author states that today, for the first time, we have an art which abandons the positions of nineteenth-century theory and keeps up with the simulative techno-science of today, progressing in a circular or spiral form, rather than a straight line. But irrespective of whether we ascribe a plus or a minus sign to the current situation, the only thing that is certain, as has always been the case with art, is the uncertainty of the outcome; on the other hand, what is certain about this uncertainty is the continuation of the journey, perhaps using a different means of transport and perhaps in a different direction.

Appropriation, of course, is too general a designation to be able to say anything specific about the individual formulations of specific artists. What it points to here is a method (which has always been present in art, after all), a manner which recent art employs to relate to the heritage of its recent or distant past; from this heritage, art now quite freely, without hiding anything and without any feeling of guilt, takes over formal, iconic or conceptual elements which become (the fundamental) constitutive factors of work. Appropriation art does not designate any particular stylistic-linguistic model of strictly defined morphological or syntactic rules, it is a category whose semantic range is very elastic and which can encompass entirely different formal and operative models. In its specific 'discourse' practice, this 'language of appropriation' is therefore used in many stylistic variants. It is, naturally, used in the practice of our [Yugoslavian] artists as well, and in this respect we may say that, more often than not, they have tended to resort to 'repetition with differences', free adaptation and transformation of the units quoted, iconographic or stylistic models, whereas they have rarely resorted to direct appropriation, accurate 'copying', verbatim repetition 'without any difference whatsoever'. The use of this type of statement within the framework of 'the appropriationist rhetoric' characterizes, it would seem to us, the work of the Belgrade artist Goran Djordjevic, who, from 1979 onwards, for the most part without adequate critical reception, has quite self-consciously responded to the challenges of the so-called era of the crisis of the subject, the crisis of the concept of 'the original' and of the artist as 'creator'. In a number of works/projects, which retain the conceptualist features of analyticity and self-reflectivity, he first of all problematizes the phenomenon of the copy and the copy-original relation, provoking a re-examination of some of our established notions and pointing to the need for rethinking the purpose and the meaning of the use of these terms in the context of art. In the final result of his (post)conceptualist speculations, which probably rely on the postulate that two things can never be absolutely identical, or absolutely different for that matter, we may discern the view about an entirely conventional meaning of the original, but before that, we would be

faced with a number of questions. How can we know at all that something is the original and something else a copy? A copy, it would appear to us, presupposes the original, which consequently means that there can be no copy without the original. But if it is not possible to have an absolute original, something which is in each and every detail original, primaeval, unique, does that not mean that it is not possible to have an absolute copy either, for if such a copy did exist, how could we ever recognize it and distinguish it from the original? It appears that a copy simultaneously presupposes and excludes both identity and difference, that it must be, at the same time, identical to and different from the original.

And ... it is as if we were caught up in endless circular motion where we lack the certainty, the finality of the original, something we can use for orientation, something to start from, as if, to use the picturesque description of Thomas McEvilley, the copy and the original were chasing each other in a storm, like two leaves or two snowflakes perpetually changing places. This uncertainty is not at all pleasant. The hypothesis is that we are entering an age when the idea of the original will have no meaning whatsoever, when production and reproduction will have equal status, so that only copies, that is, copies of copies will exist. If this hypothesis is well grounded at all, can we hope that those copies will be at least original? Or is it more acceptable to settle for a compromise projection – that there will exist neither originals nor copies, but something else altogether that should bear a different name? Still, we cannot be quite certain in our assessment of the real meaning of these and similar issues for art today and art in the future. Maybe we shall soon have to admit that these issues were actually merely marginal, that they arose in a transitional era of a certain hiatus or exhaustion, in an era with fundamental doubts as to whether it is still appropriate and meaningful to base any activity, including artistic pursuits, on the concepts of creativity, authenticity, originality, subjectivity, projectivity and the like. Such doubt may very soon appear to have been a passing adventure whose outcome is not inspirational at all.

In the course of the previous year, we were in a position to note several events of this nature, directly reflecting the concept of identity within the framework of the use of 'the discourse of direct appropriation'. The events in question were characterized by a simultaneous appropriation and cancelling of identity; the author did not sign his or her works, wishing to remain unknown. We have in mind here exhibitions like the one held in a private flat in Belgrade under the title of 'The Last Futurist Exhibition of Pictures 0.10' and subsequently at the SKUC Gallery in Ljubljana, then the lecture (held at Cankarjev Dom in Ljubljana) about six paintings by Mondrian, actually copies, which, according to the official announcement, was to be delivered by Walter Benjamin, but was in reality a text written by an unknown author and read by an actor. In the

periodical *Art in America*, we could recently read a text, actually a letter sent from Belgrade and signed K. Malevich; the magazine *POP-lava* published reproductions of three drawings by Duchamp (copies again), which were signed with the initials of the leading protagonist of fauvism and entitled 'The Unknown Henri Matisse'; finally, at the Salon of Belgrade's Museum of Contemporary Art, an exhibition entitled 'International Exhibition of Modern Art' was held towards the end of last year, and was subsequently repeated at the SKUC Gallery in Ljubljana.

In appropriating the name of the well-known Armory Show held in New York in 1913, this last exhibition reveals the idea behind a coherent project which actually follows a traditional principle of composition, individual elements (works) are subordinated to the whole (exhibition), and it is primarily, if not solely, within the framework of that whole that they take on their purpose and meaning. Let us recall Daniel Buren: it is networks of art that are exhibited here; it is the exhibition itself that is exhibited. Individual works, therefore, are of secondary importance, even though they may have their own problematic content (for example, sculpting, that is to say, the manual execution of Duchamp's readymade, or the painting of Kosuth's photographic reproductions of the linguistic definitions of the terms 'painting' and 'idea'). The fifty-odd works, pictures, sculptures and objects, exhibited more in the manner of a museum display than a gallery display, actually represented copies of works of nineteen world-renowned artists, whose names are a must in any history of modern art. The notices accompanying the exhibits contained the correctly written names of the authors (the originals), whereas the years of their making were changed, shifted to the past, present or future, thereby pointing to the transhistorical value of art work in general and at the same time inviting a re-examination of the view about the unconditionally historical determining of developments in art.

Apart from reproductions of copies, the exhibition catalogue, which took over the characteristic graphic design of the Armory Show catalogue, contains one text in the form of an interview; however, there are no indications whatsoever concerning its participants. It is a simulated conversation of unknown subjects, but with a certain amount of effort, it could be established that it was made up of excerpts of the texts, statements and interviews of the artists whose works had been copied. By means of textual retro-montage, fragments of personal statements became elements of a new whole, a new context in which their meanings, often quite directly, refer to the problematic content of the exhibition itself.

It would appear that we should not overlook lightly the possibility that the works presented at this exhibition were not created by one but by two or more

authors, which would make it an unusual collective exhibition. But what could this mean? Also, would we think of this exhibition in a different way if we knew its author or authors? It is as if someone wanted to persuade us that the important thing for us is precisely not to know (or to think as if we did not know) who made those copies. Therefore, we have only the works themselves before us, and we should accept the fact that we can speak of only the works and the exhibition and not about the author or authors. Since we now lack the element and the context that we always presuppose and start from, this position is unusual in that these are not original works of an unknown, unsigned author, of which there are many in art history.

Therefore, it shifts us from that state of equilibrium established in the modern era through the relation of identity between the author (subject) and his/her work (object), a relation in which the work is a mirror reflection of the artist's personality, an accurate expression and reflection of his/her subjectivity, own-ness, individuality, embodied in the concept of a personal style. The works presented at this exhibition, signs/symbols of eminently personal plastic discourses taken over and repeated, are actually instruments used in the elaboration of an 'ideology' of zero-level subjectivity. The sum total, set of personal styles is transformed into an absence of any style whatsoever; this absence, however, does not become a new personal style, but is established as the end point of depersonalization.

This renunciation of personality and identity, this discourse in the indefinite, not the first person, is thus not presented to us merely through the decision to leave out one's own signature and name, or through the appropriation of the names of others; it is manifested on the level of visible plastic data, in the overall execution of these works, Even at first glance, it is clear to us that we must give up the conventional aesthetic/fine arts analysis, which we resort to almost out of habit, even though doubts about the purposefulness of such an analysis could arise due to the fact that we know we are faced with copies. When copies are concerned, should we look for anything there apart from asking ourselves how accurately they reproduce the originals? Seeking and finding signs of the individual, the subjective, elements of some personal 'handwriting' and personal stylistics, appears absurd to say the least. The analysis we are talking about would be appropriate only if it stopped upon reaching an awareness of its own inappropriateness.

We are not confronted with any new-painting fragmentary quotations (in the manner of indirect speech or retelling), wherein the appropriated iconic and formative elements are processed within the framework of an individual/subjective plastic discourse, but with verbatim quotations, the 'copying' of entire works. Various deviations from the original (starting from the

works' dimensions, not always conforming to the 1 to 1 ratio), inaccuracies and deformations that we discover quite easily and, in the final analysis, the overall execution, do not allow the possibility of perceiving any recognizable individuality, any personal stylistic pattern. Our copies are not so 'perfect' that we could mistake them for the originals, but they are not sufficiently removed from the originals to be authorial, individual interpretations resulting in a new work, as yet unseen. They were made according to reproductions of the originals from art books, that is, based on models which, to an ordinary recipient, represent the most frequent source of information for getting to know art, and what they reproduce is precisely this popular, layman's, somewhat naïve notion of art, based, among other things, on an almost mythical view of the original. We may take them to be surrogates, substitutes for the inaccessible modernist 'icons', artificial, sterile products which, however, at the same time cast an ironic light on the mythical-religious status of the original in our culture. These almost infantile simulations, simplified copying of modernist patterns, are actually first of all documents, notes of (post)conceptualist mental operations, thought processes directed at a problematization of the charismatic status of the (personal) subject and the original, the despotism of the creative and the new.

Indeed, these works are by no means appealing; not only do they lack the 'taste' of the original, they almost lack its look as well, because its pictorial qualities have disappeared here. Therefore, one reviewer is quite right to observe that 'it is quite evident that "Matisse" in no way resembles Matisse', feeling hurt by the lack of talent in the anonymous 'genius' and ridiculing his/her incoherent professional execution. However, one did not have to be very intelligent to understand that reproduction of the pictorial qualities of the original, an accurate reproducion of the method, brushstrokes, chromatic data, and all the other details, was not the point here.

Moreover, the author has, quite consistently, given up on the challenge of elaborating any pictorial qualities: he/she did not want to produce either 'quality' copies or 'quality' originals, applying the practice of painting so 'casually', 'irresponsibly', and in such an 'undisciplined' manner that it is not unusual at all if his/her creations hurt someone or even if they arouse detestation or contempt. He/she certainly does not take any pleasure in painting, and that is why, it would appear to us, he/she does not offer or expect anything in his/her products, which do not address our sensual but our cognitive perception.

If, then, these neutral, impersonal and lifeless copies, resembling artificial flowers sprinkled with (bad) perfume, deny us any possibility of authentic excitement, can they have any bearing on our mental and cognitive apparatus? We would say that this exhibition involves us in a state of uncertainty and insecurity, it leads us into a space lacking anything to rely on, where we are

surrounded only with the real and the unreal, the known and the unknown, the truth and lies, finally, with copies and originals. It provokes us to re-examine our own understanding of these terms, not only in the context of art but also in relation to ourselves. It is as if we were floating from the truth to lies, from meaning to meaninglessness, irritated by the somewhat rough challenge of having to re-examine something which we always took as self-evident, perhaps even our own identities. But we should not worry unduly about the possible confrontation with these or other uncomfortable facts. We can always defend ourselves quite easily accepting, for example, one of the roles mentioned in a story by Hans Richter about a meeting between Kurt Schwitters and George Grosz:

> One day Schwitters decided he wanted to meet George Grosz. George Grosz was decidedly surly; the hatred in his pictures often overflowed into his private life. But Schwitters was not one to be put off. He wanted to meet Grosz, so Mehring took him up to Grosz's flat. Schwitters rang the bell and Grosz opened the door. 'Good morning, Herr Grosz. My name is Schwitters.'
> 'I am not Grosz', answered the other and slammed the door. There was nothing to be done. Half way down the stairs, Schwitters stopped suddenly and said, 'Just a moment.'
> Up the stairs he went, and once more rang Grosz's bell. Grosz, enraged by this continual jangling, opened the door, but before he could say a word, Schwitters said 'I am not Schwitters, either', and went downstairs again.
> Finis. They never met again.[1]

1 Recounted by Hans Richter, in his *Dada: Art and Anti-Art* (London: Thames & Hudson, 1965) 145.

Slobodan Mijuskovic, 'Discourse in the Indefinite Person', *Moment*, no. 8 (Belgrade, 1987), 27–31; trans. from Serbian by Novica Petrovit, in *What is Modern Art?*, ed. Inke Arns and Walter Benjamin (Berlin: Künstlerhause Bethanien/Frankfurt am Main: Revolver – Archiv für Aktuelle Kunst, 2006) 37–40.

Walter Benjamin
Interview with Beti Zerovc//2006

In the past few years, the international biennale audience (Biennale of Sydney, Whitney Biennial, Venice Biennale) has seen some specific recreations of important past art events among the exhibited artworks. We spoke with Walter Benjamin, who has had the chance to see and follow most of these projects:

Beti Zerovc I'm wondering why people recreate events in this way at all and why those particular events. But, of course, I'd also like to know why I am speaking with 'Walter Benjamin'?

Walter Benjamin Obviously the name I took for this conversation relates to the well-known early twentieth-century philosopher, but it also relates to the Walter Benjamin who gave a lecture in Ljubljana in 1986 titled 'Mondrian '63–'96', a lecture about Mondrian's paintings between 1963–96. It is the same Benjamin whose statement 'Copies are memories' is being used as a motto for the 'Americans 64' exhibit at the Arsenale in Venice this year.

I not only had a chance to see most of the works and exhibits we are going to talk about, but also I learned a lot by trying to understand them, trying to explain them to myself.

I assume we are talking about (authorless) projects like the 'International Exhibition of Modern Art' (dated 2013), the 'Salon de Fleurus' in New York (established 1992), the small-scale Museum of Modern Art (dated 1936 and attributed to Alfred Barr Jr.), the Museum of American Art that recently opened in Berlin, and finally the collection 'Americans 64' of the Museum of American Art just shown at the Arsenale. The theme of this last exhibit is the American participation in the 1964 Venice Biennial.

Zerovc Yes, I meant those projects. So why recreate them and why exactly those ones?

Benjamin As you said, the themes of these works are clearly events that are important for the art-history narrative. For example, Gertrude Stein's Salon in Paris and the Museum of Modern Art in New York could be understood as an American interpretation of European modern art. It seems that it was Gertrude Stein's Salon where works of Cézanne, Matisse and Picasso were exhibited for the first time (1905). Alfred Barr Jr. was just three years old back then. From

today's perspective Gertrude Stein looks like a proto-curator and her Salon like a precursor of the Museum of Modern Art. Until recently the MoMA permanent exhibit started with Cézanne, from whom the story splits toward Fauvism (Matisse) on the one hand, and Cubism (Picasso) on the other.

In contrast, the theme of the Museum of American Art in Berlin is the 'invasion' of postwar Europe by American art. The museum's collection is built around four MoMA travelling shows curated by Dorothy Miller in the 1950s. It is about the European reception of American modernism and the gradual expansion of American art, which was in a way officially recognized by the Grand Prize given to Rauschenberg at the 1964 Venice Biennale.

I would say that these events in fact shaped the narrative of twentieth-century modern art, especially Barr's concept of the Museum of Modern Art conceived at the 1936 exhibition 'Cubism and Abstract Art'. It still cannot be stressed enough that, here, Alfred Barr was not a chronicler who recorded the events as they unfolded in front of his eyes, but someone who in fact retroactively constructed (invented) the narrative. It is this particular narrative that subsequently became the dominant modern-art narrative for many decades. At this show, he managed not only to historicize the first three decades of twentieth-century art, but also later assembled and arranged MoMA's permanent exhibit according to this narrative. Thus, the exhibition 'Cubism and Abstract Art' became the blueprint for MoMA for many years to come.

All this of course makes an interesting story. But it is just a story. Now, having a work that takes that story as its subject matter is a completely different thing. It is a material (physical) reflection (interpretation) of that story. This work in fact contains its own context, its own narrative, and you don't need additional clues if you know modern art history. You don't even need to know who the authors of these works are. It is questionable if the notion of the 'author' is applicable here at all.

I believe there is a good chance that these works are not going to be seen as art at all. The fact that they are shown within an art context today doesn't imply that they can be seen only as works of art. This is why it is important that, for the time being, both the Museum of American Art in Berlin and Salon de Fleurus in New York are located in private spaces. They are trying to be modestly visible, but not to be totally incorporated in the art world, i.e., not to be read exclusively within the art context.

Zerovc But are they really trying not to be incorporated into the art world? I guess not very hard, since we could see these projects at the two last Venice Biennales, and some years ago also at the Whitney Biennial, the Biennale of Sydney, etc.

Benjamin They are definitely shown in the art context, but what other venues exist today for these kinds of works/ideas? As I said, the fact that they are shown in the art context doesn't mean that these are art works. A group of visitors at the Arsenale, talking in front of the Museum of American Art exhibit, used the word 'Meta-Kunst' (meta-art). This might be an appropriate term. If art history as a narrative becomes the internal subject matter of a work (its internal narrative), if it is contained inside that work, then this immediately opens up a possibility for a position 'outside' of art history. This would be in fact a meta-position in relation to art history.

Zerovc I don't have a problem with the fact that one day these works could be seen as something else as well. That could be. But for now the situation is that those works are really well accepted by the art system; they are understood, written about, exhibited and have a price exactly like artworks and not as something else.

Benjamin Yes, sure. They are definitely perceived as more or less interesting works of art. But there could be another explanation. When, for example, Copernicus wrote his treatise on the movements of the celestial bodies, it was not a scientific but a theological paper, because back then there was no science, no scientific infrastructure, no scientific language. Basically, at that time, there was only one dominant platform (ideology) with a developed physical and conceptual infrastructure: Christianity. It took a couple of centuries to fully develop that other position (platform) we today call science.

Today, in a similar way, the dominant narrative is art history, and there is not another platform or infrastructure from where you could 'read' these works in another way. This is the limitation of the time we live in. I think that is why these works are today seen only as art. Not because they are inherently art works. The very fact that those visitors could see it as a 'meta-art' shows that even today for some people this is not 'art'. [...]

Today we should start thinking about how to define the position (platform) that represents a meta-position in relation to art history and thus a meta-meta-position in relation to the [established] narrative. In other words, the question is how to move out of art history, how to establish another platform from where we can see art history from the outside, while at the same time not forgetting art history and museums, but rather recontextualizing them.

This is why those works that have art history as their subject matter might help us establish this meta-position. These authorless works based on copies have the art-history narrative confined or 'buried' within themselves, together with the notions of the artist and artwork as unique entities. In such works we

can see that their subject matter, their internal narrative, is art history. But it is still unclear what could be a meta-narrative for this work. Basically, this is yet to be established. On that meta-level it will be possible of course to use notions like art, artist, work of art, art history, but they'll have quite a different and most likely not so important meaning. These are not going to be formative notions for the meta-position.

I repeat: the facts that these works are shown within the art context and that they came out of the art context don't mean that this is the only way they can be read. Furthermore, I do not think it is the proper way to read them. I am more and more convinced that these are in fact not works of art. [...]

I believe this is where the change is taking place today. Gradually, it will become clear that Art History and Art itself are exhausted concepts. They're going to be abandoned, or perhaps will become little more than entertainment for some people who continue to believe in history, the way religion is an entertainment for some people today.

Zerovc But that's how it is already. Art is just an entertainment for some people.

Benjamin Sure, this is why Art as such is not relevant for me any more.

Zerovc So wouldn't it be more fun and make more sense to leave the art context altogether now?

Benjamin You see, you have to have a place from where you start learning things. Sometimes a certain narrative already gives you a platform from which you can start and from where you can make the 'next move'. Why abandon it then completely? When Art History was being established, it didn't forget the Christian narrative. It just recontextualized it. And these Meta-Art works are not forgetting the narrative of Art History. They might be one way of recontextualizing it. So what we have is recontextualization rather than a deconstruction of the historical narrative. While deconstructing is in some way closer to 'forgetting', recontextualizing might come closer to 'remembering'. Copies are memories.

Walter Benjamin and Beti Zerovc, extracts from interview, in *What is Modern Art?*, ed. Inke Arns and Walter Benjamin (Berlin: Künsterhaus Bethanien/Frankfurt am Main: Revolver – Archiv für aktuelle Kunst, 2006) 28–9; 34.

Boris Groys
Interview with John-Paul Stonard//2007

John-Paul Stonard [...] You often refer to Pop art in your writings and have discussed its importance for the unofficial art world in Moscow during the 1970s and 1980s.

Boris Groys Well, I recently wrote an essay on Warhol for a show in New York. I think that this shift from Abstract Expressionism and the high-minded attitude of the fifties, which took effect historically in America in the late 1950s and early 1960s, was a movement that on the one hand was understood as an opening to the wider audiences, to the world of the mass media. It was a way out of the isolation of the academies and the art scene. It was a movement from the particular of the art system to something more universal and general, which is the world of mass culture and the mass media. But there was an element of self-deception, in that American artists tended to identify mass culture solely with their own mass culture; this was a great mistake. As a Soviet spectator, for example, I saw Campbell Soup tins and Brillo Boxes for the first time in art books rather than on the supermarket shelf. All this Pop art referred to realities that were in fact unknown to the general public in the Soviet Union. What happened in the Soviet Union under the influence of these images was a kind of new nationalism in art. This was a corollary of the obvious fact that Soviet mass culture was very different from American mass culture. So instead of trying to go for the universal, to be open to the international art system, Soviet artists began to concentrate on their own culture. [...] Principally Komar and Melamid, Ilya Kabakov and Eric Bulatov. They were the first to generate a strong interest in Soviet rather than Western culture. They turned their backs to the West under the influence of American Pop art. The same happened to German artists, who reacted to American Pop art with a kind of nationalist programme of German Pop, based on everyday life in Germany, but also on images of the Nazi past, and later with images of the German terrorists, and so on. What this type of reaction creates is a new artistic nationalism – this was certainly the result of American Pop art in Eastern and Central Europe. It produced a strong awareness of the specific configuration of their own mass culture. Yet on the other hand we can say that this kind of reflection on their own mass culture was made to be sold on the international cultural market. That means that it was obvious for a Russian artist, for instance, that he could not be successful with an image of Elvis Presley – even if he knew who Elvis Presley is – because nobody was interested

in an image of Elvis produced by a Russian artist. But everybody was interested in the images of Stalin and Lenin produced by the Russian artists and many other things that are easily recognizable as being Soviet. This strategy was very well received on the international art market. So we can say that the universal aspirations of modernist art were substituted by the commercial aspirations to be successful on the international art market and in terms of universal art institutions such as the Biennales, Documenta, and so on. The purpose of these universal art institutions is to provide an overview of what is happening in the world, so that every part of this world is compelled to represent itself in its specific terms, if it wants to or not. There is no original will to represent oneself in this manner; it is more the case that there is a compulsion to accommodate the international art institutions and to accommodate the international art market. This is universalism on a different level. [...]

Stonard Could you say a little about the research project *The Post-Communist Condition*, which you directed? As most of the research publications from this were in German, it is little known in the non-German-speaking world.

Groys Well, I must confess that in the first place it was an attempt on my part to do something a bit nostalgic. It was a reaction against the type of nationalism that is now rampant in Eastern Europe. Almost everybody is involved in building their national identity, or discovering their national identity, or something like that, which seems to me not to be a very challenging task. So I was interested rather in the internationalist, universal and utopian aspirations of communism: how and in what forms it has survived these waves of nationalism. Of course it has survived in almost all former communist countries, especially amongst intellectuals and artists connected with the international art scene. Many of them are very interested in referring to the communist period. The problem is that this nationalist wave is to a certain degree reactionary – literally reactionary – as it erases forty, fifty, seventy years of history as being a mistaken history, because it was communist history. For many countries it was precisely in this period that they emerged into the modern world. What actually happens is that under the pretext of ideological struggle against communism something like erasure of modernism in general takes place. There is the supposition that one can go back to the time before communism to build national identity anew, which usually involves a regression to a pre-modern or early modern time. This is something very irritating. So the project was about that: reinterpreting communism as a project of modernization; asking what was specific about that that has survived; how are artists dealing with that now; and how on the discursive level we can reflect on that. The outcome was three volumes. One was

about projects for achieving personal immortality which were formulated at the beginning of the Soviet period.[1] There was a party, which is not very well known, called the 'Immortalists-Biocosmosists'.

Stonard Is this where Nikolai Fedorov comes in?

Groys Nikolai Fedorov was a precursor and his ideas were used by the Immortalists-Biocosmists, but they were moreover a political party that were represented in St. Petersburg and Moscow. They promoted immortality, the right to free movement in cosmic space as fundamental human rights and wanted to compel the state to contribute to these rights. The Soviet Space Programme was born out of this movement – initially the rockets were designed to take immortals to other planets. Only later did it take some kind of military turn. There are two other volumes: one about the politics of the Russian avant-garde and one very thick volume which is the contribution of contemporary Russian and Eastern European authors to the contemporary situation in Eastern Europe.[2] And then I organized an exhibition, 'Privatisations', which was about the appropriation, or privatisation of the communist myth that took place in Russian and Eastern European art parallel to privatisation in the economic sphere.[3]

Stonard Is it easier to be post-communist outside of the former Soviet Union? It seems that all the artists you are interested in moved to Manhattan as soon as they could. Does this imply that communism is finished only in as much as individuals have the chance physically to escape?

Groys Oh, no. The Russian artists living in Russia also work a lot with the Soviet material. This material is very rich, pretty exotic and still interesting for the international public. That is what I describe as 'cultural privatisation': individual, artistic appropriation of the collectivist communist heritage. [...]

1 B. Groys, M. Hagemeister, *Die Neue Menschheit. Biopolitische Utopien in Russland zu Beginn des 20. Jahrhunderts* (Frankfurt am Main, 2005)

2 B. Groys and A. Hansewn-Löve, eds, *Am Nullpunkt. Positionen der Russischen Avantgarde* (Frankfurt am Main, 2005); B. Groys, A. van der Heiden and P. Weibel, eds, *Züruck aus der Zukunft. Osteuropäische Kulturen im Zeitalter des Postkommunismus* (Frankfurt am Main, 2005).

3 Privatisations. Contemporary Art from Eastern Europe (Berlin: Kunst Werke, 2004).

Boris Groys and John-Paul Stonard, extracts from 'Boris Groys in Conversation', *Immediations*, no. 4, (London: 2007) 131–2; 135–7.

I THOUGHT 'WOW, FIVE MINUTE PSYCHO, THAT WOULD BE REALLY BRILLIANT!' SO I TRIED TO WATCH PSYCHO REALLY FAST, AND IT WAS FAIR ENOUGH, AND THEN I STARTED DOING JUST THE OPPOSITE, LIKE YOU DO

POSTPRODUCTION

Nicolas Bourriaud Deejaying and Contemporary Art,
 2002//158
Katrina M. Brown Douglas Gordon: *24 Hour Psycho*
 (1993), 2004//163
Lucy Soutter The Collapsed Archive: Idris Khan,
 2006//166
David Evans War Artist: Steve McQueen and
 Postproduction Art, 2007//169

Nicolas Bourriaud
Deejaying and Contemporary Art//2002

When the *crossfader* of the mixing board is set in the middle, two samples are played simultaneously: Pierre Huyghe presents an interview with John Giorno and a film by Andy Warhol side by side.

The *pitch control* allows one to control the speed of the record:
24 Hour Psycho by Douglas Gordon.

Toasting, rapping, MC-ing:
Angela Bulloch dubs *Solaris* by Andrei Tarkovsky.

Cutting:
Alex Bag records passages from a television programme; Candice Breitz isolates short fragments of images and repeats them.

Playlists:
For their collaborative project *Cinéma Liberté Bar Lounge* (1996), Douglas Gordon offered a selection of films censored upon their release, while Rirkrit Tiravanija constructed a festive setting for the programming.

In our daily lives, the gap that separates production and consumption narrows each day. We can produce a musical work without being able to play a single note of music by making use of existing records. More generally, the consumer customizes and adapts the products that he or she buys to his or her personality or needs. Using a remote control is also production, the timid production of alienated leisure time: with your finger on the button, you construct a programme. Soon, Do-It-Yourself will reach every layer of cultural production: the musicians of Coldcut accompany their album *Let Us Play* (1997) with a CD-ROM that allows you to remix the record yourself.

 The *ecstatic consumer* of the eighties is fading out in favour of an intelligent and potentially subversive consumer: the user of forms. Deejay culture denies the binary opposition between the proposal of the *transmitter* and the participation of the *receiver* at the heart of many debates on modern art. The work of the Deejay consists in conceiving linkages through which the works flow into each other, representing at once a product, a tool and a medium. The producer is only a *transmitter* for the following producer, and each artist from

now on evolves in a network of contiguous forms that dovetail endlessly. The product may serve to make work, the work may once again become an object: a rotation is established, determined by the use that one makes of forms.

As Angela Bulloch states: 'When Donald Judd made furniture, he said something like "a chair is not a sculpture, because you can't see it when you're sitting on it". So its functional value prevents it from being an art object; but I don't think that makes any sense.'

The quality of a work depends on the trajectory it describes in the cultural landscape. It constructs a linkage between forms, signs and images.

In the installation *Test Room Containing Multiple Stimuli Known to Elicit Curiosity and Manipulatory Responses* (1999), Mike Kelley engages in a veritable archaeology of modernist culture, organizing a confluence of iconographic sources that are heterogeneous to say the least: Noguchi's sets for ballets by Martha Graham; scientific experiments on children's reaction to TV violence; Harlow's experiments on the love life of monkeys; performance; video; and Minimalist sculpture. Another of his works, *Framed & Frame (Miniature Reproduction 'Chinatown Wishing Well' built by Mike Kelley after 'Miniature Reproduction Seven Star Cavern' built by Prof. H. K. Lu)* (1999), reconstructs and deconstructs the Chinatown Wishing Well in Los Angeles in two distinct installations, as if the popular votive sculpture and its touristic setting (a low wall surrounded by wire fencing) belonged to 'different categories'.[1] Here again, the ensemble blends heterogeneous aesthetic universes: Chinese-American kitsch, Buddhist and Christian statuary, graffiti, tourist infrastructures, sculptures by Max Ernst, and abstract art. With *Framed & Frame*, Kelley strove 'to render shapes generally used to signify the formless', to depict visual confusion, the amorphous state of the image, 'the unfixed qualities of cultures in collision'.[2] These clashes, which represent the everyday experience of city dwellers in the twenty-first century, also represent the subject of Kelley's work: global culture's chaotic melting pot, into which high and low culture, East and West, art and non-art, and an infinite number of iconic registers and modes of production are poured. The separation into two of the Chinatown Wishing Well, aside from obliging one to think of its frame as a 'distinct visual entity',[3] more generally indicates Kelley's major theme: *détourage*,[4] which is to say, the way our culture operates by transplanting, grafting and decontextualizing things. The frame is at once a marker – an index that points to what should be looked at – and a boundary that prevents the framed object from lapsing into instability and abstraction, i.e., the vertigo of *that which is not referenced*, wild, 'untamed' culture. Meanings are first produced by a social framework. As the title of an essay by Kelley puts it, 'meaning is confused spatiality, framed'.

High culture relies on an ideology of framing and the pedestal, on the exact

delineation of the objects it promotes, enshrined in categories and regulated by codes of presentation. Low culture, conversely, develops in the exaltation of outer limits, bad taste, and transgression – which does not mean that it does not produce its own framing system. Kelley's work proceeds by short-circuiting these two focal points, the tight framing of museum culture mixed with the blur that surrounds pop culture. *Détourage*, the seminal gesture in Kelley's work, appears to be the major figure of contemporary culture as well: the embedding of popular iconography in the system of high art, the decontextualization of the mass-produced object, the displacement of works from the canon towards commonplace contexts. The art of the twentieth century is an art of *montage* (the succession of images) and *détourage* (the superimposition of images).

Kelley's 'Garbage Drawings' (1988), for example, have their origin in the depiction of garbage in comic strips. One might compare them to Bertrand Lavier's 'Walt Disney Productions' series (1985) in which the paintings and sculptures that form the backdrop of a Mickey Mouse adventure in the Museum of Modern Art, published in 1947, become real works. Kelley writes: 'Art must concern itself with the real, but it throws any notion of the real into question. It always turns the real into a façade, a representation and a construction. But it also raises questions about the motives of that construction.'[5] And these 'motives' are expressed by mental frames, pedestals and glass cases. By cutting out cultural or social forms (votive sculptures, cartoons, theatre sets, drawings by abused children) and placing them in another context, Kelley uses forms as cognitive tools, freed from their original packaging.

John Armleder manipulates similarly heterogeneous sources: mass-produced objects, stylistic markers, works of art, furniture. He might pass for the prototype of the postmodern artist; above all, he was among the first to understand that the modern notion of the new needed to be replaced with a more useful notion as quickly as possible. After all, he explains, the idea of newness was merely a stimulus. It seemed inconceivable to him 'to go to the country, sit down in front of an oak tree and say: 'but I've already seen that!'[6] The end of the modernist *telos* (the notions of progress and the avant-garde) opens a new space for thought: now what is at stake is to positivize the remake, to articulate uses, to place forms in relation to each other, rather than to embark on the heroic quest for the forbidden and the sublime that characterized modernism. Armleder relates acquiring objects and arranging them in a certain way – the art of shopping and display – to the cinematic productions pejoratively referred to as B-movies. A B-movie is inscribed within an established genre (the western, the horror film, the thriller) of which it is a cheap byproduct, while remaining free to introduce variants in this rigid framework, which both allows it to exist and limits it. For Armleder, modern art

as a whole constitutes a bygone genre we can play with, the way Don Siegel, Jean-Pierre Melville, John Woo or Quentin Tarantino take pleasure in abusing the conventions of film noir. Armleder's works testify to a shifted use of forms, based on a principle of *mise-en-scène* that favours the tensions between commonplace elements and more serious items: a kitchen chair is placed under an abstract, geometrical painting, spurts of paint in the style of Larry Poons run alongside an electric guitar. The austere and minimalist aspect of Armleder's works from the 1980s reflects the clichés inherent in this B-movie modernism. 'It might seem that I buy pieces of furniture for their formal virtues, and from a formalist perspective', Armleder explains. 'You might say that the choice of an object has to do with an overall decision that is formalist, but this system favours decisions that are completely external to form: my final choice makes fun of the somewhat rigid system that I use to start with. If I am looking for a Bauhaus sofa of a certain length, I might end up bringing back a Louis XVI. My work undermines itself: all the theoretical reasons end up being negated or mocked by the execution of the work.'[7] In Armleder's work, the juxtaposition of abstract paintings and post-Bauhaus furniture transforms these objects into rhythmic elements, just as the 'selector' in the early days of hip-hop mixed two records with the crossfader of the mixing board. 'A painting by Bernard Buffet alone is not very good, but a painting by Bernard Buffet with a Jan Vercruysse becomes extraordinary.'[8] The early 1990s saw Armleder's work lean toward a more open use of subculture. Disco balls, a well of tires, videos of B-movies – the work of art became the site of a permanent scratching. When Armleder placed Lynda Benglis' Plexiglas sculptures from the 1970s against a background of Op-art wallpaper, he functioned as a remixer of realities.

Bertrand Lavier functions in a similar way when he superimposes a refrigerator onto an armchair (Brandt on Rue de Passy) or one perfume onto another (Chanel No. 5 on Shalimar), grafting objects in a playful questioning of the category of 'sculpture'. His *TV Painting* (1986) shows seven paintings by Jean Fautrier, Charles Lapicque, Nicolas De Stael, Lewensberg, On Kawara, Yves Klein and Lucio Fontana, each broadcast by a television set whose size corresponds to the format of the original work. In Lavier's work, categories, genres and modes of representation are what generate forms and not the reverse. Photographic framing thus produces a sculpture, not a photograph. The idea of 'painting a piano' results in a piano covered in a layer of expressionistic paint. The sight of a whitened store window generates an abstract painting. Like Armleder and Kelley, Lavier takes as material the established categories that delimit our perception of culture. Armleder considers them subgenres in the B-movie of modernism; Kelley deconstructs their figures and compares them with the practices of popular culture; Lavier shows how artistic categories (painting,

sculpture, photography), treated ironically as undeniable facts, produce the very forms that constitute their own subtle critique. [...]

It might seem that these strategies of reactivation and the Deejaying of visual forms represent a reaction to the overproduction or inflation of images. The world is saturated with objects, as Douglas Huebler said in the 1960s, adding that he did not wish to produce more. While the chaotic proliferation of production led conceptual artists to the dematerialization of the work of art, it leads postproduction artists towards strategies of mixing and combining products. Overproduction is no longer seen as a problem but as a cultural ecosystem. [...]

1 [footnote 7 in source] Mike Kelley, 'The Meaning is Confused Spatiality, Framed', in *Mike Kelley*, exh. cat. (Grenoble: Le Magasin, 1999) 62.

2 [8] Ibid., 64.

3 [9] Ibid.

4 [10] *Détourage*: process of blocking out the background (of a profile, etc.). [Trans.]

5 [11] Mike Kelley, op. cit.

6 [12] John Armleder in conversation with Nicolas Bourriaud and Eric Troncy, *Documents sur l'Art*, no. 6 (Autumn 1994).

7 [13] Ibid.

8 [14] Ibid.

Nicolas Bourriaud, extract from *Postproduction/Culture as Screenplay: How Art Reprograms the World*, trans. Jeanine Herman (New York: Lukas & Sternberg, 2002) 39–45; first published in English. French edition published by Les Presses du réel, Dijon, 2004.

Katrina M. Brown
Douglas Gordon: *24 Hour Psycho* (1993)//2004

Is there anyone in the world who doesn't know that in *Psycho* a girl is stabbed in the shower? – Stuart Morgan

Despite the tendency for this work to be considered in terms of its relationship to film theory and the cinematic, Gordon himself has often described it more aptly as existing 'somewhere between the academy and the bedroom'. Its academic credentials lie in its structural analysis of film in general: stripping it of sound, reducing it to the purely visual, slowing the progression of images to such an extent as to expose each single frame and the transition from one to the next, Gordon leaves us with the basics of image and movement. But its origins in the bedroom are perhaps the more significant, for it grew as much out of the proliferation of domestic video recorders in the 1980s as from any structural analysis. The readily available technology allowed many people both to watch and manipulate films in the comfort and familiarity of their own homes. Comedy was to be found in the use of the fast-forward function, while many a teenage erotic fantasy could be triggered by the use of slow motion. Recalling how the idea for the piece first came about, Gordon has said:

> I was back home, it was Christmas Eve, the pubs were closed, my friends weren't around, I'm not used to going to bed very early. There was nothing on the television, my family were all asleep. I remember lying upstairs in my wee brother's bedroom, just playing about with the video recorder, and whatever tapes he happened to have ... he had a tape lying about and it was *Psycho*, and when I saw it I thought 'Wow, Five Minute Psycho, that would be really brilliant!' So I tried to watch *Psycho* really fast, and it was fair enough, and then I started doing just the opposite, like you do. So I started watching it slow, and there were specific sequences in it that I thought I wanted to watch again in slow motion, and that's really the root of where the idea came from: the more I watched in slow motion, the more I realized how interesting this could be.

An understanding of the distinction between both the manner of watching and the type of film watched in the home as opposed to the cinema is a key starting point for much of Gordon's work with video. In a conversation with the late David Sylvester he explains:

I think that ways of looking are determined more by the circumstances in which a film is seen than the commercial or 'alternative' intent of the director. I try not to be too nostalgic about it but, to be quite honest, most of the films that I've watched, I've watched in bed rather than in the cinema ... It was not exactly the social context but the physical context of watching that knitted together all of my experiences ... The cinema was much more of a controlled environment, whereas at home there were always some wise-cracks from your mum or dad, or someone on the telephone, or someone ad-libbing the next line or whatever. This happened more with *film noir* and B-movies than anything else. Our house was much more Sydney Greenstreet, John Wayne and Barbara Stanwyck than Jean-Paul Belmondo and Jeanne Moreau. Or Steven Spielberg for that matter.

The multi-layered physical experience of, and bodily involvement in, watching is clearly as important for Gordon's work with video as it is for his text-based works. The ability to encounter an extraordinary narrative and unknown characters and places in a familiar, ordinary environment while simultaneously hearing and seeing one's own immediate reality outside the film is the crux of the specifically domestic experience of film that lies behind *24 Hour Psycho*. It conjures a recollection of the all too real fear and foreboding experienced by anyone choosing to watch a late-night thriller on TV, even in the comfort and safety of the home, essentially playing on the way in which the fictional can seep into our memory and intertwine with real, actual and personal experiences.

I used to work on a late shift in a supermarket, and when I came back home the clock was already at midnight or 1 a.m., and everyone in the house was asleep, but I needed to rest and calm down before going to bed. This was around the time in Britain when Channel 4 had just started. It was a very, very important thing: Channel 4 was the only thing on TV at that time of night. They ran a pretty esoteric film series, from what I can remember. And that's how I got to see Godard; that's how I got to see Truffaut, Rohmer, and everyone else. As well as the *Vague* boys, I also got an introduction to the B-movies and noirs – Nicholas Ray or Rudolph Matté or Otto Preminger, for example.

Such films were to be the starting points for later works, such as *Confessions of a Justified Sinner* (1996), which uses an excerpt from Rouben Mamoulian's 1932 version of *Dr Jekyll and Mr Hyde*, and *Déja-vu* (2000), which features a Matté classic *noir* from 1950. *Psycho* is, however, a better known if not altogether 'popular' film. It is seen mostly on TV, whether as a late-night screening or on video. Made cheaply and in forty-one days, *Psycho* has attained classic status, described as 'one of the key works of our age' by Robin Wood, doyen of

Hitchcock critics. Introducing some of the key themes to be found in Gordon's later works, such as right and wrong (the film starts with the 'heroine' Marion Crane stealing money from the bank in which she works), madness and the split personality, it also plays deliberately and directly to a taste for horror. From the outset there is a heightened voyeurism, explicit in the opening scene when we find Marion in bed in a hotel room with her lover. From this point on, the viewer is implicated in the events that follow, choosing to watch. The film, as Hitchcock himself said in conversation with François Truffaut, 'allows the audience to become a Peeping Tom'. Gordon's slowed-down version exploits the voyeuristic tendency and overlays it with a physical involvement that only strengthens the way in which the viewer is implicated in what unfolds. Since the viewer is able to walk around the screen, see the projection from both sides and become aware of the manipulation to which the material has been subjected, the images are more approachable than they appear in the cinema. They are therefore closer to one's experience of and physical involvement with them via the domestic video recorder, while existing on a scale that surrounds and dominates the viewer, who is effectively suspended in a relentless present.

> I was concerned above all with the role of memory. While the viewer remembers the original film, he [sic.] is drawn into the past, but on the other hand also into the future, for he becomes aware that the story, which he already knows, never appears fast enough. In between, there exists a slowly changing present.[1]

1 All quotations from interview with David Sylvster, in Sylvester, London Recordings (London: Chatto & Windus, 2003).

Katrina M. Brown, extract from *Douglas Gordon* (London: Tate Publishing, 2004) 24–6.

Lucy Soutter
The Collapsed Archive: Idris Khan//2006

In the mid 1990s, postmodern appropriation was still a hot topic in art schools. Students would get worked up by the sheer audacity of Sherrie Levine, the bad-boy libido of Richard Prince, and the kitsch sensationalism of Jeff Koons. But in recent years it's all fallen rather flat. Appropriation has become, not *passé*, but so ubiquitous as to be beyond notice. The last Tate Triennial proposed that appropriation has become the dominant trend in contemporary art practice, and that appropriated material no longer need signify anything in particular: not the death of the author, not a critique of mass-media representations, not a comment on consumer capitalism. On the contrary, it seems that appropriation is a tool of the new subjectivism, with the artist's choice of pre-existing images or references representing a bid for authenticity (my record collection, my childhood snaps, my favourite supermodel).

Idris Khan's work offers another chapter in the story of appropriation. Last year I tossed his good-looking composites of blockbuster cultural texts into the tail end of the postmodernism lecture. I offered works such as *Every ... Bernd and Hilla Becher Prison Type Gasholder* and *Every ... William Turner Postcard from Tate Britain* as examples of appropriation work that transforms as well as steals, and which demonstrates engagement with the past as well as the artist's desire to make his own mark. The fit was almost too perfect. Khan's work slotted into the art-historical narrative so smoothly, it was almost as if it were designed to go there.

On the basis of his recent show at Victoria Miro, it is clear that Khan locates his practice very self-consciously. His work to date has drawn on a range of works significant to the practice of art photographers and cultural producers more broadly. Whether it is every page of Barthes' *Camera Lucida*, or every page of the *Koran* (making reference to his own paternal heritage). Khan's sources are always both familiar and highly loaded. The works in his recent exhibition cement his claim to canonical status by taking on Muybridge and Blossfeldt, Bach, Mozart and Beethoven, Freud's *The Uncanny*, and a selection of Caravaggio's late paintings. [...]

Khan's process – what a traditional photographer would describe as a post-production process – appears to be simple addition. One might assume that the artist follows a strict conceptual script, giving equal and impartial emphasis to every page or image in a series. In fact, he makes free use of camera, scanner and digital-imaging software to push and pull the different strata. He has control

over framing, scale, contrast and transparency, and uses these variables to nuance the appearance of the final image. It is thanks to the intervention of the artist that illustrations of Leonardo paintings emerge to make make filmy eye contact from the pages of Freud's *The Uncanny*, and that Blossfeldt's flower studies have condensed into a strange atomic mushroom.

Khan's involvement in the process gives him control over both the appearance and tone of the work. This is clearest in the three musical works. Superimposing every page of Bach's *Six Suites for Solo Cello*, or Mozart's *Requiem* or Beethoven's *Sonatas*, was bound to yield different results, given the variation in the musical scores involved. Khan has heightened the differences so that Bach's suites produce a light and airy composition, with the top and bottom bars of notes rising and falling across the surface in soft greys. Beethoven's sonatas, in contrast, block up into masses of dramatic blackness, with individual notes visible only at the fringes of overlapping staves. The sense of erasure created provides a convenient metaphor for the deafness that descended on the composer while he wrote these pieces.

It was a brilliant move to make a set of works layering the serial images from Eadweard Muybridge's *Human and Animal Locomotion* – the resulting compositions are striking, dynamic. But it seems illogical to have used platinum printing, known for its luscious grey tones, to reproduce the half-tone dots of the original book. In this context, platinum serves as a gratuitous signifier of Art Photography and of value for value's sake.

In the Dada tradition of photomontage, artists often borrowed bits and pieces of images, and threw them together roughly in order to produce a jarring, confrontational image. The composite has a very different effect, smoother and altogether more comfortable for the viewer. It would be unfair to make more than passing reference to the main historical precedent for composite photography, nineteenth-century eugenicist Francis Galton. Khan's work has none of the sinister content of Galton's composites of criminals, consumptives or Jews, originally used to argue against the evil of perceived social decline. Yet it is certainly worth referring to Allan Sekula's classic text 'The Body and the Archive', which analyses the tremendous persuasive force of the composite. Of particular relevance here is Sekula's observation that the composite offers a collapsed form of the archive, which claims the archive's authority as a model of knowledge. Khan's works take advantage of this condensed archive effect to achieve their authoritative presence. The pieces in which the process is most obvious help to undermine the composite's pseudo-objective power.

In Galton's case, the authority of the composite was used as a talisman against the decline of the human race. In Khan's case it is the decline of Western culture that is at stake. His ambitious, elegant works set out to reverse that

decline, appropriating brand name masterpieces with a great deal of intelligence. Khan's works do not have a shred of postmodern irony, nor do they represent the more subjective trend in appropriation. While Khan must have his own personal relationship to his sources, his images lead us to muse on high culture in general, and our own relationship to it. [...]

Lucy Soutter, extract from 'The Collapsed Archive', review of Idris Khan at Victoria Miro Gallery, London (2–30 September 2006), *Source*, no. 49 (Winter 2006) 46–7.

David Evans
War Artist: Steve McQueen
and Postproduction Art//2007

Since it opened in 1917, the Imperial War Museum in London has been acquiring art in various ways. Most of the museum's art collection deals with the two world wars, and drawing and painting are the favoured media. There is an emphasis on art as a document or record, although this does not preclude experimental work. Since 1972, the museum has specifically commissioned art related to contemporary conflict involving British forces. Currently, the Art Commissions Committee of the Imperial War Museum has eight members and is chaired by sculptor Bill Woodrow. Gill Smith, the secretary of the committee, recently explained to me how artists are commissioned:

> The process which the Committee adopts for selecting and commissioning artists is that a short list of artists is drawn up. This will comprise any artists who might have written in to express an interest in a future commission as well as artists (not necessarily always established) who the Museum would like to have represented in their collection, or whom the Committee believes might present a good approach to a particular subject. The list is narrowed down to some 6–8 artists … Prior to [each] interview, the artists are sent a short brief but the Committee does not at this point necessarily expect an artist to know exactly what the result of a commission might be. A period of research, which would normally involve a visit to the 'combat zone', is undertaken and a proposal submitted at a later date to the Committee for their agreement before the final work is made. The Committee very much realizes that commissions of this sort must, to a certain extent, be artist-led in order to achieve the best results.[1]

In recent years, commissioned artists have been sent to Northern Ireland (Ken Howard, 1973, 1977); the Falkland Islands (Linda Kitson, 1982); the Gulf (John Keane, 1991); Bosnia (Peter Howson, 1993) and Kosovo (Graham Fagen, 1999/2000); Afghanistan (Paul Seawright/Langlands & Bell, 2002); and most recently, Steve McQueen was sent to Iraq (2003).[2]

For McQueen to create significant work in response to the war in Iraq is easier said than done. In late 2003 he visited the war zone and spoke with British troops in and around Basra. However, plans to film in Baghdad were disrupted by the security situation. Such practical limitations were no doubt compounded by creative considerations. For what can an artist create that differs substantially from the work of Victorian artist-reporters, or

contemporary media professionals like photojournalists or editorial cartoonists? And what can an artist learn about a complex war situation after a brief visit, under official supervision? Not a lot, feared Nico Israel, whose 2004 article for *Artforum* about artists in Iraq specifically mentions McQueen's lightning tour:

> Given McQueen's filmic track record, he will almost surely produce something provocative and weighty, but can McQueen really learn that much more in seven days 'on site', in the presence of Defence Ministry representatives, than, say, George W. Bush can learn talking turkey with US servicemen?[3]

He concludes:

> Is tourism-as-art ... part of the same set of forces as art-as-tourism (biennials, fairs, etc.) with the same power structures undergirding them? If so, the more difficult subsequent question – how and whether it is possible to avoid being embedded, either as a tourist, artist, or journalist (even art journalist) – remains to be answered.[4]

That McQueen managed subsequently to produce something 'provocative and weighty', despite the multiple problems outlined above, is worth further examination and discussion.

After the short, abortive trip to Iraq, McQueen returned home to Amsterdam. There, he came up with a new idea that did not require extended time in the war zone: an installation based around commemorative stamps for British soldiers who had lost their lives in the conflict. Called *Queen and Country*, the work was completed in 2006. It is neither journalism nor 'tourism as art'. Rather, it is challenging, contemporary art, informed by current debates, but by no means 'difficult' for those who do not inhabit the art world.

With the aid of a researcher, McQueen contacted 115 bereaving families, explaining his project. Eventually, 98 families supplied photographic portraits of their sons and daughters in uniform that were made into stamps, complete with the standard silhouette of the queen in the top right-hand corner. Digitally printed sheets of the perforated works were subsequently put into 49 vertical sliding drawers with each one containing two sheets. The 98 sheets are presented chronologically and stored in an oak cabinet in a way that evokes the presentation of rare stamps in the British Museum. The project was initially shown in the impressive Great Hall in the Central Library in Manchester as part of the city's International Festival in 2007, followed by an exhibition at the Imperial War Museum.

There have also been attempts to get the stamps accepted as designs for official postage stamps. So far there has been little success despite support from some Members of Parliament that gained press publicity. Yet precedents exist, like the set of six stamps brought out by the Royal Mail in 2004 to commemorate the 150th anniversary of the Crimean War (1854–56). The series is based on photographic portraits of war veterans, commissioned by Queen Victoria, and taken by Joseph Cundall and Robert Howlett, mainly in Aldershot, England. Nevertheless, it is hard to imagine McQueen's comparable series being taken on board by the Royal Mail, even in post-Blair Britain. The commemoratives for the Crimean War show ageing survivors; McQueen's stamps show young people who were to become fatalities. The Crimean War is long over and the vocal public criticisms are long forgotten; the Iraq war is far from finished and continues to generate unprecedented scales of protest that began in earnest even before the war started. In short, while the Crimean commemoratives are a reminder of the distant past, *Queen and Country* references a tragedy that is still unfolding. McQueen knows very well that the Royal Mail only wants stamps that are courteous state ambassadors. He leaves it to the viewer to reflect on why *Queen and Country* does not follow suit.

In September 2007, McQueen begins shooting a film in Northern Ireland called Hunger. Commissioned by Channel 4, it deals with the final weeks of Bobby Sands (Republican hunger striker and elected Member of Parliament for Fermanagh and South Tyrone) who starved himself to death in the Maze Prison near Belfast in 1981. Criminal or hero? As with the war in Iraq, the debate continues, and the choice of theme might be treated as further proof that McQueen specializes in emotively charged, explicitly political themes.[5]

'Political artist' is probably a label that McQueen would reject. Yet Sarah Whitfield's suggestions that McQueen manipulates the camera 'to create a contemporary version of the history painting' or that his narratives 'have always leaned towards the historical and political, and his targets are invariably carefully selected and subtly judged'[6] are quite compelling.

On the other hand, a critic like Joanna Lowry sees McQueen (and contemporaries like Stan Douglas, Douglas Gordon, Pierre Huyghe, and Gillian Wearing) as an emblematic artist specializing in film and video whose work involves 'drawing our attention away from the content of the recording and requiring us to pay attention to the mechanics of the recording practice itself'.[7] Through techniques like slowing down the footage, looping it, playing it backwards, redubbing it, and so on, Lowry suggests that McQueen and his contemporaries alert us to 'the tension between the processes of technological reproduction and our experience of temporality'.[8]

Lowry foregrounds the politics of form; Whitfield, the politics of subject matter; others insist that form and content cannot be divorced, like Charles Darwent, writing about *Western Deep* (2002):

> It struck me, seeing the movie, that McQueen's transfer of his work from [8 mm] film to video offers a neat analogy for a shift in history. Blown up for the screen, *Western Deep* has the graininess of your dad's home movies: which is apt enough, since things at Tautona are just as they were when your father wielded his old cine camera. The gold mine is still owned by the company that owned it under apartheid; the miners are black, the people who profit from them predominantly white; the conditions are still hellish. *Western Deep* isn't a journey to a physical extreme but to a moral one, a modern-day heart of darkness.[9]

The different critical responses to McQueen's film and video works are relevant to an appreciation of *Queen and Country*, whose message can be explored via its form or its explicit content. But this work also references other contemporary debates, such as the one around the ideas of Nicolas Bourriaud, curator-critic and former co-director of the experimental arts centre at the Palais de Tokyo, Paris.

The British edition of *Glamour*, a magazine solidly committed to a celebration of celebrity culture, also wants to contribute to the 'war against terror', it seems, and had recently planned a picture feature on British war widows who had lost their husbands in Iraq or Afghanistan. Attempts were made to contact widows who had to be both photogenic and aged between thirty and thirty-eight, but the planned feature was dropped after Military Families Against the War refused to cooperate'.[10] Nevertheless, the story is symptomatic of what Bourriaud calls the 'society of extras' where:

> Everyone sees themselves summoned to be famous for fifteen minutes, using a TV game, street poll, or news item as go-between. This is the reign of 'Infamous Man', whom Michel Foucault defined as the anonymous and 'ordinary' individual suddenly put in the glare of media spotlights. Here we are summoned to turn into extras of the spectacle, having been regarded as its consumers.[11]

For Bourriaud, the 'society of extras' is an advanced form of the 'society of the spectacle', as theorized by Guy Debord in the 1960s, and is the backdrop for his two highly influential art manifestos, published in English as *Relational Aesthetics* (2002) and *Postproduction* (2002).

Bourriaud's writings endorse Debord's critical ideas about advanced

capitalism, but reject his dismissive attitude towards the art world. For Debord, professional art was irredeemably part of the spectacular-commodity economy, and he was only interested in the merging of art and everyday life. In contrast, Bourriaud argues that the gallery or museum can offer a 'space partly protected from the uniformity of behavioural patterns' where 'social experiments' and 'hands-on utopias' can be explored.[12] Much of *Relational Aesthetics* identifies and endorses artists active in the last decade whose work involved conviviality and collaboration. These 'micro-utopias' are not to be treated as self-contained affairs, Bourriaud insists, but as 'part of an eclectic culture where the artwork stands up to the mill of the "Society of the Spectacle".'[13]

These ideas are at the core of *Relational Aesthetics* and have been criticized from various angles: rehashed sixties happenings; democracy without antagonism, Debord without revolutionary politics, and so on.[14] Nevertheless it is striking how the ideas provide a framework for assessing the achievement of *Queen and Country.* While the project is rightly credited to McQueen, it gains its strength through the active involvement of bereaving families outside of the art world. It has been discussed in the specialist art press but has also been extensively discussed in the mainstream press in Britain and further afield. It is also one of the few examples of contemporary art that has been mentioned in the Houses of Parliament. The work itself is accessible and has multiple social functions, most obviously as a site of mourning, a spur to critical reflections on the 'war on terror' and a challenge to the 'society of extras'.

Relational Aesthetics is complemented by Bourriaud's second book *Postproduction* (2002). The basic Debordian framework ('society of the spectacle'/'society of extras') is the same, but the focus is now upon contemporary art that uses pre-existing artefacts as raw material to be edited, programmed or sampled. Bourriaud is the first to acknowledge his indebtedness to another key notion associated with Debord and the Situationists – *détournement* – but insists that what he is identifying is a new articulation of familiar elements. He is particularly keen on comparisons between contemporary art and Deejaying and has a special section in which he identifies art equivalents to crossfading, pitch control, toasting, cutting, and the playlist.[15] Again, Bourriaud has been criticized for simply using attractive, up-to-date analogies to disguise old ideas and techniques that used to be called the readymade, montage or appropriation.

Equally impressive are the affinities between Bourriaud's ideas on postproduction art and the achievement of *Queen and Country.* The work basically involves a double appropriation of two modest, often overlooked, types of imagery: the postage stamp and the family photograph. Other artists – John Heartfield (1891–1968), for instance – were drawn to stamps as conveyors of

state ideologies; and more recently, feminist artists like Jo Spence (1934–92) have treated the family album as a site of class and gender struggles. But McQueen's work is different. In his hands, private family photographs become part of a public, accusatory archive.

A one-day conference devoted to the ideas of Bourriaud was held at the Whitechapel Gallery in London in 2004. The artist and critic Dave Beech covered the event for *Art Monthly*, writing: 'Not since the early years of Postmodernism's theoretical reign has the art community been so intimidated, enthralled or annoyed by a theory than it is today by Nicolas Bourriaud's writing on relational aesthetics and postproduction'.[16] Upon reading the review, it becomes clear that Beech is annoyed rather than intimidated or enthralled. However, *Art Monthly* has also provided a platform for others who are more sympathetic, like art historian and critic Marcus Verhagen. He concludes his article 'Micro-Utopianism' with the following judgement:

> At its best, relational art brings viewers together in temporary configurations that buck the trend towards fractured communities and regimented social dealings. The micro-utopia comes with a minimum of theoretical baggage. It is a pared-down utopianism, but that may at times be a strength. It is neither nostalgic nor totalizing. It is responsive to local contingencies. And, unlike classic utopianism, it isn't tied to the ideology of progress, which has with time become a fig leaf for commercial expansionism and neocolonialism. It may not shake the foundations of the present order, but at least it chips away at the noxious conviction that there is no alternative to it – and that is a start.[17]

McQueen's name does not appear in either of Bourriaud's books, and I doubt if he would want to be described as a relational aesthetician or a postproduction artist. Nevertheless, I suspect that he would sympathise with the passage just cited. Without irony, *Queen and Country* fosters an active, critical citizenry. In this day and age, that is quite an achievement.

1 Gill Smith, e-mail correspondence, 3 July 2007.

2 Artists in war zones have received most publicity, but the Imperial War Museum has also been commissioning work on other diverse themes such as army recruitment (Ray Walker, 1981); the military burns unit (Jeffrey Camp, 1987); women in the military police (David Hurn, 1987); and even the tailoring of army officers' uniforms (Shanti Panchal, 1986).

3 Nico Israel, 'Atelier in Samaraa: Nico Israel on Artists on the Iraq Front', *Artforum*, vol. 42, no. 5 (January 2004) 36.

4 Ibid.

5 'Channel 4 Goes inside the Mind of Bobby Sands', *The Independent* (16 May 2007).

6 Sarah Whitfield, 'Exhibition Reviews/London/Douglas Gordon/Steve McQueen', *Burlington Magazine*, vol. 145, no. 1198 (January 2003) 46. Whitfield was referring in particular to two films McQueen made in 2002: *Caribs' Leap*, about the mass suicide in 1651 of a large number of Caribs who refused to surrender to French soldiers on the island of Grenada, and which, for Whitfield, also evoked memories of 9/11; and *Western Deep*, about the Tautona gold mine near Johannesburg, South Africa, the deepest in the world. Both were shown at Documenta 11, an event noted for its foregrounding of issue-based documentary photography, still and moving.

7 Joanna Lowry, 'Slowing Down: Stillness, Time and the Digital Image', *Portfolio*, no. 37 (June 2003) 52.

8 Ibid.

9 Charles Darwent, 'Art at the Extremes', *Art Review* (June 2006) 82.

10 'Magazine Requested "Photogenic" War Widows', *The Independent* (22 September 2006).

11 Nicolas Bourriaud, *Esthétique relationelle*; English edition, *Relational Aesthetics* (Dijon: Les Presses du réel, 2002) 113.

12 Ibid.

13 Ibid.

14 See, for example, Claire Bishop, 'Antagonism and Relational Aesthetics', *October*, no. 110 (Fall 2004) 51–79; Hal Foster, 'Arty Party', *London Review of Books* (4 December 2004) 21–2; Tom McDonough, *'The Most Beautiful Language of My Century': Reinventing the Language of Contestation in Postwar France, 1945–1968* (Cambridge, Massachusetts: The MIT Press, 2007) 190–5; Claire Bishop, ed., *Participation*, Documents of Contemporary Art (London: Whitechapel/Cambridge, Massachusetts: The MIT Press, 2006) 160–71; 190–5. Also relevant is the response of the artist Liam Gillick to Bishop's 2004 article, and her counter-response. See *October*, no. 115 (Winter 2006) 95–107.

15 Nicolas Bourriaud, *Postproduction* (New York: Lukas & Sternberg, 2002; new edition, 2005).

16 Dave Beech, 'Relational Aesthetics: The Art of the Encounter', *Art Monthly*, no. 278 (July–August 2004) 46.

17 Marcus Verhagen, 'Micro-Utopianism', *Art Monthly*, no. 272 (December 2003–January 2004) 4.

David Evans, 'War Artist: Steve McQueen and Postproduction Art', *Afterimage*, vol. 32, no.2 (September–October 2007) 17–20.

At the risk of sounding any New Age bells, I'd like to think of current practices of appropriation in terms of homeopathy

Johanna Burton, 'Subject to Revision', 2004

Each act of appropriation is a promise of transformation: each act of acquisition anticipates the supposed transubstantiation. But instead, it generates and perpetuates reification, the malaise appropriation promises to cure

Benjamin H.D. Buchloh, 'Parody and Appropriation in Francis Picabia, Pop and Sigmar Polke', 1982

APPRAISALS

Benjamin H.D. Buchloh Parody and Appropriation in Francis Picabia, Pop and Sigmar Polke, 1982//178
Douglas Crimp Appropriating Appropriation, 1982//189
John C. Welchman Global Nets: Appropriation and Postmodernity, 2001//194
Johanna Burton Subject to Revision, 2004//205
Isabelle Graw Fascination, Subversion and Dispossession in Appropriation Art, 2004//214
Sven Lütticken The Feathers of the Eagle, 2005//219

Benjamin H.D. Buchloh
Parody and Appropriation in Francis Picabia, Pop and Sigmar Polke//1982

It is not the passion (whether of objects or subjects) for substances that speaks in fetishism, it is the passion for the code, which, by governing both objects and subjects, and by subordinating them to itself, delivers them up to abstract manipulation. This is the fundamental articulation of the ideological process: not in the projection of alienated consciousness into various superstructures, but in the generalization at all levels of a structural code.
– Jean Baudrillard, *Fetishism and Ideology*, 1981

All cultural practice appropriates alien or exotic, peripheral or obsolete elements of discourse into its changing idioms. The motivations and criteria of selection for appropriation are intricately connected with the momentary driving forces of each culture's dynamics. They may range from the crudest motives of imperialist appropriation of foreign (cultural) wealth to the subtle procedures of historic and scientific exploration. In aesthetic practice, appropriation may result from an authentic desire to question the historical validity of a local, contemporary code by linking it to a different set of codes, such as previous styles, heterogeneous iconic sources, or to different modes of production and reception. Appropriation of historical models may be motivated by a desire to establish continuity and tradition and a fiction of identity, as well as originating from a wish to attain universal mastery of all codification systems.

In its most fickle but most powerful version – the discourse of fashion – appropriation as a strategy of commodity innovation reveals its quintessential function: to grant a semblance of historical identity through ritualized consumption. Each act of appropriation is a promise of transformation: each act of acquisition anticipates the supposed transubstantiation. But instead, it generates and perpetuates reification, the malaise appropriation promises to cure. The social behaviour of the contemporary individual, defining itself in the gridlock of depoliticized consumption and consumerized politics, finds its mirror in the model of the contemporary neo-avant-garde artist.

Restricted by postwar Modernism to an artistic practice cut off from socio-political perspectives and the production of use value, the artist was condemned to produce pure exchange value. A contemporary work's capacity to generate exchange value has become the ultimate gauge of its aesthetic validity. The question of style, in much emerging contemporary painting, involves a kind of secret pact, between the producers and their audience, to accept the historical

limitations imposed upon them and to abide by them in a futile repetition of symbolic liberation. This pact of style implies the tacit understanding that, for a period of time, a very limited and precisely defined set of operations on the pictorial signifier is accessible and permitted. All other activities, different or deviant, are temporarily excluded from public perception and suffer defeat before they can acquire cultural standing.

The Modernist artist's isolation from socio-political practice has been framed and legitimized in such ideological concepts as aesthetic autonomy and formalism. It has been continually assaulted from within aesthetic practice itself, by artists who have appropriated production procedures and materials, iconic references, and modes of reception from the domain of so-called 'low' culture or 'mass' culture, introducing them into the discourse of 'high' culture. The range of historical and geographical provinces from which the elements required for the generation of a particular cultural coding system are extracted changes as rapidly as the avant-garde's need for innovative appropriation. A case in point is the shift from the late nineteenth-century interest in *japonisme* to the Cubists' discovery of *art nègre* only to be followed by the Surrealists' subsequent uncovering of yet another terrain of authentic primitivism on the way to children's art and *art brut.* From *faux bois* to *faux naïf,* one discovers in each historical instance of appropriation as much disguise as revelation. High art poses as low art; sophisticated academic erudition poses as primary, unmediated expression; exchange value poses as use value; contemporaneity (and exposure to very specific current ideological pressure) appears in the guise of a concern for universality and timelessness. Every time the avant-garde appropriates elements from the discourses of low, folk or mass culture, it publicly denounces its own elitist isolation and the obsolescence of its inherited production procedures. Ultimately, each such instance of 'bridging the gap between art and life', as Robert Rauschenberg famously put it, only reaffirms the stability of the division because it remains within the context of high art. Each act of cultural appropriation, therefore, constructs a simulacrum of a double negation, denying the validity of individual and original production, yet denying equally the relevance of the specific context and function of the work's own practice.

When Marcel Duchamp appropriated an industrially produced, quotidian object, in order to redefine the cognitive and epistemological status of the aesthetic object, the prophetic voice of Guillaume Apollinaire rightfully hailed him as the one artist who might possibly reconcile art and the people in the twentieth century.

However, this original productivist dimension in Duchamp's work – the symbolic substitution of use value objects for exhibition/exchange value – was ultimately lost in the work's acculturation process. The readymade was reduced

to a philosophical speculation on the epistemological status of objects that function as semiotic elements within an aesthetic structure. Almost fifty years later, at the origin of American Pop art, similar questions were addressed and the same contradictions became apparent. When Robert Rauschenberg and Andy Warhol introduced mechanically produced, 'found' imagery into the high art discourse of painting (by technological procedures of reproduction, such as the dye transfer process and silkscreen printing), gestural identity and originality of expression were repudiated. The very procedures that had concretized notions of creative invention and individual productivity in the preceding decade were now negated in the mechanical construction of the painting. Yet, within the subsequent acculturation process, these works acquired a historical 'meaning' that entirely inverted their original intentions. They became the artistic masterpieces and icons of a decade that established a new viability for the procedures of painting. This occurred despite their radical assault on the isolation of high art, their critique of the rarefied, auratic status imposed on objects in acquiring exchange value, and their denunciation of the obsolescence of artistic constructs originating from the conditions of this isolated social practice.

Each act of appropriation, therefore, inevitably constructs a simulacrum of a double position, distinguishing high from low culture, exchange value from use value, the individual from the social. It perpetuates the separation of various cultural practices, and reaffirms the isolation of individual producers from the collective interests of the society within which they operate. It widens the gap it set out to bridge; it creates the commodity it set out to abolish. By becoming the property of the 'cultural', it prevents the political from becoming real. Politically committed producers become singularized and classified as 'political' artists, in opposition to 'formally' oriented artists or 'self' and 'expression' oriented artists.

Thus, each act of appropriation seems to reaffirm precisely those contradictions it set out to eliminate. Parodistic appropriation reveals the divided situation of the individual in contemporary artistic practice. The individual must claim the constitution of the self in original primary utterances, while being painfully aware of the degree of determination necessary to inscribe the utterance into dominant conventions and rules of codification; reigning signifying practice must be subverted and its deconstruction must be placed in a distribution system (the market), a circulation form (the commodity), and a cultural legitimation system (the institutions of art). All these double binds cancel out the effect of avant-garde interference within the signifying practice, and turn it into a renewed legitimation of existing power structures. Parodistic appropriation anticipates the failure of any attempt to subvert the ruling codification and allies itself, in advance, with the powers that will ultimately turn its deconstructive efforts into a cultural success. Its seemingly radical denial

of authorship, in fact, proposes a voluntary submission to, and passive acceptance of, the hierarchical ordering systems of the code, the division of labour, and the alienation resulting from the work's reification as a commodity. It remains open whether those who pursue strategies of parodistic appropriation know, in advance, that they will emerge victorious from the game of self-denial, once they have been processed through the rules of cultural industry. Or whether their apparent negation of subjectivity and authorship is ultimately only a device to encourage passive acceptance of the limitations that the ideological moulds of society hold for its subjects.

The diversity and range of modes of appropriation were already evident in the first decade of this century, when the original avant-garde confronted the implications of the mass-produced object and its impact on the auratic, singular work of art. If we compare Duchamp's introduction of use value objects into the sphere of exhibition/exchange value with the drawings and paintings of Francis Picabia's mechanical period, the former seems, at first glance, to be far more radical and consequential. Picabia's parodistic appropriation of the drawing style of engineering plans and diagrams makes the linear, individual drawing gesture appear like the blueprint of an alien conception that cancels out the presence of the artistic author; yet this parody remains entirely on the surface of the pictorial construct and within the confines of Modernist avant-garde practice. From its very inception, Picabia's ultimately conservative work limited itself to the dialectical juxtaposition of parodistic mimicry and libidinal reification, which operates within the signifying system alone.

On the other hand, it is Duchamp's radicality that seemingly breached the confines of Modernist aesthetic practice, by actually exchanging the individually crafted or painted simulacrum for the real mass-produced object in actual space. Paradoxically, it is the radicality of this solution – a petit bourgeois radicality, as Daniel Buren once called it – that obliterates the ideological framework (the institution of the museum and the discursive formations of avant-garde production) determining the manipulation of the code. Inevitably, Picabia's position, which remains within the conventions and delimitations of the discourse (while manipulating the codes in a parodistic fashion), is now, once again, the more successful and comfortable position for artists to assume.

Parody, as a mode of ultimate complicity and secret reconciliation (a mode in which the victim identifies itself voluntarily with its defeat, in spite of its seemingly demolishing victory over the oppressor's codes by laughter), not only generates a higher degree of analytical precision in limiting itself to operations upon the signifying system, but also generates a higher degree of historical authenticity, in taking sides with the ruling order (it bathes in ideology, as Louis Althusser once described the condition of art in general). Its opposite denies the

exclusive validity of the system and its codification and insists upon the necessity of transgressing the historical limitations in order to establish a dialectical relationship with realities existing outside of high art practice (such as Duchamp's readymade concept, Productivist art, the theory of factography, and recent contemporary strategies focusing on the introduction of political and critical practice into aesthetic discussion). Despite the apparent radicality and actual critical negation that this work provides, it most often fails to enter the circuit of distribution, the modes of viewing and reading established and maintained by institutions and audiences alike. Ultimately, in as much as these aspects are all integral parts of artistic production, such work thereby paradoxically fails to change the practice of art.

What does it mean, therefore, when a cultural centre that for thirty years has almost programmatically ignored and rejected contemporary art on the European continent, suddenly 'discovers' the 'indigenous' cultural products of its satellites and recycles them into its present-day cultural life? Is it historical justice that the current American interest in European (specifically, Italian and German) painting marks a rediscovery of the cultural autonomy of the overseas provinces?

Or does the expertise in traditional modes of meaning production, generally attributed to Europe as a purveyor of traditionally produced luxury goods, revalidate and authenticate the 'discovery' of local representational painting? If a warranty is needed for the authenticity of historically obsolete practices within an advanced context (cultural or socio-political), one may be found in 'exoticism', the structure by which one language appropriates elements from a foreign or ancient language to recognize and rationalize its own contemporary atavisms. It is symptomatic of these situations that the proper criteria of evaluation, belonging to the cultural standards of the appropriator as well as those inherent in the language of the colonized culture, are not even recognized. The primary function of this model is not to document the existence of alien rituals, rules or practices, but to cast the local atavism into a historical or alien form, to authenticate and valorize the local product. It is not surprising that in the present 'discovery' of German painting by the American market, neither the criteria of quality that have been developed within the North American context itself are applied, nor are the 'discovered' artists those who actually played a significant role in artistic production in Europe during the 1960s and 1970s.

Therefore, it is necessary to introduce into the current (re)discovery of early 1960s German neo-Expressionist painters of minor interest (if we can call the vigour of momentary needs of taste and fashion 'minor') a figure whose body of work from the 1960s and early 1970s is far more consequential for actual pictorial thinking and production, and demonstrates a far more complex understanding of Modernist European and German art of those two decades.

Sigmar Polke is an artist from the historical and geographical provinces of picture production. His work emerged in a situation marked by a lack of understanding and neglect of its proper historical sources, and one that had to open itself all the more to the dominance of American art. The impact of Dada and Duchamp, the positions of the Constructivists and Productivists, were not recognized and reinterpreted, in the German context, until the advent of Fluxus activities, embodied in such figures as George Maciunas. For example, in a letter to the German Fluxus artist Tomas Schmit, Maciunas wrote:

> The goals of Fluxus are social (not aesthetic). Ideologically, they relate to those of the LEF group in 1929 in the Soviet Union, and they aim at the gradual elimination of the fine arts. Therefore, Fluxus is strictly against the art object as a dysfunctional commodity, whose only purpose is to be sold and to support the artist. At best, it can have a temporary pedagogical function and clarify how superfluous art is and how superfluous ultimately it is itself … Secondly, Fluxus is against art as a medium and vehicle for the artist's ego; the applied arts must express objective problems which have to be solved, not the artist's individuality or ego. Therefore, Fluxus has a tendency toward the spirit of the collective, toward anonymity and anti-individualism.

In contrast, the present situation is marked by disillusionment and skepticism toward that progressive legacy of the Modernist tradition. If the first situation was one of naïvety, the second is one of cynicism. The early beginnings of the neo-avant-garde's practices and the current conclusions (which '[stir] in the thickets of long ago', in Walter Benjamin's phrase) seem to have congruent features but they have different origins. Still, both situations – the amazement that originally accompanied the discovery of the avant-garde and now, twenty years later, the cynical rejection and disbelief – use parody as a rhetorical mode for denouncing the claims of a dominant Modernist ideology lacking validity today.

In the early 1960s, when Polke (born in 1941) studied at the Düsseldorf Academy of Fine Arts (after leaving East Germany in 1953), West Germany was a cultural wasteland. The viable indigenous activities of the Weimar Republic had yet to be unearthed from the rubble of the various local mimicries of post-Surrealist automatist painting. German variations of Tachism and Informel painting dominated the academies, and the markets attention was split between imports from the old avant-garde centre, Paris, and the newly emerging domination of the New York School. Avant-garde culture was a foreign language, whose speakers had French, Italian or American names. This country that had recently abandoned its own Modernist traditions had become an ideal province for the importation of neo-avant-garde art, and now generated visual strategies

of parody and appropriation, gazing at the legacy of Modernism from the outside while adapting to its linguistic standards through quotation. The first exhibition in which Polke participated took place in a rented butcher's shop in Düsseldorf in 1963, and grouped him with three other artists. One of them (then a close friend of Polke's) was Gerhard Richter, who has since become known as a key figure in the ironic deconstruction of painting by painting itself. From the very beginning Polke and Richter systematically opposed the inauthentic attempts of neo-Expressionist painters such as Georg Baselitz (who also began working and exhibiting in the early 1960s) to re-establish a local or national continuity of painting, but one that ignored those major developments in twentieth-century German art production after Expressionism that were just about to be rediscovered in the second decade of the postwar period.

Polke and Richter, representing the second generation of the neo-avant-garde in Europe (if we consider Joseph Beuys, Yves Klein and Piero Manzoni to be the first), adopted strategies of appropriation, quotation and parody in a manner similar to that of the generation of American artists that had rediscovered these strategies as part of a more general understanding of the implications of the works of the Dadaists. Labelled 'Pop artists', Roy Lichtenstein, Andy Warhol and their generation faced the same historical dilemma as the European neo-avant-garde. The set of problems was not entirely different from the questions posed by the original avant-garde of the period between 1915 and 1925: the blatant contradictions between mass culture and high culture; the extraordinary impact of technical processes of reproduction on the notion of the unique, auratic work; and the seemingly unbridgeable gap between the isolated, elitist practices of high art production and its ultimate powerlessness in attaining readability for mass audiences. In addition, the neo-avant-garde had to contend with the extraordinary increase in visual manipulation brought about by the rise of advertising, photography, cinema and television. The utopian, naïve hopes for a possible reconciliation of the two spheres – which had inspired the writings of the Russian Productivists and the Surrealists, as well as the theoretical reflections of Walter Benjamin (who was indebted to both) – could no longer be maintained after the war.

It was no surprise, then, that within such a seemingly hermetically secured system of product propaganda and ideological stratification the manipulation of visual signifiers – if they related to objects of reality at all – was performed with an attitude of camp and melancholy, parody and indifference, resignation and indulgence. At the same time, a deeply rooted skepticism toward the validity of the continued production of isolated, high art activities marked the attitude and statements of this generation. When, for example, Lichtenstein talks about his interest in the iconography of the comic strip and Richter talks about his interest

in the iconography of amateur photography, both artists refer to the sources that seem to protect their own artistic production from being instantly identified with being merely a high art practice. Criticism of such strategies as being purely affirmative of mass cultural manipulations, and glamorizing collective alienation, fails to ask the crucial questions these strategies raise, and fails to recognize the actual place of these strategies within the tradition of twentieth-century art. Such criticism also fails to take into account the context of the Modernist tradition as contemporary art's proper historical framework, which must be evaluated before art's transgression of its own codes can be discussed. Therefore, it is not accidental that, in the early to mid 1960s, artists such as Lichtenstein and Warhol interchangeably used iconic representations of objects from advertising and 'low' commodity culture as much as they did the fetish images from the catalogue of mechanically reproduced works of high art. The same holds true for such European artists of the mid to late 1960s as Richter, and, in a more programmatic, parodistic fashion, for Polke.

In Germany at that time, Richter and Polke chose the programmatic stance of what they called 'Capitalist Realism'. The profile of this stance became most poignantly evident during Richter's and Konrad Lueg's *Demonstration for Capitalist Realism* in Düsseldorf (1963), when, for several hours, the two artists placed themselves – as living sculptures – in comfortable chairs on pedestals, in the furniture showroom of a department store. The artists on display epitomized this historical dilemma between high art practice and mass culture, which started with Duchamp and continues right into the present. In Polke's work of that period, this dialectic is concretized in the constant juxtaposition of iconic appropriations from low culture and stylistic appropriations from the signifying practices of high culture. In his large group of 'dot' paintings, produced between 1963 and 1969, Polke introduced mechanically generated iconic schemes (found photographs representing stereotypes of perception). These were imposed on his iconic, chromatic and compositional ordering principles of a rigid, predetermined nature, and enabled him to refrain from almost all 'creative' decisions. Yet, this apparently total determination of iconic representation was negated by its actual construction and manual execution in the painting procedure itself. As in Jasper Johns' flag paintings and Lichtenstein's and Richter's paintings of the early 1960s (and in stark contrast to Warhol's production), each pictorial unit is meticulously executed; critical balance is maintained between the mechanically mass-produced icons and the individually crafted brushstroke, juxtaposing reified code and subversive recodification. In much of this work, from Rauschenberg to Polke, the very nature of the procedure of manufacturing individual visual signs denies its own validity as a process of individuation, by limiting itself to a tightly controlled painterly exercise.

On the other hand, in a group of cloth paintings Polke produced during the same period, all of these principles are inverted. Whereas in the 'dot' paintings, the particularization of the constituent elements of the visual signifier decomposed the found figure into a molecular field, the 'cloth' paintings introduce found materials (black velvet, fake leopard skin, bed sheets, cheap chinoiserie silk) as supports. Superimposed on grounds of deliriously bad taste, as in *Polke as Astronaut* for example, we then find gestures of Modernist painting emptied, made futile by parodistic repetition. In these paintings, expressive and constructive gestures (as well as the self-referential brushstroke and the belaboured denotative contours of iconic representation) are often arbitrarily placed side by side, becoming abbreviations of historical obsolescence and ostentatious stylistic incompetence. They are reminiscent of the involuntary parodistic accumulation of pictorial styles in late Kandinsky or in early Abstract Expressionist work such as Hans Hofmann's, in which automatism, biomorphism and geometric abstraction were juggled.

At this point, it might be worthwhile to remember that these were strategies Picabia had fully developed by the 1920s. We see succeeding sets of parodistic appropriations in the various phases of his oeuvre: the carbon copy icons of his mechanical period, and the contour fixations of art-historical references in his 'transparency' series of the mid 1920s (when he traced and trailed the authoritarian tendencies of *retour à l'ordre* Neoclassicism), followed by his mimetic rendition of pornographic imagery from cinematic or product propaganda sources all through the 1930s and into the early 1940s. By that point, Picabia's production had been overtaken by a compulsive return to representation, the reduction of the visual construct and of perceptual apprehension to isolated scopic acts of identifying and repeating outlined prefigurations. This regressive process corresponded to the fascist violation of political life, in which Picabia participated as an artist (and ultimately as a political subject).

Nowadays, the aesthetic neutralization of the political conflict between high culture and mass culture generates the demeaning pleasures of camp appropriations. Bad taste and black velvet are used as supposedly subversive antidotes to the elitist isolation of bourgeois easel painting and its infra-linguistic disputes. Yet it seems that camp always ultimately sides with the paternal law, as do all discursive practices that attempt to resolve the conflict of domination by disguising their actual oppositional, historical identity in mockery of the ruling order. As in fashion, defined by Walter Benjamin as the 'tiger's leap into the past that happens in an arena which is commanded by the ruling class', the manipulation of a code in stylistic terms alone never leads to the transgression of the code.

Successfully entering the symbolic order of aesthetic language and its conventions, a given style is instantly recognized, commodified and imitated. But the highly overdetermined language conventions of Modernist art practice allow only for a limited number of meaning operations within Modernism's framework; among them are appropriation and quotation, parody and mimicry. Appropriation of style functions as an arbitrary, but strictly delineated, gesture of symbolic subversion of the original code of the style. To remain recognizable, or to be deciphered as parody, the simulacrum has to follow the outline of the code and must ultimately remain within its limits. However, the relationship between the two structures of codification juxtaposed in a parody can vary from tautological to dialectical, and the mode of quotation established with the object, which quotes from them, can range from undulating, ornamental paraphrase to negation of the validity of the coding convention itself.

As previously noted, a given style is the tacit ideological handshake between an author and the institutions that control the definition and distribution of cultural meaning. Thus style, as the very model of individual identity, ends up being a tool for producing instant cultural alienation. The rigour with which a culture has to protect its hierarchical order and privileges determines the degree to which its art will be stylized and the range of stylistic options that will be admissible. The cynical quotation of the historical limitations of a particular stylistic practice today functions as a reassurance for the validity of that practice. Much parodistic appropriation of style denies the speaker's presence and his or her role in attempting to reveal the obsolescence of the discourse. This parodistic speech borders on style only to negate style's validity. Parody of style, however, is not a reliable position. Its ambiguity and balance can be tilted at any moment, and it can easily turn from subversive mimicry to obedience. The mode of parody denies the notion of individuality as private property, which the practice of style in much other contemporary art production seems to suggest. In fact, parodistic appropriation might ultimately deny the validity of art practice as individuation altogether.

Therefore, the historical place of Polke's work is at a juncture (as was that of late Picabia) and emerges from a moment when the credibility of Modernism is in shambles, and its failure and obsolescence have become all too obvious. But this failure is dictated by the violence of political and economic conditions, not by individual or aesthetic circumstances. If we look at parody from the outside, from a perspective that has left behind the field of petty Modernist jokes, which are duplicated by each generation that spirals along the cul-de-sac of Modernism, then its work looks clownish, enslaved and despondent; it appears to be lost in desuetude. If we look at parody from the inside, however, it seems to perform liberation with subversive vigour; it seems to battle successfully

against the haunting spirits of false consciousness that the socio-cultural practice of visual meaning production – once rightfully called 'Modernist art' – nowadays releases. What it fails to claim is the historical option of a perspective that looks at Modernism from the outside, one that insists on reconciling both the individual's constitution in language and ideology, and a foundation in material production and political consciousness.

Benjamin H.D. Buchloh, 'Parody and Appropriation in Francis Picabia, Pop and Sigmar Polke', *Artforum* (March 1982) 28–35; reprinted in Benjamin H.D. Buchloh, *Neo-Avant-garde and Culture Industry: Essays on European and American Art from 1955 to 1975* (Cambridge, Massachusetts: The MIT Press, 2000) 343–64.

Douglas Crimp
Appropriating Appropriation//1982

The strategy of appropriation no longer attests to a particular stance towards the conditions of contemporary culture. To say this is both to suggest that appropriation *did* at first seem to entail a critical position and to admit that such a reading was altogether too simple. Appropriation, pastiche, quotation – these methods extend to virtually every aspect of our culture, from the most cynically calculated products of the fashion and entertainment industries to the most committed critical activities of artists, from the most clearly retrograde works (Michael Graves' buildings, Hans Jürgen Syberberg's films, Robert Mapplethorpe's photographs, David Salle's paintings) to the most seemingly progressive practices (Frank Gehry's architecture, Jean-Marie Straub and Danièle Huillet's cinema, Sherrie Levine's photography, Roland Barthes' texts). If all aspects of the culture use this new operation, then the operation itself cannot indicate a specific reflection upon the culture.

The very ubiquity of a new mode of cultural production does, however, underscore the fact that there has been an important cultural shift in recent years, a shift that I still want to designate as that between modernism and postmodernism, even if the latter term is utterly confusing in its current usages. *Postmodernism* will perhaps begin to acquire meaning beyond the simple naming of a zeitgeist when we are able to employ it to make distinctions within all the various practices of appropriation. What I would like to do here, then, is to suggest some ways in which these distinctions might be approached.

To begin, I should perhaps look more closely at the assertions of the regressive/progressive character of the uses of appropriation by the artists previously named. How, for example, can we distinguish Graves' use of pastiche from that of Gehry? Let us take the most famous building by each architect – Graves' Portland Public Services Building and Gehry's own house in Santa Monica. The Portland building displays an eclectic mix of past architectural styles drawn generally from the orbit of classicism. But it is an already eclectic classicism to which Graves turns – the neoclassicism of Boullée and Ledoux, the pseudo-classicism of Art Deco public buildings, occasional flourishes of beaux-arts pomp. Gehry's house, in contrast, appropriates only a single element from the past. It is not, however, an element of style; it is an already existing 1920s clapboard house. This house is then collaged with (surrounded by, shot through with) mass-produced, from-the-catalogue materials of the construction industry – corrugated iron, chain-link fence, plywood, asphalt.

Differences between these two practices are immediately obvious: Graves appropriates from the architectural past; Gehry appropriates laterally, from the present. Graves appropriates style; Gehry, material. What different readings result from these two modes of appropriation? Graves' approach to architecture returns to a pre-modernist understanding of the art as a creative combination of elements derived from a historically given vocabulary (these elements are also said to derive from nature, but nature as understood in the nineteenth century). Graves' approach is thus like that of beaux-arts architects, against whom modernist architects would react. Although there can be no illusion that the elements of style are originated by the architect, there is a very strong illusion indeed of the wholeness of the end product and of the architect's creative contribution to the uninterrupted, ongoing tradition of architecture. Graves' eclecticism, thus maintains the integrity of a self-enclosed history of architectural style, a pseudo-history immune to problematic incursions from real historical developments (one of which would be modern architecture, if it is considered as more than merely another style).

Gehry's practice, however, retains the historical lessons of modernism even as it criticizes modernism's idealist dimension from a postmodernist perspective. Gehry takes from history an actual object (the existing house), not an abstracted style. His use of present-day products of the building trade reflects on the current material conditions of architecture. Unlike the sandstone or marble that Graves uses or imitates, Gehry's materials cannot pretend to a timeless universality. Moreover, the individual elements of Gehry's house resolutely maintain their identities. They do not combine into an illusion of a seamless whole. The house appears as a collage of fragments, declaring its contingency as would a movie set seen on a sound stage (a comparison this house directly solicits), and these fragments never add up to a style. Gehry's house is a response to a specific architectural program; it cannot be indiscriminately reapplied in another context. Graves' vocabulary, on the other hand, will seem to him as appropriate to a tea kettle or a line of fabrics as to a showroom or a skyscraper.

What, then, becomes of these differences when applied to photography? Can analogous distinctions be made between the photographic borrowings of Robert Mapplethorpe on the one hand and Sherrie Levine on the other? Mapplethorpe's photographs, whether portraits, nudes or still lifes (and it is not coincidental that they fall so neatly into these traditional artistic genres), appropriate the stylistics of pre-war studio photography. Their compositions, poses, lighting, and even their subjects (*mondain* personalities, glacial nudes, tulips) recall *Vanity Fair* and *Vogue* at that historical juncture when such artists as Edward Stiechen and Man Ray contributed to those publications an intimate knowledge of

international art photography. Mapplethorpe's abstraction and fetishization of objects refer, through the mediation of the fashion industry, to Edward Weston, while his abstraction of the *subject* refers to the neoclassical pretences of George Platt Lynes. Just as Graves finds his style in a few carefully selected moments of architectural history, so Mapplethorpe constructs from his historical sources a synthetic 'personal' vision that is yet another creative link in photographic history's endless chain of possibilities.

When Levine wished to make reference to Edward Weston and to the photographic variant of the neoclassical nude, she did so by simply rephotographing Weston's pictures of his young son Neil – no combinations, no transformations, no additions, no synthesis. Like the 1920s house that forms the core of Gehry's design, Weston's nudes are appropriated whole. In such an undisguised theft of already existing images, Levine lays no claim to conventional notions of artistic creativity. She makes use of the images, but not to constitute a style of her own. Her appropriations have only functional value for the particular historical discourses into which they are inserted. In the case of the Weston nudes, that discourse is the very one in which Mapplethorpe's photographs naïvely participate. In this respect, Levine's appropriation reflects on the strategy of appropriation itself – the appropriation by Weston of classical sculptural style; the appropriation by Mapplethorpe of Weston's style; the appropriation by the institutions of high art of both Weston and Mapplethorpe, indeed of photography in general; and finally, photography as a tool of appropriation. Using photography instrumentally as Levine does, she is not confined to the specific medium of photography. She can also appropriate paintings (or reproductions of paintings). In contrast, the rejection of photography as a possible tool guarantees the atavism of the painters' recent pastiches, since they remain dependent on modes of imitation/transformation that are no different from those practiced by nineteenth-century academicians. Like Graves and Mapplethorpe, such painters appropriate style, not material, except when they use the traditional form of collage. Only Levine has been canny enough to appropriate painting whole, in its material form, by staging, in collaboration with Louise Lawler, an exhibition at/of the studio of the late painter Dimitri Merinoff.

The centrality of photography within the current range of practices makes it crucial to a theoretical distinction between modernism and postmodernism. Not only has photography so thoroughly saturated our visual environment as to make the invention of visual images seem archaic, but it is also clear that photography is too multiple, too useful to other discourses, ever to be wholly contained within traditional definitions of art. Photography will always exceed the institutions of art, will always participate in non-art practices, will always

threaten the insularity of art's discourse. In this regard, I want to return to the context in which photography first suggested to me the moment of transition to postmodernism.

In my essay 'On the Museum's Ruins', I suggested that Robert Rauschenberg's works of the early 1960s threatened the museum's order of discourse. The vast array of objects that the museum had always attempted to systematize now reinvaded the institution as pure heterogeneity. What struck me as crucial was these works' destruction of the guarded autonomy of modernist painting through the introduction of photography onto the surface of the canvas. This move was important not only because it spelled the extinction of the traditional production mode but also because it questioned all the claims to authenticity according to which the museum determined its body of objects and its field of knowledge.

When the determinants of a discursive field begin to break down, a whole range of new possibilities for knowledge opens up that could not have been foreseen from within the former field. And in the years following Rauschenberg's appropriation of photographic images – his very real disintegration of the boundaries between art and non-art – a whole new set of aesthetic activities *did* take place. These activities could not be contained within the space of the museum or accounted for by the museum's discursive system. The crisis thus precipitated was met, of course, by attempts to deny that any significant change had occurred and to recuperate traditional forms. A new set of appropriations aided this recuperation: revivals of long-outmoded techniques such as painting al fresco (albeit on portable panels to ensure saleability) and casting sculpture in bronze, rehabilitations of *retardataire* artists such as nineteenth-century *pompiers* and between-the-wars realists, and re-evaluations of hitherto secondary products such as architects' drawings and commercial photography.

It was in relation to this last response to the museum's crisis – the wholesale acceptance of photography as a museum art – that it seemed to me a number of recent photographic practices using the strategy of appropriation functioned. Thus, Richard Prince's appropriation of advertising images, his thrusting unaltered pictures into the context of the art gallery, exactly duplicated – but in an undisguised manner – the appropriation by art institutions of earlier commercial photography. In like fashion, it appeared that the so-called directorial mode of art photography (which I prefer to call auteur photography) was wryly mocked by Laurie Simmons' setup shots of doll houses and plastic cowboys or by Cindy Sherman's ersatz film stills, which implicitly attacked auteurism by equating the known artifice of the actress in front of the camera with the supposed authenticity of the director behind it.

Certainly I did not expect this work simply to function as a programmatic or instrumental critique of the institutional force of the museum. Like

Rauschenberg's pictures, all works made within the compass of existing art institutions will inevitably find their discursive life and actual resting place within those institutions. But when these practices begin, even if very subtly, to accommodate themselves to the desires of the institutional discourse – as in the case of Prince's extreme mediation of the advertising image or Sherman's abandonment of the movie still's *mise-en-scène* in favour of close-ups of the 'star' – they allow themselves simply to enter that discourse (rather than to intervene within it) on a par with the very objects they had once appeared ready to displace. And in this way the strategy of appropriation becomes just another academic category – a thematic – through which the museum organizes its objects.[1]

A particularly illuminating example of the current conditions of art is provided again by the work of Rauschenberg. In his recent work he has returned to one of his early interests –photography. But now he uses photography not as a reproductive technology through which images can be transferred from one place in the culture to another – from, say, the daily newspaper to the surface of painting – but rather as an art medium traditionally conceived. Rauschenberg has become, in short, a photographer. And what does he find with his camera, what does he see through his lens, but all those objects in the world that look like passages from his own art. Rauschenberg thus appropriates his own work, converts it from material to style, and delivers it up in this new form to satisfy the museum's desire for appropriated photographic images.

1 The reference here was pointed: this essay was written for the catalogue of *Image Scavengers: Photography*, part of a double exhibition also including *Image Scavengers: Painting*, presented at the Institute of Contemporary Art, University of Pennsylvania, 8 December 1982 – 30 January 1983, using 'appropriation' as an organizing theme.

Douglas Crimp, 'Appropriating Appropriation', in *Image Scavengers* (Philadelphia: Institute of Contemporary Art, 1983); reprinted in Douglas Crimp, *On the Museum's Ruins* (Cambridge, Massachusetts and London: The MIT Press, 1993) 126–37.

John C. Welchman
Global Nets: Appropriation and Postmodernity//2001

[...] Seen across one of its longest horizons, the term 'appropriation' stands for the relocation, annexation or theft of cultural properties – whether objects, ideas or notations – associated with the rise of European colonialism and global capital. It is underwritten by the formation of disciplines such as anthropology, museology and allied epistemologies of description, collecting, comparison and evaluation. Consideration of cultural appropriation has given rise to several sustained enquiries into the reach and restrictions of intellectual property, copyright law, governmental restitution and reparations, and questions of ownership and community rights. Ranging across art, music, narratives, symbolic systems, scientific knowledge, materials and land, these include studies of the aestheticization and sheer consumption of cultural difference, whose exchange and mart has been understood as the great driving force of appropriation.[1] Thinking especially of the uneven flows of citation and taking instituted between Western and non-Western cultures, one measure of the impact of appropriation has been gauged through both the tangible and invisible damage it may inflict on local communities through various 'deprivation[s] of material advantage'.[2] Yet the notion of 'advantage' has become increasingly difficult to fix. The Cuban writer Gerardo Mosquera is one of several Latin American commentators who have addressed the paradox that the globalized vortex of 'mixing, multiplicity, appropriation and resemanticizing' takes place in a situation where 'all cultures "steal" from one another, be it from positions of dominance or subordination'.[3] In his view, a number of Latin American and Los Angeles-based artists have 'maximized the complexity of implications wrapped up in transcultural citation and appropriation', and, along with their associated critics, have therefore served as 'transgressors and transferors [*trasvasadores*] of meaning, developing a theory of appropriation as anti-hegemonic cultural affirmation'.[4]

Within the systematic deracination of property legitimized by colonialist discourse and the powers of capital, the museum has played a key role both as a repository and an 'appropriating agency'.[5] In the 1990s, a shift has taken place in staging the historical self-consciousness of the museum or gallery and its parameters of exhibition. The first wave of institutional critique, arriving in the late 1960s and early 1970s, and concerned largely with exposing or ironizing the structures and logic of the museum, has given way to more interactive, performative interventions, which also meditate on the question of appropriation itself. This first generation included the parodic counter-

classifications of Marcel Broodthaers' *Museum of Modern Art* (1968-72).[6] Around the same time, Hans Haacke began a series of projects insisting that the museum should become an arena of declarative economic realism, a repository for art-assisted research on the social conditions and political implications of its own function – corporate sponsorship, trustee activities, the social profile of its visitors, the historical exchange-value of the objects it collects, and so on. Building on this base, more recent institutionally oriented practice, including work by Fred Wilson, Renée Green, Andrea Fraser, Barbara Bloom and others, has opened up new spaces for reckoning with the living history of the museum, its social outreach and pedagogy, and the itineraries it organizes or presupposes. Some of this work reflects on the Eurocentric relocation of appropriated material and its relationship to Western art objects, and to the racial politics caught up between the museum's managers, workers and audiences.

The late 1980s and early 1990s also spawned a series of para-museums and reinterpretational centres, such as the Museum of Jurassic Technology[7] and The Center for Land Use Interpretation –the former located in Venice, California, the latter with an office there, and outstations and activities elsewhere. They also gave rise to a number of exhibitions, situated within and around conventional museums, that sought to interrogate 'the museum-culture of appropriation'.[8] *The? Exhibition?* aka 'The Curator's Egg' (Ashmolean Museum, Oxford, December 1991 – May 1992) offered one of the fullest of these reckonings, attempting to interrupt normative museum experience and display routines by reconfiguring interpretative labelling, juxtaposing popular cultural material with revered classical art objects, and deconstructing the exhibition space itself. The original objective of this show was to 'speak through ... the museum's appropriative discourses: to prise them apart',[9] by making visible questions of curatorial etiquette and decision-making, challenging the devices that inscribe the visitor into the museum experience (comment books, marketing, finance, taste, classification) and disturbing the prescribed routines of silent contemplation, non-tactile interaction, and one-way routing. Prompted by the Ashmolean's ancient collection and historic location, a related focus suggested that the Western culture of appropriation had an origin in one of the greatest historical exercises of material repossession: the annexation and absorption of other European and Mediterranean cultures by the Roman Empire from the second century BCE to the third century AD. Within this regime of fragmentation, dismemberment and plunder – and the scholarly sanctification that has often attended it – 'The Curator's Egg' made it clear that '"Appropriation" is already written in the history of ancient objects'.[10]

Among the theorists of appropriation, it is Georges Bataille who offers the term perhaps its greatest, and most troubling, cultural extension. In his essay on

the Marquis de Sade, Bataille correlates appropriation with bodies, unitary and collective, identifying 'two polarized human impulses: EXCRETION and APPROPRIATION' which follow on from 'the division of social facts into religious facts ... on the one hand and profane facts ... on the other'.[11] Excretion, he suggests, is associated with the heterogeneous expulsion of foreign bodies: with 'sexual activity ... heedless expenditure ... certain fanciful uses of money' and 'religious ecstasy'.[12] Appropriation, on the other hand, finds its 'elementary form' in 'oral consumption', and its process 'is thus characterized by a homogeneity (static equilibrium) of the author of the appropriation, and of objects as a final result'. Appropriational experience may begin with the ordering of foreign bodies through digestive incorporation, but it extends to analogous forms of additive material: 'clothes, furniture, dwellings, and instruments of production ... finally ... land divided into parcels'. 'Such appropriations', notes Bataille, 'take place by means of a more or less conventional homogeneity (identity) established between the possessor and the object possessed'.[13] In this reckoning, appropriation is aligned with what Gilles Deleuze and Félix Guattari describe as the striation of space with hierarchization, convention, identity, classification and possession, while excretion is a form of becoming-animal staged in the smooth space of deterritorialized desire.[14] Like Deleuze and Guattari, however, Bataille refuses to lock his oppositional constructs into binary separation, for 'production can be seen as the excretory phase of a process of appropriation, and the same is true of selling', while the practice of 'heterology' 'leads to the complete reversal of the philosophical process, which ceases to be the instrument of appropriation, and now serves excretion; it introduces the demand for violent gratifications implied by social life'.[15] If the borderline 'philosophy' that Bataille calls 'heterology' can be redeemed in voiding and violence, no such gratificatory discomfort is associated with representation itself. For the desire to imitate, make or copy is caught up in 'the persistence of a dominant need for appropriation, the sickly obstinacy of a will seeking to represent, in spite of everything, and through simple cowardice, a homogenous and servile world'.[16] This trenchant attack on the predicates of representation serves as a caution and a blindside. For the species of representation that the art world has for two decades called 'appropriation' invests, on its surface at least, in an even more extreme antithesis (more cowardly, obstinate, sickly and servile) to the heterological discharge elevated by Bataille. [...]

One of the fullest reassessments of appropriation at the end of the 1980s arrived with Mike Kelley's rehabilitation of craft objects. Consideration of this work also grants us access to a different formation of the spectralism so often associated with the photographic or citational sign; returns to the more disturbing aspects

of appropriation proposed by Bataille; and offers an important critical narrative across the divide between the 1980s and 1990s. Kelley's found, stuffed-toy animals, afghans and rugs offered a reversion to the blank or invisible object that, as he insisted from his student days at Cal Arts, substituted for the reductivism of the Conceptual aesthetic (with its imageless art works) and 'the making of blank things'.[17] Cut out of an Oedipal triangle in which Kelley's mother made quilts, cosies and pillows, and the adolescent Kelley took up sewing largely to snipe at his father's desire for a manly son,[18] craft-type soft stuff made its first appearance with the felt banner of *Janitorial Transcendence* (1980) and the funny frog doll projected as part of the slide show in *Confusion* (1982). As Kelley began to accumulate thrift-store materials, he built a double sense of profusion and singularity into the first of several overlapping waves of work with craft objects initiated by *More Love Hours Than Can Ever Be Repaid* (1987) [discussed in the context of the gift and the rebate in *Art after Appropriation*, chapter 5]. A second phase of Kelley's craft work moved away from wall-bound hanging pieces that invested his found objects with pictorial individuality. The 'Arena' and 'Dialogues' series posed objects on covers and blankets in order to solicit – and sometimes thwart – interactive exchange with the viewer. Finally, the 'blunt' taxonomic organization of *Craft Flow Morphology Chart* (1991) made another explicit move against the persistent association of Kelley's craft objects with nostalgia and infantile recidivism. Laid out on 52 folding table tops according to their size and iconography, and photographed against a ruler, like archaeological bones or shards, the congregation of found, homemade stuffed animals was reconfigured as material units and conferred with sculptural sheen. The work took on the restoration of analytic 'order' to objects whose 'culturally unconscious production modes' had always tended to resist inquiry and dissolve into affect.[19]

Mobilizing the unsung, labour-intensive, personal-yet-anonymous investments of craft, long vilified or disparaged by the high-art tradition, Kelley moves through a key terrain in what I have referred to [earlier in this essay] as post-appropriation. For in addition to posing emblematically kitschy material in counter-nostalgic, non-heroic aggregates, Kelley's floor pieces engage in a specific dialogue with the 'classical',[20] enshelved commodity objects of Haim Steinbach. The two bodies of work are locked in an unremitting dialogue of differences and overlays, rare if not unique in Kelley's career. Sited on the floor (and later hanging from the ceiling), the afghans, blankets or other ground covers refuse to raise up the stuffed animals and rag-dolls dwelling on them to the at-arm's-length commodity platforms of Steinbach's unearthly para-Minimalist shelves. Instead, they work with the other hand. Their stitching, knitting, plucking, throwing, tinkering gestures, issued from rural, suburban or working-class cultures, are clenched in a retort to the *noli me tangere* seduction

of the mass-produced commodity and the metropolitan vitrine. As we read between the lines of these appropriations, however, all is not what it seams.

In one sense, the 'arrangements' and conversational postures of Kelley's pieces, assembled in witty confrontations and loopy scenes of mutual address, are every bit as organized as Steinbach's pristine products. As if to emphasize this through a form of retreat – crossing it with the idea of invisibility already associated with craft in general – Kelley sometimes relocates his menagerie (or rather, what we assume are his animals) under the covers, creating an undulating landscape of hidden protrusions. These revisions of the Surrealist object efface the now-unseen appropriated material with a cover, or ground, that is itself appropriated. Such a removal of the primary object underneath its own cover resembles the infant's adoption of special objects in its journey to the Not-Me symbolic order. The piece of blanket, symbolic of the mother's breast, becomes in Kelley's work both the transitional object (not yet a whole teddy bear, or whatever) and its territory, that which wraps around it. It is, simultaneously, the figure and ground.

Worn, chatting, furry, sometimes unstitched – but always spinning their yarns – Kelley's creatures stage their encounter with hard, unsoiled commodities on the unravelled underside of Steinbach's perfectly bevelled shelves. They are tossed, thrown, kicked and played with, while Steinbach's are stacked, polished, balanced, eyed-up – and possibly, though gingerly, handled. Moving from Steinbach to Kelley allows us to trace the difference between the abstraction and concretion of exchange, predicated on symmetrical moves from hands-on to hands-off production. Kelley's fluffy poseurs are props, characters and subjective residuals. We invest them with a kind of pathetic sublime, while they engulf us in retroactive infancy. Steinbach's objects radiate iconic prestige and upward mobility; Kelley's are worn, discarded and inept. Both are recycled, Steinbach's simply through their disposition; Kelley's across generations, as they pass through thousands of hours of mauling, desire and abuse. Steinbach's commodities seem obedient only to their decracinated origins, finally coming to rest in an ineffable double market as their art-bound afterlife replaces an imaginary sell-by shelf life.

In an important sense, Steinbach is interested in object positions and social simulations, Kelley in object relations and interpersonal dynamics. According to clinical psychologist D.W. Winnicott, transitional objects broker the 'sequence of events which starts with the new-born infant's fist-in-mouth activities, and that leads eventually to an attachment to a teddy, a doll or soft toy, or to a hard toy'.[21] Like Kelley's soiled playthings, they are often 'dirty and smelly', and may be left unwashed to preserve their associative and future symbolic values. Both Kelley and Winnicott are especially interested in the move to a social afterlife that

starts out at the trailhead of the remaindered object. In what Winnicott refers to as the 'health' situation of normative decathecting (psychological relinquishment), transitional objects are subject to decisive but memorial abandonment: they are, he says, 'not forgotten and not mourned'. The terrain shared between Kelley's arrangements and the observations of clinical psychology both splits and converges around the transitional object. Kelley's preoccupation with the 'failure'[22] of the craft object (signalled by its soiled imperfection) to live up to the ideals encoded in the manufactured commodity, crosses with psychological outcomes of the child's negotiation with these key forms. The transitional object, successfully abandoned in the art arena, forms a horizon for Kelley's encounter with subjective and art histories, popular culture, deviance, criminality and the 'differences' encountered in and between them. These coordinates reappear as functions of post-object behaviour as Winnicott thinks through the socialized afterlife of the transitional object. Founded in the administration of 'illusion', the childhood use and post-infantile 'distortion' of transitional objects embraces the individual's capacities for the 'intense experiencing' that belongs to 'play', 'artistic creation', 'religious feeling' and 'dreaming'. At the same time, a regressive actualization may result in adult 'fetishism' and criminality – 'lying and stealing' as Winnicott has it. The play of the transitional object 'gives room for the process of becoming able to accept difference and similarity',[23] lifelong activities that also form the symptomatic axes, props and stage of Kelley's whole associative drama.

The decay and resurrection of Kelley's folk cosmologies are always embodied, not rationalized; performed not taken, experienced not proven, and projected rather than encoded. They thrive not in an abstract geometry of opinion but in that special arena he has made his own, formed between mainstream and alternative popular cultures as they self-consciously meddle in the production of art. But Kelley presses further, merging this intersection not only with the empirical insights of object relations but also with Bataille's notion of heterogeneity. Bataille associates 'homogenous reality' with the domain of 'inert objects', 'with the abstract and neutral aspect of strictly defined and identified objects'. Like Kelley, Bataille is less interested in 'the specific reality of solid objects' than in 'symbols charged with affective value' located in the 'passage' of a 'force or shock' – 'as if the change were taking place not in the world of objects but only in the judgements of the subject'.[24] This is the final arena in which the craft objects function, a territory of exchanges, transitions, shocks, and affective forces that catch the subject in process and reveal how its judgements or desires rise, and fall.

How do these positions relate to the narratives [developed earlier in the essay] of 1980s postmodern appropriation? Kelley identified his relationship to the New

York 'Pictures' generation as founded in their assumption of different disguises or masquerades. While Prince, Sherman and company, he suggested, 'adopted media personas, I tended to adopt different subcultural personas'.[25] Another way to come at this difference, crucial to Kelley's location in the East Coast dominated theorization of 1980s visual postmodernism, might be to address the different referential outcomes of their strategies of appropriation. In both cases, these turn on a form of troubled, almost invisible, or ghostly, re-formation of a quoted sign. The ghost-like residua glimpsed in canonical postmodern appropriation is invested in the palpitation of the solid referent. Such work trades in the contraband aura of things with hard edges, whether the vibrational side of the found object or the definitional chemistry of a recycled photograph. Douglas Crimp, for example, writes of the 'Hitchcockian dimension' of 'strangeness' brought on by Prince's rephotographed photographs as they are invaded by the 'ghosts of fiction'. The 'brutal familiarity' of their initial appearance is short-circuited in this reading by the arrival of 'an aura … not of presence but of absence'. Their originless inauthenticity gives rise, then, to a moment in which 'the aura has become only a presence, which is to say a ghost'.[26]

Kelley's spectral vision works almost in reverse. His realization of ghostly forms starts out with vivid caricatures of literal spirits, moves to an ironic mimicry of the kind of psychological cliché 'which explains the child's attraction to such conventionalized images of horror as ghosts', and ends in spectral extremity.[27] Rather than metaphorizing ghostly effects as an apparition of doubled meaning, he offers us mock séance and social parody, crossing these with an associative commentary on the implicatons of 'possession'. At the centre of his contribution to *The Poltergeist* (1979),[28] a collaboration with occult Conceptualist David Askevold, and Kelley's most obvious repository of ghoulish forms, he posed a set of four black and white, pseudo-vintage photographs, each representing the artist as a transported subject exhausting faked ectoplasm from the nose in streaming upward torrents, and surrounded by a rim of off-beat choric text – 'carnal baggage left behind on a trip to the spiritual'. Ranking these are two drawing-texts, *Bo Bo Cuck is a Ventriloquist* and *Energy Made Visible,* which associate the force of the poltergeist with the disturbed eruptions of adolescence, for the 'Poltergeist is a force and not a being like a ghost …'.

Kelley offered the piece as a kind of revenge on the poker-faced factographic enquiries of Conceptually oriented photo-texts and socially critical 'documentary'. Gaming in the conditions of fake and truth, and absconding with the perfervid simulation of the turn of the century (rather than the knowing one at the end of it), Kelley routes his phantom history from an overcoded popular cultural transcendence to the extenuations of adolescence. In each of these appearances, however, as well as in further metaphors and allusions suggested in the

accompanying texts, the spectral is an emanation, a literal (if faked) stream of substance, or an uncontrollable flow-and-blockage system of juvenile desire and guilt. Tied to eruptive physicality and its symptoms, found material is never fully sequestered from its context, as with much of the appropriation art of the 1980s. Or at least not for long. It is a mark of Kelley's borrowings that they operate in a dense switch-system of embedded allusion which shuttles reference between histories (*fin-de-siècle* occultism and post-McCarthyite fantasy), genres (spiritualist documentation, the comic strip), subjects (the possessed, the juvenile), and affects (the rush of the poltergeist, the swings of adolescence). This to-and-fro referential exchange is not only plural and mobile, it is also unbuffered: Kelley releases the effects of his pieces to collide and collude together, delivering something of the shock of their appearance and reformulation in a manner altogether different from the restraint and formal order of most New York appropriation and its critical predicate of 'unitary deconstruction'. [...]

Hal Foster, Douglas Crimp and other commentators on the 1980s, we recall, often supplied their position-papers addressing New York postmodernism with sustained reference to the achievements and contradictions, as well as the limits and failures, of previous art movements. Foster's essay on the double agenda of Minimalism, for example, exemplifies their careful negotiation with the recent past.[29] And Crimp, shifting a decade, suggests that while Performance, with its sense of duration and spectatorial presence, was the dominant 'aesthetic mode' during the 1970s, the photo-based interrogation of representation, with its 'predicate of absence', which began to replace it around 1976, in fact delivered up an 'extraordinary presence', available only in and through its correlate and seeming antithesis. In a similar vein, Crimp also raises the 'question of subjectivity' around photography that was embedded in discourses of the originless copy and authorless production.[30]

The Derridian sleight of hand that produces this dialectical exchange returns us, finally, to those ghost stories told in the firelight of the New British Art, and forever echoing around the body or object of appropriation. Crimp, as we have seen, narrates the effects of postmodern photographies with his own version of phantom history that – even though we catch him reading backwards – stands the unseen on its head. In New York in the early 1980s, everything that was on the side of the spectral in London a decade later – everything on which art might be predicated – is lodged in the site of representation. Crimp's determination that Prince's rephotographs attain a 'Hitchcockian dimension' of 'strangeness' as they are invaded by the 'ghosts of fiction', and his avowal that their originless inauthenticity gives rise to a moment in which 'the aura has become only a presence, which is to say a ghost',[31] offers the spectral effect as a retort to the

Bataillian dismissal of appropriation as the most weak-willed and servile form of representation – which is itself in the service of sickly order and social constraint. In the later 1980s and 1990s, revisionist scholarship and the critical avant-garde of the art world would find an external referent for the spectral effects that Crimp has subtly internalized, routing them from the mechanics of appropriation to a reflexive drive for inclusion that gave rise to what Clifford Geertz once referred to as 'haunted reflections on Otherness'.[32] [...]

1 See Deborah Root's *Cannibal Culture: Art, Appropriation and the Commodification of Difference* (Boulder, Colorado: Westview, 1996), a somewhat meandering 'topography of the West's will to aestheticize and consume cultural difference ... organized around the central image of the legendary cannibal monster who consumes and consumes, only to become hungrier and more destructive' (xiii). If appropriation is thought of as an exchange value, already implicated in commodification, its borrowings are invested with a strong sense of return, not of that which was appropriated, but of the cultural interest raised from newly hybridized products (see page 68). Relevant also, in the sphere of writing and publication, are theories of 'intertextuality', especially those advanced by Julia Kristeva, who suggests that 'any text is constructed as a mosaic of quotations; any text is the absorption and transformation of another': 'Word, Dialogue and Novel', in *Desire in Language: A Semiotic Approach to Literature,* trans Thomas Gora, Alice Jardine and Leon S. Roudiez (New York: Columbia University Press, 1980) 66. See also Martha Woodmansee and Peter Jaszi, eds, *The Construction of Authorship: Textual Appropriation in Law and Literature* (Durham, North Carolina: Duke University Press, 1994). For discussion of intertextuality in the visual arts, see Wendy Steiner, 'Intertextuality in Painting', *American Journal of Semiotics*, vol. 3, no. 4 (1985) 57–67.

2 See Bruce Ziff and Pratima Rao, eds, *Borrowed Power: Essays on Cultural Appropriation* (New Brunswick: Rutgers University Press, 1997), especially pages 14 and following, where the legal judgement for seven Aboriginal painters against a manufacturer of patterned carpets who appropriated their designs is cited from an Australian court ruling.

3 Gerardo Mosquera, 'Stealing From the Global Pie: Globalization, Difference and Cultural Appropriation', *Art Papers*, vol. 21 (March–April 1997) 13–14.

4 Ibid., 14. See also Nelly Richard, *La estratificación de los márgenes* (Santiago de Chile: Francisco Zegers Editore, 1988).

5 Susan Pierce, ed., *Museums and the Appropriation of Culture* (*New Research in Museum Studies*, vol. 4) (London: Athlone Press, 1994) 1.

6 Initiated in 1968, the *Musée d'Art Moderne, Département des Aigles, Section XIXe Siècle* (the full title of the project according to the letterhead specially prepared by Broodthaers) continued in a series of exhibitions and installations culminating in *L'Angélus de Daumier* at the Palais Rothschild in 1975. See Benjamin H.D. Buchloh, 'The Museum Fictions of Marcel Broodthaers' in *Museums by Artists*, ed. A.A. Bronson and Peggy Gale (Toronto: Art Metropole, 1983) 45–56.

7 For a brief, early (1991), account of the MJT, see Ralph Rugoff, 'The Museum of Jurassic

Technology', collected in *Circus Americana* (London and New York: Verso, 1995) 97–100. Rugoff emphasises the MJT's 'romantic' inversions, 'cognitive dissonance', sedimentations of a fugitive past, and its role in the revelation of 'the bizarness of our cultural institutions'. Its clarified packaging of borderline disinformation 'belies the coherent identity of any museum collection' (100).

8 Ibid., 7.

9 Mary Beard and John Henderson, '"Please Don't Touch the Ceiling": The Culture of Appropriation', in ibid., 7–8. However, instead of being able to speak through these issues, the exhibition eventually became 'an exploration within the museum's own culture and language: an exploration of the values, the claims to value, the legitimation of value, that the museum supports; a questioning of the voices to be heard within the museum …; a meditation on 'what we see' there, on the ways that vision is policed, on the museum's appropriation of its visitors' eyes; a question mark plac[ed] over the museum as a whole – whose museum? whose objects? whose story? whose questions?' (8).

10 Ibid., 12.

11 Georges Bataille, 'The Use Value of D.A.F. de Sade', in Allan Stoekl, ed., *Visions of Excess: Selected Writings 1927–1939*, trans. Stoekl, with Carl R. Lovitt and Donald M. Leslie Jr. (Minneapolis: University of Minnesota Press, 1985) 94.

12 Ibid., 94.

13 Ibid., 95.

14 See chapter 14, '1440: The Smooth and the Striated' in Gilles Deleuze and Félix Guattari, *A Thousand Plateaus*, vol. II of *Capitalism and Schizophrenia* (1980), trans. Brian Massumi (Minneapolis: University of Minnesota Press, 1988) 474–500.

15 Ibid., 95; 97.

16 Ibid., 98.

17 [footnote 145 in source]. Interview with John Miller in William S. Bartman and Miyoshi Barosh, eds, *Mike Kelley* (Los Angeles: A.R.T. [Art Resources Transfer], 1992) 7.

18 [146] For details see Marsha Miro, 'Mike Kelley destroys all art preconceptions', in *Destroy All Monsters: Geisha This,* [compilation of the first six issues *of Destroy All Monsters* magazine 1875–79], ed. Gary Loren (Oak Park, Michigan: Book Beat Gallery, 1995) np; interview with John Miller, op. cit; and Mike Kelley, 'Some Aesthetic High Points' (1992), in *Mike Kelley* (Los Angeles: A.R.T., 1992).

19 [147] Interview with José Álvaro Perdices, 'My Universal System is a Dystopian One', *Sin Título*, no. 5 (Cuenca, Spain: Centre de Creación Experimental, 1988) 22.

20 [148] See interview with John Miller, op. cit., 19, where Kelley explains that he was 'trying to put all the things into them [his 'arrangements on the blankets'] that I felt Haim left out of his [works]'.

21 [149] D.W. Winnicott, 'Transitional Objects and Transitional Phenomena' (1951), in *Through Paediatrics to Psycho-analysis* (New York: Basic Books, 1975) 229.

22 [150] Mike Kelley and Julie Sylvester, 'Talking Failure', *Parkett*, no. 51 (1992) 100.

23 [151] Winnicott, 'Transitional Objects', op. cit., 232–4; 242.

24 [152] Georges Bataille, 'The Psychological Structure of Fascism', in *Visions of Excess*, op. cit., 145.

25 [153] Thomas Kellein, 'Mike Kelley/Thomas Kellein: A Conversation' (Stuttgart: Cantz, 1994) 15.

26 [154] Ibid., 159.

27 [155] Mike Kelley, *We Communicate Only Through Our Shared Dismissal of the Pre-Linguistic* (1995), case no. 2, 'John P'; reprinted in John C. Welchman, Isabelle Graw, Anthony Vidler, *Mike Kelley* (London and New York: Phaidon, 1999) 152.

28 [156] 'The Poltergeist: A Work Between David Askevold and Mike Kelley' (Los Angeles: Foundation for Art Resources, 1979).

29 [161] See Foster, 'The Crux of Minimalism', in Howard Singerman, ed., *Individuals: A Selected History of Contemporary Art 1945–1986* (Los Angeles: The Museum of Contemporary Art/New York: Abbeville, 1986); a modified version appears as chaper 3 in *The Return of the Real* (Cambridge, Massachusetts: The MIT Press, 1996).

30 [162] Crimp, 'The Photographic Activity of Postmodernism', in Howard Risatti, ed., Postmodern Perspectives: Issues in Contemporary Art (Engelwood Cliffs, New Jersey: Prentice-Hall, 1990) 136.

31 [163] Ibid., 139.

32 [164] Clifford Geertz, *Works and Lives: The Anthropologist as Author* (Stanford: Stanford University Press, 1988) 16.

Due to limitations of space it has not been possible to represent the discussion in *Art after Appropriation* of a number of contributions to and modifications of appropriation by artists and groups working with new formations of feminism, border cultures and questions of hyphenated identities; including the work of Orshi Drozdik (discussed in chapter 3: New Bodies: The Medical Venus and the Techno-grotesque, 1993–94); Art Rebate (chapter 5: Public Art and the Spectacle of Money: On Art Rebate/Arte Reembolso, 1993); and Cody Hyun Choi (chapter 8: Culture Cuts: Post-appropriation in the work of Cody Hyun Choi, 1998).

John C. Welchman, extract from 'Introduction. Global Nets: Appropriation and Postmodernity', *Art after Appropriation: Essays on Art in the 1990s* (Amsterdam: Overseas Publishers Association/G+B Arts International, 2001) 1–3; 41–7; 52.

Johanna Burton
Subject to Revision//2004

Amid dozens of artworks stridently addressing the politics of identity at the infamously 'PC' 1993 Whitney Biennial, Glenn Ligon's *Notes on the Margin of the Black Book* took a more elliptical and ambiguous approach. This elegantly conceived structural amendment to Robert Mapplethorpe's original *Black Book* consisted of two rows of individually framed images, appropriated directly from the photographer's controversial series of black male nudes. In the newly expanded 'margin' between the photographs, Ligon inserted all manner of uniformly typed texts on race and sexuality, appropriated from heretofore unrelated commentators, ranging from high theorists and articulate drag queens to conservative politicians and zealous evangelists. Yet what Ligon was really inserting into the margins was himself. Insisting on the double connotation of 'margin', he slyly suggested that as a black, gay artist, he'd always been there anyway, and perhaps we'd all do well to shift our attention to the sidelines. It was there that he claimed a space in which his own ambivalent desires, identifications and resistances might circulate among the desires, identifications and resistances of others: not so much within the pirated images as between them.

Ligon's intervention revealed a potentially deep connection between appropriative practices and investigations of identity, a link that was overlooked during the important early phase of theorizing appropriation in the 1980s – especially as far as an artist like Mapplethorpe was concerned. For if Ligon was able to see in Mapplethorpe's work a latent *point de resistance* at the height of the identity-driven art of the nineties, such potential had not always been obvious. On this point, in 1982, Douglas Crimp, now considered one of the foremost theorists on subjectivity and representation, penned a short essay that he later deemed necessary to amend. Crimp's text, 'Appropriating Appropriation', was an attempt to establish and then contrast two types of appropriative strategies: a modernist appropriation of style and a postmodernist appropriation of material.[1] Crimp deemed the first mode conservative, aligned as it was with traditions of 'aesthetic mastery'. The second was heralded as deconstructive, able, however briefly, to interrupt such modernist discourses. Crimp chose Robert Mapplethorpe and Sherrie Levine to flesh out his argument. Mapplethorpe, he argued, provided an example of the first kind of appropriation since – despite the sometimes explicit content of much of his photography – he appropriated numerous stylistic devices from pre-war studio photography (whether *Vogue* fashion spreads or neoclassical nudes). Levine, on the other

hand, undermined modern myths of mastery by baldly re-presenting high-art images without the camouflage of 'originality'. Rather than join a filial chain of creative genius by taking up and subtly transforming (or even actively refuting) the work of previous generations, she performed a kind of stopgap measure, disabling the smooth mechanisms of artistic legacy.

Looking back on this essay a decade later (coincidentally enough, in the same year that Ligon reread the *Black Book*), Crimp saw that he had neglected the relevance of Levine's position as a female artist who typically seized on allegorical images of those society deemed 'Others'.[2] But even more surprising to the author in retrospect was a radical element of Mapplethorpe's practice that had remained to him as invisible as Poe's purloined letter, hidden in full view. 'What I failed to notice in 1982', Crimp writes in the introductory essay for *On the Museum's Ruins*, 'was what Jesse Helms could not help but notice in 1989: that Mapplethorpe's work interrupts tradition in a way that Levine's does not'.[3] That interruption, Crimp continued, had nothing to do with Mapplethorpe's style, which had seemed to him so cozily aligned with tradition, nor did it depend on appropriating the literal material of other art, as in Levine's approach. Rather, Mapplethorpe's radical interruption was defined by what his images facilitated outside the frame: how they 'momentarily rendered the male spectator a homosexual subject', thus offering the possibility for an active, political, self-defining (defining through desiring) representation of gay subculture.[4]

My reason for rehearsing Crimp's critical double take is relatively simple. In the 1980s, appropriation came to be seen as one particularly effective means to reveal the working mechanisms of various cultural, social and psychic institutions – and thus considerations of subjectivity and identity necessarily surfaced in such deconstructive terrain. Yet these latter exposés, in contrast to those directed at the museum, the media, or structures of signification, were apparently much harder for critics, artists and audiences to see. In fact, an episode similar to Crimp's transpired for Craig Owens, whose canonical essay 'The Discourse of Others' recounts his initial blindness to sexual difference in Laurie Anderson's 1979 *Americans on the Move*. (In part 2 of 'The Allegorical Impulse', his discussion of the semiotic ambiguity of the raised-arm gesture for 'hello' in one of Anderson's slides failed to note that the erect arm of the gesturer – a nude male – could be read in more obvious ways.)[5] But why this blindness? Was Crimp's queer eye eclipsed by the imperatives of institutional critique, and Owens' feminism temporarily trumped by his role as poststructuralist? Were such critical identities not simultaneously habitable? Were considerations of identity and subjectivity seen as incompatible with more 'rigorously' critical enterprises?

As it turns out, such overdetermined exclusions of race, gender and sexuality were not the only omissions to be made in the name of a properly critical

definition of appropriation in the early eighties. Pop art suffered an even more direct disavowal at the hands of Benjamin H.D. Buchloh in his seminal 1982 essay 'Allegorical Procedures: Appropriation and Montage in Contemporary Art'.[6] In that text, Buchloh took pains to reject Pop as a precursor for a number of up-and-coming artists (interestingly enough, all women, though gender is not addressed by the author), including Dara Birnbaum, Jenny Holzer, Barbara Kruger, Louise Lawler, Sherrie Levine and Martha Rosler. Instead, he assigned them an overtly political bloodline – Dada, Productivism, and, later, institutional critique – while completely dismissing Pop as so many 'well balanced and well-tempered modes of appropriation, and the successful synthesis of relative radicality and relative conventionality.'[7]

Yet to refuse Pop – itself considered by some the prodigal offspring of Dada – any significant place in the history of analytical appropriation is to equate arguably 'well-tempered' Pop objects too quickly with some of Pop's more far-reaching, insurgent effects, as well as to assume that a pose of ambiguity holds no promise of critical return. In this regard, one should consider in particular Warhol, since no other artist so successfully synthesized (and thus confused) the radical and the conventional and since his example is a key to any investigation of the intersection between appropriation and subjectivity (a topic, it should be said, that falls outside the parameters of Buchloh's project). It is often argued that Warhol's concept of subjectivity rendered all subjects nonsubjects, merely 'one-dimensional', interchangeable goods. Yet even if (or perhaps because) this is the case, he revealed all identity, including that of the avant-garde, to be perpetually shifting and always for sale, at once constructed and devoured by social and economic forces. While this formulation hardly suggests much subversive potential at first glance, its fundamental turn away from the fiction of stable, normative subjectivity offers some compelling alternatives, particularly to those who actively read themselves as already outside or between the frames of conventional reference. To take just one example, Richard Meyer has recently argued that Warhol took up the very structure of postwar capitalism – its logic of repetition and difference – as a kind of sly metaphor for identity, and, in particular, gay male identity.[8] His camp sensibility and at times homoerotic code reframed 'identity' simultaneously as an index of complicit consumerism and as a potential vehicle for resisting social norms.

It was precisely this ambiguous criticality that compelled Buchloh to cut Pop's limb from appropriation's family tree. For if Pop objects operated as so many 'delicate constructs of compromise' (to adopt one of Buchloh's phrases), then it would surely undo any 'clean' master narrative of decidedly political art – emphasizing instead the ambivalent, even duplicitous nature that is, in fact, inherent in every act of appropriation.[9] So too with considerations of race,

sexuality and gender, which, as evidenced by Crimp and Owens, show how localized identity and subjectivity threatened the comprehensive gamuts of poststructuralist approaches and institutional critique. (It is perhaps worth noting that the Freudian concept of identity is itself defined by compromise, in that the self is produced and maintained by the balanced assimilation and rejection of the properties and attributes of others.) Eighties appropriation, at its best, was deeply invested in precisely these questions – how to disable naturalized master narratives, how to remonstrate the singular and usher in the multiplicitous. To dismiss either Pop or localized identity structures was unintentionally to reinscribe a familiar, ultimately conservative, genealogy – one that did not account for artists' necessarily updated relationship to contemporary culture. After Pop, it was impossible to fantasize a space of resistance outside commodity culture from which to levy critique. Instead, repressive structures were potentially revealed and deconstructed (though also potentially revealed and multiplied) precisely through rapt immersion in and critical consumption of them. However different in effect, the success of both Richard Prince's presentations of masculinity as a handful of well-packaged accoutrements and Barbara Kruger's ventriloquization of coercive stereotypes relied on the artists' decidedly intimate relationships to their subjects. In order to resist the cultural riptides, one needs to plot (however tangentially) one's own longitude and latitude within them. The notion may have been best articulated by Hal Foster in 1982, when he asserted that this approach to culture suggested a model wherein artists treated 'the public space, social representation or artistic language in which he or she intervenes as both a target and a weapon.'[10]

The notion that appropriation might be seen as a mode of revealing language, representation and even social space to be so shape-shifting as to subsist simultaneously as both weapon and target (and thus as both subject and object) still resonates today. Yet rather than deploy appropriated elements of culture as so many sharpened weapons and demarcated targets, a number of artists working now – including Amy Adler, Glenn Ligon, Aleksandra Mir, Francesco Vezzoli and Kelley Walker – recycle them to reveal critically the ways that subjectivity is crafted, consumed and controlled. Most of these artists are interested in redirecting or confusing circuits of exchange rather than jamming them entirely, perhaps having learned the latter's near impossibility. In other words, Foster's weapon-and-target analogy can be usefully amended by adding a drop of Pop's insistence on consumption – and the sometimes unexpected results of digestion. At the risk of sounding any New Age bells, I'd like to think of current practices of appropriation in terms of homeopathy, which treats diseases by administering small doses, as remedy, of what could otherwise be lethal. It is Derrida's famous 'Plato's Pharmacy' that first suggests such a bodily

metaphor as a critically useful deconstructive tool.[11] There, Derrida plays with the Greek concept of *pharmakon* – loosely translated as 'medicine' but defined equally as 'cure' or 'poison'. It is the ambiguity of the *pharmakon* that appeals to the philosopher: if the same substance that destroys the body can also save it, such an opposition is effectively unmoored.[12] Perhaps considering culture itself as a kind of loosely integrated body, we can imagine artists operating within its sphere by sampling and reinjecting its elements in less benign doses – not so much to 'cure' the incurable as to render its symptoms visible, manipulable. Understood this way, homeopathy is the ultimate compromise, literally recalibrating and strengthening by recirculating (or, to recall its contrasting definition, potentially weakening the system from within).

It is, then, somewhat ironic that the concept of compromise best defines the ways in which artists are most compellingly utilizing appropriation today, often with overtly Pop overtones. Lest the word be read as passive (rather than passive-aggressive), let's turn to Mir, one of the more political artists of the day, whose projects nearly always involve collaboration – whether with artists, non-artists, or even entire communities. Mir's work coyly modifies both memories and mores, often in order to point to their underpinnings of class, gender and race. She has temporarily run a cinema for the unemployed (specializing in Hollywood disaster movies) and spectacularly staged the landing of the first woman on the moon (with the help of an enthusiastic crowd, including altruistic construction workers who bulldozed a beach on the Baltic Sea into a lunar setting). In every case, Mir traces meaning back to a complex network of social and psychic concessions, which are at once the site of institutional oppressions and of potential resistance against them. To this end, Mir's 2003 book *Corporate Mentality* examines the pervasive incorporation of art into the sphere of commerce by archiving projects by various artists who take up the corporate structures of late capitalism only to confound them, however subtly.[13] Her ongoing manipulations of and linkages between the mass media and private photography (such as her *Hello* projects and her recent Barthesian manifesto, titled *Finding Photographs*) recall a statement made by Sherrie Levine in reference to some of her own work some twenty years ago: 'I like to think of my paintings as membranes permeable from both sides so there is an easy flow between the past and the future, between my history and yours.'[14] If Mir's and Levine's appropriative methods have anything in common, then, perhaps it is an understanding of the work as a connective tissue, mediating the flow of collective and individual histories – and providing the opportunity to insert oneself, however promiscuously, within them.

Vezzoli and Adler pursue a similar kind of insertion, stitching themselves into the glamorous fabric of celebrity culture. Vezzoli, who often appears in his

own films, themselves rife with intertextual knots, has featured (or, failing that, conjured) divas from Edith Piaf to Bianca Jagger, all of whom serve as camp vessels through which desire loosely circulates. In Vezzoli's most recent work, for the Fondazione Prada in Milan, he pays tribute to his long-standing muse, Pier Paolo Pasolini. For part of the installation, Vezzoli recreated a vintage movie theatre in which his own altered remake of Pasolini's 1964 *Comizi d'Amore* (Love Meetings) was continually screened. Vezzoli would seem to subscribe to Pasolini's belief in film as a kind of nonsymbolic language nimbly attuned to characterizing social realities – but only so long as those realities are always shown to be constructed. For his version of *Comizi d'Amore*, the artist recast the original film as a contemporary reality-TV show, in which four divas – Catherine Deneuve, Jeanne Moreau, Marianne Faithfull and Antonella Lualdi – engage in emotionally detached mating rituals, the scope of which exceeds any gay/straight dichotomy and revels instead in polymorphous perversity. Audience participation is, of course, key but completely inconsequential, and the four women take turns watching as various men, one woman and a drag queen vacuously vie for their affections. The payoff for the winning couple (determined by audience poll) is the opportunity to marry publicly, then consummate. Such overdetermined decadence is typical of Vezzoli, whose attraction to velvet couture and strands of pearls translates into a perfectly fetishistic aesthetic – so many disavowals and recuperations.

No less interested in the malleable patina of glamour and fame, Adler is aware that the slightest of turns can render deeply conventional celebrity images not quite right and thus available as screens for the play of presumably unintended projections. She finds her subjects not in vintage cinema but in teen magazines or on the cover of *People*: River Phoenix, Jodie Foster, Britney Spears, Leonardo DiCaprio. Yet just as often she pictures herself as a conglomerate of everygirl and It Girl, looking just familiar enough to sneak into the universe of pop-cultural imagery. Adler usually begins a work by selecting pre-existing photographs of celebrities or herself, though sometimes snapping pics of her own, and then making drawings after her photographic 'originals' (a contradiction in terms if there ever was one). Next she photographs these drawings, after which point they are destroyed. Thus her drawings merely serve as transit stations between different phases of photographic copies, since they are modelled on and ultimately presented only as photographs. One can discern the influence of Cindy Sherman here, since Adler alludes to the vocabulary of film through her still images, which are nearly always done in series, stressing that the relationship between images is more important than any single one. (In a different, if related, vein it is perhaps no coincidence that both Sherman and Adler created 'centrefolds' when commissioned to do projects for *Artforum*.)

Adler, however, lets her own desires seep into the images she produces; it's hard not to notice that she sees a little of herself in *Leo* or that the guitar chick in the recent exhibitions 'Different Girls' bathes in the glow of more than just house lights. Such willfully contaminated modes of identification (do I want to be Jodie or have Jodie?) pleasurably echo from the *mise en abîme* of Adler's images.

For Walker, there is no *abîme* when it comes to images – only an impossibly flat, ever-increasing stack of them. Walker literally scans the field in which he operates, taking images starkly from their contexts and reinserting them, often awkwardly, back into circulation. Using his scanner as a camera, the artist updates Rauschenberg's 'flat-bed picture plane'. He combines photographic images – pictures of race riots similar to those usurped by Warhol, selections from Benetton's controversial ad campaigns, photos of Martin Luther King – with tactile stuff imported from the realm of the real: streamers of *Crest* toothpaste, cereal boxes, pantyhose and bricks. Walker's digital assemblages foreground the ways in which media images are intended to work as ideological signposts, desire-piquing decoys, or pure propaganda, while testifying to the inherent multifariousness of every such message. This approach is underscored by the potentially unending manipulation of many of Walker's works, which are often sold on CDs with the stipulation that the owner may continue to alter his or her purchase. Walker suggests that nearly every mass-media image partakes in the trafficking of identity, proffering uneven reflective surfaces on which to glimpse ourselves as estranged part-objects. Such a reading is made literal in his multicoloured, mirrored Plexiglas Rorschach splotches, which come off less as keys to the unconscious than as icy allusions to its saleability.

Against the backdrop of this discussion, it is worth returning to the work of Glenn Ligon, who, for a recent series of work, gave 'black-themed' seventies colouring books to schoolchildren, most of whom coloured in figures like Malcolm X with no trace of anxiety over the details of race. The resulting pictures (many of which Ligon took as models for his own full-scale paintings) were weird palimpsests – outlines of ideology undone by the not fully indoctrinated scribbling of a child. Such work draws on many of the artist's earliest ventures, from his well-known minimally painted appropriations of texts culled from all manner of black history (James Baldwin's prose, or Richard Pryor's jokes) to his *Notes on the Margins of the Black Book*. And while Ligon's response to Mapplethorpe was in many ways aligned with Crimp's reassessment of the photographer, it also shows significant differences. Just as Crimp had noted that Mapplethorpe's images offered room for play of desire around their edges, so too did Ligon – though Ligon revealed how less affirmative desires are played out there, as well. And, the question of race, not addressed by Crimp, was taken up explicitly by the young artist, whose response to the nude black body

was neither simply desire nor identification but instead a kind of staged inquiry into the ways in which blackness and sexuality are so often entwined in the cultural unconscious.

Of course, by grouping these artists together as latter-day appropriationists (a term dubiously adopted even in its day), one risks plotting yet another genealogical strand, a family tree in which Warhol is, well, Pop. This is hardly the intention of this essay; rather, by invoking Pop's model of compromise, I have attempted to address its ramifications in some current modes of appropriation, particularly those that call on (or call out) representational strategies of identity. These modes of appropriation, predicated on recycling rather than on out-and-out refutation, are necessarily contaminated and quite often ambiguously intentioned. To this end one recalls Harold Bloom's treatise – addressing not the plastic arts but, rather, Romantic poetry – in which any notion of a respectable genealogy is succinctly sullied. He argued, 'Poetry is the anxiety of influence, is misprision, is a disciplined perverseness. Poetry is misunderstanding, misinterpretation, misalliance. Poetry (Romance) is Family Romance. Poetry is the enchantment of incest, disciplined by resistance to that enchantment.'[15] Warhol as peculiar uncle, then.

1 Douglas Crimp, 'Appropriating Appropriation', in *Image Scavengers: Photography* (Philadelphia: Institute of Contemporary Art, University of Pennsylvania, 1982); reprinted in Crimp, *On the Museum's Ruins* (Cambridge, Massachusetts: The MIT Press, 1993) 126–37.

2 On the allegorical implications of Levine's work see Craig Owens, 'Sherrie Levine at A & M Artworks', *Art in America* (Summer 1982) 148; reprinted in Craig Owens, *Beyond Recognition: Representation, Power, and Culture* (Berkeley and Los Angeles: University of California Press, 1992) 114–16.

3 'Photographs at the End of Modernism', in Crimp, *On the Museum's Ruins*, op. cit., 7.

4 Ibid., 27.

5 Craig Owens, 'The Allegorical Impulse: Toward a Theory of Postmodernism (Part 2)', *October*, no. 13 (Summer 1980) 58–80. Republished in Owens, *Beyond Recognition*, op. cit., 70–87. Owens, 'The Discourse of Others: Feminists and Postmodernism', in *The Anti-Aesthetic: Essays on Postmodern Culture*, ed. Hal Foster (Port Townsend, Washington: Bay Press, 1983) 57–77; reprinted in Owens, *Beyond Recognition*, 166–90.

6 Benjamin H.D. Buchloh, 'Allegorical Procedures: Appropriation and Montage in Contemporary Art', *Artforum* (September 1982) 43–56.

7 Ibid., 46.

8 Richard Meyer, *Outlaw Representation: Censorship and Homosexuality, in Twentieth-Century American Art* (Boston: Beacon Press, 2002) 150.

9 Buchloh, 'Allegorical Procedures', op. cit., 46. The phrase 'delicate constructs of compromise' here refers specifically to Rauschenberg's *Factum I* and *Factum II* as well as Johns' first *Flag*, with

regard to the balance between painterliness and readymade they effected. Yet, given Buchloh's earlier description of American Pop's programme as 'one of liberal reconciliation and successful mastery of the conflict between individual practice and collective production, between the mass-produced imagery of low culture and the icon of individuation that each painting constitutes', I am allowing the phrase to stand more broadly for his conception of Pop.

10 Hal Foster, 'Subversive Signs', in *Recodings: Art, Spectacle, Cultural Politics* (Port Townsend, Washington; Bay Press, 1985) 100. Such a definition of the procedures effected on and by way of culture gave an indication of the artist's changed position – as no longer a 'producer of art objects' but, rather, a 'manipulator of signs'. (Not new to the eighties, such strategies are traced back – as with Buchloh – by Foster to include Duchamp, Broodthaers and Haacke, though he significantly acknowledges the ways in which such an inheritance is markedly recast in the eighties by artists with overt feminist interests.)

11 Jacques Derrida, 'Plato's Pharmacy', in *Dissemination*, trans. Barbara Johnson (Chicago: University of Chicago Press, 1981) 63-171.

12 Apropos of the current argument, Derrida argues that 'the pharmakon is the movement, the locus, and the play: (the production of) difference'. Ibid., 127.

13 Aleksandra Mir, *Corporate Mentality*, ed. Mir and John Kelsey (New York: Lukas & Sternberg, 2003).

14 Quoted in Flisabeth Sussman, 'The Last Picture Show', in *Endgame: Reference and Simulation in Recent Painting and Sculpture* (Cambridge, Massachusetts: The MIT Press, 1986) 61.

15 Harold Bloom, *The Anxiety of Influence: A Theory of Poetry* (Oxford: Oxford University Press, 1973) 95.

Johanna Burton, 'Subject to Revision', *Artforum* (October 2004) 258–62; 305.

Isabelle Graw
Fascination, Subversion and Dispossession in Appropriation Art//2004

VI Appropriation as Subversion; a Criticism of Language; and Replacement
Since the 1980s, scarcely any distinction has been made between 'artistic appropriation' and 'appropriation' in the sense of a fundamental way of relating to the world. The question of what is specifically artistic about appropriation ceases to be valid if appropriation is seen as critical (in the sense of a criticism of language) or subversive per se. The general understanding of Appropriation art is still influenced by this critical-subversive emphasis today; this even goes as far as the current lexical definitions that describe the act of artistic appropriation itself as 'recoding' or a 'shift in meaning'.[1] This means that a shift in meaning takes place purely due to the fact that an original image has been appropriated. The interest in how artistic appropriation takes place did not begin until the end of the 1980s, because then it became necessary to differentiate between 'good' and 'bad' appropriation. With such a large number of artists – such as David Salle, Julian Schnabel, Philip Taaffe, Jeff Koons and Haim Steinbach – all riding the ticket of appropriation, a set of criteria was required. The critic Douglas Crimp, who had more or less 'given birth' to Appropriation art with his legendary exhibition 'Pictures', admitted that critics had made things a little too simple for themselves by maintaining that appropriation was per se critical.[2] The scheme that he now offered, however, was no less arbitrary and also tended to quick conclusions. Crimp suggested that a distinction be made between a simple appropriation of style and an appropriation of the material, whereby the latter was to be accepted and the former rejected. This 'criterion' also seemed to remain abstract, not taking into account the concrete aesthetic phenomena and not making strong enough distinctions. Is it not the case that every 'appropriation' inevitably adapts the style of the original, whatever kind that original might be? And, if style cannot be avoided, what would be so bad about that? Could the appropriation of a style not lead to the open display and emptying out of the style, as is demonstrated in David Salle's pictures in their appropriating reference to Picabia or Polke? The works of Sherrie Levine or Louise Lawler can also be seen to over-answer to a certain extent the style of the art they have appropriated. The fact that the artist might not have an entirely critical and detached view of the originals was an idea that did not easily go hand in hand with the main critical assumption, not least because criticism implies a critical distance. On closer examination, Levine's careful, if not affectionate, copy of a drawing by Egon Schiele indicates

a relationship charged with obsessive fascination, which would presuppose another critical term. This applies equally to Louise Lawler's photographs, which also witness a relationship based on fascination.[3] 'Here, the object is seen both casually, while at the same time through the eyes of a lover. The idiosyncratic, detached perspectives, and pictures of installations which seem to have been taken in passing, and the arbitrary and seemingly abrupt sections all speak for the gaze of a connoisseur.[4] Richard Prince's photos were all the more suspect for progressive critics the more they were clearly indebted to personal fascination, as for example the photos in *Biker Girls*.[5] In the case of Levine the logic of subversion was taken to extremes: even as far as to celebrate her work as theft, and thus to confuse it with a criminal act.[6]

'Confiscation' was another very popular metaphor for appropriation, one that is characteristic in as much as it bestows on the artist the confiscating power of a state authority.[7] This metaphor also marks the lack of interest in the appropriated object.

VII Appropriating Dispossession

It cannot be said often enough that the understanding of appropriation in the 1980s was based on the Marxist interpretation of the term. In retrospect, it really does seem as if capital was deliberately made of the Marxist background, for example when the artist Sherrie Levine was celebrated for the fact that she dispossessed the male artists whose work she appropriated.[8] In the *Manifesto of the Communist Party*, Marx and Engels had proposed the 'abolition of property' as the first measure to be taken,[9] and more than a hundred years later, such a method of dispossession was believed to be possible of artistic works. It was as if Levine had robbed the male artists of their male privileges and their status of genius. Artistic appropriation became a legitimate, in this case feminist motivated, counter-measure. In the same way that the Marxist background played into the understanding of appropriation, the concept of appropriation was also subject to significant changes in the course of its usage in Appropriation art. It increased in value and took a turn for the better. Whereas appropriation had been the central problem of society for Marx – the *Communist Manifesto* contains an appeal to break with existing forms of appropriation – it was now the case that artistic appropriation was ascribed socio-critical power. While for Marx appropriation was simply the form in which exploitation took place, because capital appropriated alienated labour, alienating and dispossessing the workers from their own appropriation of the product of their labour, artistic appropriation of Appropriation art now – under conditions of private property, alienation and totalized spectacle culture – became a legitimate and necessary method: a kind of self-defence. That which Marx believed should be abolished, in order to

achieve 'real appropriation', was now one of the inevitable preconditions that could at least be artistically appropriated.

The objection at this juncture could be, with good reason, that artistic appropriation is something completely different to the Marxist understanding of 'appropriation through labour'. Is it not the case that artists, in contrast to workers, have the possibility to transfer the appropriated object naturally into their work, for which they can then claim authorship? And is their work not in principle less alienated – even under conditions of the art market and the productions of commodities? This is certainly the case, whether artists experience their work as alienating or not. Even those artistic attempts programmatically to stylize art into an externally determined or impersonal venture, such as Conceptual art, ultimately come to be seen as a product of their 'creator'.

Referring to Feuerbach, Marx had pointed out that work could not function without its objects.[10] However, he did not pay any particular attention to these objects or their potential for resistance. Under the conditions of the abolishment of private property, he imagined 'real appropriation', in which the worker would no longer be dispossessed through his or her product and in which alienation was eliminated. The concept of appropriation today also continues to be determined by this ideal of 'real appropriation' – in as much as there was scarce interest in the appropriated objects, with instead a concentration on the appropriating subject of the artist and the question of whether or not this subject had committed the act of appropriation with an affirmative or a critical intention. It was the artistic subject that was important; the subject should also be in the position to give appropriation another (critical and subversive) direction. In other words, this means that the appropriating artist was seen as not only having the power to appropriate particular objects or situations (beyond their concrete resistance and momentum), but in addition, the object or situation that was dispossessed and now appropriated could even experience a transformation of meaning. Appropriation became a method that one assumed would stand up to alienation. This was due to the concept of a strong artistic subject, which ultimately would remain in control of the situation. And yet the signs of alienation, which restricted the power to validity of the subject, were unmistakable. Private property, for example, was more than just intact in New York in the 1980s. This was the period of the real estate boom, frenetic consumerism and high growth rates. Nonetheless, the artist was supposed to be able to master this situation by engaging with it and giving it more potency.[11] The notion of a strategy of surpassing began here, and since then this strategy has been frequently drawn on in art theory debates. This strategy also assumes a powerful artistic subject that fights back using the same methods and attempts to surpass that which it struggles against. It is true that appropriating artists

continue the logic of the appropriated object where appropriate, particularly since the object is approached from an artistic angle. However, here it is also necessary to concede that the object always displays a moment that is extrinsically determined. Yet it is exactly this idea of a confrontation between the subject and its alienation that is played down in favour of a concept of appropriation, which – as had already been the case in Marx – is seen one-dimensionally as a process of 'taking', and, what is more, then goes a step further by claiming that this 'taking' is automatically critical. That artists who appropriate also subject themselves to the object has been blotted out of this scenario, where in the long run only the assets count.

It was the Italian philosopher Giorgio Agamben who further twisted the spiral of appropriation, with his suggestion that alienation itself could be appropriated.[12] He put forward this theory in the book *Means Without End*, raising the possibility that humankind may appropriate their own historical being, their alienation, themselves. Seen from this perspective, the idea of not being in control of oneself is a status quo that cannot be reversed. Appropriation provides the possibility to find a stance vis-à-vis this status quo, to appropriate it. Yet whatever is appropriated in this manner will always remain alienated. According to this, there is no possibility to come to oneself, something that Marx still believed in, and something that was implicitly taken up by the apologists of Appropriation art. On the other hand, this theory makes it possible to work from this point of alienation, to work with it. Alienation becomes a premise that cannot be shaken.

Aside from the questionable tendency to make alienation a kind of law of nature, this model has the advantage of being able to draw appropriation and alienation together and take into account the fact that they are interdependent. Numerous artists in the 1990s have used this as a starting point, by either appropriating the alienated identity that has been ascribed to them (Renée Green), or by allowing the boundaries between the real and the alienated to constantly shift, as Andrea Fraser does in her performances. In the end, however, these options remain within the logic of property that Marx wanted to abolish. Are they therefore ultimately accomplices of the idea that capitalism is here to stay? To propose this would amount to assuming an intention, which artistic work cannot be reduced to in any case. These approaches rather represent an attempt to find a productive attitude toward a situation that no one believes can be unilaterally changed. After all, this situation has influenced us all too. But at that moment when it is artistically appropriated, and an attitude toward it is found, something has changed. What has actually changed can only be determined by investigating concrete, specific works. In a society that is based on private property – and it is this kind of society that we are dealing with at the

moment – it appears that there is no way around this 'appropriation of dispossession'. [...]

1 [footnote 22 in source] The entry on 'Appropriation Art', in *Prestel Lexikon: Kunst und Künstler im 20. Jahrhundert* (Munich et al., 1999) 20 (translated).

2 [23] Douglas Crimp, 'Das Aneignen der Aneignung', in *Über die Ruinen des Museums* (Dresden and Basel: 1996) 141. See also Isabelle Graw, 'Der Kampf geht weiter: Ein Interview mit Douglas Crimp über Appropriation Art', *Texte zur Kunst*, no. 46 (June 2002) 34–44.

3 [24] See the following comments by Louise Lawler in conversation with Douglas Crimp. Here a relationship of fascination may be assumed, although of course the artist's statements are not to be taken as the 'truth' or the 'meaning'. Image, text and programmatic statements are to be seen as forms of artistic articulation that belong together, without having to be treated on one, intertextual, level: 'When I am working, I take lots of pictures. It's a way of working that's fairly flatfooted in that I have a sense that something is worthwhile documenting, but the pictures that work are those that are affecting in some other way'. It is clearly the pictures that affect the artist that are the pictures that work.

4 [25] See Isabelle Graw, 'Leistungsnachweise: Cindy Sherman, Barbara Kruger, Sherrie Levine, Louise Lawler', in *Die bessere Hälfte: Künstlerinnen des 20, und 21. Jahrhunderts* (Cologne: 2003) 64–78.

5 [26] See Isabelle Graw, Interview with Richard Prince, *Texte zur Kunst*, no. 46 (June 2002) 44–60.

6 [27] See Douglas Crimp, 'Pictures', in Brian Wallis, ed., *Art After Modernism: Rethinking Representation* (New York: 1984) 185: 'Levine steals them [the works of art] away from their usual place in our culture and subverts their mythologies'.

7 [28] See Craig Owens, 'The Allegorical Impulse: Toward a Theory of Postmodernism. Representation, Appropriation and Power': 'Allegorical imagery is appropriated imagery; the allegorist does not invent images but confiscates them'.

8 [29] See Craig Owens, 'The Discourse of Others: Feminists and Postmodernism', in Ibid., 182: 'She expropriates the appropriators'.

9 [30] See Karl Marx and Friedrich Engels, 'Manifest der Kommunistischen Partei 1848', in Iring Fetscher, ed. *Karl Marx, Friedrich Engels. Studienausgabe*. vol. 3 (Frankfurt/Main, 1990) 59–89.

10 [31] See Karl Marx, 'Ökonomisch-philosophische Manuskripte' (1844), in *Studienausgobe*, vol. 2, 38–128.

11 [32] See Jean Baudrillard, 'Die absolute Ware' in *Die fatalen Strategien* (Munich: 1991) 144–8.

12 [33] See Giorgio Agamben, 'The Face', in *Means Without End: Notes on Politics* (Minneapolis: 2000) 91–100.

Isabelle Graw, extract from 'Dedication Replacing Appropriation: Fascination, Subversion and Dispossession in Appropriation Art', in George Baker, et al., *Louise Lawler and Others* (Ostfildern-Ruit: Hatje Cantz, 2004) 59–64.

Sven Lütticken
The Feathers of the Eagle//2005

Barthesian Thefts

Around 1980, Richard Prince and Sherrie Levine 'rephotographed', respectively, contemporary ads and historical masterpieces of photography, while Louise Lawler photographed works of art installed in museums or collectors' homes, or at auction houses. Critics – most notably Douglas Crimp and Hal Foster – regarded these artists as Barthesian mythologists who 'steal' and subvert media myths: 'Drawn to pictures whose status is that of a cultural myth, Levine discloses that status and its psychological resonances through the imposition of very simple strategies ... [she] steals them away from their usual place in our cultures and subverts their mythologies'.[1] Although it may be slightly crude, this Barthesian discourse – by now part of appropriation art's history – can also serve as the starting point for a more differentiated discussion.

As is well known, the 'myths' studied and criticized by Roland Barthes in *Mythologies* (1957) were examples in the media of a bourgeois ideology that transformed history into nature, hijacking signs and giving them a saturated surplus meaning. Myth was a second-degree semiotic system grafted onto a first-degree one. The image of a black soldier saluting, presumably before the French flag, had a second, 'mythical' meaning beyond the literal one: it signified that France was a great nation, its principles were universal, and people of different races gladly pledged allegiance to it.[2] Barthes defined his mythology as a synthesis of two sciences: semiology and ideology – the latter possessing a historical dimension, unlike semiology.[3] Founded during the French Revolution by Destutt de Tracy to enable rational inquiry into the human mind and ideas, the science of ideology was a fruit of the Enlightenment's reassessment of knowledge and beliefs. Ideology's roots 'lie deep in the Enlightenment dream of a world entirely transparent to reason, free of the prejudice, superstition and obscurantism of the *ancien régime*'.[4]

Yet, of course, the term 'ideology' came to stand for the opposite, in the curious inversion of meaning that seems to beset words ending in '-ology', as Terry Eagleton has pointed out: psychology has become a synonym for psyche, and ideology has come to stand for dogmatic beliefs and false consciousness – the very things that should be investigated by 'ideologists'. Sometimes the two meanings coexist: 'psychology' can refer both to the psyche and to the discipline devoted to the study of it; 'mythology' can mean both a group of myths and the systematic study of myths and mythologies (in the first sense of the term). It is no

coincidence that the eighteenth century saw the rise of a discipline of mythology as the critical study of myths. The Enlightenment needed myth as its other, or negative *Doppelgänger*. While mythology as a discipline deals primarily with myths in ancient Greece, Egypt or contemporary non-Western cultures, ideology is the science of the modern, apparently post-mythical world. If this was a discourse that often led to various depreciations of non-Western cultures, it could also lead to a critique of Western culture itself. To someone like Destutt de Tracy – who wrote an extensive text about that monument of French Enlightenment mythology, Dupuis' *Origine de tous les cultes* – it was painfully clear that irrational religious sentiments and political misconceptions were far from extinct.[5] Hence it is also not surprising that Barthes positions himself as a mythologist of modern media.

Some time ago, when the Kunst-Werke in Berlin planned an exhibition on 'Mythos RAF' – devoted to artistic and media responses to the Red Army Faction – the German press and political elite went into a state of collective hysteria, having apparently read the term 'myth' not in Barthes' sense but in line with the Romantic view of it as a poetic force sadly lacking in the modern world. From this point of view, speaking of the myth of the RAF seemed tantamount to glorifying terrorism. But while Romantic ideas of mythology generally look back to historical examples, bemoaning their absence in the modern age, the tradition descending from the Enlightenment sees myth everywhere. Here the idea of myth, as the Other of reason, increasingly loses its moorings in concrete narratives about gods or heroes, issuing into a generic conception according to which anything can become a myth or be infected by it. Adorno and Horkheimer deploy a particularly grim version of this idea in their famous analysis of the reversal of modern rationality into myth; Barthes sees 'bourgeois myth' everywhere in the 1950s media. At a certain point in *Mythologies*, he remarks that our mentality is still pre-Voltairean; it is, in other words, still riddled with myth, and a second Enlightenment is needed.[6] But Barthes is also close to Lévi-Straussian structuralism and the notion that some sort of logic, however harmful, is inherent in 'mythic thought', which can therefore be submitted to structural analysis.

By presenting his *Mythologies* project as part of a second Enlightenment, Barthes appears to subscribe to a simplistic ideal of complete rationality and 'transparent communication', seeing the Other of reason as something to be completely eradicated. However, in the end he develops a more dialectical model of a practice that involves hijacking myth in its turn. 'Since myth robs us, why not rob myth?'[7] This would result in a 'true mythology', Barthes claims, and one can scarcely wonder that the defenders of appropriation art have latched onto this, since this 'true mythology' could be an artistic as well as a theoretical project. One of his most important models, after all, was a literary one – Flaubert's last

unfinished novel, *Bouvard et Pécuchet*, perhaps the book he invoked most often throughout his career. Barthes presents this sardonic portrayal of a certain segment of the nineteenth-century bourgeoisie as an experimental 'second-degree myth'.[8] With the mature Flaubert, literary composition became a matter of rewriting, copying, appropriating. Breaking with the romantic model of the writer as a divinely inspired seer, he developed a merciless art of second-degree writing by quoting and paraphrasing material from a wide variety of sources. But whereas Flaubert's attitude was one of conservative, sneering retreat, Barthes tried to turn Flaubertian language-theft into a progressive strategy.

Barthes' list of terms and their definitions in *Mythologies* is clearly modelled in part on the *Dictionnaire des idées reçues*, a catalogue of clichés that Bouvard and Pécuchet were presumably to compile from various sources at the end of Flaubert's unfinished novel, recording the human follies in which they themselves indulged so freely. In the *Dictionnaire*, clichés of the nineteenth-century bourgeois *Weltanschauung* are distilled into sardonically minimal sentences. In *Mythologies*, Barthes clearly attempted something similar with his enumeration of cyclists and the 'African Grammar' ('God. – Sublimated form of the French government).[9] Through his use of Flaubert, Barthes hints at a true mythology in which logos and mythos criticize, transform and liberate each other. *Mythologies* does not claim to be an example of this 'true mythology'. It is a vision of something else, of a practice that goes beyond *Mythologies*, a promised land occasionally glimpsed but perhaps never to be reached. Appropriation art too is more promise than achievement; it can only hope to achieve at least some degree of success if it is as obsessive as Flaubert's oeuvre, and follows a less than transparent logic.

Divine Spirit, Conquest, Imperialism

Appropriation art's link with Barthesian mythology does not begin in New York in the late 1970s. Marcel Broodthaers' seminal exhibition 'Der Adler vom Oligozän bis heute' ('The Eagle from the Oligocene to the Present'), held in Düsseldorf in 1972, was a direct artistic response to the challenge posed by *Mythologies* by an artist who, according to his contemporaries, studied Barthes' book extensively. The exhibition – consisting of the *Section des Figures* of his Musée d'Art Moderne, Département des Aigles – contained numerous images of eagles in all media, two- and three-dimensional, from various eras and ranging from high art to kitsch. The eagle is a creature of the air laden with mythical connotations but also a real animal, not merely a product of the mythopoeic imagination. Zeus' pet is perfect material for demonstrating how an object can be appropriated by myth and subjected to 'always the same meaning on different levels – comparable to the circles of a bird in flight: grandeur, authority, power. Divine spirit. Spirit of

conquest. Imperialism'.[10] At the 1972 Documenta, the exhibition was followed by the *Section Publicité* of the Musée d'Art Moderne, which contained photos and slide projections of eagles on various products. In his article 'Adler Pfeife Urinoir' ('Eagle, Pipe, Urinal') – of which Broodthaers published an extract in the catalogue of his eagle show – the anthropologist Michael Oppitz claimed that the German Mark had a 'mythical surplus value' that made it embody German prosperity or the *Wirtschaftswunder*. The Mark of course sported the *Bundesadler*, the federal eagle. Oppitz claims that Broodthaers 'defuses' the mythical power of the eagle by multiplying eagles and also showing the 'weak derivatives' of the German national emblem in the logotypes of various organizations and wrappings for 'deutsche Markenprodukte'. 'In the constant interconnections suggested by the serial arrangement, the eagles are made to part with their mythical feathers'.[11]

Broodthaers concurred with this reading, but noted that the mythic eagle was alive and well in advertising: 'The language of advertising targets the unconscious of the spectator-consumer, and so the magical eagle regains his power ... I have pulled some feathers from the mythical eagle. But in advertising it remains intact, as aggressive as is necessary'.[12] He also provided the kind of statement of intent that is appreciated by those who like their art critical: 'It can be easily ascertained that I wanted to neutralize the use-value of the eagle symbol, to reduce it to its zero degree in order to introduce a critical dimension into the history and use of this symbol'.[13] This is the stern theoretical face of Broodthaers. But his amassment of eagles is also an absurd and hilarious exercise of a Flaubertian type. Having absorbed Barthes' ideology critique, Broodthaers tried to create a 'true mythology' that would use the exhibition space and catalogue as second-degree media in which the poetic becomes critical and vice versa.

In analysing myth, Barthes focused on the additive aspect: myth is, as it were, grafted onto a text or image that remains outwardly intact.[14] Thus, such an addition is also a negation; it cancels actual or potential meanings that do not square with the naturalizing tendency of myth. The result is an outwardly identical second sign that is inflected by mythical connotations; the historicity and complexity of the – hypothetical – first representation is largely undone. In turn, intimations of a 'true mythology' would have to negate the coherence and closure of myth and (re)introduce different meanings. But this would not necessarily lead to literal appropriation.

Photographs and Readymades

In *Mythologies* Barthes analyses images as well as writings, but just as there are no long quotations, there are no illustrations, no direct visual appropriations. The images are represented only through descriptions. But then Barthes advocated stealing myths rather than specific images or texts. If a true mythology is a meta-

language that uses myth as its signified, this does not necessarily mean that texts or images have to be used wholesale. The mythologist might, on the contrary, want to extract the myth from its host or hosts and condense it into a few lines or paragraphs. Yet one can defend the interpretation of appropriation in Barthesian terms. Placing an image or a text – or a fragment of one – in a new context can make the myth which it 'hosts' explicit. This kind of practice became common in visual art rather than in literature, once the avant-garde had made the simple 'taking' of a pre-existing object or image a valid artistic act. It can be argued that photography served as an important model for this: the camera facilitates the two-dimensional appropriation of objects, and in this respect Duchamp's readymades can be seen as a radical manifestation of a culture informed by photography.[15]

In later writings, particularly in 'Eléments de sémiologie' (1964), Barthes recasts the distinction between first- and second-degree (mythical) semiological systems as the difference between denotation and connotation.[16] This is also the idiom of the famous reading of photographic ideology in pasta advertisements that he developed in 'Rhetoric of the Image', an essay of the same year. According to Barthes, photographs appear at first sight to be pure denotation, identical to 'things as they are'. Connotation is disguised by the illusion that the photographic image is completely natural. In this sense photography is the mythic medium par excellence; indeed, one could posit photography as the basis of Barthes' model in *Mythologies*, which employs the fiction of a purely denotative first-degree sign that is then 'infected' by mythical connotations. In photography, Barthes showed that connotation is introduced through cropping, composition and captions – as in the Panzani pasta advertisements, where everything is made to signify a cliché of Italianness.[17] When first published, 'Rhetoric of the Image' was accompanied by a full-page colour plate of the advertisement: in the era of Pop art and Situationist *détournements*, Barthes revealed himself a rephotographer *avant la lettre*, who underscored his analysis by appropriating the image in question. Artistic appropriation then as it were scraps Barthes' analysis (or takes it as read), its effect mainly depending on changes of context. Rephotography and other forms of photo-based appropriation turn photography's naturalizing tendency against itself by making apparent the images' constructed and coded character.

In the catalogue to the 1972 eagle exhibition, Broodthaers acknowledged Duchamp's readymades – as well as Magritte's famous pipe painting – as crucial precursors. While modernist movements tried to purge art of representational elements, foregrounding the formal properties of the visual sign, readymades are ordinary objects which serve as their own representation through alteration of context and negation of their original function; in the process they accrue strangely solipsistic surplus meanings. A subcategory of Duchamp's readymades

consists of appropriated industrial images such as the kitsch landscape print of *Pharmacy* (1914) or the Mona Lisa postcard of *L.H.O.O.Q.* (1919). Here, the negated and represented element is already a representation, already the negation of presence. Broodthaers too used images as readymades, but these ranged from photographs and slides to rare and precious artefacts. It was above all in the catalogue that all his images became compatible as mechanical reproductions. When he moved on to the *Section Publicité* at the 1972 Documenta, photography became dominant, the whole presentation essentially consisting of a slide show and mounted photographs. With the *Section Publicité*, Broodthaers moved further away from the appropriation of images as objects to the appropriation of images through photography (or in some cases rephotography).

Art which aims to reflect on media myths by a conceptual use of photography risks becoming mythified itself. The myth it embodies is that of a 'critical' art which a priori differs from other commodified images. This quasi-Barthesian misconception accompanied classical appropriation art, and is still alive and well: when the RAF exhibition finally opened in Berlin – rechristened 'Zur Vorstellung des Terrors' (Representing Terror) – the critic Tom Holert took the curators to task for presenting the artist Hans-Peter Feldmann as the prototype for practitioners who take on myth by 'singling out', 'monumentalizing', 'reprivatizing', 'filtering' and 'distancing' what the media produce. The effect, he thought, was to idealize the relation between art and mass media.[18] Here a Situationist critique of the art world was required: by pretending to 'purify' media images, art disavows its own implication in spectacle. While the current art world freely indulges in Situationist chic, its art of negation – which uses and perverts Barthes and Broodthaers by assuming its appropriations are automatically critical – has forgotten this lesson. [...]

The dialectical whims of appropriation have barely begun to be examined. The theories of myth that informed the various discourses and practices considered here are in many ways anachronisms in contemporary intellectual life. But a critical re-evaluation and reactivation of the historical forms of mythological critique, and of artistic mythology, could help break open this present and regain the initiative. Time is running out. At the very moment that contemporary consumers are celebrated as happy hackers, ever more fundamentalist copyright legislation is creating taboos that will make even partial and ephemeral realizations of a true mythology of difference extremely difficult.

1 [footnote 7 in source] Douglas Crimp, 'Pictures' (1977/79), in Brian Wallis, ed., *Art after Modernism: Rethinking Representation* (New York: New Museum of Contemporary Art/Boston: David R. Godine, 1984) 185.

2 [8] Roland Barthes, *Mythologies* (1957) (Paris: Seuil, 1970) 189.

3 [9] Ibid., 185.

4 [10] Terry Eagleton, *Ideology: An Introduction* (London and New York: Verso, 1991) 64.

5 [11] Antoine-Louis-Claude Destutt de Tracy, *Analyse raisonnée de 'l'Origine de tous les cultes du Religion Universelle'; Ouvrage publié en l'an III, par Dupuis, Citoyen français* (Paris: 1804).

6 [12] Barthes, *Mythologies*, op. cit., 63.

7 [13] Barthes, *Mythologies*, op. cit., 209; quoted by Hal Foster in a discussion of appropriation art in *Recodings: Art, Spectacle, Cultural Politics* (Seattle: Bay Press, 1985) 169.

8 [14] Barthes, *Mythologies*, op. cit., 209–10.

9 [15] Barthes, *Mythologies*, op. cit., 130.

10 [16] Marcel Broodthaers, 'Section des figures' (1972), in *Marcel Broodthaers par lui-même*, ed. Anna Hakkens (Ghent: Ludion, 1998) 90.

11 [17] Michael Oppitz, 'Adler Pfeife Urinoir', in *Der Adler vom Oligozän bis heute*, vol. 2 (Düsseldorf: 1972) 20–21. This extract has been stripped of the more 'technical' Barthesian parts. The complete text (signed Mark Oppitz) appeared in *Interfunktionen*, no. 9 (1972) 177–80.

12 [18] Broodthaers, 'Section des figures', in *Marcel Broodthaers par lui-même*, op. cit., 91.

13 [19] Broodthaers, 'Le Degré zéro' (1973), in Ibid., 95.

14 [20] Barthes, *Mythologies*, op. cit., 194–204.

15 [21] On photography and the readymade see Rosalind Krauss, 'Notes on the Index: Part 1' in *The Originality of the Avant-Garde and Other Modernist Myths* (Cambridge, Massachusetts: The MIT Press, 1985) 196–209.

16 [22] Barthes, 'Eléments de sémiologie', in *Communications*, no. 4 (1964) 99–134. See also, in the bibliography of this publication, the description of the project of *Mythologies* as a theory of mass-media myths defined as '*des langages connotés*' (137). Barthes is one of the authors of this bibliography, and is no doubt responsible for this subtle reformulation of this earlier project.

17 [23] Barthes, 'Rhétorique de l'image', in Ibid., 40–51.

18 [24] Tom Holert, 'Enzyklopädisches Sammelsurium', *Jungle World*, no. 6 (9 February 2005), available at www.jungle-world.com

Sven Lütticken, extract from 'The Feathers of the Eagle', first published in *New Left Review*, no. 36 (November–December 2005) 109–25; reprinted in Sven Lütticken, *Secret Publicity: Essays on Contemporary Art* (Rotterdam: NAi Publishers, 2006) 111–18; 125.

Biographical Notes

Malek Alloula is a Paris-based Algerian-born writer whose books include *Le Harem colonial, images d'un sous-érotisme* (1981; *The Colonial Harem*, 1986) and, with Khemir Mounira and Elias Sanba, *Alger photographiée au XIXè siècle* (2001).

Louis Aragon (1897–1982) was a poet and writer closely associated with the Surrealist movement at its inception in the early 1920s, parting company in 1935 due to their divergent respective positions on the cultural role of communism. His surrealist meditation on the city, *Paysan de Paris* (*Paris Peasant*, 1926) included typographic replicas of signs and notices encountered in the street. From 1953 to 1972 he was director of *L'Humanité*'s literary supplement, *Les Lettres françaises*.

Jean Baudrillard (1929–2007) was a French cultural and social theorist and philosopher. His works include *Le système des objets* (1968), *Pour une critique de l'économie du signe* (1972; *For a Critique of the Political Economy of the Sign*, 1981), *Simulacres et simulations* (1981; *Simulations*, 1983), *Cool Memories* (1987) and *The Conspiracy of Art* (2005).

Walter Benjamin is a well-known philosopher and theoretician of art history, whose work has addressed the issues of originality and reproduction. Many years after his tragic death he reappeared in 1986 to hold the lecture Mondrian '63-'96 at the invitation of the Marxist Center in Ljubljana, and he appeared again the following year on the TV Gallery in Belgrade.

Nicolas Bourriaud is a French art theorist and curator who introduced the term 'relational aesthetics' in texts such as his catalogue introduction to the *Traffic* group exhibition at capcMusée d'art contemporain, Bordeaux (1995). His essays are collected in *Esthétique relationelle* (1998; *Relational Aesthetics*, 2002) and *Postproduction* (2002).

André Breton (1896–1966), the French poet and intellectual, worked in a psychiatric ward for shell-shocked soldiers in 1917. There he and fellow medics and writers Philippe Soupault and Louis Aragon first encountered the traumatic states of altered consciousness that were formative to the investigations and politics of the Surrealist movement they co-founded with other writers and artists at the start of the 1920s. Appropriated photographs, imagery and objects were central to Surrealism, from the group's first periodical *La Révolution surréaliste* (1924–29) onwards.

Katrina M. Brown is Curator at Dundee Contemporary Arts, Scotland. She is the author of a monograph on Douglas Gordon (2004) and co-editor, with Rob Tufnell, of *Here and Now: Scottish Art, 1990-2001* (2001).

Benjamin H.D. Buchloh is the Franklin D. and Florence Rosenblatt Professor of Modern Art, Harvard University, an editor of *October* and a contributor to *Artforum*. His books include a first volume of collected writings, *Neo-Avantgarde and Culture Industry: Essays on European and American Art from 1955 to 1975* (2001).

Johanna Burton is an art historian and critic who teaches at the Center for Curatorial Studies, Bard College, and the School of the Arts, Columbia University, New York. She is the author of *Cindy Sherman* (2006) and a regular contributor to journals such as *Artforum* and *Grand Street*.

Deborah Cherry is Research Professor in the History of Art at Central Saint Martins, University of the Arts, London, and Editor of *Art History*. Recent books include *Local/Global: Women's Art in the*

Nineteenth Century, co-edited with Janice Helland (2005).

Douglas Crimp is Professor of Art History, Visual and Cultural Studies at the University of Rochester. An early exponent of postmodernist criticism in the 1980s, he was among the founders of the discipline of visual studies. His works include *On the Museum's Ruins* (1993), *AIDS: Cultural Analysis/Cultural Activism* (1998) and *Melancholia and Moralism* (2002).

Thomas Crow is Rosalie Solow Professor of Modern Art at the New York University Institute of Fine Art. His books include *Painters and Public Life in Eighteenth-Century Paris* (1985), *Modern Art in the Common Culture* (1996) and *The Rise of the Sixties: American and European Art in the Era of Dissent* (1996).

Guy Debord (1931–94), the French writer, theorist and filmmaker, formed the Situationist International with the artist Asger Jorn and others in 1957. His books include *La Société du spectacle* (1967; *Society of the Spectacle*, 1970); *Commentaires sur la société du spectacle* (1988; *Comments on the Society of the Spectacle*, 1990); and the edited collection *Guy Debord and the Situationist International* (ed. Tom McDonough, 2002).

Georges Didi-Huberman is an art historian and theorist who teaches at the École des Hautes Études en Sciences Sociales, Paris. His books include *Fra Angelico: Dissemblance and Figuration* (1995) and *Invention of Hysteria: Charcot and the Photographic Iconography of the Salpêtriére* (2003)

Marcel Duchamp (1887–1968) was an independent French artist and chess player, associated with Dada and Surrealism. From 1913 his readymades and from *c.* 1945 his concepts such as the 'infra-slim' influenced aspects of Fluxus, Pop, performance and conceptual art. Retrospectives include Pasadena Museum of Art (1963) and Philadelphia Museum of Art (1987).

Paul Éluard (Eugène Émile Paul Grindel, 1895–1952) was a French poet who first met André Breton and Louis Aragon in 1918 and was a member of the Surrealist group at its official launch in 1924.

Okwui Enwezor is Dean of Academic Affairs and Senior Vice President at San Francisco Art Institute. A poet, art historian and curator, he was Artistic Director of Documenta 11, Kassel, Germany (1998–2002) and the 2nd Johannesburg Biennale (1996–1997), among numerous other projects. He is founder and editor of the critical art journal *Nka: Journal of Contemporary African Art.*

Gustave Flaubert (1821–80), the French writer and novelist, first conceived of the *Dictionnaire des Idées reçues* around 1850. It was in note form at his death and was edited and published posthumously in 1911–13. Its form introduced an ambivalent mode of satire, examining clichés and platitudes by appropriating them.

Jean-Luc Godard has been since the early 1960s arguably the most influential French film director, critic and theoretician of cinema. Among the key periods in his filmmaking career are those known as the New Wave (1959–67), the Dziga-Vertov Group (1968–72) and the Second Wave (1979–88). Based in Switzerland he has continued to produce groundbreaking work such as the *Histoire(s) du cinéma* (1988–98).

Jean-Pierre Gorin is a French film director and professor of film history, editing and scriptwriting at the University of California at San Diego. During Jean-Luc Godard's 'revolutionary' period, Gorin co-founded with him the socialist-idealist Dziga-Vertov cinema group (1968–72). They co-directed a number of the films outlining its politics, including *Tout va bien* (1972).

Isabelle Graw is a Berlin-based art critic and founding editor of the Cologne-based international art

journal *Texte zur Kunst.* Her writing on contemporary art has been published in many international art journals, including *Parkett, Artforum* and *Flash Art.*

Johan Grimonprez is a Belgian-born artist who works in Brussels and New York, most noted for his video collage *Dial H-I-S-T-O-R-Y,* shown at Documenta X, Kassel in 1997, which examines the representation of aeroplane hijackings, and *Looking for Alfred* (2007), which explores Hitchcock's cameo appearances in his films via doppelgängers, deceptions and simulations.

Boris Groys is a philosopher, art critic, media theorist and expert on late-Soviet postmodern art and the Russian avant-garde. He has written extensively on the philosophy and politics of new media, on installation art, and on individual artists such as Ilya Kabakov. He is Global Distinguished Professor of Russian and Slavic Studies at New York University.

Raoul Hausmann (1886–1971) was one of the leading members, as an artist and writer, of the Berlin-based section of Dadaism from 1917 to the mid 1920s. His work included photomontage, assemblage and text imagery. Retrospectives include Berlinische Galerie, Berlin (1994).

Barbara Kruger is an American artist and critical writer based in New York and Los Angeles internationally known since the early 1980s for her text and photograph montages which address positions and dynamics of power in society. Retrospectives include The Museum of Contemporary Art, Los Angeles (1999). She is a Professor at the University of California at Los Angeles.

Sherrie Levine is a New York-based artist who first gained critical attention in 1981 with her rephotography of reproductions of photographs by Walker Evans and others re-presented as simulacra. She has more recently investigated the readymade. Group exhibitions include 'The Last Picture Show: Artists Using Photography 1960–1982', Walker Art Centre, Minneapolis (2003).

Lucy R. Lippard is an American art historian, writer and curator who was closely associated with the emergence of conceptualism and feminism in the 1960s and 1970s. Her books include *Six Years: The dematerialization of the art object from 1966 to 1972 ...* (1973; revised edition 1997).

Sven Lütticken is an Amsterdam-based art historian and critic. He is the editor of the journal *De Witte Raaf* and regularly contributes to exhibition catalogues, journals and periodicals such as *Artforum, New Left Review, Afterimage, Camera Austria* and *Texte zur Kunst.*

Cildo Meireles is a Brazilian artist based in Rio de Janeiro who was a pioneer of Latin American conceptual art and later of installation in the 1970s. Solo exhibitions include the New Museum of Contemporary Art, New York (1999; retrospective, touring to Museu de Arte Moderna, Rio de Janeiro; Museu de Arte Moderna, São Paulo) and Tate Modern, London (2008).

David A. Mellor is Professor of History of Art at the University of Sussex, England. An authority on post-war British art, he has written extensively on this subject and has collaborated with the Arts Council of England, the Tate and Barbican galleries, London, in presenting new perspectives on British visual culture through a series of exhibitions and publications.

Kobena Mercer is a London-based critic and writer on art and culture. He is the author of *Welcome to the Jungle: New Positions in Black Cultural Studies* (1994) and editor of *Cosmopolitan Modernisms* (2005), *Discrepant Abstraction* (2006), *Pop Art and Vernacular Cultures* (2007) and *Exiles, Diasporas and Strangers* (2008) in the series Annotating Art's Histories: Cross-Cultural Perspectives in the Visual Arts.

Slobodan Mijuskovic is a historian of modern art who teaches in the philosophy department of the University of Belgrade. His books include a study of Malevich (1980) and *From Self-Sufficiency to the Death of Painting (Art theories /and practice/ of the Russian Avant-Garde* (1998).

Laura Mulvey is a British theorist of film and experimental filmmaker whose key texts include 'Visual Pleasure and Narrative Cinema' (1975) and the essays collected in *Visual and Other Pleasures* (1989) and *Death 24 x a Second: Stillness and the Moving Image* (2006). She is Professor of Film and Media Studies at Birkbeck College, London.

Michael Newman is Associate Professor of Art History, Theory and Criticism at the School of the Art Institute of Chicago. He is the author of *Richard Prince: Untitled (couple)* (2006) and was the co-editor with Jon Bird of *Rewriting Conceptual Art* (1999). He has contributed to numerous catalogues and periodicals including *Z/G, Parachute, Artforum* and *Art in America*.

Miguel Orodea has written on Latin American cinema and was director of the documentary *Letter to Spain* (1989) about the lives of Spanish migrants to Britain during the Franco era.

Richard Prince is an American artist whose early work of the late 1970s introduced the rephotography of existing photographs from advertising posters and other found sources. Retrospectives include the Whitney Museum of American Art, New York (1992). Selected works can be viewed online at his website www.richardprinceart.com

Jorma Puranen is a Finnish photographer, internationally known for his series of works *Imaginary Homecoming, Language is a Foreign Country, Shadows, Reflections* and *Icy Prospects*, which explore cultural memory through images reappropriated from archival sources. He is Professor of Photography at the University of Art and Design, Helsinki.

Retort is an informal collective of writers, artists and activists, based for the past two decades in the San Francisco Bay Area, which has organized around and published on political issues and events. In 2005 the collective members Iain Boal, T.J. Clark, Joseph Matthews and Michael Watts published the book *Afflicted Powers: Capital and Spectacle in a New Age of War*.

Lucy Soutter is a Senior Lecturer in Photography at The London College of Communication, and is an artist, art historian and critic. She writes for publications including *Afterimage, Portfolio* and *Source*. Her artist's books are in the collections of The Museum of Modern Art, New York, and The National Art Library, Victoria & Albert Museum, London.

Jo Spence (1934–92) was a British photographer, socialist and feminist who became a leading figure in politicized photography practice. In her work documenting her treatment for cancer she led the way to a transformation in the patient/doctor relationship and the right to choose alternative medicine. Retrospectives include Museu d'Art Contemporani de Barcelona (2005). Her work was included in 'Protest and Survive', Whitechapel Gallery (2000) and Documenta 12, Kassel (2007).

John Stezaker is a London-based artist whose work investigates the effects and meanings of imagery mediated through collage and photomontage, often with reference to Surrealism. He was included in Aperto, Venice Biennale (1982), 'Simulacra', Riverside Studios, London (1983) and the Tate Triennial, Tate Britain, London (2006). Solo exhibitions include Kunstverein, Munich (2005).

Susan Stoops has since 1999 been Curator of Contemporary Art at the Worcester Art Museum, Worcester, Massachusetts, and teaches at Massachusetts College of Art and Design. Exhibitions

she has curated include 'Staged! Contemporary Photography by Gregory Crewdson, Rosemary Laing and Sharon Lockhart (2002) and 'Martha Rosler: Bringing the War Home' (2008).

Elisabeth Sussman is Curator and Sondra Gilman Curator of Photography at the Whitney Museum of American Art, New York, and the author of numerous monographs and catalogue essays. Among the Whitney exhibitions she has curated are 'William Eggleston: Democratic Camera' (2008), 'Nan Goldin: I'll Be Your Mirror' (1996) and 'Mike Kelley: Catholic Tastes' (1991).

Gene R. Swenson (1934–69) was a New York-based writer and art critic who rose to prominence at the start of the 1960s when he became closely involved with the emerging generation of Pop artists. From 1961 to 1965 he was as an editorial associate at *ARTnews* and is particularly remembered for his 'What is Pop Art?' series of interviews with artists.

Lisa Tickner is Professor Emerita of Art History at Middlesex University and Visiting Professor at the Courtauld Institute, London University. In addition to numerous articles on the history and theory of art, she is the author of *Dante Gabriel Rossetti* (2003) and *Modern Life and Modern Subjects: British Art in the Early Twentieth Century* (2000).

Reiko Tomii is a New York-based independent art historian and curator who investigates post-1945 Japanese art in global and local contexts. As well as publishing numerous essays, articles and translations, she curated the Japanese sections of 'Global Conceptualism', Queens Museum of Art, New York (1999) and 'Century City', Tate Modern, London (2001).

Jeff Wall is a Canadian artist based in Vancouver whose work since the 1970s has explored dialogues between photography and pictorial narrative in painting and cinema. Solo exhibitions include Galerie nationale du Jeu de Paume, Paris (1995), Whitechapel Gallery, London (1998), Museum für Moderne Kunst, Frankfurt am Main (2001), Schaulager, Basel; Tate Modern, London (2005).

Andy Warhol (1928–87), among the most influential artists of the Pop, Minimal and Conceptual era in the 1960s and 1970s, used serial repetition of appropriated images in his work from 1962 onwards. Retrospectives include The Museum of Contemporary Art, Los Angeles (2002). The most extensive collection and archive of his work is at the Warhol Museum (www.warhol.org).

John C. Welchman is Professor of Modern Art History at the University of California at San Diego. His books include *Modernism Relocated: Towards a Cultural Studies of Visual Modernity* (1995) and *Art After Appropriation: Essays on Art in the 1990s* (2001). He is editor of *Rethinking Borders* (1996) and two volumes of the artist Mike Kelley's writings: *Foul Perfection: Essays and Criticism* (2003) and *Minor Histories: Statements, Conversations, Proposals* (2004).

Gil J. Wolman (1929–95) was a French artist, writer and agitator who, with Isidor Isou, founded the Lettrisme movement in 1950 and, with Guy Debord, the Internationale Lettriste in 1952, which was succeeded by the Internationale Situationiste in 1957. In the early 1950s he made experimental films such as *Atochrone* (1951), which reversed the cinematic process by breaking up a second into 24 parts, and the imageless film *L'Anti-concept* (1952).

Bibliography

Further Reading. For the anthology bibliographic references please see citations at the end of each text.

Adamowicz, Elsa, *Surrealist Collage in Text and Image: Dissecting the Exquisite Corpse* (Cambridge: Cambridge University Press, 1998)

Appignanesi, Lisa, ed., *Postmodernism* (ICA Documents series) (London: Institute of Contemporary Arts/Free Association Books, 1989)

Burton, Johanna, ed., *Cindy Sherman* (Cambridge, Massachusetts: The MIT Press, 2006)

Appropriation Now! Special issue of *Texte zur Kunst*, no. 46 (June 2002)

Buchloh, Benjamin H.D., 'Allegorical Procedures: Appropriation and Montage in Contemporary Art', *Artforum*, vol. 21, no. 1 (September 1982)

Campbell, David and Durden, Mark, *Variable Capital* (Liverpool: Liverpool University Press, 2008)

Enwezor, Okwui, *Archive Fever: Uses of the Document in Contemporary Art* (New York: International Center of Photography, 2007)

Erjavec, Ales, ed., Postmodernism and the Postsocialist Condition: Politicized Art under Late Socialism (Berkeley and Los Angeles: University of California Press, 2003)

Evans, David, 'Brecht's War Primer: The "Photo-Epigram" as Poor Monument', *Afterimage*, vol. 5, no. 30 (March–April 2003)

Evans, David, 'The Situationist Family Album', *History of Photography*, vol. 2, no. 29 (Summer 2005)

Foster, Hal, *The Anti-Aesthetic: Essays on Postmodern Culture* (Seattle: Bay Press, 1983)

Groys, Boris, Hollein, Max and Fontán del Junco, Manuel, eds, *Total Enlightenment: Moscow Conceptual Art 1960-1990* (Ostfildern Ruit: Hatje Cantz, 2008)

Jones, Amelia, ed., *A Companion to Contemporary Art since 1945* (Oxford: Blackwell, 2006)

Kihm, Christopher, 'Performance in the Age of its Re-enactment', in *Contemporary Performances*, special issue of *Art Press*, vol. 2, no. 7 (November–December–January 2008)

Langford, Martha, 'Strange Bedfellows: Appropriations of the Vernacular by Photographic Artists', *Photography & Culture*, vol. 1, no.1 (July 2008)

Lee, Ann, *Appropriation: A Very Short Introduction* (Oxford: Oxford University Press, 2008) [Lulu.com]

Müller, Heiner, 'On Heartfield' in Pachnicke, Peter and Honnef, Klaus, eds, *John Heartfield* (New York: Harry N. Abrams, 1992)

Nelson, Robert S., 'Appropriation' in Nelson, Robert S., and Schiff, Richard, eds, *Critical Terms for Art History* (Chicago: University of Chicago Press, 1996)

Newman, Michael, *Richard Prince: Untitled (couple)* (London and Los Angeles: Afterall Books/Cambridge, Massachusetts: The MIT Press, 2006)

Owens, Craig, *Beyond Recognition: Representation, Power and Culture*, ed. Scott Bryson, Barbara Kruger, Lynne Tillman and Jane Weinstock (Berkeley and Los Angeles: University of California Press, 1992)

Roberts, John, *The Intangibilities of Form: Skill and Deskilling in Art After the Readymade* (London and New York: Verso, 2007)

Root, Deborah, *Cannibal Culture: Art, Appropriation and the Commodification of Difference* (Boulder, Colorado: Westview Press, 1996)

Ross, David A., ed, *Between Spring and Summer: Soviet Conceptual Art in the Era of Late Communism* (Cambridge, Massachusetts: The MIT Press, 1990)

Schneider, Arnd, 'Appropriations' in Schneider, Arnd, and Wright, Christopher, eds, *Contemporary Art and Anthropology* (Oxford: Berg Publishers, 2006)

Sladen, Mark and Yedgar, Ariella, eds, *Panic Attack! Art in the Punk Years* (London and New York: Merrell, 2007)

Spector, Nancy, ed., *Richard Prince* (New York: Solomon R. Guggenheim Museum, 2007)

Sussman, Elizabeth, ed., *On the Passage of a few people through a brief moment in time: The Situationist International 1957–1972* (Cambridge, Massachusetts: The MIT Press, 1989)

Taylor, Brandon, *Collage: The Making of Modern Art* (London: Thames & Hudson, 2004)

Teitelbaum, Matthew, ed., *Montage and Modern Life 1919–1942* (Cambridge, Massachusetts: The MIT Press, 1992)

Walker, John A., *Art in the Age of Mass Media* (London: Pluto Press, 2001)

Wallis, Brian, ed., *Art After Modernism: Rethinking Representation* (New York: New Museum of Contemporary Art, 1984)

Ziff, Bruce, and Rao, Pratima V., eds, *Borrowed Power: Essays on Cultural Appropriation* (New Brunswick: Rutgers University Press, 1997)

Index

Aaron, Henry 'Hank' 88

Abramovic, Marina 16

Adams, Mac 100

Adler, Amy 22, 208-11

Adorno, Theodor 16, 220

Agamben, Giorgio 217

Akasegawa, Genpei 15, 45-7

Alberro, Alexander 62n4

Alloula, Malek 19

Althusser, Louis 18, 19, 108, 115, 181

Álvarez, Santiago 16-17, 34, 56-7

Anderson, Laurie 77, 206

Apollinaire, Guillaume 179

Aragon, Louis 15

Arendt, Hannah 72

Armleder, John 160-61, 162

Arnatt, Keith 100

Askevold, David 200

Atta, Mohammed 72-3

Bach, Johann Sebastian 166, 167

Bag, Alex 158

Baldessarri, John 102

Baldwin, James 211

Barker, Thomas Jones 132-3

Barnwell, Ysaye Maria 124

Barr, Alfred, Jr. 149, 150

Barrie, Ray 18

Barry, Robert 77

Barthes, Roland 12, 13, 14, 18, 22, 87, 108, 110,
 166, 189, 219-24, 225n16

Baselitz, Georg 21, 184

Bataille, Georges 22, 32, 195-6, 197, 199

Battcock, Gregory 50, 88

Baudelaire, Charles 124, 128

Baudrillard, Jean 13, 18, 87, 88, 89, 108, 113,
 122, 178

Beech, Dave 174

Beethoven, Ludwig van 166, 167

Belmondo, Jean-Paul 164

Benglis, Lynda 161

Benjamin, Walter 13, 16, 32, 33, 93, 108, 144,
 183, 184, 186

'Benjamin, Walter' (Slovenian artist), 149-52

Berlau, Ruth 33

Bernabé, Jean 137

'Bernstein, Cheryl' 87, 88, 89

Beuys, Joseph 184

Bickerton, Ashley 13

Bidlo, Mike 88

Birnbaum, Dara 207

Bleckner, Ross 92, 94

Bloom, Barbara 195

Bloom, Harold 212

Blossfeldt, Karl 166, 167

Boone, Mary 112

Bourriaud, Nicolas 20-21, 172-3, 174

Brando, Marlon 53

Braque, Georges 27

Brauntuch, Troy 12, 76, 94

Brecht, Bertolt 15, 32-3, 41, 68, 71, 108

Breitz, Candice 158

Breton, André 31

Broodthaers, Marcel 22, 195, 202n6, 221-4

Brooks, Rosetta 102

Buchloh, Benjamin H.D. 13, 16, 21, 22, 207,
 213n9

Buffet, Bernard 161

Bulatov, Eric 153

Bulloch, Angela 158, 159

Buren, Daniel 43, 145, 181

Burgin, Victor 18, 95, 96, 99, 101, 109

Burton, Johanna 22

Bush, George W. 61, 170

Bush, John Ellis ('Jeb') 1

Campus, Peter 77

Caravaggio (Michelangelo Merisi da

Caravaggio) 166

Castro, Fidel 68

Celant, Germano 142

Cézanne, Paul 149, 150

Chamoiseau, Patrick 137

Chaplin,Charlie 29

Chateaubriand, François-René, vicomte de 72

Cherry, Deborah 19

Chicago, Judy 109

Chirico, Giorgio de 85

Clemenceau, Georges 36

Clinton, Bill 68

Cocteau, Jean 66

Colomina, Beatriz 62

Confiant, Raphaël 137

Copernicus, Nicolaus 151

Cravan, Arthur 27

Crimp, Douglas 12, 18, 21, 22, 94, 100, 200, 201-
2, 205, 206, 208, 211, 214, 219

Custer, George Armstrong 66

Dalí, Salvador 31

D'Annunzio, Gabriele 38

Darwent, Charles 172

David, Catherine 17

de la Tour, George 33

De Stael, Nicolas 161

Dean, James 121

Debord, Guy 13, 15, 17, 67, 71, 108, 172-3

Deleuze, Gilles 196

DeLillo, Don 67

Deller, Jeremy 16

Deneuve, Catherine 210

Derrida, Jacques 124, 208-9, 213n12

Destutt, Antoine-Louis-Claude, comte de Tracy
219, 220

Dibbets, Jan 101

DiCaprio, Leonardo 210

Djordjevic, Goran 143

Douglas, Kirk 53

Douglas, Stan 171

Ducasse, Isidore *see* Lautréamont, Comte de

Duchamp, Marcel 15, 26n, 27, 28, 31, 51, 145,
179, 181, 182, 183, 185, 223-4

Dupuis, Charles François 220

Duval, Jeanne 124

Eagleton, Terry 219

Eisenhower, Dwight D. 120

Eisenstein, Sergei 33, 35, 68

Engels, Friedrich 215

England, Lynddie 61

Enwezor, Okwui 19, 20

Ernst, Max 159

Fagen, Graham 169

Faithfull, Marianne 210

Falconetti, Maria (Renée Jeanne) 53

Fanon, Frantz 133

Fautrier, Jean 161

Fedorov, Nikolai 155

Feldmann, Hans-Peter 224

Feuchtwanger, Lion 33

Feuerbach, Ludwig Andreas 216

Fisk, Robert 20

Flaubert, Gustave 15, 220-21

Fonda, Henry 52

Fonda, Jane 16, 52, 53, 55

Fontana, Lucio 161

Ford, John 52

Foster, Hal 201, 208, 213n10, 219

Foster, Jodie 210, 211

Foucault, Michel 14, 67, 87, 89, 172

Fraser, Andrea 195, 217

Freud, Sigmund 97, 108, 122-3, 166, 167

Fried, Michael 76, 77, 78

Galton, Francis 21, 167

Gautier, Théophile 128

Geertz, Clifford 202

Gehry, Frank 189, 190, 191

Giacometti, Alberto 31

Gidal, Peter 120

Gilroy, Paul 133

Giorno, John 158

Gish, Lillian 53

Glissant, Édouard 133, 134

Godard, Jean-Luc 16, 17, 34, 164

Goebbels, Joseph 33

Goering, Hermann 33

Goldstein, Jack 12, 76, 78, 94

Gordon, Douglas 21, 158, 163-5, 171

Gorin, Jean-Pierre 16, 17

Graham, Dan 15, 43-4, 77

Graham, Martha 159

Graves, Michael 189, 190, 191

Graw, Isabelle 22

Green, Renée 195, 217

Greenberg, Clement 90, 109

Griffith, D.W. 37

Grimonprez, Johan 17, 67-8

Grosz, George 148

Groys, Boris 20, 153-5

Guattari, Félix 196

Guitry, Sacha 38

Gutenberg, Johannes 47

Haacke, Hans 195

Haeberle, Ronald 50n

Halley, Peter 13, 18, 88, 89-90, 92, 94

Harris, Wilson 133

Harry, Debbie 121

Hausmann, Raoul 15, 59

Heartfield, John 20, 59, 116, 173

Heidegger, Martin 87

Helms, Jesse 206

Herder, Johann Gottfried von 33

'Herron, Hank' 87-90

Hewlett, Robert 171

Himid, Lubaina 124, 125

Hitchcock, Alfred 101, 165

Hitler, Adolf 33

Höch, Hannah 59

Hockney, David 102

Hofmann, Hans 186

Holert, Tom 224

Holzer, Jenny 207

Horkheimer, Max 220

Howard, Ken 169

Howson, Peter 169

Huebler, Douglas 160

Huillet, Danièle 189

Huyghe, Pierre 158, 171

Ingres, Jean-Auguste-Dominique 15

Irigaray, Luce 109, 110

Israel, Nico 170

Jagger, Bianca 210

Johns, Jasper 185

Judd, Donald 79n4, 159

Jung, Carl Gustav 96, 97

Kabakov, Ilya 153

Kahlo, Frida 121

Kandinsky, Wassily 186

Kawara, On 161

Keaton, Buster 29

Kelley, Mike 22, 159, 160, 162, 196-201, 203n20

Kelly, Mary 18

Khaled, Leila 68

Khan, Idris 21, 166-8

Kiefer, Anselm 92

King, Martin Luther 211

Kitson, Linda 169

Klein, Yves 161, 184

Komar, Vitaly 153

Koons, Jeff 13, 166, 214

Kosuth, Joseph 145

Krauss, Rosalind 79n5, 94, 101

Kristeva, Julia 202n1
Kruger, Barbara 18, 19, 94, 101, 111-17, 207, 208
Kuleshov, Lev 53

Lacan, Jacques 18, 108
Lacenaire, Pierre-François 66
Lafreniere, Steve 12
Langlands & Bell (Ben Langlands and Nikki Bell) 169
Lapicque, Charles 161
Lautréamont, Comte de (pseud. of Isidore Ducasse) 28, 35
Lavier, Bertrand 160, 161-2
Lawler, Louise 191, 207, 214, 215, 218n3, 219
Lawson, Thomas 99
Ledoux, Claude-Nicolas 189
Lenin, Vladimir 154
Leonardo da Vinci 167
Lerski, Helmar 30
Lévi-Strauss, Claude 14
Levine, Sherrie 12, 14, 18, 21, 76, 88-9, 92, 94, 101, 103n21, 166, 189, 190, 191, 205-6, 207, 209, 214-15, 219
Lewensberg 161
Lichtenstein, Roy 93, 184, 185
Ligon, Glenn 22, 205, 206, 208, 211
Linker, Kate 99-100
Lippard, Lucy 17
Lomax, Yve 18, 110
Long, Richard 77
Longo, Robert 12, 76, 94
Lowry, Joanna 171-2
Lualdi, Antonella 210
Lueg, Konrad 185
Lütticken, Sven 22
Luxemburg, Rosa 72
Lynes, George Platt 191

McCarthy, Joe 121
McEvilley, Thomas 144

Maciunas, George 183
McLean, Bruce 100, 101
McQueen, Steve 21, 169-74, 175n6
Magritte, René 223
Malcolm X (Malcolm Little) 211
Malevich, Kazimir 88, 89, 145
Mallarmé, Stéphane 78
Man Ray 190
Manzoni, Piero 184
Mao Zedong 47
Mapplethorpe, Robert 21, 22, 189, 190, 191, 205, 206
Marden, Brice 89, 92
Mariani, Phil 117
Marx, Karl 54, 215-16, 217
Matisse, Henry 145, 147, 149, 150
Matté, Rudolph 164
Meireles, Cildo 17
Melamid, Alexander 153
Mellor, David A. 18
Melville, Jean-Pierre 161
Mercer, Kobena 19
Merinoff, Dimitri 191
Merleau-Ponty, Maurice 87
Meyer, Richard 207
Miles, Jonathan 82
Milton, John 69, 70
Mir, Aleksandra 22, 208, 209
Miró, Joan 88
Mondrian, Piet 144, 149
Monet, Claude 32, 33
Monroe, Marilyn 121-2
Moreau, Jeanne 164, 210
Morgan, Stuart 163
Morris, Robert 77
Moskowitz, Robert 79, 103n21
Mosquera, Gerardo 194
Mozart, Wolfgang Amadeus 166, 167
Müller, Heiner 20, 71
Mulvey, Laura 19

Muybridge, Eadweard 166, 167

Nadar, Félix 124
Nairn, Tom 131
Nauman, Bruce 77
Newman, Barnett 88, 89, 92
Newman, Michael 14, 18
Nietzsche, Friedrich 72
Nixon, Richard 53, 54
Noguchi, Isamu 159

Oppenheim, Dennis 99
Oppitz, Michael 222
Orodea, Miguel 17
Orttonen, Martta 136
Owens, Craig 13, 14, 22, 206, 208

Pakula, Alan 52
Pelechian, Artavazd 34
Phillips, Christopher 16
Phoenix, River 210
Piaf, Edith 210
Picabia, Francis 21, 27, 28, 181, 186, 187, 214
Picasso, Pablo 27, 50n, 96, 149, 150
Piper, Keith 19, 131-4
Poe, Edgar Allan 206
Polke, Sigmar 21, 92, 183-7, 214
Pompidou, Georges 53
Poons, Larry 161
Preminger, Otto 164
Presley, Elvis 153-4
Prince, Richard 12-15, 18, 21, 83-6, 94, 100, 101, 102, 166, 192, 193, 200, 201, 208, 215, 219
Proudhon, Pierre-Joseph 54
Pryor, Richard 211
Puranen, Jorma 19

Rainer, Yvonne 77
Rauschenberg, Robert 150, 179, 180, 185, 192, 193, 211

Ray, Nicholas 164
Redon, Odilon 102
Rembrandt van Rijn 32, 40
Renger-Patzsch, Albert 30
Renoir, Pierre-Auguste 28
Retort 17-18, 69-73
Richter, Gerhard 21, 34, 184-5
Richter, Hans 148
Rilke, Rainer Maria 101
Robespierre, Maximilien 38
Roche, G. 135
Rohmer, Éric 164
Roosevelt, Franklin D. 53
Root, Deborah 202n1
Rosenthal, Joe 20, 139
Rosler, Martha 17, 58-62, 207
Rothenberg, Susan 79
Rugoff, Ralph 202-3n7
Rumsfeld, Donald 69
Ryman, Robert 89

Saddam Hussein 61
Sade, Marquis de 196
al-Sadr, Muqtada 61
Saint-Just, Louis de 35
Salle, David 21, 92, 94, 100, 189, 214
Sand, George 37
Sander, August 30
Sands, Bobby 171
Sartre, Jean-Paul 87
Schama, Simon 136
Schiele, Egon 88, 214
Schmit, Tomas 183
Schnabel, Julian 214
Schwitters, Kurt 148
Scott, Ridley 82
Seawright, Peter 169
Sebald, W.G. 34
Sekula, Allan 167
Serra, Richard 77

Sex Pistols 131

Sherman, Cindy 13, 19, 21, 100-101, 118-23, 192, 193, 200, 210

Siegel, Don 161

Simma, Per 135

Simmons, Laurie 192

Smith, Gill 169

Smith, Philip 12, 76, 94

Smithson, Robert 77

Solzhenitsyn, Alexander 53

Soutter, Lucy 21

Spears, Britney 210

Spence, Jo 18, 173

Spielberg, Steven 164

Stalin, Joseph 154

Stanislavsky, Constantin 52

Stanwyck, Barbara 164

Stein, Gertrude 149, 150

Steinbach, Haim 197, 198, 203n20, 214

Steinbeck, John 52

Stella, Frank 87, 88, 89, 92

Stephanson, Anders 19

Stezaker, John 18, 82, 95-8, 101-2, 103n21

Stiechen, Edward 190

Stoops, Susan 17

Straub, Jean-Marie 189

Sulter, Maud 19, 124-5

Sussman, Elizabeth 13

Sutherland, Donald 52

Syberberg, Hans Jürgen 189

Sylvester, David 163

Taaffe, Philip 88, 92, 214

Tacitus 72

Tarantino, Quentin 161

Tarkovsky, Andrei 158

Teitelbaum, Matthew 16

Tickner, Lisa 18-19

Tiravanija, Rirkrit 158

Tretiakov, Sergei 33

Truffaut, François 164, 165

Vaisman, Meyer 13

Valentino, Rudolph 53

Vercruysse, Jan 161

Verhagen, Marcus 174

Vernet, Horace 128

Vertov, Dziga 16, 17, 53, 56-7, 68

Vezzoli, Francesco 22, 208, 209-10

Victoria, Queen 171

Vidal-Naquet, Pierre 72

Walcott, Derek 133

Walker, Alice 124

Walker, Kelley 22, 208, 211

Wall, Jeff 15

Wallis, Brian 59

Wandja, Jan 82

Warburg, Aby 32

Warhol, Andy 15, 22, 41-2, 90, 93, 111, 112, 158, 180, 184, 185, 207, 211, 212

Wayne, John 52-3, 164

Wearing, Gillian 171

Weiner, Lawrence 77

Welch, Raquel 53

Welchman, John 21-2

Weston, Edward 21, 94, 191

Whitfield, Sarah 171, 172, 175n6

Williamson, Judith 103n9

Wilson, Fred 195

Winnicott, D.W. 198-9

Wittgenstein, Ludwig 87

Wolman, Gil 15

Woo, John 161

Woodrow, Bill 169

Yates, Marie 18

ACKNOWLEDGEMENTS

Editor's acknowledgements

Special thanks to Iwona Blazwick, Ian Farr, Hannah Vaughan, Katrina Schwarz and Caraline Douglas at the Whitechapel Gallery; and to Iain Boal, David Campany, Michael Chanan, Patrizia Di Bello, Mark Durden, Byron Evans, Stephanie James, Nina Kirk, Franck Knoery, Michael Krejsa, Annet Kuska, Erica Levin, Tara McDowell, Kris Paulsen, Frédérique Poinat, Paul Roberts, Marc Silberman, Karen Vanmeenen and Richard West. Thanks also to the Arts Institute at Bournemouth for a research fellowship that allowed me to complete this project.

Publisher's acknowledgements

Whitechapel Gallery is grateful to all those who gave their generous permission to reproduce the listed material. Every effort has been made to secure all permissions and we apologize for any inadvertent errors or ommissions. If notified, we will endeavour to correct these at the earliest opportunity.

We would like to express our thanks to all who contributed to the making of this volume, especially: Malek Aloulla, Nicolas Bourriaud, Katrina M. Brown, Benjamin H.D. Buchloh, Johanna Burton, Michael Chanan, Deborah Cherry, Douglas Crimp, Thomas Crow, Okwui Enwezor, Robert Fisk, Isabelle Graw, Johan Grimonprez, Boris Groys, Peter Halley, Georges Didi-Huberman, Ken Knabb, Barbara Kruger, Sherrie Levine, Lucy R. Lippard, Sven Lütticken, Cildo Meireles, David A. Mellor, Kobena Mercer, Slobodan Mijuskovic, Laura Mulvey, Michael Newman, Hans-Ulrich Obrist, Richard Prince, Jorma Puranen, Retort, John Roberts, John Stezaker, John-Paul Stonard, Susan Stoops, Elisabeth Sussman, Lisa Tickner, Reiko Tomii, Jeff Wall, John C. Welchman. We also gratefully acknowledge the cooperation of: ADAGP/The Estate of Marcel Duchamp; *Afterimage*; AK Press; *Artforum*; *ARTnews*; *Camerawork Quarterly*; Éditions José Corti; *Flash Art International*; Éditions Galilée; The Estate of Raoul Hausmann; *Index Magazine*; Lapis Press; Moderna galerija Ljubljana; The MIT Press; *New Left Review*; Oxford University Press; Les Presses du réel; Jo Spence Memorial Archive; University of Minnesota Press; *Revolver*; *Source*; *Tel Quel*.

Whitechapel Gallery

whitechapelgallery.org

Whitechapel Gallery is supported by